MW01062794

UNSPEAKABLE ACTS

Also by Nancy Princenthal:
Agnes Martin: Her Life and Art

UNSPEAKABLE ACTS
WOMEN, ART, AND SEXUAL VIOLENCE IN THE 1970s

NANCY PRINCENTHAL

 Thames & Hudson

Unspeakable Acts © 2019 Thames & Hudson Inc.

Designed by DeMarinis Design LLC
Jacket design by Gabriele Wilson

First published in 2019 in the United States of America by
Thames & Hudson Inc., 500 Fifth Avenue, New York, New York 10110

www.thamesandhudsonusa.com

Library of Congress Control Number 2019934255

First published in 2019 in the United Kingdom by
Thames & Hudson, Ltd, 181A High Holborn, London, WC1V 7QX

www.thamesandhudson.com

British Library Cataloguing-in-Publication Data:
A catalogue record for this book is available from the British Library

ISBN 978-0-500-02305-1

Printed in China by Reliance Printing (Shenzhen) Co. Ltd.

Artwork by Yoko Ono © Yoko Ono, Ana Mendieta © The Estate of Ana Mendieta Collection, LLC, and Nancy Spero © The Nancy Spero and Leon Golub Foundation for the Arts: Images courtesy of Galerie Lelong & Co., New York. Artwork by Suzanne Lacy: Images courtesy of Suzanne Lacy Studio. Artwork by Joyce J. Scott: Images courtesy of Goya Contemporary Gallery, Baltimore. *Tapp-und Tast-Kino*: © 2019 Artists Rights Society (ARS), NY/Bildrecht, Vienna. Photo courtesy of Pomeranz Collection (pommeranz-collection.com). *Cut Piece*: Photo by Minoru Niizuma. *Broad Jump*: Image courtesy of Maria Acconci. *The Mythic Being*: © Adrian Piper Research Archive Foundation, Berlin. *Torture of Women*: Licensed by VAGA at Artists Rights Society (ARS),NY. *Lucretia:* The Minneapolis Institute of Art: The William Hood Dunwoody Fund. *Interior*: Philadelphia Museum of Art: The Henry P. McIlhenny Collection in memory of Frances P. McIlhenny, 1986-26-10. *Sexual Murderer(Der Lustmörder)*: © 2019 Artists Rights Society (ARS), NY/VG Bild-Kunst, Bonn Photo. Photo: bpk Bildagentur/ Volker-H. Shneider/Art Resource, NY. *A Funny Thing Happened*: © Sue Williams: Image courtesy of 303 Gallery, NY. *Lustmord*: © 2019 Jenny Holzer, member Artists Rights Society (ARS), NY. Photo: Courtesy Jenny Holzer/Art Resource, NY. *Gone*: ©Kara Walker, courtesy of Sikkema Jenkins & Co., NY. Kara Walker: My Complement, My Enemy, My Oppressor, My Love, Hammer Museum, LA, 2008. Photo: Joshua White. *The Day After Rape: Gathering Water*: Collection of Amy Eva Raehse & David Tomasko. *Me as Muse*: © Mickalene Thomas/ Artists Rights Society, NY, 57.5 × 106.25 × 32 in., 146.1 × 269.9 × 81.3 cm overall MTVD16-007.1. *And Nothing Happened:* © Naima Ramos-Chapman.

for Joseph

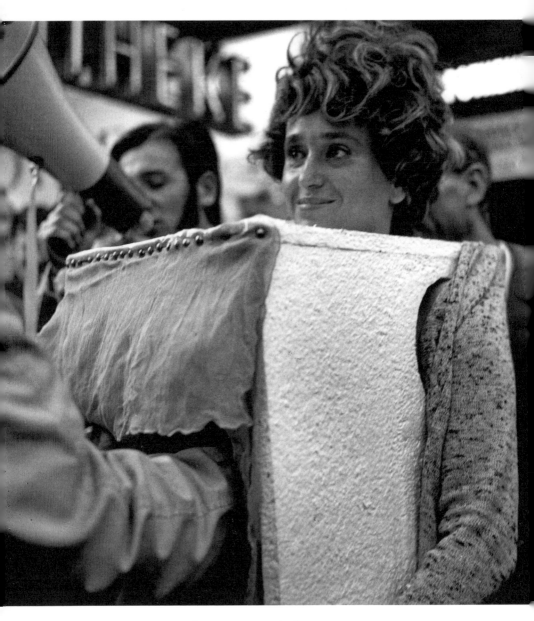

TAPP- UND TAST-KINO (TAP AND TOUCH CINEMA) Vienna, 1968

VALIE EXPORT

© 2019 Artists Rights Society (ARS), New York / Bildrecht, Vienna.

Photo: Courtesy of Pomeranz Collection (pomeranz-collection.com)

BODY LANGUAGE

"'What if,'" Suzanne Lacy asked Judy Chicago in 1970, "'we brought an audience into a theater, lowered the lights, and simply played audio tapes of women recounting, in elaborate detail, the story of their rape?' Neither of us had ever heard women talking personally to each other about these things, let alone to an audience,"[1] she later wrote. "You have to remember that in 1970 you could not find stories of women who were raped."[2] To broadcast these experiences, even if only anonymously, to an audience of strangers, was radical—to a degree nearly incomprehensible now, in an age where memoir is the default means of cultural expression, and trauma its dominant narrative. Yet this is what the two pioneering West Coast artists and activists encouraged a group of women to do for a shattering 1972 performance called *Ablutions*, breaching a cultural silence with testimony that was as straightforward as it was devastating. From there, the conversation has only gotten more complicated.

If we are going to talk about sexual violence, we will have to come to terms with what it is. This is harder than it seems. Acts of gendered aggression range from workplace coercion and everyday harassment to vicious and even fatal physical attacks by intimates and by strangers. All have been called rape, and no form of violence is more susceptible to redefinition by shifting cultural forces. In the spectrum of dramatic injury—of harm organized for maximum emotional as well as physical impact—sexual violence occupies a uniquely potent, and unstable, place. Tricky to define, sexual offenses are even more difficult to depict.

Popular culture, with its warp-speed feedback loops, has long dominated the understanding of sexual violence, affecting perpetrators and victims alike. We've all seen the movie, the TV show, the video clip; we've read the article, the post, the tweet. This is how it's done, we learn. This is how it feels. It is no contradiction to add that the commercial media's view of sexual violence has always been distorted, favoring sensationalism over factual or emotional honesty.

But artists, almost by definition, challenge popular formulations. They give shape to experiences we don't quite know how to picture or name. The pioneering women artists who explored sexual violence in the 1970s had a wide-open arena, and plenty to say. We are enormously in their debt; slowly, mainstream culture has been learning to pay attention. This book addresses the contributions of these pioneers (and also the work that influenced and succeeded theirs) and proposes that we can move forward with something more than a sense of awe at their courage and ingenuity.

While I was writing it, I was often told that I had hit upon an especially timely subject. In truth, there have been screaming headlines for decades about such assaults—in the military and in religious institutions, in schools and within families; indeed any place where power is unequally distributed. Yet some moments are decisive. The seventies was one. It was an era of extraordinary violence in the United States, from urban crime to political protest, the latter a form of street theater that was fast turning deadly. War had long since become a theater, too, in more ways than one; the protracted conflict in Vietnam was the first to be televised, an exceptionally ugly conflict played out on home screens in real time. At the same time, the emergence of second-wave feminism, and the reconfiguration of relations between men and women wrought by the "sexual revolution," together with a dramatically rising incidence of rape, thoroughly reshaped attitudes about sexual assault.

The early seventies also marked a turning point for art. At a time when Minimalist and Conceptual precepts, brawny processes, and industrial materials prevailed, and when not only personal experience but nameable content of any kind was looked at askance, progressive women artists turned things inside out. With embodiment as their fundamental premise, newly emboldened women stripped themselves naked, literally and emotionally. Taking their bodies as subjects meant exploring physical life in the positive, active sense—celebrating what women do, both routinely and exceptionally—and also the reverse: looking closely and honestly at the things that have been done to us, eternally and without recognition, much less accountability. Restoring personal meaning to art and finding a language to talk about embodied experience were inseparable goals.

For several reasons, confronting sexual violence was not the first challenge undertaken by women artists of the time, nor was it an early concern of second-wave feminism—although once addressed, it came to exemplify the feminist art movement. And as many writers in several disciplines have argued, finding language for violence is the first step in mitigating its effects. If actions have meaning—if communication occurs—they are not purely evil, says literary critic Terry Eagleton. "Evil is supremely pointless," he writes.[3] And similarly, "Pure autonomy is a dream of evil."[4] Extending that insight by arguing that the sense of selfhood is fundamentally interpersonal—in other words, that we define ourselves in relation to others—feminist theorist Judith Butler has recently argued, "Violence is, always, an exploitation of that primary tie . . . in which we are, as bodies, outside ourselves and for one another."[5] With physical or emotional injury, "human vulnerability to other humans is exposed in its most terrifying way, a way in which we are given over, without control, to the will of another."[6] It is a point that psychiatrist Judith Herman had made with respect to trauma—a term not nearly as widely used in the 1970s

as it has become (nor was post-traumatic stress disorder—PTSD—which the American Psychiatric Association didn't introduce to its diagnostic manual until 1980). "Traumatic events call into question basic human relationships," Herman explained, "They shatter the construction of the self that is formed and sustained in relation to others."[7] In *The Body in Pain* (1985), a book that has attained iconic status, literary figure Elaine Scarry stated the matter plainly, arguing that torture can be understood as an assault on human connection. "Whatever pain achieves," Scarry begins, "it achieves in part through its unshareability, and it ensures this unshareability through its resistance to language."[8]

If there is some agreement on the importance of shared expression in relieving the harms of violent assault, visual art tends to unsettle the assumptions on which that consensus is reached. An equation linking art and terror goes back at least to Edmund Burke, who defined the sublime as an admixture of beauty and mortal peril. Both exceed words. Art too is—at its best—pitched beyond the reach of simple verbal translation. The crucial caveat is that art is always modulated by thought—by an attempt at intelligibility. Simple terror shuts down understanding. To the extent that it can be conceived as a form of expression—of power, or rage—pure terror is peculiarly solipsistic. To use the term coined by J. L. Austin to describe words and phrases that do what they say (I pledge, I vow, I curse you), rape might be called a speech act of the body.[9] And as a speech act, what rape expresses is pure denial,[10] rendering a woman silent while also forcing her submission to the aggressor's terms. Perhaps it is too tidily significant that "violation" is just a few letters away from "volition": the former names an impulse to hurt and dominate, and above all to substitute one will for another, moving an "I" into a place where it doesn't belong.

Yet: verbal and visual languages offer different recourses to violence. If instead of inflicting silence, we think of rape as robbing its

victims of wordlessness—as stealing the refuge, and the pleasure, of pure feeling—it can be seen as a condition which art is uniquely positioned to address. To be sure, some women who took on the subject in the seventies stated their aims verbally, loudly, and clearly. The text-and-image work by Nancy Spero is one towering example. But many more enacted them primarily with their bodies. That is where the issues they were addressing were rooted. And the body's language, when spoken by women, was singularly free of that patriarchal influence then just coming to be understood as shaping verbal exchange. Most of the early works were made by young women at the beginning of their artistic careers, all facing physical, emotional, and professional risks, or some combination thereof.

Among early examples: A woman alone onstage, inviting attack. Another acting similarly on the street. Women gathered in a room, testifying, haltingly, to horrific sexual assaults. A woman's body, naked below the waist, tied to a table, blood dripping down her legs, or, again bloodied, lying still in a field. Women coordinating with a metropolitan police force and local broadcast media to draw attention to, and help guard against, the stunning proliferation of rape in a major city. The artists involved—they include Yoko Ono, VALIE EXPORT, Ana Mendieta, and Suzanne Lacy—were demanding that the unsayable be said. Extended exercises in role playing, notably by Lynn Hershman Leeson and Adrian Piper, further probed the boundaries of physical and emotional safety. By the later 1970s, Lacy, Leslie Labowitz, and others had waged remarkably successful campaigns for awareness of sexual violence and civic action against it. Along with contributing to the birth of an art form called performance, female artists addressing sexual violence introduced a tactic that joined art and activism, a mode now called social practice. These activists were key in forging the notion that in a sexist culture—a rape culture, as it came to be called—every woman is a victim, and victimhood is not shameful.

They've generated a complicated legacy. Giving shape to encounters that had been virtually invisible, artists of this period also, deliberately or not, advanced expressions of solidarity that eclipsed personal experience. Recent efforts to rally widespread support for bringing perpetrators (mostly men) to justice by suggesting that we're all equally victims (specifically, by identifying with the movement that bears the unfortunately childish hashtag, #MeToo), show we are still grappling with the impact of their work.

But then, everything concerning sexual violence is complicated. It is exceedingly difficult to put rape into statistical terms and treat its incidence objectively. Underreporting is the biggest challenge. Evidence, if it exists, is often inconclusive. Even the most terrorizing attacks may result in no visible damage; violent assaults can disable memory. Disparities of class determine who is most vulnerable. Most importantly, there is no agreement, political, legal, or social, about what rape is. Is it an act, or the intention behind an act? Can it be identified long after the fact? Are there irreconcilable differences between women's drive for empowerment as a class, and victims' need for honesty as individuals? Is it practical, or advisable, to establish legally enforceable protocols of verbal consent? Moreover the fault lines that opened almost from the start in the feminist movement of the 1970s, prominently including race and gender identity, are hardly less divisive now than they were then; indeed the increasingly challenging question of what defines a woman had not yet been raised. A study of feminist art in the seventies addressing sexual violence will inevitably miss a great deal in the landscape of rape, including especially crimes against men and boys. The full range of gender identity that has slowly come to be understood and in some measure accepted, including transgender men and women, was nearly inivisble to prominent feminists at the time.

Representation entails its own equally thorny issues, few more vexatious than pornography. To accept (much less embrace) it is

considered by many feminists an inexcusable betrayal. Others insist on the freedom of expression that permits it. But then, candor about the lasting damage caused by sexual violence can itself be considered a breach of feminism's pledge to strength and independence. Writes Maggie Nelson, "A woman who delves into the relation between Eros and Thanatos is not typically regarded as someone making a transgressive, probing move, but as a self-abasing traitor aiding and abetting rape culture. Likewise, a woman who explores the depths of her despair or depression isn't typically valorized as a hero on a fearless quest to render any 'darkness visible,' but is instead perceived as a redundant example of female vulnerability, fragility, or destructiveness."[11] These are questions facing anyone addressing sexual violation; they pose a special challenge to visual artists. And there are also a few that are particular to us spectators. They start with, Why look? Whereas there is, for instance, "a certain moral and social obligation to face up to the horrors of war," writes art historian Maria Tatar, "no such code governs the casualties of what we call random acts of violence." She was addressing a genre of pictorial artwork called *Lustmord*, which arose in Germany between the two world wars, and which generally featured raped and murdered women, often prostitutes. Regarding this work, Tatar conceded, she often found herself thinking not, "You have to look at that," but rather, "How can you possibly look at that?"[12] Morbid curiosity and its accessories—sensationalism, exploitation—are the moral hazards that accompany this subject. Of course, avoiding it presents hazards of its own.

Many milestones mark the long road toward a frank exploration of sexual violence. As Susan Brownmiller plainly stated in the initial pages of her groundbreaking 1975 book, *Against Our Will: Men, Women and Rape*, at the time she joined the women's movement, "Rape wasn't a feminist issue." Indeed when one of her friends brought up the subject at a 1970 women's meeting, she says she "fairly shrieked

in dismay."[13] Brownmiller was a key participant in second-wave (that is, post-suffragette) feminism, which had grown out of—and deliberately away from—the political activisms of the sixties. Those movements had become increasingly, and finally intolerably, sexist, but at least they provided a sturdy paradigm. "The views I used to hold about rape were compatible with the kinds of causes, people and ideas I identified with generally," Brownmiller wrote, naming "the civil rights movement, defense lawyer heroics, and psychologic sympathy for the accused." When the women's movement emerged, an unassailable plank of its platform was solidarity. Speaking up for classes of people oppressed by social injustice was deemed far more urgent than advocacy for individuals who fell subject to a crime, however systemic that crime had become.

Emerging feminists were adamant about focusing on goals common to all women: equality in professional and personal life; parity in social, political, and financial opportunity. Drawing attention to personal grievances was condemned; so were self-identified victims. Until it was defined as a crime to which virtually all women were subject, rape was far too intimate to fit the agenda.

Nor was sexual violence a prominent concern of the primary texts shared at consciousness-raising sessions, feminist collective meetings and reading groups, notably including those formed by artists, in the early years of second-wave feminism. Foremost among those texts was Simone de Beauvoir's *The Second Sex*, of 1949 (first translated into English in 1953). Like the authors of key feminist books that would follow—from Betty Friedan to Kate Millett, Robin Morgan, Germaine Greer, and others—Beauvoir was primarily concerned with the lack of professional and personal equity and opportunity for women. It was a baffling, galling time for thinking women, whose possibilities had seemed greater when they were girls. For all its hardships, World War II offered women a degree of independence and responsibility that was surrendered only reluctantly when returning troops reentered

the workforce. In these women's youth, suffrage was a fresh—and in some places, ongoing—struggle: American women won the vote in 1920, French women in 1945. Birth control was illegal in France until 1967, abortion until 1975, two years later than in the US. Higher education was segregated by sex as well as race. Beauvoir had an active understanding of how hard the long first wave of suffragettes had fought, and thought any sequel would be easier; she worried, in fact, that her peers might think her story was belated. "I hesitated a long time before writing a book on woman," she began. "The subject is irritating, especially for women; and it is not new."[14]

The Second Sex is epic, a sweeping indictment that starts with ethnology ("Biological Data") and sexual relations in the lower regions of the animal kingdom, proceeds through a review of selected world literature and history, and includes a summary of women's life experiences from childhood to old age, marriage to prostitution, narcissism to mysticism; she borrows from Husserl and Heidegger, Balzac and Colette. Throughout, Beauvoir works from the premise, "Humanity is not an animal species: it is a historical reality."[15] Later she famously restates this axiom in terms of gender: "One is not born, but rather becomes, woman."[16] That process, as she describes it, was unremittingly grim. From the moment when crops and animals were domesticated, she writes, women were property; they fared poorly in the ancient world, and no better under later regimes: the Jewish tradition is "fiercely antifeminist;" "Christian ideology played no little role in women's oppression."[17] The privilege that has accrued to men since the dawn of civilization and the servitude that is women's lot are, in her telling, extreme. While violence is not a primary theme in her book, Beauvoir does not shy away from it, first taking it up in her section on myth and literature, where she writes that in the traditional narrative, "Man does not merely seek in the sexual act subjective and ephemeral pleasure. He wants to conquer, take, and possess;... he penetrates her as the plowshare in the furrows;...

these images are as old as writing.... Woman is her husband's prey, his property."[18] Being observed and taken, done to rather than doing—being in-itself, rather than for-itself, immanent rather than transcendent, in the Existentialist language she helped formulate—as Beauvoir frames it, that is the fundamental condition for females; it is what makes us the second sex.

But it is in her account of contemporary "lived experience" that Beauvoir addresses most directly the violence she believes is structurally inherent to sexual relations. Sexual initiation, Beauvoir states, is inevitably an act of brutality; even marital intercourse is a form of assault. A first sexual act, she wrote, "always constitutes a kind of rape; this was an act of violence that changed the girl into a woman; it is also referred to as 'ravishing' a girl's virginity or 'taking' her flower. This deflowering is . . . an abrupt rupture with the past." If this description strikes current readers as tendentious and a little abstract, Beauvoir also notes, almost in passing, the frequency with which first sexual experiences are of rape and incest as they are more conventionally defined: "It often happens that some of the caresses of friends of the household, uncles, cousins, not to mention grandfathers and fathers, are much less inoffensive than the mother thinks; a professor, a priest, or a doctor was bold, indiscreet."[19] In a later passage, she is even more explicit: "It is not uncommon that the young girl's first experience is a real rape and that man's behavior is odiously brutal; particularly in the countryside, where customs are harsh, it often happens that a young peasant woman, half-consenting, half-outraged, in shame and fright, loses her virginity at the bottom of some ditch. What is in any case extremely frequent in all societies and classes is that the virgin is rushed by an egotistical lover seeking his own pleasure quickly, or by a husband convinced of his conjugal rights who takes his wife's resistance as an insult, to the point of becoming furious if the defloration is difficult. In any case, however deferential and courteous a man might be, the first penetration is always a rape."[20]

These views would eventually be carried further by such scholars as Andrea Dworkin and Catharine MacKinnon. But few feminists would condone Beauvoir's even more provocative claims that the "young girl"—conditioned as she is—is not always an unwilling party; on the contrary, she "understands that she is destined for possession because she wants it: and she revolts against her desires. She at once wishes for and fears the shameful passivity of the consenting prey ... the idea of rape becomes obsessive in many cases."[21] While "Rape is abhorrent to her," she "aspires to passivity."[22] On the other hand, Beauvoir notes young women's habits (however unavailing) of resistance, observing that self-mutilation is frequent in adolescent girls (this is a behavior each generation seems to discover anew). "[S]adomasochistic practices are both an anticipation of the sexual experience and a revolt against it," she writes. "[W]hen she swallows a bottle of aspirin, when she wounds herself, the girl is defying her future lover: you will never inflict on me anything more horrible than I inflict on myself."[23] Again, in a subsequent passage she is more direct: "The little girl who dreams of rape with a mixture of horror and complicity does not desire to be raped, and the event, if it occurred, would be a loathsome catastrophe."[24] Though she might be consumed by thoughts of it, the young girl is not hoping to be attacked. In fact not just initial sexual acts but all heterosexual intimacies, including those of established partnerships, are threatened, as she saw it, by a basic inequity: "In intercourse the man introduces only an exterior organ: woman is affected in her deepest interior," she argues. While the woman's feeling of "danger" ultimately subsides, she continues to feel "carnally alienated."[25] And once more, this abstract language is supported, later, by rather more concrete assertions, as when Beauvoir approvingly cites Havelock Ellis's estimation that "There are certainly more rapes committed in marriage than outside of marriage."[26]

Beauvoir believed that the marriage contract was a disservice to men as well as women: she and Sartre never married and allowed

each other (and themselves) outside relationships, while remaining lifelong partners. She described motherhood as an unremitting misery and had no children. And the restrictions on erotic experiences available to women angered and saddened her; she writes about cross-dressers and same-sex lovers calmly and with a good deal of respect, devoting a radically (for the time) nonjudgmental chapter to lesbians. She viewed homosexuality as simply a choice—one she acted on herself—and goes so far as to say, "Every woman is naturally homosexual."[27] (By contrast Friedan, author of *The Feminine Mystique*, another key text of the movement, was hostile to homosexuality. She would not be the only leading feminist to resist solidarity with gender nonconforming women and men.)

But in judging the feminine capacity for active self-possession, Beauvoir was particularly severe. Women love to act helpless, she claims. "It is both a protest against the harshness of their destiny and a way of endearing themselves to others."[28] The passive position was a long time in the making: "When the ashes of Pompeii's statues were dug out, it was observed that the men were caught in movements of revolt, defying the sky or trying to flee, while women were bent, withdrawn into themselves, turning their faces toward the earth."[29] But she argues that such docility is a result of training, not biology, writing, "The woman is already naturally deprived of the lessons of violence."[30] It was time to learn them.

If Beauvoir's book was ahead of its time, Friedan's enormously popular *The Feminine Mystique* (1963) was a little late, which did her no harm; the timing of its publication was such that it roused many women to action against a servitude to domesticity that was already declining, and fast. In any case, the mystique Friedan identified lasted a heartbeat, its short life partly the result of the swift turnover she documented between generations in the baby-booming postwar period: the child brides against whom she inveighed were soon being challenged by the teenagers they raised. The last thing

those teens wanted was to settle down with a husband and three children. The Pill—it needed no other name, which no one would have spoken anyway—was introduced in 1960 and famously made sex less fraught, as did the legalization of abortion thirteen years later. Both Beauvoir and Friedan despaired over what they saw as a vast multitude of girls in their early teens pressured by popular culture into having sex without pleasure or a sense of control, a subject on which the older generation never changes its mind. It's helpful to be reminded that this opprobrium from the old folks—now that the young women of the sixties and seventies are becoming grandmothers, with the longtime feminists among them joining their daughters in decrying just this problem—is more or less eternal. And despite the volcanic explosion of talk about sex in the sixties, and entirely new codes of propriety, neither Beauvoir's book nor Friedan's, nor any other in their immediate wake, made for significantly more open conversations about violence.

The silence held with a staple-bound handbook called *Women and Their Bodies* that appeared in 1970. Subtitled "a course by and for women," it grew out of a 1969 workshop at a small Boston college, whose participants, an introduction explained, "were then in women's liberation." As the Boston Women's Health Collective, they collated a group of articles to provide the structure for a self-guided seminar in women's health and well-being. However empowering, it contained nothing on rape or sexual violence. But it did have, under the heading "Sexuality," an explosive little article by Jane de Long, Ginger Goldner, and Nancy London which proclaimed, "The sexual revolution—liberated orgastic women, groupies, communal fucking, homosexuality—have all made us feel that we must be able to fuck with impunity, with no anxiety, under any conditions and with anyone, or we're some kind of up-tight freak. These alienating inhuman expectations are no less destructive or degrading than the Victorian puritanism we all so proudly rejected. Robin Morgan, a

Women's Liberationist in New York, says 'Goodbye to Hip Culture and the so-called Sexual Revolution which has functioned toward women's freedom as did the Reconstruction toward former slaves— reinstituted oppression by another name.'"[31] That homosexuality was entered in a list of unwelcome freedoms is as telling, and perhaps as startling, as the rest of this angry blast aimed at the coercive behaviors conducted under the banner of women's liberation, a movement then still in formation. Clearly, the otherwise welcome revolution—against sexual repression, but also against the war in Vietnam and the military-industrial complex supporting it, against capitalism and racism and oppression in general—was, at a personal level, pressuring a lot of women to put out whether they wanted to or not. There are few more honest statements of the bind in which newly liberated women found themselves.

Published in an edition of 5,000 and priced at 75 cents, *Women and Their Bodies* sold out quickly. Nine more printings in the following two years, with press runs of 25,000 each, also flew off the presses. As Susan Brownmiller later reported (in an unpublished article[32]), "Women's groups across the country were buying the handbook in bulk and selling it at their meetings.... The Collective tallied its costs, reduced the price per copy to 30 cents, and made one big change. At a meeting someone had blurted out, 'Hey, wait a second—it isn't women and *their* bodies, it's *us, our* bodies. Ourselves." In the fall of 1972, Simon and Schuster bought the rights (for $12,000), and in 1973 released *Our Bodies, Ourselves*, which brought the nonprofit collective that had written it half a million dollars in five years. A softbound volume of advice and information comparable to the then hugely popular *Whole Earth Catalog*, it began with chapters on the anatomy, physiology, and psychology of sexuality, nutrition, and health—and, new with this edition, on lesbianism. ("In Amerika They Call Us Dykes" was contributed by an outside group of gay women in the Boston area who requested both control and, again tellingly, anonymity.)

Also new in the 1973 edition was a consideration of sexual assault. Following a chapter on exercise and preceding one on venereal disease, there was a short chapter titled "Rape and Self-Defense." It began with a definition: "Rape is sexual intercourse without consent, or violent sexual aggression by a man (or men) against a woman (or child). Rape causes mental and physical damage." Its first heading, "Whose Fault is Rape?" was a question answered by denouncing the "myth" that most women want it, and then by stating, in distinctly Friedan-ian terms, "Basically, rape is the fault of our cultural emphasis on 'sex and violence,' now an American idiom like 'love and marriage.' Many newspapers, magazines, and movies encourage people to groove on sadism by graphically illustrating incidents of sexual violence." A photograph on this page shows a young man and a couple of boys looking at skimpy lingerie in a sex-shop window. (Shame on them!) The chapter goes on to dispel the misconception that most rapes are perpetrated by black men against white women (one study conducted at the time put the proportion of such rapes at 3 percent of the total) and to lament the failure of police and courts to prosecute sex crimes.

The bulk of this slender chapter, though, is on women taking control and being prepared to fight back. "In this violent society, learning to protect ourselves from male attack is an integral part of our physical and psychological health," the authors proclaim. The world is dangerous; malicious strangers abound. "A reported rape occurs every seven minutes in America—at about the same frequency as births of baby girls," they note. "Then there are the sex murders of women, many more than the sensational ones by men like the Boston Strangler or Richard Speck. Every woman—whether or not she is the victim of one of these vicious crimes—knows the fear of dark, deserted streets, strange noises in the middle of the night, obscene phone calls and the everyday humiliation of dirty remarks and gestures on the streets."

Cowering at home is not the answer, the writers hasten to say; neither is relying on men for protection. Instead, the authors "encourage all women to learn some basic techniques of self-defense that include actual fighting." They suggest checking the Yellow Pages and the local YWCA for helpful courses, and advise learning the relative merits of taekwondo and judo; readers are cautioned to watch out for male teachers of these techniques who are dismissive or sadistic. The authors go on: "Begin right now to think about self-defense.... Practice with friends. Think through possible situations. What would you do if someone came up and grabbed you from behind? How would you respond if someone approached you while you were in a telephone booth? Suppose a man's hand started creeping up your knee on a subway. Take turns playing the attacked and the attacker." Be creative, they urged. Consider what you're wearing—will it enable you to fight unencumbered? Might a belt-buckle or a heavy pocketbook serve as a weapon? Deodorant spray? Thank about carrying a knife; consult with local police about the legality of purchasing a gun. When you're fighting back, "let out a yell—not a scream for help, but a loud, blood-curdling battle cry. This will give you a psychological boost and scare your attacker." And then, *Run. Fast.* In short, take responsibility for your own safety. This early salvo against the rising threat of sexual assault clearly put the onus on women to protect themselves. No quarter was given to tender emotions; such weakness ill suits feminists. "Fear is a deadly emotion that may keep you from remembering what to do," the chapter concludes. Strikingly, it is the only one in the book cowritten by a man (the authors are Gene Bishop and Roxane Hynek). *Our Bodies, Ourselves* is not footnoted, and there is no bibliography. In the "further reading" section, there is nothing on rape. Clearly, more needed to be said on the topic.

Indeed, in September 1971 *Ramparts* magazine ran a cover story by the poet and feminist Susan Griffin called "Rape: The All-American Crime."[33] Griffin's *Ramparts* article begins, simply enough, "I have

never been free of the fear of rape. From a very early age I, like most women, have thought of rape as part of my natural environment." And she goes on to make observations that have long since become truisms. She notes that the sexual "scenario" for women is "complicated by the expectation that, not only does a woman mean 'yes' when she says 'no,' but that a really decent woman ought to begin by saying 'no,' and then be led down the primrose path to acquiescence."[34] She wonders, with respect to tight skirts and high heels, "Is it not an intriguing observation that those very clothes which are thought to be flattering to the female and attractive to the male are those which make it impossible for a woman to defend herself against aggression?" And she states, "rape is a kind of terrorism."[35]

By 1971, Brownmiller was already at work on *Against Our Will*, which shares the historical sweep of *The Second Sex* and also its commitment to prodigious research. Brownmiller too begins with an ethnological survey of sexual relations, this time with a view toward intraspecies violence in the animal kingdom, to conclude, "No zoologist, as far as I know, has ever observed that animals rape in their natural habitat."[36] Like Beauvoir, Brownmiller reviews the march of civilization from the Stone Age through ancient civilizations and on to Judaic and Christian teachings and modern history, charting an unending trail of sexual violence. She considers the record of rape during the two world wars, and then returns to the early history of the United States, reviewing white settlers' and slave-owners' routine attacks against Native American and African-American women. Everywhere and at all times, she finds, rapaciousness abounds. And she ends with a call to arms—with an exhortation to self-determination and forthright political resistance.

Against Our Will was an enormous success: it was crucial in placing sexual violence squarely within the range of feminist concerns— and of the broader public's. Brownmiller, who toured the country giving talks, was named one of 1975's Women of the Year by *Time*

magazine, and her book appeared on the *New York Times*'s bestseller list (at the same time that *Helter Skelter*, about the Manson Family murders, was #1 on the nonfiction list; *Looking for Mr. Goodbar*, Judith Rossner's novelization of a true crime story, in which a young teacher was raped and murdered, was on the fiction list at #4 and was soon made into a movie starring Diane Keaton). While much of the response to *Against Our Will* was favorable, there was hostility as well. In a rather freewheeling 1976 panel discussion, Brownmiller was challenged by a convicted rapist who bemoaned his treatment ("the society I live in discriminates against that type of crime"—at which point Brownmiller interrupted to say, "that's a funny way to put it, but go on"—and he retorted: "Believe you me, there are strong emotional and social connotations attached to the very word 'rape'") and defended his behavior ("I lacked the sexual communicating skills necessary to get the girl to acquiesce to sexual intercourse; I didn't have the social maturity to accept the answer of 'no'"[37]); men evidently were studying the sympathy increasingly accruing to victims. On the same panel, Brownmiller was attacked for her "attitude to sex," which a female book critic found suspiciously hostile. No one on the panel spoke for the experience of being violated. If rape was, by 1975, an issue widely aired in public, its nature was hardly a settled question.

Nor was there a stable balance between supporting victims and defending the legal rights of those they accused. Brownmiller, a journalist at the time she wrote *Against Our Will*, had contributed to mainstream magazines including *Vogue*, *Mademoiselle*, *Esquire*, and the *Village Voice*, as well as ABC News, and in May 1968 wrote an article for *Esquire* about three young black men in Baltimore who had been convicted of raping a white teenage girl, sentenced to death, and subsequently exonerated. With full justification by the facts given, the story reads as a triumph of justice over barbarous racism, of false accusations reversed, and deserving young men freed from death row. But nothing about the event in question was that tidy.

Brownmiller reported—with a striking lack of sympathy—that the accuser, admittedly promiscuous, was emotionally troubled enough to have been recently hospitalized. The sex she'd had with two of the accused had been consensual in the sense that she'd apparently invited it. But she was young and had been drinking, and the encounter between her and the three men was hardly the kind to invite celebration of the accuseds' exoneration. That Brownmiller didn't hesitate to use the girl's sexual history in maligning her only confirms the zero-sum calculations often made at the time, in which racial justice was gained at the expense of victims' rights. The only fixed element of this equation was the implacable power of white men.

"It was the fear of playing into the hands of racists, or an undifferentiated sympathy for the criminal as society's victim" that led women in the movement to treat violence with "noncomprehension or hostility,"[38] Brownmiller wrote in *Against Our Will*; surely she had the Baltimore case in mind. Writing twenty-five years later, Brownmiller recalled, "When I began researching law review articles back in 1971, cutting-edge theory on criminal justice was devoted to making arrests and convictions more difficult in order to safeguard defendants' rights. That was the accepted liberal thrust.... The anti-rape movement, on the other hand, was determined to make the law and the courts work for victims. This stunning break with conventional liberal thinking was not easy for everyone to manage, even inside Women's Liberation."[39] The concern was not misplaced. As Jill Lepore has recently observed, by 1972, the term "victims' rights" had been coined by "law-and-order" politicians (another newly minted usage) to oppose protections for defendants recently established by a liberal Supreme Court, led by Chief Justice Earl Warren. These conservatives found unlikely support from women's-rights activists, Lepore continues, who sought "more aggressive prosecutions of and stricter sentences for rape and sexual assault."[40] Together, they began to unravel centuries of legal thinking dedicated to keeping victims'

testimony out of courtrooms, where it is notoriously prejudicial, in ways both classist and racist. When I asked Brownmiller in 2016 how her work of the 1970s looked in retrospect, she returned to the conflict that had plagued her community's thoughts on sexual violence. "For the first time the women's movement was on the side of prosecutors. I think when we realized it, we thought, shit! Doesn't mean we're for law and order, but we are for law and order in these cases."[41] The conflict has not become less vexing.

One measure of how meager and faulty the literature on rape was when Brownmiller was writing is her reliance—and Susan Griffin's, and Diane Russell's, and others'—on *Patterns in Forcible Rape*, a book published in 1971 by Menachem Amir. Extrapolating from data compiled by the Philadelphia police in the years between 1958 and 1960, Amir took a decade to complete his book, which was a signal contribution. But its problems are grave and manifold, and they begin with its title. "Forcible rape," a term still in use, has been widely challenged as worse than tautological, since it implies there are rapes that are otherwise, that rape is not in and of itself an expression of force. Other, more serious problems concern race. While Amir notes that African-American rape defendants suffer from discrimination, he offers the appalling assessment, "The Negro subculture is an historically unique subculture which embodies all the characteristics of lower-class subculture but ... in a more pronounced form." It is "characterized by ... a search for thrills through aggressive actions and sexual exploits."[42] As is clear, Amir finds moral failings tied to both race and class. While he grants "that there are constant pressures for sexual gratification and experience among all males and that some aggression is an expected part of the male role in sexual encounters"—boys will be boys—he also argues, "There are also class and subcultural differences in the legitimation given to coercion and manipulations used in securing the cooperation of females for sexual relations."[43] In other words, some boys are worse than others.

The novel formulations about which Amir seems to have felt most satisfied build on these assumptions. One concerned what he called "group rape"—assaults by gangs. While arguing that sociologists like himself "accept the view that current [that is, psychoanalytic] definitions of 'normal' and 'abnormal' sexuality are culturally and historically determined,"[44] Amir cited Freud and his associates to claim that gang rape can be attributed to "the erotized adulation of one boy for another."[45] Indeed, he believed, "Aggression, like sexual drives, is acted out when fears about sexual adequacy or latent homosexuality exist."[46] Again, Amir implicates boys who grow up disadvantaged: "The existence of actual or latent tendencies for aggressive behavior prevails in the lower-class adolescents."[47]

But the claim Amir is most eager to make—a claim foreshadowed in such terms as "meeting place" and "relationship" to describe circumstances of rape—is that girls who grow up in such "lower class" conditions are often responsible for their own rapes. He introduces the term "victim-precipitated rape" to explain, "it is not always the offender alone who is to be blamed."[48] Sometimes, he writes, "victims can be equally blamed." (In addition to survivors of rape, he cites such "guilty victims" as drug addicts, women who seek abortions, and homosexuals.) The law doesn't recognize precipitation, Amir notes sadly, but it should. Precipitation, he argues, happens when the woman's (or girl's) behavior "is interpreted by the offender either as a direct invitation for sexual relations or as a sign that she will be available for sexual contact if he will persist in demanding it."[49] It can consist of an act of commission (as when she agrees to drink or ride with a stranger), or omission (if, for example, she fails to react strongly enough to sexual suggestions).

Precipitation can even consist of saying no. "Perhaps the resistance is merely feigned to satisfy the cultural definition of the female role in the love game; or, with some women, aggression and resistance are internal needs in the sexual encounter, either to increase gratification

or to deal with guilt problems which may arise after the behavior."[50] Again citing founding psychoanalysts, Amir suggests "women have some masochistic tendencies, as well as an inclination to submit themselves to forceful sexual relationships. Therefore, psychologists find it not surprising that in actual rape situations many women will submit without any genuine resistance."[51] Amir hastens to say that such rapes, which women have consciously or otherwise invited, are not free of aggression. On the contrary, fully 93 percent of them involve violence (as compared with 83 percent of other rapes).[52] Perhaps most astounding, he finds significant numbers of "victim-precipitated" rapes even in the youngest group of victims, those up to the age of nine, and in more than a tenth of victims between the ages of ten and fourteen.[53] Studies showed, he said, that often, "contrary to popular belief, and to victims' and parents' accounts, the child or adolescent victim showed complicity in the criminal situation if not active participation."[54] Indeed, "Some writers even claim that there is a universal wish among women to be raped." Hence, "Whatever is one's judgment on such views, it follows that rape may be a primarily pleasurable event or provides a secondary gain as a liberating experience."[55] Among the "misconceptions" that he claims his work to have dispelled is, "Rape victims are innocent persons."[56]

These stunning conclusions matter because their author was taken very seriously, including by leading feminists in the 1970s. The choice is easily explained; they had few other sources for hard data. And Amir can't simply be dismissed as an isolated woman-hating, homophobic, white supremacist wing nut (a type then associated with the benighted South, lately revealed as ascendant everywhere). On the contrary, he seemed to believe he spoke for an enlightened objectivity. The recipient of a doctorate in sociology from the University of Pennsylvania, he published his book with the University of Chicago Press, and his paper on "Victim Precipitated Forcible Rape" in the journal of Northwestern University School of Law. Amir can be

credited (as he dearly wished) with actively opposing the notion that "Negro men are more likely to attack white women than Negro women" (that's his first "conclusion"). Among his useful contributions are, "neighbors and acquaintances are the most potentially danger-ous people as far as brutal rape is concerned." And, "The closer the relationship between victim and offender, the greater is the violence used against the victim."[57]

Based on studies conducted in the late fifties, Amir's book is, in short, a wildly conflicted missive from a shaky moment. He seems to see, in his mind's eye, young men—juvenile delinquents—proving their masculinity in ways that include sexual conquest, of girls who may sort of want it; really the guys' interest is in each other. He also imagines bleak ghettos where, rather inscrutably, dark-skinned people growing up without love or moral guidance prey on each other. He observes that since World War II, sexual norms had grown more lax—in large measure as a result of soldiers' exposure to "European attitudes." (Gay Talese would later develop this point at length.[58]) The results, as he saw them, were something like chaos, which entailed new liberties—"a rejection of the puritanical attitudes toward sex; the elimination of the double-standards for the sexes"[59]—as well as harms.

So alone on the shelf when it appeared, *Patterns of Forcible Rape* was read avidly. Griffin, in her 1979 book *Rape: The Politics of Consciousness*, thanks him in her acknowledgments and cites without comment several of his more cogent points, including that most rape is planned, not impulsive.[60] Brownmiller relies on him heavily, devoting more than fifteen pages to his findings. The feminist scholar Diana Russell, who also wrote about rape, cites him widely as well. They used his statistics for their own purposes—and the assumptions he makes were so commonplace at the time his book was published that they aroused little protest. Startling now, this absence of outrage sharply illuminates the resentment toward feminism felt by women who were not white and privileged. When I asked Griffin about Amir

recently, she answered, "It's been so long since I read that book. It was so early, before feminists were writing about rape. I'm sure there's stuff in there that's very sexist. It wouldn't have been looked at as anything particularly remarkable; that's what the landscape was like. In fact, we were probably celebrating the fact that he didn't consider *all* rape 'victim precipitated.'"[61]

Women's—and girls'—responsibility for their own sexual assaults; the propensity of poor and black men to do violence; these are the assumptions that haunted artists in the 1970s as they undertook to explore a culture in which violence against women was both terrifyingly frequent and nearly invisible.

LOOKING FOR TROUBLE

By resisting the exploration of individual experiences of harm, leading feminist writers and thinkers would substantially shape the art made in response to sexual violence. In her crucial 1971 essay, "Why Have There Been No Great Women Artists?," American art historian Linda Nochlin, a pioneering and lifelong feminist, warned that many in the sisterhood shared "the naïve idea that art is the direct, personal expression of individual emotional experience, a translation of personal life into visual terms." But, Nochlin continued, with some heat, "Art is almost never that, great art never is." Instead, "The making of art involves a self-consistent language of form. . . . it is neither a sob-story nor a confidential whisper."[1] The message Nochlin delivered—not unlike that sent by Beauvoir, or Brownmiller, or the anonymous collective which wrote and published *Our Bodies, Ourselves*—was, in essence, suck it up, ladies. Let's not embarrass ourselves by dwelling on personal injury; we've got more important things to do. First-person work about such violence appeared belatedly, aroused more discomfort than support, and departed quickly, although not without leaving an indelible mark. The earliest artworks to address threats against women's bodies, from the mid-sixties, did so allusively, expressing the vulnerability inherent in daily female experience. Inviting physical contact with the public, a few bold artists flirted with the possibility of significant harm. By yielding to the whims of audience members and also of random pedestrians, these artists asked for trouble—literally—while also soliciting protection, undertaking a range of variably

passive and aggressive roles in their ongoing negotiations with an increasingly violent environment.

The emerging medium to which these efforts belonged was called, simply, "performance art." By the late 1950s in the US, the waning energies of Abstract Expressionism, the cresting Beat poetry movement, and the emergence of Pop together fed the Happenings that took shape in New York. Their madcap spirit had, in turn, ebbed by the mid-sixties, though their legacy remained potent. At the same time, a widely read 1967 essay by art historian Michael Fried argued that even the rigorously abstract, geometric sculpture that came to be called Minimalist was in fact essentially theatrical, since it engaged the viewer in an encounter that was more physical than optical. Other, more direct sources of influence on performance art included Viennese Actionism and the international movement called Fluxism.

Performance, which is still an active and evolving genre, is notoriously hard to define and only the more captivating for that elusiveness. What most distinguishes it from other kinds of art is its grounding in an often confounding and always deeply moving ambiguity about the relationship between artist and role. Performance artists were not taking on scripted characters in the sense of traditional theater, but neither were they simply living their lives in public. Instead, the work involved a middle position that has always been unstable—and never more so than when it was new. Michael Kirby, an influential drama critic of the time, offered an outline of the situation in 1972. "In most cases acting and not-acting are relatively easy to recognize and identify. In a [traditional] performance we usually know when a person is acting and when he is not," Kirby wrote. "But," he explained, "there is a scale or continuum of behavior involved, and the differences between acting and not-acting may be quite small."[2] He then specified, with examples ranging from Japanese Kabuki to the Living Theater and Happenings, a series of positions on that continuum, including "non-matrixed performing," "non-matrixed

representation," "received acting," "simple acting," and "complex acting." The classificatory effort seems peculiarly American and of its time: it is dispassionate and logical; it allows behavior to be diagrammed. Kirby concluded that we can identify acting as "the point at which the emotions are 'pushed' for the sake of the spectators."[3] Watching actors, we know that they are pretending to have the emotions the script calls for; watching performance artists, we can't be sure. Kirby's lexicon emphasizes the impassivity of performance. On the other hand, art historian Jane Blocker's assessment turns toward the stress fractures of internal experience. "Performative identities are not false; they are not the function of the kind of artifice or masking that implies a hidden 'real' self," Blocker writes; "rather, they challenge the coherence of that presumed real." In other words, Blocker defies the commonsense conviction that an individual possesses one coherent self, arguing that performance allows an artist to negotiate among latent identities that emerge in the event.[4] This ambiguity is particularly effective when the performer is conveying the experience of being terrified—of finding one's sense of self displaced by the physically or psychologically overwhelming actions of another.

The first works involving the unmediated presence of performing bodies cut especially close to the bone. For performances presented forty years ago and more, the immediate impact is of course now occluded: proverbially, you had to be there. But video documentation offers a good record of these events; indeed, by the end of the 1970s, much performance was staged not for a live audience but for the video camera. In either mode, this much is clear: art always tips us away from ourselves. Artists spill over into their work. And, as viewers, we reach toward an experience that we know may be unbalancing. We savor that disorientation, even as we resist it. When viewing performance art that deals with violence or its threat, we lend ourselves to the experience and feel threatened, just as we inevitably identify with the offender, insofar as we fail to stop the

damage, or even—if only at the artist's behest—comply with it. It is a potent compound.

Among the earliest—and most ambiguous—such works was Yoko Ono's *Cut Piece*, first performed in 1964. Its script is simple: "The performer sits on stage with pair of scissors placed in front of him [the pronoun was meant to be neutral; later Ono made it clear male performers were welcome[5]]. It is announced that members of the audience may come on stage—one at a time—to cut a small piece of the performer's clothing to take with them. Performer remains motionless throughout the piece. Piece ends at the performer's option. Average time: 30'." (This was the "first version for a single performer"; a never-performed "second version for audience" invited members of the audience to cut each other's clothing for "as long as they want."[6]) As initially presented—there have been later enactments—Ono sat silently onstage in a proper black dress, or sweater and skirt, "in traditional Japanese feminine position—knees folded beneath her," as one observer put it.[7] One by one, audience members approached to cut away at her clothes, which they tended to do hesitantly at first and then with increasing zeal. Throughout, she maintained her composure.

Ono, who was born in Tokyo in 1933 and educated both there and in the US, came to be a pioneer of performance through an early interest in experimental music, whence her connection to the loose affiliation of international artists known as Fluxus. Picking up the mantle of the early twentieth-century Dada movement, Fluxus, which emerged in 1962, promoted a species of deep absurdism and favored anything that couldn't be preserved, monetized, or embraced by critics. Prescribing themselves a healthy of dose of Zen Buddhism, Fluxists embraced paradox and chance, sight gags and screwball antics. Art was declared to be present in acts of public sitting, jumping, eating, toothbrushing, and haircutting. Many Fluxists used musical instruments, often in off-label ways, as when Charlotte Moorman played

a John Cage composition by bowing a string stretched across the bare back of video pioneer Nam June Paik in 1965, at the Café Au Go Go in New York.

Various stages of undress were common in Fluxus performances. A kinship surely exists, for instance, between Ono's *Cut Piece* and fellow Fluxist Benjamin Patterson's *Lick Piece*, performed in 1964 in NYC. The score for *Lick Piece* was also simple: "cover shapely female with whipped cream / lick / ... / topping of chopped nuts and cherries is optional." Though intended, in one historian's account, to celebrate "the pleasures of mutual erotic consent" in a repressed time, its unmistakably "sexist overtones"[8] became clear soon enough. If clarity about gender politics emerged at all in these early performance works, it was forged in the crucible of such jejune provocations. For Ono, the period was marked by personal conflict as well. A divorce in 1962 led to a deep depression and she entered a sanatorium, during which time she met the American filmmaker Anthony Cox, who would shortly become her second husband; they had a daughter in 1963. On July 4, 1964, at the "Contemporary American Avant-Garde Music Concert: Insound and Instructure" in Tokyo, Ono performed *Cut Piece* for the first time; the following month, she presented it in Kyoto.

While personal conditions of considerable turmoil provided some of the impetus, or at least the context, for *Cut Piece*, local conditions also affected its several presentations. In Kyoto, a man came on stage and held the scissors over Ono's head for some time, as if threatening to stab her. "Ono's response was dismay rather than fear," says feminist scholar Kristine Stiles, "for this gesture made her action more theatrical than she intended, a theatricality she avoided by suppressing her emotions and not reacting." Generally, though, the audiences in her native country seem to have been more reticent than elsewhere. Continues Stiles, "Ono remembered that in Japan the audience was more discreet about cutting away her clothing than in New York."[9]

In March 1965, Ono performed *Cut Piece* in Carnegie Recital Hall in New York. A film of this performance shows her sitting onstage in proper black, legs tucked, her hair in a tidy bun. No eye contact is made with any of the audience members who come onstage, each picking up the big, shiny scissors. The first to do so is a woman who slits a part of one sleeve. Thereafter men predominate. Most are matter of fact and quick. All are dressed with a propriety matching Ono's. The recording yields murmurs from the crowd, indistinct conversation, and an occasional chuckle. (Perhaps they are thinking this is supposed to be funny—or protesting that this a joke, not art; most likely, the laughter reflects discomfort.) One man viewing Ono's performance seems to have waited until he could take a cut at an undergarment—she is wearing a full-length white slip over her white bra; he cuts away the slip. Her breathing as he does so is visibly heavy. The audience may be enjoying this, at least a little, but Ono doesn't seem to be having any fun at all.

The following year, Ono participated in the 1966 Destruction in Art Symposium (DIAS), in London, where she again performed *Cut Piece*. Organized by Gustav Metzger, DIAS included a month of performances before a three-day symposium and drew artists and poets from fifteen countries in Europe, the US, South America, and Japan, among them pioneers of Happenings, Viennese Action Art, and Fluxus, and also writers associated with concrete poetry and the antipsychiatry movement of R. D. Laing. Ono was one of two women to speak at the symposium and the only one to perform her own work.[10] As she had in Japan and New York, she sat motionless onstage, but in London, "a wild scene ensued, exacerbated by the presence of cameras and the press, and the audience cut off all her clothing," including her underwear.[11]

In an autobiographical statement of 1966, Ono wrote, in a decidedly melancholy key, "People went on cutting the parts they do not like of me finally there was only the stone remained of me that was

in me but they were still not satisfied and wanted to know what it's like in the stone."[12] Inside a vulnerable body, she seemed to be saying, there is a rock, consoling just to the extent that it is both impregnable and unknowable—that is, woefully scarce consolation. The following year, in the underground magazine *Unit*, Ono gave interviewers a considerably less introspective account: *Cut Piece*, she said, "was a form of giving, giving and taking. It was a kind of criticism against artists, who are always giving what they want to give. I wanted people to take whatever they wanted to, so it was very important to say you can cut wherever you want to." Similarly, in a 1974 statement, she said, "I had always wanted to produce work without ego in it. I was thinking of this motif more and more, and the result of this was *Cut Piece*. Instead of giving the audience what the artist chooses to give, the artist gives what the audience chooses to take." But she added, somewhat less magnanimously, "I was poor at the time, and it was hard. This event I repeated in several different places, and my wardrobe got smaller and smaller.... The audience was quiet and still.... I felt kind of like I was praying. I also felt that I was willingly sacrificing myself."[13] Self-sacrifice was also a theme she advanced in talking to the interviewers at *Unit*, when she related *Cut Piece* to the story of Buddha's sacrifice of his children, wife, and clothing, and ultimately of himself.[14]

By the time she recorded an explanation of *Cut Piece* for the MoMA website, in 2015, Ono invoked explicitly feminist purposes—and admitted her fear. "When I do the *Cut Piece* I get into a trance so I don't feel too frightened," she said. The piece, she continued, presents "several layers of meanings." The first is, "Hey, you're doing this to women. We're all in it." But the second is, "don't fight. Let it happen. By not fighting we show them that there's a whole world that could exist by being peaceful." She also talks about the "beautiful music" created by the "long silence between one person coming up [from the audience] and the next," the rhythm of their footsteps, and then

of the cutting, which she voices as a soft explosion. Qualifying her call to active solidarity with a plea for peaceableness—passivity—in the face of danger, she also hinted, perhaps inadvertently, at the emotional dislocation experienced by victims of the kinds of attacks she was obliquely staging.

If Ono's intentions with *Cut Piece* remain unfixed, the critical response over the years has similarly run the gamut. Curator and museum director Alexandra Munroe, who presented a survey of Ono's work in 2000, writes in her catalogue essay, "*Cut Piece* expresses an anguished interiority while offering a social commentary on the quiet violence that binds individuals and society," an expression Munroe contrasts with other Fluxus events, which she says are "more sensuous and psychological." Ono's references in other performance notes at the time "to touching, rubbing, hiding, sleeping, dreaming, and screaming" placed her, Munroe concludes, "in a protofeminist space defined by the terror, and the wish, to connect."[15]

The key word in Munroe's assessment may be "protofeminist"— that is, *Cut Piece* spoke of, and to, a movement not yet quite launched, as is clear from some contemporary reports. In its June 1968 issue, *TAB*, a "gentleman's magazine," had taken note of *Cut Piece* under the heading, "The Hippiest Artistic Happening: 'Step Up and Strip Me Nude.'" *TAB* reported that following her appearance in London, "Yoko, a Japanese lovely now performing on the continent, does not take her clothing off ... the audience does it for her. Guys who used to sit back and yell 'Take it off!' now have the golden opportunity to take it off for her."[16] Assault was *Cut Piece*'s language, and eroticism was undeniably at issue, yet neither the artist nor her early critics talked about it as an expression of sexual violation. If Ono was conflicted about the work's meaning, her audience had to have been even more confused. Indeed confusion may have been its most potent effect.

Not long after Ono's first presentations of *Cut Piece*, Austrian artist VALIE EXPORT took the hazards of *Cut Piece* into the streets, with a

series of flagrantly provocative outdoor urban performances. In *Tapp-und Tast-Kino*, EXPORT provided passersby the opportunity to touch her breasts by reaching behind a curtain covering the front of a box (variously recalled as styrofoam, metal, plastic, and wooden) that she wore over her torso as both invitation and protection. Literally *Tap and Touch Cinema*, the title is usually translated as *Touch Cinema*; feminist scholar Peggy Phelan notes that this shorthand elides the kind of fumbling grope in the dark that the full title implies.[17] In her first presentations of this work, in Munich and then in Vienna, EXPORT was accompanied by her partner Peter Weibel, who served as a kind of carnival barker—or, less jovially, pimp—soliciting the attention of passersby; curator and scholar Chrissie Iles has compared the performance to bawdy Victorian street theater.[18] Subsequent presentations of *Touch Cinema* involved the participation of a female friend, and EXPORT later recalled that "because we were two women ... the people on the street became very aggressive, and thought we were prostitutes."[19] Later the same year, EXPORT presented *Genital Panic*, for which she cut out a triangular patch of her pants at the crotch and walked through the aisles of an art-house cinema in Munich, her exposed pubis at eye level. The event's most lasting image is a photograph made for a 1969 poster, *Action Pants: Genital Panic*, which shows her sitting on a bench staring straight at the camera, her hair wild, legs spread, and a machine gun in her hands. There are additional photos in which she stands or straddles a chair, always flaunting the gun.

Staging encounters that were far more random than those offered to *Cut Piece*'s self-selected audiences, *Touch Cinema* and *Genital Panic* involved a higher degree of risk for the artist, and a more intimate, and arguably more disturbing, form of physical contact. For viewers of EXPORT's work, which was not presented on a lit stage, there was both less accountability and, perhaps, less opportunity to do real harm. If engaging in a risqué act on a busy street or in the seating

rows of a dark theater is a different kind of act from one presented onstage, it's not clear which situation generates a deeper sense of exposure—for either artist or viewer/participant. But for all these differences, the provocations the performances posed were similar. Moreover, just as *Cut Piece* has had no real counterparts in Ono's subsequent career, *Touch Cinema* and *Genital Panic* were early and anomalous projects for EXPORT, although she went on to perform other works, for indoor audiences, in which she subjected herself to pain and exposure.

Perhaps not coincidentally, both *Touch Cinema* and *Genital Panic* show EXPORT enacting a deep self-estrangement—with the first work in particular. With her head separated from her body by the intervening box, she faced men whose hesitant searching touch remained unseen by both. Indeed, so strong was the need for men who took the bait to repress the experience that, according to EXPORT, "each was evidently too ashamed of his publicly enacted voyeurism to share his experience," with the result that "the men who decided to go along with the game did not know what lay behind the curtain."[20] (In truth, it doesn't seem it would have been hard to guess.) In fact the artist's 1967 decision to take the name VALIE EXPORT—she was born Waltraud Lehner; Valie derived from the nickname Wally, and EXPORT from a cigarette brand—can also be seen as an act of self-estrangement, at the same time being, as she claimed, a rejection of patriarchy.

Alternatively, *Touch Cinema* may be seen in the light of a conceptually grounded effort less concerned with challenging protocols of sexual conduct than of film as a medium. By drawing attention to a fundamental element of cinematic seduction—in movies, viewers see what they can't touch (a prohibition defended at gunpoint in *Genital Panic*); in *Touch Cinema*, they touched what they couldn't see—it signaled EXPORT's association with the emerging "Expanded Cinema" movement, which advanced a shift from screen to three-dimensional

space. Writing about *Touch Cinema*, curator Robert Fleck describes the setup as "a 'projection box' for feeling and fondling, functioning like a cinema screen—that is a socially constrained phantasm."[21] Feminist theorist Kristine Stiles strikes a similarly academic note when she writes, "The classic metaphor of the female body as domestic shelter is transformed into an ironic caricature of the body as a cinematic site of unconscious desire."[22] Of course, the "phantasm," "screen," and "cinematic site" onto which these desires for sex and comfort are being directed is a fully sensate body.

Like Ono, EXPORT was influenced by Fluxus but also, and more strongly, by the element of Viennese culture that engaged, as Chrissie Iles puts it, in the "cathartic liberation of the political and social body that occurred worldwide in the sixties." While Freudian theory remained suppressed in Vienna during this period, as it had been during World War II, the urges psychoanalysis sought to understand were set loose in the culture.[23] More specifically, EXPORT's initial performance work was in part a reaction to the gruesome ritualistic work of Viennese Actionists Otto Muehl, Günter Brus, and above all, Hermann Nitsch, which involved physical mutilation and animal sacrifice. Nitsch's infamous *Orgien Mysterien Theater*, first staged in the early 1960s and lasting days at a time, mined the early Greek cult of Dionysus and its echoes in Christian theology for their deepest, darkest theatrical resources, just as Nietzsche had done in his writing. EXPORT was personally acquainted with the Actionists; she attended many of their events, and shared their inclination to flout cultural and social taboos. But she broke with them by including film and video in her work and, more importantly, by her use of the female body. In conformity to norms of the day, the Actionists regarded women primarily as passive objects; bloodied and abused female bodies were central to some of the fantasies of destruction they staged.[24] Fleck observes that in Nitsch's *Orgien Mysterien Theater* only the male artists would be portrayed as one of the drama's pagan

gods, just as in Otto Muehl's work sexuality is meant to be revolutionary but "deteriorates into humiliating sequences for the female protagonists." Fleck concludes, "*Genital Panic* may be understood as a militant reversal of these macho happenings."[25]

In short, EXPORT's early works were—inevitably—marked by the sexual politics as well as the cultural developments of the place and time in which they emerged. Like Ono, EXPORT, who was born in Linz, Austria, in 1940, had early experience of the devastation of World War II, though in her case as a very young child. (Ono, whose wealthy family moved back and forth between the US and Japan during the 1930s and '40s, nonetheless suffered considerable privation at times.) And there was the presence, in Germany as in the US, of increasingly violent political protest. In both countries, many of the activists who became radicalized had backgrounds in the performing arts; all drew upon a long tradition of political street theater. Although some see in *Action Pants: Genital Panic* an eerie premonition of the pose Patty Hearst took for the camera a few years later, there was also, closer at hand, the activity of the nascent Red Army Faction. RAF member Andreas Baader (who had been radicalized by seeing Berlin police kill a young protester demonstrating against the visiting Shah of Iran in 1967) perpetrated his first bombing, of a Frankfurt department store, in 1968; his girlfriend, Gudrun Ensslin, assisted. As in the US, women—including Ulrike Meinhof, considered the intellectual leader of the group, as well as Ensslin—were to play a prominent role in the actions of what came to be known as the Baader-Meinhof gang.

The increasingly fraught politics of postwar Europe also played a role in the formation of performance artist Marina Abramović, who was born in 1946 in Belgrade to parents who were both military heroes of World War II; some have seen in her early work the influence of "traditional Balkan tropes of women's roles—of heroine and victim."[26] In a conversation with Thomas McEvilley, Abramović confirmed the importance of her family and cultural history, although

her gender politics were decidedly unconventional. "In my life before leaving Yugoslavia," she says, "I took a completely male approach, really go for it and heroism and the possibility of being killed. And I think that if I had continued my work as it was going, at some point I would have been killed."[27]

Between 1973 and '75, Abramović produced a series of spectacularly risky performances called *Rhythms*, the most challenging of which was probably the first presentation of *Rhythm 0*, in Naples in 1974. During the six-hour-long event, Abramović invited the audience to do what they liked to her using a range of objects she provided; six dozen in all, they ranged from grooming tools to lethal weapons. By the end, all of her clothes had been sliced off her body, she had been cut, crowned with thorns, and had a loaded gun pressed against her head.[28] By explicitly tempting viewers to do the artist real harm, this performance considerably upped the ante on Ono and EXPORT's work of the previous decade. For other works in the series, Abramović again placed her welfare in the hands of the audience by creating situations of danger and awaiting rescue. In *Rhythm 5*, she constructed the outline of a five-pointed star with gas-soaked wood shavings, lit it, and, after tossing cut-off pieces of her hair and nail parings onto its points, lay down inside it—soon passing out from lack of oxygen, which the fire consumed. Two further works caused Abramović to lose consciousness. In *Rhythm 2* she ingested psychoactive drugs. For *Lips of Thomas* (1975), which followed the *Rhythm* series, she ate a pound of honey, drank a liter of red wine, carved a five-pointed star on her stomach with a knife, flagellated herself, and finally lay on a cross of ice, under a suspended heater. At the end of this work's initial presentation, audience members carried her away.

The philosopher and art critic Arthur C. Danto called this performance shamanistic and compared it to Counter-Reformation images as specified by the Council of Trent, which were meant to use unsparing brutality as a way of enforcing faith. "The psychology of empathy,

which participants in the Council understood perfectly, was to use the depiction of suffering as a way of bonding between viewer and victim,"[29] Danto wrote. Similarly, he argued, Abramović's purpose was to "forge a bond between audience and performer through art that uses the real body as its means."[30] Curator Klaus Biesenbach takes the spiritual connections further, comparing the artist to early Christian ascetics, as well as to Mahatma Gandhi and even leaders of the Civil Rights movement in the US.[31] For her part, Abramović claims that she is capable of achieving a "state of luminosity," rare but shared with some artists and scientists, which is so subtle that generally "our own energy obstructs its entrance."[32] Far from conveying an experience of vulnerability through her submission to viewers, as did EXPORT and Ono, Abramović aims to express her triumph over danger and pain. A list of artistic mandates she compiled for a manifesto of 2010 included these proclamations: "An artist should develop an erotic point of view on the world" and "An artist should suffer, / From the suffering comes the best work, / Suffering brings transformation, / Through the suffering an artist transcends their spirit."[33] Unlike Ono and EXPORT, who staged sexualized encounters but declined to discuss eroticism openly, Abramović gladly declares its primacy. And while other artists of the period undertook physical and emotional hazards, none courted them as assiduously as Abramović, nor with greater confidence in overcoming them.

Feminist scholar Sharon Marcus has observed, of performances such as Ono's, EXPORT's, and Abramović's, that while on the one hand they are "reproducing the most insidious ways of thinking about rape, which is that women want to be raped and provoke men to rape them," on the other hand, "it's very aggressive to expose yourself in public. We usually experience someone exposing themself as something of a threat. These artists are saying, 'Instead of *you* staging this, *I'm* staging this. Now you're part of my scenario.' It's very aggressive."[34] If it is hard to see *Cut Piece* as an act of aggression, it

is not impossible, and the effort is surprisingly productive. To shine a light on environments of sexualized threat is, at least implicitly, to refuse unquestioning acquiescence—to begin to imagine, as Marcus urges, rewriting the script of sexual violence. Simply by seizing the initiative in enactments of danger, she suggests, these artists help conceive a safer world.

Ono, EXPORT, and Abramović are very different artists and women. Yet the conditions under which their sensibilities were shaped unite them, at least by comparison with those of American women in this period. While there was a far higher rate of street crime in the US, in Europe misogyny, particularly in the form of rather brutish condescension, seems to have been worse—it was both more prevalent there and more enduring. And by the middle seventies, performance was important enough on both continents that Lucy Lippard could write an essay judging the relative strengths of "European and American Women's Body Art." She began by comparing the two US coasts, finding that the feminist performances taking place in Los Angeles fizzled on the East Coast, where the stern, steely sculptures and conceptualist exercises of artists like Donald Judd and Richard Serra prevailed. But in Europe, Lippard judged, things were even worse. Its male establishment, she wrote, was unsympathetic to women's participation in the art world as equal competitors, but "has approved (if rather patronizingly and perhaps lasciviously) of women working with their own, preferably attractive, bodies and faces."[35]

By the mid-seventies, a number of male artists, like their female counterparts, were exposing themselves to harm, or simply to the eyes of viewers. Best known among self-injuring artists of the time was Chris Burden, who famously had himself shot in the arm by a friend in 1971, and soon thereafter crucified on the hood of his car; he also engaged in daunting tests of solitary physical endurance. At around the same time, Barry Le Va staged a three-hour action in which he ran back and forth across a room, crashing repeatedly

into its opposing walls, an exercise that left him exhausted, bloody, and bruised.

At the same time, as Lippard noted, women who did the same were accused of narcissism—and perhaps with some merit: "There is an element of exhibitionism in all body art," she wrote, sounding the same note Nochlin had struck in her groundbreaking essay. Nudity had become epidemic in feminist art by the mid-seventies, and no one pushed the issue of "exhibitionism" further than Hannah Wilke, who flaunted her considerable beauty in performances and photographic self-portraiture that was provocative in every way; Lippard worried that Wilke had confused the roles of "flirt and feminist."[36] More approvingly, Lippard concluded, "A good deal of this current work by women, from psychological makeup pieces to the more violent images, is not so much masochistic as it is concerned with exorcism, with dispelling tabus, exposing and thereby defusing the painful aspects of women's history."[37]

Although they were gaining momentum, those pursuing this introspective work, bold and raw, struggled to be taken seriously in both New York and California. No one better demonstrates the lengths to which artists would go to suppress psychological content in even the most undeniably emotional work than Vito Acconci. A gruff, gravelly voiced, Bronx-bohemian poet manqué of immense if unlikely charisma, Acconci was among the first in the US to address sexual violence (and he remains one of the few men to do so). Yet he insisted that his often deeply provocative and heavily sexualized performance works, which began in 1969 and continued through the early 1970s, were concerned with the same things that conceptually driven sculptors were addressing: perception, language, and their intersection.

Perhaps not surprisingly, these early works (and his statements about them) reveal bruising conflict both explicit and seemingly unconscious. They also capture a powerful sense of displacement, of

dissociated wonder, often expressed by sculptors who invested simple, common things—geometric forms made of plywood; bodies in space—with the characteristics of unfathomable mystery. Philosopher Maurice Merleau-Ponty, a guiding figure for artists at this time, observed: "Our body ... applies itself to space like a hand to an instrument; and when we wish to move about ... [we] transport it without instruments as if by magic, since it is ours."[38] This meditation was quoted in the introduction to a 1984 anthology of early writings about performance art by Robert Nickas, who goes on to cite Lucy Lippard's assertion that performance is "the most immediate art form, which aspires to the immediacy of political action itself."[39] But Nickas is closer to the spirit of Acconci's early work when he asks, "might we speak, with the concept of the artist's presence in mind, of 'painting aloud' or 'sculpting aloud' or 'writing aloud' [as Barthes had put it] within the framework of performance?"[40] In a 1972 essay about Acconci's performances, the critic Robert Pincus-Witten began by saying, "Vito Acconci, perhaps more than any other figure working in that aspect of post-Minimalism associated with the Conceptual performances ... allies those open and anarchic stances with the abstract reductivist enterprise known as Minimalism." Pincus-Witten concluded that Acconci "conducts the Conceptual performance in a virtually autistic vacuum. In this sense he approaches social indifference."[41]

Acconci saw his work that way himself. In a 2008 interview, he said of his performance work, "It wasn't that far away from Minimalism," which was the work "that meant most to me."[42] Having attended the legendary Iowa Writers' Workshop, where his admiration for the austerities of Alain Robbe-Grillet's *nouveaux romans* won him few friends, he returned to New York and soon found a more sympathetic community among the artists with whom he began associating; they included the dancer Yvonne Rainer, known for her stripped-down, everyday movements, and Minimalist musicians Steve Reich and Philip Glass. (On the other hand, Acconci said, "Fluxus seemed a little bit

like, watch me make a fool of myself and this counts as art."[43]) He was drawn to Edward Hall's *The Hidden Dimension* (1966), a study of social space ("proxemics"), and to Erving Goffman's *Interaction Ritual* (1967), from which Acconci learned, "the body was analogous to a word-system as a placement device—there was an attempt made to 'parse' the body: it could be the subject of an action, or it could be the receiver, the object."[44] Mostly, he added, "'I' acted on 'me.'"

Indeed, such early works as one that involved rolling a rubber ball across the floor of a big loft until it stopped (*Roll*, August 1969); walking down the street, trying not to blink, and shooting his camera whenever he failed (*Blinks*, August 1969); and falling forward, taking a photograph as he hit the ground (*Fall*, October 1969), were indisputably Minimalist. Soon, though, things heated up. While the initial pieces, Acconci explained, "were very much oriented towards defining my body in space," after 1969, "the interest has really been in an interactive element, what I would call throwing my voice, setting up a power field, though not so much that I want to grab and trap someone."[45] Interaction, and inklings of emotion, had arguably been present almost from the start, as in the May 1969 performance *12 Pictures*, during which Acconci entered the stage of a dark theater and aimed his camera at the audience, the flash illuminating them briefly twelve times. His notes state, "Face an audience: I might be afraid of them, I'm in the dark about them (control my fear, control the audience, they're blinded by the flash)."[46]

But the first provokingly interactive performance to have been widely noted, and remembered, is *Following Piece*, which took place during three weeks of October in 1969. Part of a program called *Street Works*,[47] *Following Piece* was based on a simple self-instruction: "Each day I pick out, at random, a person walking in the street. I follow a different person everyday; I keep following until that person enters a private place (home, office, etc.) where I can't get in."[48] Some of these unilateral relationships were short-lived, but one man was

followed to dinner and into a movie theater—for a double feature, no less. Another followee, this one a woman, led Acconci into three shoe stores, a bookstore, and the subway to the Upper East Side, an escapade that took a full three-and-a-half hours.

As a series of physical acts, *Following Piece* was perfectly ephemeral: unseen, unknown. But in November, Acconci mailed a series of notes to various art world players, dedicating a different itinerary to each. Produced in one-a-day fashion, like the following acts themselves, the notes were addressed to established critics, gallery owners, and artists;[49] in December of that year there was even a public "reactivation" (in the form of an exhibition) of the "private" mailed-note pieces. In other words, from the start, Acconci was canny about the tricky business of publicizing irreducibly private work. (Later, he admitted that the photographs generally used to illustrate *Following Piece* in magazines and books were made after the fact, too; being accompanied by a photographer for the original performances would have blown his cover, but he came to understand that to have a presence in the art world, and particularly in its then all-important monthly magazines, there would have to be pictures.[50])

Critic David Bourdon's response, on getting his typewritten report, was not altogether favorable. "My sympathies were entirely with his 'victim,' who, in addition to a solitary meal in a spaghetti parlor and a couple of dumb movies, surely had enough to worry about in getting to that apartment on a wild edge of the Lower East Side without being trailed by one of New York's most hirsute and malevolent-looking artists,"[51] Bourdon wrote in 1973. Summing up such performances, he concluded, "Aesthetically, it seems to me, the movement does not add up to very much. But sociologically, I suspect, it is of dire importance."[52] The "wild edge" to which Bourdon referred was the area around Union Square, a neighborhood which today poses few significant hazards to the homeward-bound pedestrian. But as Bourdon predicted, the sociological element would become an

important element of Acconci's undertaking. Looking back, it's easy to see that before cell phones, before nearly omnipresent surveillance and universally available Internet connectedness, both solitude and unwanted contact with others were less readily mitigated. One was often alone in a frightening way; help was not always at hand. The flip side of the period's vaunted recklessness was a deeply internalized wariness; one chose one's routes carefully—a habit that Acconci exploited. Insinuating himself into the lives of strangers, he turned the table—but not all the way around—on voluntary submission to the will of strangers as enacted by Yoko Ono and VALIE EXPORT. Aggressive though it was, his predatory role left Acconci open to retaliatory action, thereby expressing, acutely, the city's prevailing mood of unease.

Most of Acconci's notes about *Following Piece* hew to a Conceptualist egolessness. "What I wanted was to step out of myself, view myself from above,"[53] he wrote. Pursuing an analogy between the performance work and his poetry, he further explained, "I'm not interested in *performance* … rather the conditions of performance—something subjective, infinitive, not tied down."[54] And, of the blind tango of *Following,* "Adjunctive relationship—I add myself to another person—I let my control be taken away—I'm dependent on the other person—I need him, he doesn't need me—subjective relationship. A way to get around, get into the middle of things (I'm distributed over a dimensional domain)—out in space—out of time (my time and space are taken up into a large system)."[55] These abstract formulations of space and of the grammar of performance, like Acconci's preference for the conditional mood ("you would want me," "I would have to"), support the project's Conceptualist affiliations. But Acconci also stated plainly, "The person I follow has his privacy intruded upon: he becomes public. Since he is unaware that his privacy is being intruded upon, his privacy is doubly intruded upon."[56] While use of the male pronoun as universal was conventional at the time, it was also the case that

of twenty-one people Acconci trailed for the official *Following Piece*, only seven were women. Later, however, many of his performances would find him tangling, in various ways, with female partners.

Following was preceded by a few related ad hoc experiments, such as *A Situation Using Streets, Walking, Running*, performed on Fourteenth Street between Fifth Avenue and Sixth Avenue in April 1969, for which Acconci declared he would "stand at one corner— pick out a person walking from that corner to the next—run to the next corner and wait for him to arrive."[57] The question it presented, as he explained later, was: "Do I outrun him, or does he beat me to the corner?" Subsequent pursuits of strangers were less boyishly competitive and more disturbingly insinuating. During the month of June 1970, for an exhibition at the Dwan Gallery in Los Angeles, he solicited viewers at long distance, sending a daily telegram to the gallery that was pinned to the wall; the messages were variants of, "You in the orange shirt I want you."[58] In September 1970, for the exhibition "Software" at the Jewish Museum, Acconci appeared in person for *Proximity*, which involved him in "Standing near a person and intruding on his/her personal space." As he described it, "From *Following Piece* to *Proximity*, the interests are entirely shifted. In *Following Piece* my space and time are being controlled: I'm follow-ing a person, but I'm certainly not a spy, I'm being dragged along. In *Proximity*, I'm crowding a person."[59] Of course, Acconci was "controlled" only within parameters of his own choosing. (While the same was true in comparable acts by female peers, it can be argued that women experienced greater physical vulnerability in doing so, and thereby expressed more potently the experience of sexual viola-tion; they also created an opportunity to subvert that experience by invoking it themselves.)

The increasing menace Acconci identified in *Proximity* was applied to himself as well as to others. Among his performances of 1970 were those that involved pulling out hairs one at a time around his

navel; putting a match to the back of his neck and a candle to his chest; rubbing his forearm until it bled; biting his own legs and arms, and then inking the bite marks for printing. These hesitant, intimate self-injuries could be seen as half-hearted efforts at sex change, as were other works in which he tucked his penis between his legs, or pulled on his nipples. The mournful mock-jesting tone of these exercises veers away, slightly, from the more damaging (and, putatively, heroic) self-injury in work by Chris Burden, Barry Le Va, and others. Acconci's nakedness was generally a means of expressing alienation from his own physical being.

But just as often, Acconci used his (clothed) body to create tension—and sometimes open struggle—with various protagonists, most often women. Several performances were organized around the maintenance and severance of eye contact. In the videotape *Pryings* (January 1971), we see Acconci attempting to pry open the tightly shut eyes of Kathy Dillon, his romantic partner at the time. She resists vigorously, while he holds her head in his hands and uses his fingers to try to push up her eyelids; when he succeeds, the whites of her eyes are visible, which heightens the tension, even horror of the scene. She ducks her head to evade him and keeps her mouth tightly shut, along with her eyes, and since the framing is tight around their faces, viewers feel trapped, too. You hear footsteps clomping; eventually you hear panting. Some of Acconci's gestures appear almost tender, but he is relentless, and the fear and outrage Dillon's face expresses seem altogether real. Acconci's notes state, without apology, "Here the performer will not come to terms, she shuts herself off . . . my attempt is to force her to face out. . . . I might get under her skin." Writing for the *New York Times* in 2001—thirty years after the performance—Kay Larson described *Pryings* as "an action that takes on overtones of rape."[60] That seems exactly right. Enacting a struggle for control, Acconci makes it appear that superior physical strength belongs to him naturally, as a man; watching, we're

given no reason to doubt it (the conditions of the performance seem not to permit Dillon fighting back with everything she's got). But in persistently refusing to *see* him, she hits him where it hurts, in his bid for recognition. Force is on his side, but, here, it's his only resource.

If there were unacknowledged intimations of sexual violation in *Pryings*, a performance staged four months later raised the stakes considerably. For *Broad Jump 71*, presented in May 1971 during the "Boardwalk Show" at a computer convention in Atlantic City, Acconci made his best effort at a broad jump; the distance was marked, and viewers were challenged to outjump him. "The broad-jump," he explained to willing participants, "is a jump for a broad: each successful contestant wins, from me, a woman for two hours. Winners can choose between two women, whose photographs hang on the wall." In documentation of the performance, a handwritten note clarifies the arrangement: a chosen "girl" "is obliged to spend two hours with each winner. The winner can, of course, extend the time, through his own power." The documentation includes photos of Acconci jumping and sultry headshots of both women, presumably for the benefit of men choosing their prize.

The thoroughgoing ugliness of this performance was, it seems, lost on Acconci at the time. Rather than an offense against two women, Acconci's notes suggest he saw it as a trial for himself (and an opportunity for wordplay): "The contestant's victory over me has consequences: I'm defeated in my role of 'sportsman,' 'sporting man,' 'adequate male,' 'adept male.' The prize is something prised away from me: I've been living with Kathy for three years—Pam has been with us for three weeks—I'm in love with both of them. Each woman is set loose...."[61] Nothing is said about what the experience might entail for the women. When Acconci was asked two years later by the writer and publisher Willoughby Sharp whether there was some self-testing involved, he answered, "More a testing of what kind of force can I exert over a space." But in the set of performance notes

published in *Avalanche*, in 1972, *Broad Jump 71* is documented on a page headed, "Occupied Zone—Moving in, Performing on Another Agent," which clearly expresses a more interpersonal dynamic. In his notes, Acconci writes: "I had to challenge each girl, convince her to take part, make sure she didn't change her mind ... I had to remain in training: work myself into an ownership principle, make myself believe I was in the position to give a girl away (I had to feel the possibility of a real loss) [the ellipses are Acconci's]."[62] His training supersedes theirs, his "loss" the last word.

Acconci briefly notes, in his own writing about the piece, the striking circumstances of this performance: the exhibition accompanied a business convention for a nascent computer industry; it took place in a dying Atlantic City that was the site of the still hugely popular annual Miss America contest. But he didn't mention that the beauty pageant had been the setting, two and a half years earlier, for a landmark feminist protest at which bras were trashed (though not, as legend has it, burned) along with girdles, false eyelashes, cooking pots, and mops, and a banner was unfurled proclaiming "Women's Liberation." If there was unintended irony in the coincidence, there was likely an element of deliberate self-mockery in such hyperbolically confrontational events as *Claim* (September 1971), for which Acconci stationed himself at the bottom of stairway, wielding a metal bar and threatening anyone who might approach; he could be seen on a video near the doorway upstairs, muttering "I'll keep you away... get rid of you ... I'll do anything to stop you ... I'll kill you." The same is true of *Seedbed* (January 1972), probably Acconci's best-known work, in which he lay unseen beneath a ramp constructed for him in the Sonnabend Gallery in New York's SoHo, ostensibly masturbating, while his voice was broadcast above, darkly implicating viewers he could hear but not see: "You're moving away but I'm pushing my body against you, into the corner ... you're bending your head down, over me ... I'm pressing my eyes into your hair."[63]

At a stretch, *Seedbed* could be considered funny as well as creepy. Acconci often cited his father's love of puns and indulged in them freely; he cited the Marx Brothers as well. In a 2006 essay, critic Gregory Volk describes Acconci's artistic voice as, among many other things, "forthright and hilarious."[64] But observers at the time were unlikely to see the joke. Indeed it's still not easy to see humor in works that directly involve real women, especially when identified by name and further revealed to be Acconci's lovers. In *Remote Control* (October 1971), he and Kathy Dillon, both confined to small wooden boxes, are visible to each other on live-feed video monitors; he directs her to tie herself up with rope, and she does. The action doesn't bode well, and indeed in *Stop-over* (April 1973), Acconci delivers a monologue in which he says (without naming his subject), "After all, I have to keep hitting you, knocking you down—I can't make myself stop, I realize what I'm doing only after I start. But maybe there's no reason to stop: at least, there's no reason to feel guilty for all the times I haven't been able to make myself stop." In *Line-up: Defense* (Paris, October 1973), he refers to Dillon by name, and talks about their breakup, suggesting, "Tell them she's out of her mind ... what's she complaining about? ... she knows what I am ... I never pretended anything else ... she knows what she got herself into ... she was a good fuck, and that's all I wanted ... "[65]

Full Circle, a video work that was one of Acconci's last performances, was made the following month. Circling the camera, sometimes on-screen and sometimes off, he tells the audience he is "talking about circling you, wrapping myself around you, as I did around 'her,' a person from my past: a kind of trap." A tale of a slow-motion breakup, it is directed at a new lover, to whom he confesses all, with no remorse: "The way I had to shake her to get her out of her depression. You would realize I had to do it. You would have done it too," he says. And, shifting without warning toward true violence, "You would understand how I had to beat her face in.

You would have done exactly what I did. I couldn't stand her fear." When the scene changes from a snowy mountainside to an urban waterfront, he intones, "We're on the pier, lonely pier, nothing to see." Under moonlight, "There'd be a frightening shadow on the pier." And again, without warning, a tone shift: "You would have to be a little afraid of me, you'd want that, you'd want me to fuck you in the ass, you'd want me to be aggressive with you." *Full Circle* was one of several performances presented in Italy and in France; critic Kate Linker writes, "By 1973 Acconci's work was increasingly performed in Europe," and the use of simultaneous translation "led to a pluralization of voices," perhaps mitigating the work's aggression. She also wrote, of the various counterparts in these performances, "Acconci's 'other' changed roles and sexes, vacillating between commander and commanded, male and female, invader and sex-toy."[66]

It is perfectly true that Acconci was playing roles—and also, as in all performance art, that he was simply being himself. That is the irresolvable tension that gives the form its peculiar force. And he wasn't simply telling tales of his love life, or of his own insecurities, hopes and memories—many of them disarmingly, sometimes mortifyingly honest. He was also exploring, just as he claimed, the boundaries of his medium. After having thoroughly humiliated Dillon, in *Line-up: Defense*, he admits that she thought he was higher-minded than he proved to be—that he bamboozled her—though he insists she should have known: "I wasn't interested in art, I was interested in power... she should have been able to see that." Indeed he was interested in power, and didn't hide it; nothing, perhaps, is more subversive than candor on this particular subject. In the 2008 interview, he confesses of Dillon, with whom he lived for five years starting in 1967, "In retrospect, I think she should have gotten credit for those pieces ... It was more of a collaboration than I admitted." His 2006 *Diary of a Body: 1969–1973* is dedicated in part to her. But it was in the service of his art that he exposed himself with such heedless

honesty; injury to the privacy of others—or, to their emotional and physical well-being—was, as he saw it, beside the point.

In an interview from the 1980s with the performance artist Linda Montano, Acconci was pressed on the place of sex in his work. Explaining that he used it as "a sign of power in an intimate relationship and then, in turn, male power," he claimed that he intended to "tear apart [the] mystification of maleness." Acknowledging that "a lot of my earlier pieces have been seen as sexist," he insisted that "at the end of the sixties, feminism seemed almost more important than any antiwar movement." But he admitted, too, "I am still a male, and I know I think like a male." And he offered this explanation of his impulses: "if my father was in the kitchen and my mother was in the living room, my father would still ask my mother for a glass of water, as if it were a normal thing." And she would get it. "Obviously," he continued, "I grew up as if it were normal, too." He was fully aware of the explanation's inadequacy. "Being conscious of it isn't quite enough," he concluded. "Unfortunately, consciousness doesn't mean change."[67]

In many performances of the early 1970s, and the video work that developed from them, there is a paradoxical impulse toward physical histrionics and psychological muting. The body is used as an instrument that, stretched to its limits, can push past feeling. This is how most serious performance artists of the time, male or female, wished their work to be seen, which helps explain why women participated in Acconci's performances. And these are the terms by which he wanted his work judged—as indeed it was, for example in Rosalind Krauss's essay "The Aesthetics of Narcissism," which appeared in the first issue of the noted academic journal *October* (Spring 1976). Krauss was using Freud's notion of narcissism to name a self-reflexive characteristic of perception rather than a psychopathological symptom, finding video ideally suited to such narcissism because it "is capable of recording and transmitting at the same time—producing instant feedback."[68]

Acconci is Krauss's first example of an artist "using the video monitor as a mirror."[69] This assessment tidily "brackets out" (to use a favorite Krauss phrase[70]) the specificity of Acconci's artistic character, and the interpersonal—or gendered—content of his performances and videos. Sounding a little like Nochlin, who had urged women to rise above introspection if they wished to be taken seriously, Krauss praised Acconci for actively opposing the explorations of embodied emotion that women, by the middle of the decade, were just beginning to undertake. It would be false to suggest a clear division between the sexes in the performance work of this period. But it is true that gender differences were becoming clear, such that many men tended toward displays of strength and endurance (just as, in sculpture, they were choosing industrial materials and processes: forging iron, welding steel, and so forth), while women were beginning to use domestic materials and skills.

Naturally, some important work defied this dichotomy. With striking (but coincidental) similarity to Acconci's 1969 *Following Piece*, John Lennon and Yoko Ono collaborated the same year on a cinema verité film that also featured an unsuspecting subject—a woman—pursued for more than an hour by strangers, in this case a two-man camera crew. But unlike Acconci, Lennon and Ono clearly identified the emotional valence of the exercise: they called their film *Rape*. Ono, who'd met Lennon a few years earlier, had scripted a work called *"Rape (or Chase)"* in 1968; Ono described it as "Rape with camera. 1½ hr. colour synchronized sound. [The completed film is 77 minutes.] A cameraman will chase a girl on a street with a camera persistently until he corners her in an alley, and, if possible, until she is in a falling position. The cameraman will be taking a risk of offending the girl as the girl is somebody he picks up arbitrarily on the street ... Depending on the budget, the chase should be made with girls of different age, etc. May chase boys and men as well. As the film progresses, and as it goes towards the end, the

chase and the running should become slower and slower like in a dream."[71] Ono's and Lennon's vision ultimately coalesced around a single, female victim.

At first the film's subject appears flattered by the attention; she asks the cameramen if they think she is a movie star, and halfheartedly rebuffs their attention, in several languages. But she soon grows flustered. Ultimately they follow her into her apartment—without her knowledge Ono and Lennon had colluded with the subject's sister, who lent them a key—where she becomes openly distraught. Though the unremitting attention of paparazzi was likely at issue in Lennon's and Ono's project (and though the subject's acute vulnerability, as an undocumented and non-English-speaking Viennese resident in London, may have heightened her anxiety and reluctance to call the authorities), their choice of title for this movie, and of gender for its subject, clearly suggests the sexualized nature of the threat. At the same time, the subject's seeming willingness, at first, to play along vividly illustrates the confusions of the time. Chrissie Iles writes that the subject's "level of tolerance toward the strangers also reflects a general female passivity which the fledgling women's movement of the sixties was beginning to address." That tolerance—or, reluctance to express fear—also helps explain the willing complicity of Acconci's female partners. But it is clear as well that Ono and Lennon found the limits of such forbearance. By the end of the chase, Iles notes, the filmmakers' prey in *Rape* "behaves like a cornered animal, lashing out at the camera."[72]

Iles believes that *Rape* "underlines Ono's feminism."[73] But Ono has always resisted identifying herself with any single group or class. In a statement "On Rape," self-published in London in 1969, and reprinted in *Grapefruit* (1970), she struck a discordantly whimsical note, writing "Violence is a sad wind that, if channeled carefully, could bring seeds, chairs and all things pleasant to us." Asking "What would you do if you had only one penis and a one-way tube ticket

when you want to fuck the whole nation in one come?" she ends in a decidedly darker mood: "we go on eating and feeding frustration every day, lick lollipops and stay being peeping-toms dreaming of becoming Jack-the-Ripper."[74] It could hardly be called a straightforward articulation of sexual politics; Ono's disposition is toward indirection and forked paths. Searching her work for truth—personal, political, historical—is, she might say, so misguided as to be sort of funny. And the comedy of the absurd is a better guide to the world's dark places, Ono suggests, than political precepts. It makes hers a decidedly oblique perspective on rape, although hardly the least illuminating.

Laurie Anderson's equally beguiling humor is less circumspect, as was evident early on. Dispensing with Ono's wily evasions, Anderson took the voyeur's camera into her own hands in 1973 to produce a series of photographs of men and boys who'd regularly assailed her with "unsolicited comments of the 'hey, baby', type" on the streets near where she lived. The black and white images were printed with white bars covering the subjects' eyes, and conversational, hand lettered captions below. ("This man was standing at the newsstand on the corner of Houston Street and First Avenue. 'How ya doin' honey?' he said. When I asked to take his picture he said, 'An old goat like me?...'" "This man is often in a park on Houston Street. When I pass, he usually says, 'Hi there sweet 'lil angel'...'"). Art historian Anne Wagner contends, "In the name of privacy she inflicts blindness, even a kind of objecthood"—the series is called *Object/Objection/Objectivity*—"on subjects who had started out by treating her that way."[75] This is true. But Anderson, then in her mid-twenties and looking younger, surely disarmed her subjects first. Rather than presenting the steeled-for-the camera face of standard mug shots, these men seem caught off guard, defenseless against an emotional version of the jujitsu that women were being encouraged to use against attackers. Anderson's project is not an aggressive response, and it

doesn't address serious violence. But it pictures men accustomed to harassing women with impunity and quotes them, identifying, with a deftness that is almost affectionate, a kind of interaction that would no longer be tolerated. Artists would help make that so.

TESTIFYING

Bold though they were, those pioneering performance artists who staged sexualized encounters between men and women—Ono, EXPORT, Acconci—made only oblique references to outright violence. Charting the landscape of social relations, they found that fear and aggression, threat and vulnerability were among its clearest coordinates. But explicit representations of sexual violation weren't part of their terrain. As the incidence of rape increased dramatically in the seventies, as the culture grew more violent generally and, most of all, as women began to speak out about their own assaults, artists began to find ways to express experiences that had had no public language, in either words or images. The effects of these efforts—initially limited and halting, then wide-angled and bold—were explosive. At long last, the unspeakable was being said.

These outspoken performances appeared first in and around Los Angeles, where Suzanne Lacy, Judy Chicago, and other feminists were broaching issues that were seldom talked about in the privacy of women's homes, much less in public. Critic Lucy Lippard had noted that women's performance tended to be "brazen"; in Lacy's more sympathetic account, West Coast feminist performance in the seventies was "confessional by nature," introspective and emotionally honest in a way with which men seemed unfamiliar and lastingly uncomfortable. In fact, Lacy argued that it was "feminist politics expressed in the culture, and in performance, [that] substantiated the men who were doing it—people like Vito Acconci, who used

the climate created through feminist self-revelation." (Lippard agreed, in a fashion; "It *did* allow men to express their anger about women in their performances," she said, and then added, "When the confessional part came up in the male psyche, it always seemed to have to do with women or sex.")[1] Home to Judy Chicago and Miriam Schapiro's Feminist Art Program at the California Institute of the Arts, and to *Womanhouse*, the Feminist Studio Workshop, the Woman's Building, and other projects and venues that emerged from it, Los Angeles offered women artists the benefits of an active feminist community. It also presented them with considerable challenges. LA was notorious at the time for its incidence of rape, said to be the nation's highest.

But in major cities on both coasts, crime of all kinds was soaring. And the offenses were often strikingly intimate. Robberies on the street and in homes, then so common, were very personal kinds of violation. The now laughable rows of locks on doors and bars angling up from floors, trademarks of the typically gritty movies of the period, reflected a credible sense of siege. Mugging, which so typifies the period, is a word that probably derives from the archaic verb "mug," to strike in the face—itself derived from the noun, now as ever, a drinking cup. Think of those Attic Greek cups with heavily outlined, staring eyes painted inside the bowl: as one drained it and tilted it toward oneself, those eyes would meet the drinker's. As wine pours down your throat, and your vision is blocked, and, perhaps, your thoughts blur, you're being watched, sedulously, malevolently. Mugging—as it feels to say it—is a little childlike, almost friendly; it also means hamming around. But it was important to play one's part right. One learned vigilant caution. Which of those shadows are moving? Is there harm hidden there? Is someone leaning against me too hard? Is he hard? Does someone have a hand in my pocket? Is someone quietly jerking off, unzipped beneath his trench coat? What is going on around here? Are you looking at *me*?

There was plenty of reason for fear. Literary critic Elaine Showalter wrote, in an essay on sexual violence in women's fiction of the seventies, "in my own placid university community [New Brunswick, New Jersey], all of the violent crimes of the last decade have been committed against women: gang rapes, a torture murder, a decapitation (unsolved), a shooting. Two of my close women friends living in New York have been attacked by strange men—one stabbed, one shot."[2] Looking back, the storm of random malice, even the heart-pumping fear it provoked, are easy to romanticize. The level of exposure, and of damage, was so dramatic that now, in a time of soaring and enormously divisive urban wealth, it is fueling a perverse nostalgia—a kind of cultural schadenfreude. Indeed, crime and danger were romanticized before they'd passed into history, as in *Midnight Cowboy* (1969), or *The Panic in Needle Park* and *Klute* (both 1971).

As the seventies progressed, late-stage political activism, increasingly militant, became conflated with random criminality. And, with lasting consequence—notably for the exacerbation of racism and xenophobia—it began to be called terrorism. In 2015, CNN reported that while "Many Americans today are clearly convinced they are gravely threatened by terrorists.... In fact, the real Golden Age of terrorism in the United States was during the '70s," a decade during which "terrorists killed 184 people in the States and injured more than 600 others." By contrast, in the decade and a half after 9/11, terrorists had killed seventy-four. According to Rick Perlstein, the author of *The Invisible Bridge*, a history of the 1970s, there were twenty-three bombings in 1973 and forty-five in 1974; in 1975, the number jumped to eighty-nine. Clarence Kelley, FBI director at the time, intoned, "Terrorism is indeed the ultimate evil in our society. And no one can consider himself immune from terrorists acts."[3]

Of course, to apply the term "terrorist" is a political judgment. Casualties were in truth limited. And rather than seeking publicity, the myriad shifting radical affiliations of the 1970s were mostly small

and mobile, their members living hand-to-mouth and, increasingly, alone with assumed identities. Ultimately they foundered. In any case, by the middle seventies, crime was eclipsing political protest of all kinds. There was, to be sure, a certain slippage, in the popular imagination, between headline-grabbing political actors and the lone sociopaths identified by comic-book-villain names: following in the footsteps of the Boston Strangler, in the early 1960s, there were the Zodiac Killer in San Francisco in the late sixties and early seventies, the Zebra murders in the same city in 1973–74, and New York's Son of Sam, in the summer of 1975. Their hold on public attention reflects a crucial difference between violent crime of the seventies and of today. Now, although serial killings continue to occur, more attention is drawn to mass killings, whether inspired by political extremism and/or racism or by delusional impulses (or some combination of the above). A young man walks into a public place and sprays it with automatic-weapon fire, or detonates a bomb, or plows a truck into a crowd. The violence happens in an instant, and is aimed at everyone and no one—or, it has one aim alone: the media. By contrast, the terror of serial murders was not only in the waiting—anyone, it was felt, could be next—but also in the intimacy: the victim and the perpetrator together, alone. And when victims are chosen one at a time, the killers can satisfy particular appetites. In greatly disproportionate numbers, they chose women. Often rape was associated with the killings—and when it wasn't, the media often falsely suggested it was.

Less televisual than these variously motivated acts of dramatic violence were the crimes attributable to the decline of the economy—the stock market lost almost half its value between 1963 and 1974—and the evisceration of cities, which left virtually everyone who remained at risk. In a special 1975 report to Congress, President Ford admitted, "America has been far from successful in dealing with the sort of crime that obsesses Americans day and night—I mean street crime, crime

that invades our neighborhoods and our homes—murders, robberies, rapes, muggings, holdups, break-ins—the kind of brutal violence that makes us fearful of strangers and afraid to go out at night."[4] Again, the statistics are striking. A *Time* magazine cover story of June 30, 1975, reported that since 1961, the rate of all serious crimes had more than doubled. Violent crimes increased even more sharply than others; most (65 percent) were committed against strangers. In this period, the incidence of reported rape rose 143 percent.[5] In 1979, according to a Justice Department estimate based on a wide-ranging public survey, there were 2.8 rapes for every 1,000 people. (For comparison, in 2011, the same survey found that the rate had decreased to 0.9 per thousand.[6]) It is widely accepted that rape was and remains the most underreported crime.

In its 1975 report, *Time* noted that unemployment, and particularly the loss of manufacturing jobs, was a factor in the new surge of robberies, a problem compounded by the baby boom generation's demographic bulge. (The death of the rust belt has been announced many times since.) But the era's beleaguered urbanites found little sympathy. When New York City approached bankruptcy in 1975, Joe Biden, then a senator from Delaware, merely restated common wisdom when he said, "Cities are viewed as the seed of corruption and duplicity."[7] On one side of the argument that the report provoked, urbanites deserved what they got. On the other, the flight of whites from cities—which peaked in the seventies—was presented as natural and inevitable, although it was neither. During this period, Perlstein writes, "Federal subsidies flew in a torrent toward suburbs, in the form of interstate highways, mortgage deductions, and subsidies to banks that openly defied the letter and spirit of federal law by engaging in [racially] discriminatory lending patterns."[8] Those who stayed behind became the custodians of metropolitan areas deprived of their tax base and of the federal and state governments' sympathy. Many buildings burned (often for owners to collect insurance), or

were simply abandoned; parks were derelict and unprotected, as were docks, footbridges, sidewalks; basic services—schools, libraries, policing, garbage collection—languished.

Reporting disproportionate criminality among blacks, and thereby, arguably, supporting racially distorted mainstream media presumptions, *Time* noted in passing that most of the victims were black as well. This simple consequence of crime rates among the marginalized and poor is seldom given its true weight. The tendency, instead, to dwell on the victimization of wealthier whites is evident in the report's comment on rape. While noting, "most black rapists still assault black women, just as most white rapists assault white women," the (unidentified) authors also remark, "interracial rape seems to be increasing." This "seems to be" is a rare speculation in a story based on statistics; nothing further is said on the subject of rape. But it is more than enough to support fears and biases thoroughly established in the white collective mind, as attested by writers on all sides of the issue, from Susan Brownmiller to Angela Davis.

Active feminists found themselves buffeted by the crosswinds of conflicting presumptions. Willingness to face danger was considered a minimum requirement of political engagement; so was racial solidarity, although many African-American women believed—not entirely without reason; the limited presence of women of color in second-wave feminism reflects a welter of social causes—that the commitment was more rhetorical than real. But the dangers women of all colors faced were clear enough. And the recommended response was, as had been argued in *Our Bodies, Ourselves*, tactical self-defense. In her book on rape, Susan Griffin wrote, "In Berkeley, where I live, the streets have gotten more and more dangerous. Staying in one's own house is risky. There is a man who has been raping women in this city for half a decade. Still he has not been caught, and when one hears that he has moved into one's neighborhood a kind of atmosphere of fear starts to permeate the sidewalks and the trees

outside the windows. And he is not the only one. We know this from the way we have to protect ourselves."[9]

And so she does. "Much of the study of martial arts, besides the physical development of grace and skill, is a change in attitude. To work against fear, shock, a feeling of defeat. To use the energy of the attacker against himself."[10] In a 1973 column for the *New York Times* called "Street Fighting Woman," Brownmiller announced, "The F.B.I. told us that violent crimes in the nation rose again last year and that forcible rape took the biggest jump of all, a whopping 11 per cent. It is not exactly unrelated that at the age of 38 I have solemnly embarked on a dedicated program of self-defense instruction." She continued, "Japanese systems of self-defense (karate, aikido, jujitsu, kempo, take your choice) are daily gaining in popularity."[11] Brownmiller chose jujitsu, although, she wrote, "A revulsion to physical violence and a related uneasiness regarding physical strength in women is deeply embedded in my psyche." (Two months later, she ruefully admitted breaking her collarbone while practicing it; having a sense of humor is also important to self-preservation.) Though not featured on the pages of the *New York Times*, African-American women were also coming together to marshal strategies for self-protection. A broadside of the time now in the Schomburg Center in Harlem illustrates, in cartoon form, the importance to black women of learning self-defense. "In today's time of nation building," the first frame reads, "many black women are being ripped off in our communities by sick (brothers). One cure for this is knowledge of martial arts ... it teaches ... spiritual and mental control [ellipses in the original.]" The image is of a self-confident-looking woman who, in a following frame, kicks her high-heeled shoe with devastating effectiveness against an assailant. "I told ya not ta f... with that one," he mutters as he limps away. Writers Michele Wallace and Audre Lorde also addressed the necessity for women of color to recognize their own strength, and the importance of resisting violence close to home.[12]

The condition of fear under which so many women lived in urban America in the 1970s was exceptional; while sexism was nearly universal, the level of violence in this country was (and is) remarkably high. Leslie Labowitz, a Los Angeles-based feminist artist who had been living and working in Düsseldorf during these years, wrote in 1978, "In Europe I had let my defenses down and felt almost no fear about walking through the streets at night. I knew that coming back meant I would have to begin building those defenses back up—rape being the highest rising crime in the U.S. I am angry and resentful of this situation, particularly in L.A. where it is said that one out of three women will be raped in their lifetime."[13] Labowitz's statement appeared in the sixth issue of the feminist publication *Heresies*, which was dedicated to the topic "Women and Violence." A signally important magazine of the 1970s, *Heresies* addressed itself to "Art and Politics," and was published by a New York-based artists' collective of the same name. (The issue on violence was preceded by the one that proved most popular, on "Women's Traditional Art and The Great Goddess.") A year in the making, the Violence issue's production was contentious. Its seven unidentified editors, who as with every issue were independent of the collective, were young (all were under thirty-five years old) and without exception white; they described their "class backgrounds" as ranging "from working class to upper middle class; two women are lesbians; ... we have among us a carpenter, a vegetarian, a rape counselor/advocate, a book designer ... rape victims." They listed eleven criteria for reviewing submissions, beginning with "1. Where does this piece lead? Towards despair? Action? Analysis? Isolation?" and including "3. Does this piece contain potential or actual racism..?" and "4. Does the work contain class biases that go unchallenged?"[14] Acknowledging the limitations of their diversity, the editors sought, with mixed success, contributors who could broaden the issue's reach to communities of color.

After dismssing a pair of proposed approaches to countering what they saw as a male propensity to rape, the first biological (patently absurd, this approach would involve "lobotomies, physical or chemical castration or a eugenics program that would breed gentler men. Some women would dispense with men altogether and institute a program of parthenogenesis"), the second psychological (the treatment would be psychotherapy for offending men; this was condemned as too little and too late). The editors made it clear they believed that sociology offered the most promise, since it presumes that violence is neither irrational nor individual, but rather "has a social function." Reverting to the language of activist movements of the sixties, they write, "Women, like colonized people, must decide how to approach the complex relationship between the system of male domination and individual men." And they conclude, "Women who are daily fighting for survival, who are raped, sexually harassed on the job, tranquilized into passivity, and beaten cannot afford to make abstract theories."[15] Leading stories include an interview with a young member of a "clique" (gang) living in in the South Bronx, who tells of her gun use, and her brothers'; the death of a friend; and briefly, in passing, her own rape. There is an article on genital mutilation. There is a poem by Ntozake Shange and a brief but devastating poem by a young Sapphire. Once more, advice was given on self-defense; readers are cautioned against self-blame, but also urged to fight back with everything they had.

One contribution concerns the rape of a young woman by a man who picked her up hitchhiking. Recounted by poet and feminist Batya Weinbaum, partly in her own prose and partly in an interview, the assault is hazy; there is a shade of ambiguity about whether the account is autobiographical or fictional, though the stronger impression is of factuality. Weinbaum tells of being afraid to accept a ride with a black driver and of chastising herself for that fear. She says she talked back to him, but also that she expected to die. The *Heresies*

interviewer comments, "I feel if we are going to deal with the situation of white middle-class women [an identity shared with most of the issue's editors] being raped by black working-class men it should be done with some perspective on the whole issue, including the long history of white men raping black women and what that has meant/means in a racist society." Weinbaum replies, "OK. Look, let me say that *Heresies* is not the first or only feminist publication to reject these initial pieces on the grounds that the rape of white women by black men is 'too controversial' to be treated in this form. However.... The consciousness of racism was a factor in my paralysis as a female.... Women continued to participate in their oppression—by placing priority on the rights of others, putting consciousness of their own oppression as women aside." The interviewer insists that the rape, by "probably the only black guy on Harvard Square is atypical in the extreme."[16] Everything about the contribution seems not quite right; it is a uniquely disorganized, stilted piece of writing, and the interviewer is openly hostile. And yet—or, as a result—it captures some painful truths. Contacted in 2017, Weinbaum told me, "I didn't think it was healthy for women to not be able to talk about being raped in ways that weren't politically correct." She says she told the interviewer, "A black friend of mine, who was gay, was the only one I could talk to about it. And we're still friends. And I haven't seen any of those women in the collective for so long."[17]

If the issue's editors weren't all white and largely middle class—if feminism wasn't so badly torn by race on the issue of sexual violence—they might have had better access to other stories, perhaps of middle-class black women who were victims of similar crimes, by men of any race; or of poor white women being assaulted by poor white men. Clearly the editors aimed for inclusiveness; unconscious biases can't be ruled out. But Weinbaum's recollection suggests just how alone women who'd experienced frightful things continued to feel, even in the embrace of other feminists. Of course, editing by

committee is clumsy. And every story suffers from being taken out of context when there is no context. In Boston (where Weinbaum was raped), as in New York, New Haven, Philadelphia, Chicago, and elsewhere, historically exclusive, expensive, and still largely white universities (some of which had only recently begun to admit women and to make efforts at racial and class diversity) found themselves in the middle of desperately poor neighborhoods. Rather than taking steps to protect their students, university officials dissembled about the incidence of crime. The best advice that any feminist collective could offer was to learn martial arts and take responsibility for defending yourself—and to expect to deal with the aftermath if you failed, and move on. The rape crisis facing women in the seventies was quite different from the date-rape epidemic that has roiled campuses in the last ten or fifteen years, but their experiences, substantially unexplored, continue to shadow discussions of violence.

Several memoirs have come out decades after the fact, from women who suffered attacks by strangers in those years and hadn't been able to talk about them at the time. In *Denial*, Jessica Stern, who served on the National Security Council during the Clinton administration and is a lecturer at Harvard on terrorism, writes with shattering honesty and grace about being raped at gunpoint when a white stranger broke into her stepmother's home. She had been fifteen when the attack occurred, in 1973, and hadn't spoken of it until approached in 2006 by a policeman reopening the case. Stern's silence was supported by all the adults who knew of the assault, including her father.[18] Journalist Joanna Connors, who was raped in the early 1980s in an empty theater where she'd gone on assignment, writes thirty years later, "I could not allow myself to be the white woman who fears black men." She quotes James Baldwin at this admission: "My decision came out of what James Baldwin called 'that panic-stricken vacuum in which black and white, for the most part, meet in this country'" and in the epigraph that opens the

book: "Not everything that is faced can be changed, but nothing can be changed until it is faced." Connors goes to considerable lengths to fill in the story of her assailant—to learn his background, which was grim, and his circumstances, which were dire. She admits being unable to say whether she'd have declined to place herself in an empty theater with a white man. But she notes, "Interracial rapes, despite the media depictions and the drummed-up cultural panic that goes back to the Reconstruction era, are much rarer than same-race rapes."[19]

Such assaults were not, in fact, all that rare.[20] But they were also far from representative. The vast majority of white victims were and are raped by white assailants. The same applies to black victims and black perpetrators, although far fewer women of color, whether their assailants were men of color or white, have chosen to publish their stories. I've read many other rape memoirs, including those by Alice Sebold, Nancy Raine, Susan Brison, Susan Estrich, and Martha Ramsey. All are searing. Almost every one begins with a telling of the crime so urgent and raw that no effort of art or ideology can mitigate it. And nonetheless, a sense of disbelief often accompanies it. Stern's memoir begins, "I know that I was raped. But here is the odd thing. If my sister had not been raped, too, if she didn't remember—if I didn't have this police report right in front of me on my desk—I might doubt that the rape occurred. The memory feels a bit like a dream."[21] She wonders if there are parts of it she might have made up. Years of silence will do that.

It is hardly surprising, then, that it took Lacy and Chicago months to track down the seven women whose stories they taped for *Ablutions*. "I envisioned a dark auditorium, with nothing on the stage, the audience waiting expectantly. A loud audiotrack would begin, as woman after woman told her story, confronting the audience with the reality of sexual violence not yet found in public consciousness," Lacy explained. It wasn't a simple undertaking. "These women were hard to find. They did not want to talk. The rapes had been hidden

for years from family, friends, even husbands. The first stories were painful beyond belief. I heard of years of abuse by fathers and uncles, random assaults by strangers, calculated rapes by acquaintances, neighbors, and boyfriends, and brutal gang rapes. Followed by rejection by parents, divorces, psychotic episodes and suicide attempts. I saw how fear had become as natural to us as breathing."[22] Just airing these stories seemed momentous. As Lacy recalled, "The soundtrack was … really straightforward, like, 'I was walking down the street. I was pushing my child in a stroller.' Just telling in great detail the story of the rape."[23]

The recorded testimony was played throughout the performance and was at its core. But the work's conception, which came to include contributions from artists and activists Aviva Rahmani and Sandra Orgel, grew considerably more complicated. For the single presentation of the hour-and-a-half-long piece, the floor of the loft used for the occasion was scattered with broken eggshells, piles of rope, chains and heaps of offal. Amidst this grim scene stood three large metal tubs, one filled with a thousand raw eggs, another with fifty gallons of beef blood, and the third with gray, liquid clay. As described by Chicago, "After about twenty minutes one woman dressed in jeans and T-shirt led a nude woman to a chair in the back of the performance space, seated her, and began to slowly bind her feet, first one, then the other, a process that lasted forty minutes. A few minutes after the binding had begun, another woman came out and slowly eased herself into the first bathtub," which contained the eggs. "She started to wash herself, allowing the eggs to run down her body, an image of immersion in her own biology. After five minutes, she rose and moved on to the second tub, a metaphor for brutalization and at the same time a reference to menstruation." A second woman got into the egg-filled tub as the first rose from the one filled with blood and entered the third tub, from which she was lifted out by two women.

"The image, as she rose up from the clay bath, was of some ancient female fetish figure," Chicago said. "She was dried and wrapped in a sheet, then tied up like a corpse and left, while the two women did the same thing to the other bather." While all this was going on, Lacy and another woman, Jan Lester, appeared and began to nail fifty beef kidneys to the wall, at intervals of three feet, all in a line. Meanwhile the two helper-women sat facing each other, and hung ropes and chains around their heads. The bandaged, effectively mummified, seated figure was further tied with rope. Then Lacy and Lester, who had finished hammering, tied the kidneys together too, pulling tight so blood ran out of the organs and down the wall. "Round and round the women walked, tying everything up neatly, like some obsessive housekeeping duty, until the performance area was like a spider web and all the figures caught, contained, bound by their circumstances and their own self-victimization. The voices on the tape droned on," Chicago said. Finally the women left, one by one. It all "ended on a chilling note, the voice of a woman repeating the words: 'I felt so helpless, so powerless, there was nothing I could do but lay there and cry.'"[24]

The conception of *Ablutions* had begun in 1971 as part of the Feminist Studio Workshop program at the California Institute of the Arts in Valencia in 1971, which was led by Judy Chicago and Miriam Schapiro (it had been established by Chicago two years earlier, as the Feminist Art Program, at the University of California at Fresno). The program's best-known project, *Womanhouse* (January–February 1972), for which students renovated a rundown mansion where they installed artworks and staged performances, had been closed for some months before *Ablutions* was presented, but its impact lingered. Lacy, who was not a student in the program but associated with many women who were, remembered that those in it "turned to performance almost intuitively. It wasn't as 'sophisticated' as some of the conceptual performance works at the time. For the most part, we

didn't know anything about that work and I don't think Judy knew a lot about it either. We were doing what I'd call skits. She intentionally steered us away from anything that ... was removed from a direct engagement with our feelings. We made art out of our experience."[25]

They drew on consciousness-raising sessions, which Lacy—trained in psychology and sociology; she'd been a premed student at Fresno—said, with a chuckle, borrowed in turn from "the Gestalt therapy movement. People all over the country were sequestering themselves away in little rooms and screaming at each other in the service of changing their psyches."[26] But if she could laugh at such sessions' insularity, she did not deny the importance of these exchanges—nor did she dismiss the rage. "Not long after I began listening deeply," Lacy recalled, "I noticed it: every time a group of five or so women gathered, one of us had been raped. Or knew intimately someone who had. Meeting for the first time, in consciousness-raising groups and women's studies classes, we slowly began to speak of physical abuse, of sexual assault, of betrayal and shame."[27] Referring to the discussions that led to *Ablutions*, she added, "I have never been raped. I had certainly had rather forceful experiences with dates. The kind of pressure that you wouldn't ever describe as attempted rape in the fifties and sixties. So our work together was like a continuing revelation."[28] They didn't need to look far for offensive behavior. While the Feminist Studio Workshop Program was taking shape at Cal Arts, the school's legendary teacher, John Baldessari, "used to discuss such things as how rape might be considered an art form,"[29] Lacy said. Bringing rape into the open proved to offer license for some pretty ugly opinions—and behaviors—that had theretofore remained supressed, at least in public.

Rape was not the only topic that arose in the performance workshop, and the months of discussion that preceded *Ablutions* produced interest in a wide range of themes concerning the body, including Chinese foot-binding, "body anxiety," and entrapment. These

disparate and not easily integrated subjects all found expression in the collaborative performance. So too, it seems, did the influence of the Viennese Actionists (especially their use of animal entrails), and the barely controlled mayhem in the Happenings of Allan Kaprow, Claes Oldenburg, and others. But it was the recorded accounts of rape that most provoked attention. "The audience ... received *Ablutions* in shocked silence,"[30] recalled Lacy. In another interview, she again said, "The audience was stunned. They were really stunned. It was in [artist] Laddie Dill's studio, and so there was a fairly heavy-duty Venice art audience there. Apparently, several people just sort of gagged and ran for the door at the end of it. They had never been exposed—not only to that information at that level of detail but to women's perspective on it. And the rage and the intensity of the victimization."[31]

Arlene Raven, an art historian and critic deeply involved in the feminist movement of the seventies, was present in a May 1972 workshop for *Ablutions*. It was an electrifying encounter. "I had been raped three days before," Raven confessed in a later essay, "and I *was* the shock, panic, self-loathing and despair of the raped victim, because I felt so helpless all I could do was lie there and cry. But I rose on the third day."[32] That is, she told her story, and it was recorded for the performance. Doing so gave her great comfort. "I not only had a friend silently listen to my pain, but I participated in a process of feminist art which is based on uncovering, speaking, expressing, making public the experience of women", she recalled.[33] Finding in it "healing through repetition, and communication with women still isolated in silence," Raven would go on to "see this act, in retrospect, and symbolically, as initiation into the circle of women with whom I would bond." The performance, she said, "was a ritual and a spell. Of enactment and exorcism. And," she added, in an unexpected phrase that perhaps expresses how thoroughly sexual violence undermines its victim's sense of reality—or, possibly, how

such violence is a perpetrator's malign, magical-thinking assertion of his power, "of course rape is also a ritual and a spell."[34]

In a 1983 summary, the art historian Moira Roth wrote, "*Ablutions* aimed at informing the audience about the reality of rape and discrediting popular beliefs, such as rape cannot occur against one's will."[35] Documentation and first-hand accounts of the performance suggest that in its many-layered, sense-saturating allusions it delivered somewhat less—and much more—than simple and clear corrective information about a common crime. A study in excess, it expressed, perhaps inadvertently, the conviction that no image could be adequate to the subject—that addressing rape required blood slathered on eggs, and clay on blood, the clay cracking to reveal the liquids beneath; that there must also be furious banging, dripping viscera, and the bandaging and binding of women with ropes, with chains. If there was, as Raven felt, a sense of healing and ultimately of exhilaration to be gained from the performance, it also offered an image of degradation—the thousand eggs, as of those thrown at bad actors or offending politicians; the women bloodied and soiled, then bandaged and bound. The final image was of silencing and impotence, the final sound a repeated lament. It was as if the only way the four artists could represent rape was with an assault on coherence. Perhaps nothing since has been as harrowing.

Not surprisingly, *Ablutions* produced no close sequels, although it was a signal event in the careers of two enormously important artists. It marked the beginning of Lacy's still active commitment to seeking, recording, and presenting women's testimony about challenges both personal and collective. Chicago's famous *Dinner Party* project honored women across the centuries, and she continued to pursue collaborative work with global reach and determined political goals. The collective work undertaken by Lacy and Chicago was initiated within a close-knit community that also produced the audiences for much of their early work; the lines between performer and viewer

could become blurry. Roth points out that in the early performances, audiences were often small and close (and some ritual-based performances were done without audiences at all, solely for the benefit of the participants). Accordingly, Roth writes, viewers offered "immediate feedback as well as support for difficult and often painful exposures of experiences and feelings."[36] But at a time when "boundary issues" were newly vital in psychology, such intimacy raised questions, too, as Roth implied when she asked, "What is the audience's stake in personal performances which seem created exclusively to satisfy the therapeutic needs of the artist?"[37] Addressing her own question, she adds, "Sitting through a ritual performance in which one does not trust the psychological motivation and/or the spiritual vision of the performer can be both a painful and irritating experience."[38] Indeed; and her candor is refreshing. If performance was a genre in which the artist was at an uncertain distance from her role, a similar instability applied to viewers, who were called upon to actively witness—rather than impassively watch—events in which pain was real. *Ablutions* was surely nothing if not a uniquely committed emotional and ethical compact between performers and viewers.

Equally raw in its honesty and visceral impact is a series of works about sexual violence that the Cuban-born artist Ana Mendieta created in the early 1970s, when she was completing an MA in painting and taking further classes in the University of Iowa's lively Intermedia graduate program. Disappearance would be a recurring motif in Mendieta's later work, which often found her merging with the landscape, but outright violence was rare. The work she created while still a graduate student and soon after, in response to what she understood to have been the brutal rape and murder of a female nursing student on the University of Iowa campus (early reports that the victim had been sexually violated proved false) was exceptional in many ways. Shortly after the killing, which occurred in March 1973, Mendieta invited fellow workshop participants to visit her apartment. At the

designated time, faculty and students discovered the door to her unlit apartment ajar. Photographs that the artist arranged to have taken of this *Rape Scene* (she also called it *Rape Tableau*) show that her upper body, covered in a plaid shirt, was stretched across the top of a battered white kitchen table. One photo reveals bloody underpants twisted around her ankles. Facing the camera, and luridly lit, her exposed buttocks and legs were also smeared with blood. Another shot shows that her wrists were bound with heavy white rope and tied to the far corner of the table. A third image tightly frames her head, face down in a puddle of blood. There is broken white crockery on the grimy linoleum floor, and a wire hanger, pried open and hinting (a little mysteriously, under the circumstances) at the grim accessories of self-induced abortion. There is also an image of a filthy toilet bowl, faint trails of blood on the water's surface. The gory details recreated those that had been recently reported in the press, but one imagines that Mendieta's colleagues, entering the dark, silent apartment like intruders, were altogether unprepared for what they found.

Subsequent works that can be connected with the murder (even if only indirectly) were more furtive, and also more ambiguous: Mendieta left a little heap of bloody bones and discarded jeans in an alley next to her apartment building. The act was unannounced, and there is no evidence that anyone saw it. Similarly, a battered suitcase with soiled, balled-up clothing inside was wedged between rocks. As with *Rape Scene*, the suitcase installation is known through photographs, and, at least in part, was staged for them. The same is true of *Clinton Piece, Dead on Street* (1973), which found Mendieta lying on the street at night, as if a victim of violence. The roll of film documenting this event shows her searching for the minimum level of light and clarity that would reveal her prone figure. The jacket she wears becomes a faint red smear, the white shirt and jeans obscured. Blood seems to seep from her head and torso, but it's not clear. While light glints off cars, the artist's body nearly disappears.

TESTIFYING

The Iowa graduate program, led by Hans Breder (an important mentor with whom Mendieta became romantically involved), introduced students to a wide range of contemporary artists, including Kaprow, Hans Haacke, Scott Burton, and Robert Wilson. Breder had attended Fluxus events and Happenings in the 1960s, and introduced his students to the Actionists as well. Writer and publisher Willoughby Sharp was a critic in residence and discussed the work of Acconci, who visited the school in 1974. Lucy Lippard visited the following year. But it seems Mendieta wasn't aware of *Ablutions* (nor of Lacy) at this time, and that it is highly unlikely she knew of photographs VALIE EXPORT had staged of herself lying on various city streets, assuming the configurations of their curbs.[39] Nor is it probable that Mendieta was aware at the time of Chris Burden's *Dead Man*, of November 1972, in which he lay down under a tarp beside a parked car, at night, on Los Angeles' busy La Cienega Boulevard, daring motorists to hit him—and pedestrians to protect him. Beside Burden were two warning flares that were meant to last fifteen minutes; he had planned to get up when they burnt out, but was arrested before they did. (The charge—of causing false emergency—had been established in response to the increasingly violent, and violently suppressed, student activism of the time; it carried the penalty of a $1,000 fine and up to a year in jail. Burden's case was dismissed after a three-day trial.) Mendieta did not put herself at the same risk of injury, nor of arrest, but shared the climate that shaped Burden's work—of brazen actions taken in response to pervading danger, and of a sense of vulnerability compounded by the expectation that harried passersby would be too fearful, or indifferent, to intercede.

Mendieta focused even more sharply on pedestrian behavior with *People Looking at Blood, Moffitt* (1973). On a sidewalk near her apartment, beside a cracked, one-step cement stoop, she created a conspicuous spill of dark brownish-red fluid, mixed with shards of what looks, in photographs, like glass. The stretch of street she

83

chose for this installation was particularly distressed; visible in all
the photo-documentation is a beat-up storefront with a window on
which black bordered gilt letters spelled out the name H. F. Moffitt,
as if announcing the office of some film-noir gumshoe. Shooting both
video and still photographs from inside a parked car, Mendieta cap-
tured the reactions of passersby encountering the bloody spill on the
sidewalk. The stills suggest that most people paused briefly to register
mild surprise or interest; there are a few frank stares, although some
pedestrians don't register a thing. The video makes it clear that even
those who look aghast barely break stride. A single woman stops—a
nurse, maybe; she's in whites—and pokes at the bloody debris with
an umbrella. The video concludes when a workman, impassively
noting the mess, takes the initiative to clean it up, providing a nar-
rative arc that is a bit misleading; *People Looking at Blood* is mostly
about blunted affect in the face of highly provoking evidence, and
about the uncertain threshold for response. As Acconci and EXPORT
had done, Mendieta put passersby to a test, in this case of taking
time to explore, and perhaps bring official attention to, evidence of
possible violence. Mostly, they failed.

Mendieta raised the stakes with *Bloody Mattresses* (or *Mattresses*)
(1973), which she staged in a derelict farmhouse outside of town.
On the floor were several bare mattresses soaked with what looks to
be gallons of gore and heaped with indiscriminate debris—clothes,
papers, letters, and notecards. The blood is spattered high on the
wall, suggesting the aftermath of a shooting. Again, Mendieta told
no one about the piece; it is known through her photographs. Other
works produced by Mendieta in this sanguinary early period include
a 1973 performance documented on video in which she appeared to
sweat blood from her hairline, slowly; by the end, it had dripped down
her face. For *Untitled (Death of a Chicken)*, 1972, she had a chicken
butchered and stood naked, holding the decapitated bird by its legs,
while it frantically flapped its wings for what seems an eternity (in

actuality, just under two minutes). In *Blood Writing* (1974), Mendieta stands before whitewashed doors, her back to the video camera, and writes, in dripping, blood-red letters, "She Got Love"; her body conceals the words as she paints. *Blood Sign* (1974) finds her inside a studio, outlining her body in a blood-red arch, and then printing, with her fingers, "There Is a Devil Inside Me." Again her body conceals what she's writing until she departs. One can't help thinking of Yoko Ono's instruction for her uncharacteristically bleak *Blood Piece*, of spring 1960: "Use your blood to paint," with its alternate conclusions: "Keep painting until you faint. (a)/ Keep painting until you die. (b)."

In what may be the most well-known of Mendieta's body pieces/ performances, she staged a rural version of *Rape Scene*. The most frequently reproduced photograph of this *Rape* (1973) shows Mendieta again naked from the waist down, blood dripping down the insides of her legs, but here her body was draped across a log in a wintry field. Jane Blocker writes, "Angered by the violence of patriarchal culture, Mendieta invited colleagues to a 'performance' at a designated place in a wooded area near campus. Once there, the 'audience' discovered Mendieta lying half naked, facedown in the grass, her clothing torn, and her legs covered with stage blood all too convincingly applied."[40] In actuality, the "audience" for this private event—"performance" is a misnomer—consisted of at most a handful of students: mainly, it was staged for the camera. And in many of the less familiar photographs documenting this piece, her body is nearly invisible, if not altogether obscured. Only with the benefit of the more revealing, more widely circulated shots do we notice, in these other, subtler images, the isolated, inert hand, perhaps bloody, nearly covered in dried grass, or the lone foot, or forearm, or ankle. Grand Guignol wasn't altogether avoided: there is a photograph of what seems a disembodied head, its face bloody, and another that shows the artist face down on the grass, both arms stretched out, as if reaching for help, unavailingly. But for the most part Mendieta seems to have been exploring

something more liminal—to have been trying to define precisely how little we need to see to know that harm has been done. And, with far stronger implications for her future work, she placed her body in relationship to nature in ways that emphasized their intimacy, and blurred their boundaries.

Born in Cuba in 1948, and sent with her sister to the US for safety by her parents at the age of twelve, Mendieta remained deeply interested in the religions native to her homeland, including Santería and Catholicism, and in the rituals, some of them bloody, with which they are associated. More generally, exile, and the loss of family, language, and culture that ensues, contributed to a sensibility attuned to all things fugitive, including bodies and the traces they leave, briefly, in the landscape. In later works reflecting those influences, Mendieta's body, and also stylized female figures formed in clay, or flowers, or fire, are fully integrated with natural surroundings. They are clearly anticipated in *Rape*, which speaks to her enduring interest in the currents flowing between the human body and the organic environment that sustains it, physically and spiritually.

If flirting with invisibility was Mendieta's primary objective with the rape installations, she achieved blazing success. The great majority of her fellow students (and her teachers) weren't aware of this body of work. One exception was Charles Ray (who has gone on to fame as a sculptor); driving around scouting housing for himself, he stumbled across an empty-seeming farmhouse and discovered what he reported to be a grisly crime scene: trashed interior, bloody mattresses; Mendieta admitted that she had staged it.[41] But for the most part, this body of work drew little or no response at the time. Art historian Julia Herzberg interviewed every classmate of Mendieta's she could find in the mid-nineteen-nineties, for her doctoral thesis, and the transcripts[42] reveal a number of patterns. Critiques of student work stopped short of discussing motives or content. No one besides Mendieta was dealing with sexual violence. One student who did see

the interior rape piece ventured that he "Didn't know what to think about it" and "probably didn't understand what the motivations were." Another, who'd seen the Clinton Street piece, said, "I think people stood back rather than gathering around. I remember people wanted to be distanced from that, rather than coming up and sticking their finger in and asking if this was really blood." One of the few women interviewed, Monica Wilson, recalled, "Critiques were not a time in which people delved into someone's piece at length. . . . There would be a lot of silence." The most common response to female body art seems to have been studied avoidance. Wilson, who wasn't aware of Mendieta's rape-themed work, went on to describe a video she herself had made of an action in which she put a C-clamp on her hip and performed a series of deep knee bends, tightening the clamp as she did so. Her aim was to explore the "vise" put on expressing danger. "But," she recalled, "no one could see the pain."

Opinion on Breder may have been divided along gender lines, too: Wilson labeled him sexist and "extremely egotistical," while a male colleague recalled, "Hans was brilliant because he didn't teach. [He] exposed you to what was going on. And he expected you to assimilate it." Lending some detail to an atmosphere of freewheeling machismo, a male student recalled that one of Breder's favorite stories, told during a summer class residency in Mexico, "was of a fertility rite in which men masturbated into the earth to fertilize it." Acconci's name comes up often in these interviews. Even before he visited in 1974, "Everybody was completely aware of what Vito Acconci was doing," said one student. "He is an excellent speaker. . . . He loves to talk about his work. I think he can talk about his work better than anybody else. You know, he just goes on and on and on." But like Breder, "He didn't teach either." His approach was, "let's get to know each other." Wilson is again a voice of opposition: remembering Acconci's visit well, she said, "He was quite lecherous. Quite interested in being with me. He invited me to New York."

I think anyone who was an art student in the 1970s will find these accounts familiar—dismayingly (especially with respect to relations between faculty and female students), maybe comically, and perhaps, with respect to the spirit of utter abandon, even in some ways nostalgically. Mendieta's fellow students create a snapshot of a newly established Minimalist/Conceptualist orthodoxy confronting a fledgling body of expressive performance art by a woman and responding with perfect silence—which apparently was the default for group crits. Teachers (almost all of them male) talked, mainly about their own work and beliefs and those of their colleagues; students listened. Further guidance was scant.

The evidence is that that suited Mendieta just fine. From the start, she took her career into her own hands; she certainly found her experience at Iowa fruitful. And her position, with respect to the intensely charismatic leader of the graduate program, was unique. One student described her as "very verbal and articulate," though opportunities for demonstrating those skills would seem to have been scarce. In any case, the rape-themed work was clearly meant to please no one. That is not to say it wasn't directed at a dialogue, on a high level, with contemporary developments in the art world, and the more general sociocultural changes they represented. Mendieta had paid close attention to the visiting artists, and the work she staged in the wintry field was clearly indebted to Scott Burton's *Furniture Landscape* of 1970, in which salvaged residential furniture was deposited randomly in the rural environs. It matters too that Mendieta had written a thesis on Duchamp and was certainly aware of his highly provocative tableau, *Étant donnés* (completed in 1966), in which a naked woman sprawls, legs spread, on the grass.

But Mendieta's rape pieces are, in comparison with these precedents, exceedingly raw in every way. As bloody and uncooked as *Ablutions*, they are difficult for viewers, who are encouraged to look, and look harder, even if they don't want to—only to become complicit

as voyeurs. And this body-centered art was professionally as well as personally dangerous for the young artist. To put your physical self in the place of someone who has been violated and then killed is, now as then, to invite shock more than sympathy. In contrast to the preponderance of Mendieta's succeeding work, it does not honor the beauty of the landscape and its spirit, or human resilience, or the pleasures of embodied female experience. Unlike *Ablutions*, it offers no symbolism; it is appallingly literal, comprising a kind of self-sacrifice of dignity and of artfulness. Unlike *Cut Piece* (or Vito Acconci's several experiments with self-harm, or Chris Burden's), Mendieta does not submit to the possibility of significant physical injury; instead, she presents herself, if at all, as already dead. But in the more successful of these pieces, there is ambiguity, near-invisibility, and ultimately disappearance. And it is in this expression of a human being vanishing, of ghosting a scene steeped in raging hurt, that she most vividly captures the experience of intimate violation.

TAKING ACTION

In 1973, the simple, somber testimony of a brave few had been met with shocked silence; four years later, women were ready for outspoken, organized resistance—and for opening the definition of rape to forms of assault that hadn't before been thus categorized. Conditions that fostered violence would be targeted as well. By the end of 1977, as Moira Roth wrote, "Rape was ... seen as a political act rather than only as an individual sexual assault."[1] Having urged women to toughen up and fight back, and encouraged survivors to speak out, feminist artists quickly came to agree that broader-based strategies were called for against biases far more entrenched and prevalent than had been recognized. Strikingly, the social-justice work undertaken in the second half of the seventies, with its emphasis on solidarity, reinscribed sexual violence within the realm of universal female experience in which second-wave feminists had initially placed it.

For most of the women who formed the core of this new genre, activism was second nature. Many had grown up with—and away from—the protest movements of the sixties, and indeed came together as feminists in response to those movements' deep-rooted misogyny. *Women say yes to men who say no*, ran one favorite slogan of the late sixties. Burning draft cards closed some doors, perhaps, but opened others during the antiwar effort's salad days, of free love dispensed largely in terms defined by men. Thus the mounting anger that led Robin Morgan to announce, in 1970, "Goodbye, goodbye forever, counterfeit Left, counter-left, male-dominated cracked-glass-mirror

reflection of the Amerikan nightmare. Women are the real Left."[2] And thus, simplifying things only a little, did "second-wave" feminism rise from the ashes of male chauvinism's bonfires.

From the start, Americans agitating against the war in Vietnam, and against racial, economic, and social injustices on the domestic front, had taken lessons from the overthrow of colonial rule succeeding at long last in Africa, Southeast Asia, and elsewhere. At first, male leadership, as modeled by figures from Mao to Che, went unchallenged; indeed, there seemed to be no other kind. And even among women starting to fight for their own rights, leftist anticolonialism provided the dominant rhetoric for resistance of all kinds, including the sexual "revolution" and women's "liberation." It didn't serve them terribly well. Susan Griffin writes, "The strictly Marxist and socialist part of the left insisted that history moves only through class conflict, and since women are not a class by that definition, our efficacy as social changers became *sui generis* negligible. We were, in short, not important." Moreover, "In their rhetoric, the issue of rape, which seemed to be central to us—at the core of something which we could not fully explain, perhaps our being—was an epiphenomenon, a spin-off several generations away from the real cause, which was a division of labor.... Rape, after all, would only go away when capitalism did."[3]

Trouble arose as early as the 1967 March on Washington, described in a book-length account by Norman Mailer, who admittedly is no one's model of sensitivity to women. After evoking, with considerable charm, the carnival-like atmosphere of the march's early hours— "the Civil War glow of the campfire light on all those union jackets, hippies on the trail of Sergeant Pepper"—Mailer reports that some male demonstrators called out to soldiers guarding the Pentagon. "'Join us, join us,'" Mailer says the demonstrators implored. "'We have everything, look. We are free. We have pot, we have food we share, we have girls. Come over to us and share our girls.'" For their part, Mailer continues, some of the women "were gentle and sweet,

true flower girls; others were bold ... they unbuttoned their blouses, gave a real hint of cleavage, smiled in the soldier's eye,"[4] and so on.

Mailer follows this dubious (and shamelessly salacious) evocation of compliant young women with a blunt summary of what transpired when the relations between protesters and military police turned belligerent. "A startling disproportion of women were arrested, and were beaten in ugly fashion in the act," he writes. Quoting the *Washington Free Press*, he adds, "With bayonets and rifle butts, they moved first on the girls in the front line, kicking them, jabbing at them again and again with the guns, busting their heads and arms to break the chain of locked arms." He quotes another journalist who wrote, "The cops began to get really brutal. . . . These beautiful little hippie chicks had tears streaming down their faces, but they weren't about to move," and added several further descriptions of savage treatment of women, including a woman dragged "toward the Pentagon. . . . She twisted her body so we could see her face. But there was no face there: All we saw were some raw skin and blood. We couldn't see even if she was crying—her eyes had filled with the blood pouring down her head. She vomited, and that too was blood."[5] Cathy Wilkerson, an early leader of Students for a Democratic Society (SDS) who was present at the 1967 March on the Pentagon, similarly witnessed brutality against women there, including "Soldiers [who] purposefully kicked women in their breasts."[6]

None of the male protestors, Mailer notes, came to their female comrades' aid. "One wonders at the logic," he concludes, musing, with no evident irony, that the soldier "may never have another opportunity like this—to beat a woman without having to make love to her."[7] From this grab-bag of slurs and sordid fantasies (Mailer takes a moment to reflect on how many men, black and white, these hippie girls had slept with), there emerges a sharp picture of young men pimping their female comrades, however facetiously, and of soldiers—young men themselves and likely just as unprepared for the

simmering menace of the confrontation—reacting with unexpected rage. Women were simply collateral damage.

Inside the gathering places of antiwar groups, where women were relegated to kitchens and laundries, mimeograph machines and mailing lists, while the men shaped strategies and tactics and spoke at rallies, it took a few years for feminist agitating to develop—and initial efforts were not well received. Historian and former SDS leader Todd Gitlin writes, in his 1987 memoir, *The Sixties: Years of Hope, Days of Rage*, "When women brought a resolution for what was now called 'the liberation of women' to the floor of SDS's 1967 convention, parliamentary maneuvering chewed it up." He adds, "In the spirit of the time, women could argue for being taken seriously only by declaring that they had a 'colonial' relationship to men." As Gitlin was able to see clearly with the hindsight of twenty years, things got worse before they got better. "Meetings were sites for eyeplay and byplay and bedplay. Some leaders in effect recruited women in bed—what Marge Piercy ... called 'fucking a staff into existence,'" Gitlin continues. The sexually exploitatative behavior associated in recent popular culture with executives on Madison Avenue was if anything worse among the era's crusaders against capitalism. "The smoldering mixture of danger and notoriety seemed to make men more predatory.... In 1968, the druggy White Panther Party manifesto declared: 'Fuck your woman so hard she can't stand up'... five years earlier, the violence of the fantasy would have been unthinkable anywhere in the movement's orbit." In short, "During the years of New Left acceleration, a critical mass of women felt their situation worsening."[8] Not that it was good to begin with; in his long book, Gitlin mentions rape explicitly only once, in a footnote, to report that in 1966, a friend of an SDS member at the University of Chicago was raped at knifepoint in her room and was told at the student health center that gynecological exams for victims weren't covered in her plan, "and given a lecture on promiscuity."[9]

In one incident related again and again, on January 19, 1969, SDS stalwart Marilyn Webb and New York feminist theoretician Shulamith Firestone attended an antiwar march and rally in Washington organized by the National Mobilization Committee. When it was Webb's turn on the platform, she began by saying, "We as women are oppressed." In Gitlin's account, "As she warmed to the subject, pandemonium broke out in the crowd below her. She plunged on, denouncing a system that views people as 'objects and property'—and a cheer went up. She heard shouts: 'Take her off the stage and fuck her!' 'Take her down a dark alley!' 'Take it off!'" Firestone followed Webb onstage, "and attacked—not just capitalism, but men, and not just capitalist men, but the men in front of her, 'revolutionary' men. 'Let's start talking about where you live, baby,' she roared, to boos.... 'We women often have to wonder if you mean what you say about revolution or whether you just want more power for yourselves.'"[10]

In Webb's own telling, when activist Dave Dellinger announced the speakers at the "Mobe" rally, someone called out, "What about the women?" He said, "Oh yes, we're gonna hear from the girls." At which the feminist Ellen Willis shouted, "Women, you schmuck." Webb reports the obscenities with which she was assailed, and says the crowd went "berserk": "'Screams and fistfights were breaking out in front of me,'" Webb recalled. "'Men were hitting each other. Beating each other up.'"[11] The drama didn't quite end there. Some of the SDS women gathered at Webb's apartment to review the debacle, and while they were conferring, a phone call came in from a woman saying she was in the SDS staff apartment and warning, "If you or anybody else ever gives a speech like that again, we're going to beat the shit out of you. SDS has a line on women's liberation, and that is *the line*."[12] Webb replied in kind (and went on to establish, in 1970, a long-running feminist newspaper called *off our backs*).

Webb said she recognized the caller as Cathy Wilkerson. But Wilkerson denies making the call to Webb; instead, she says in a

memoir, it was probably one of the hundreds of dirty tricks enacted by FBI's COINTELPRO unit under J. Edgar Hoover. "Given the FBI's mandate to sow dissension within and between groups by exacerbating tensions, it is likely. At the time, no one knew this kind of manipulation was even a possibility."[13] As it was later revealed, Hoover's FBI was unquestionably responsible not only for a multitude of attacks both physical and psychological against the antiwar movement (and, with special ferocity, the Black Panthers). It also succeeded in creating a climate of paranoia that, at times, effectively undermined trust within the various organizations. But the vicious misogyny expressed at the 1969 rally went deeper than any mistrust the FBI could sow. And women were reluctant to speak out about it, divided among themselves about whether to push for women's recognition and rights within the movement or outside it. Even if they belittled women and blocked their careers and failed to perform their share of household chores, the men were women's fellow fighters—and, in many cases, their life partners and the fathers of their children. As Wilkerson recalls, although a few women at an SDS meeting in 1965 wanted to explore their distinctive hopes and ideas, "The idea of women meeting together separately to work out their own understanding of their experience felt powerfully subversive to both women and men."[14] Indeed, Wilkerson says, she felt that way herself: "I was wary of anything that suggested that women meet in all-women forums, fearing that this separation was too similar to the separation and trivialization of women characteristic of my mother's generation."[15]

A leitmotif of Wilkerson's memoir is her concern about failing the movement through self-centeredness. As she put it, "The issue of women's rights, more than any other so far, threw into relief the tension between [the] conviction that liberation must start within oneself on the one hand, and, on the other, my worry about the tendency of people to fight for themselves at the expense of those with less power.... The angst-filled discussions in the women's group

bordered, it seemed to me, on self-pity. We Wilkerson girls did *not* complain!" Seeing herself, in rueful retrospect, as a maidservant to the revolution, she writes, "I still instinctively reached for self-denial as a source of my power."[16]

Gitlin writes that, by 1971, there was rectification in SDS: "'Chicks' were upgraded to women; ... Wolf whistles and dirty jokes were suppressed."[17] But for many women, the change was too little and too late. A few chastened men adopting new terminology, and even an awakening sensitivity, couldn't make up for the experience of brutality that many women had suffered. It is striking how prevalent women were among the more radicalized activist groups that arose in the 1970s, particularly when one considers that gender relations within those groups were not always enlightened, for all their revolutionary rhetoric on behalf of righting injustice. According to Wilkerson, who became a member of the Weather Underground when SDS splintered, "Women's liberation meant that we should be active in the fight to end racism and colonial exploitation."[18] Women's own issues were moot. Moreover, in the radicalizing antiwar groups, there was a "campaign to end monogamous relationships and to establish a completely open social and sexual playing field"—an openness that seems to have been one-sided. Of one evening in which this liberation of the sexual playing field was put into practice, Wilkerson notes, "I was quickly convinced that this was no fun at all.... I also knew that at least one of my sexual encounters that night violated the distance and respect of a friendship."[19] In this terse allusion to a night of serial sex, it's hard not to see outright abuse. Clearly, for some newly militant women, it was a mark of credibility to reject feminist goals. Susan Brownmiller recalls Kathy Boudin—later a Weather Underground leader—coming to a Women's Lib meeting in 1968 and accusing Brownmiller and others of being "full of shit."[20]

Mistreated within the activist movements, fledgling feminists faced outside threats as well. Some women were all for meeting fire

with fire. In 1971, the new National Organization for Women had what Elaine Showalter called a Violence Meeting, instigated, she reports, by "rumors that bikers, Hells Angels, hoodlums and hardhats were planning to attack the Women's Equality Day March on August 26, to beat and rape the women demonstrators." Myrna Lamb and Robin Morgan were among those who supported a physically aggressive response; Gloria Steinem and Kate Millett were against it, and prevailed.[21] The atmosphere could hardly have been more flammable—and if women themselves sometimes raised the temperature, much of the fire, when it broke out, was aimed at them.

The rising heat of gender politics affected the Black Power movement, too. Elaine Brown, who for a time was the head of the Black Panthers, writes drily of an encounter early in her involvement with the Party during which a "bald-headed dashiki came over to us, folded his arms across his chest, and explained the 'rules' to us in a way we could understand. Sisters, he explained, did not challenge Brothers. Sisters, he said, stood behind their black men, supported their men, and respected them. In essence, he advised us that it was not only 'unsisterly' of us to want to eat with our Brothers"—Brown and a friend had ventured to help themselves to food at a dinner for which they'd help pay—"it was a sacrilege for which blood could be shed."[22] Brown also learned that "a true Sister would be happy to sleep with a revolutionary Brother."[23] As she gained more experience and more confidence, she began to challenge these attitudes; in doing so, she, like Wilkerson, was obliged to come to terms with her own ambivalence about feminism. "If ... the very leadership of a male-dominated organization was bent on clinging to old habits about women, we had a problem," she writes. "We would have to fight for the right to fight for freedom." But there was a considerable obstacle to doing so. "Like most black women of the time, we considered the notion of women's liberation to be a 'white girl's thing.' Unlike the new feminists, we were not going to take a position against men...."

Black men were our Brothers in the struggle for black liberation."[24] Indeed, she writes, "I had joined the majority of black women in America in denouncing feminism. It was an idea reserved for white women,"[25] who had the privilege of speaking out against injustices that, compared with those facing African-Americans both male and female, were taken—not without justificiation—to be trivial. At the same time, she continues, "We had no intention ... of allowing Panther men to assign us an inferior role in our revolution."[26]

If the Party's gender politics were complicated, no leader contributed more to the chaos than Eldridge Cleaver, for a while its public face and a favorite of white patrons and admirers, although his status within the Party was more complicated. Cleaver notoriously proclaimed early in his best-selling 1968 book, *Soul on Ice*, "I became a rapist. To refine my technique and *modus operandi*, I started out by practicing on black girls in the ghetto ... and when I considered myself smooth enough, I crossed the tracks and sought out white prey. I did this consciously, deliberately, willfully, methodically.... Rape was an insurrectionary act." For support, he quotes a poem by LeRoi Jones that ends, "come up, black dada nihilismus. Rape the white girls. Rape their fathers. Cut the mothers' throats." This can be deemed plain hyperbole, and Cleaver—having served jail time for serial rape, assault, and attempted murder—hastened to renounce his early self-described career as a sexual aggressor. But his language has affinities with less deliberately inflammatory prose. For example, Frantz Fanon, whose *Wretched of the Earth* was also much read at the time for its psychoanalytically based analysis of colonialism, wrote rather bafflingly, "When a woman lives the fantasy of rape by a Negro, it is in some way the fulfillment of a private dream.... it is the woman who rapes herself." Fanon followed this mysterious syllogism with the even stranger rhetorical question, "does this fear of rape not itself cry out for rape?"[27]

Cleaver was hardly a model of probity, and his fame outside the movement didn't secure him unified or lasting support within it. In any case the Black Panthers were under steady assault from the start. It is hard to exaggerate the virulence of attacks against them from Hoover's FBI and from local police, which by 1971 in LA included the new SWAT (Special Weapons and Tactics) teams. Introduced to counter "subversive groups" and rising crime in general, the teams were bent on eliminating the Panthers in particular. Elaine Brown assumed Party leadership because of her intelligence, energy, and capability; it was also true that its ranks had been decimated, either by imprisonment or at the hands of the police or FBI, and few remaining male candidates were at hand. By the end of the 1960s, between half and two-thirds of the Black Panther Party's membership was female, numbers comparable to those of the Weather Underground. But it still matters greatly that Cleaver's early pronouncements about rape, and those of Jones and Fanon, were swept under the rug, then and later. Along with the hateful statements and acts of white men in the antiwar movement, the misogynistic bluster, given cover by mindless popularizers as radical chic, normalized, and even glorified, the language of sexual violence. The consequences for women were dire and enduring.

While the Black Panthers were targeted by the authorities with special brutality, they were not alone in drawing attacks. When students and free-speech activists took over a "People's Park" in Los Angeles in 1969, a student observing from a rooftop was shot and killed by the police. A year later, amid more unrest, then Governor Ronald Reagan doubled down, announcing, "If it's to be a bloodbath, let it be now. No more appeasement."[28] Commenting on the 1971 Attica prison uprising in New York, in which thirty-three inmates were killed along with ten correctional officers, President Nixon blamed "the black business," and then ventured to predict, "I think this is

going to have a hell of a salutary effect on future prison riots.... Just like Kent State"—where four students protesting the war in Southeast Asia had been shot dead by the National Guard the previous year—"had a hell of a salutary effect."[29]

In a climate of such bigotry and rage, it's not hard to understand why men and women within the Black Panther Party and the broader Black Power movement would close ranks. Angela Davis's classic 1981 study, *Women, Race & Class*, begins with the patterns of sexual assault inherent to slavery and notes that white suffragettes dissociated themselves from advocates of racial justice. She observes, "From Reconstruction to the present, Black women household workers have considered sexual abuse perpetrated by the 'man of the house' as one of their major occupational hazards."[30] But Davis's fiercest anger was directed against the undying association between rape and African-American men. "In the history of the United States," she wrote, "the fraudulent rape charge stands out as one of the most formidable artifices invented by racism. The myth of the Black rapist has been methodically conjured up whenever recurrent waves of violence and terror against the Black community have required convincing justification. If Black women have been conspicuously absent from the ranks of the contemporary anti-rape movement, it may be due, in part, to that movement's indifferent posture toward the frame-up charge as an incitement to racist aggression."[31] "Thus," she wrote, "of the 455 men executed between 1930 and 1967 on the basis of rape convictions, 405 of them were Black."[32] Almost all were charged with attacking white women.

It is a stunning statistic, and for Davis, it mooted further discussion. "Black women ... have ... understood that they could not adequately resist the sexual abuses they suffered without simultaneously attacking the fraudulent rape charge as a pretext for lynching," she writes.[33] And she criticized Brownmiller for trying "to persuade her readers that the absurd and purposely sensational words of Eldridge Cleaver ...

are representative."[34] (Davis neither excused nor condemned him.) Near the close of her argument, she noted that of the great majority of rapes that go unreported, many "undoubtedly involve Black women as victims: their historical experience proves that racist ideology implies an open invitation to rape." Implicitly naming white men as the perpetrators of most unreported rapes, Davis concluded, "The myth of the Black rapist continues to carry out the insidious work of racist ideology. It must bear a good portion of the responsibility for the failure of most anti-rape theorists to seek the identity of the enormous numbers of anonymous rapists who remain unreported, untried and unconvicted."[35] Unfounded charges of rape brought against black men unquestionably were (and are) among the most powerful "artifices," as Davis called them, in inciting racism at its most vicious. And it is true that feminists in the suffragette movement accepted and even exploited fear of African-American enfranchisement in the service of promoting women's voting rights. There is no excusing this history. But later feminists were not, as she claimed, altogether indifferent to this country's abominable record regarding unfounded accusations of rape made against African-American men. It was one of the reasons second-wave feminists delayed putting rape on their agenda. If it isn't hard to understand Davis's anger, it's also hard not to feel she shortchanged black women by declining to condemn men in their own community who committed sexual crimes against them, as several African-American women have argued.

In the controversial and much-read book *Black Macho and the Myth of the Superwoman* (1978), the African-American activist and writer Michele Wallace took Davis to task for subordinating herself to the men in the Black Power movement, accusing her of being "removed from the struggles of her people" and of "reach[ing] right over all of the possible issues that might have been relevant to her own experience," throwing all her support to a man "who had made it eminently clear that he considered black women enslaving."[36] Joining

Elaine Brown in condemning misogyny within her own community, Wallace also had a supporter in the poet Audre Lorde. Visiting Black and Puerto Rican activists occupying City College of CUNY in 1969, Lorde recalled she saw "Black women being fucked on tables and under desks. And while we'd be trying to speak to them as women, all we'd hear is, 'The revolution is here, right?' Seeing how Black women were being used and abused," Lorde said, "was painful."[37] (Wallace, in high school at the time, had also gone to CCNY with food prepared by her mother; Lorde had brought soup and blankets.) But Lorde's accusation wasn't only intended for black men. Writing in 1982, she said, "In the 60s, white America—racist and liberal alike—was more than pleased to sit back as ... Black women were told that our only useful position in the Black Power movement was prone."[38]

It is worth recalling that much of the rhetoric on all sides in these painfully thorny exchanges among men and women, African-American and white activists in the sixties and seventies, was meant for megaphones, including those held by the media; nuance and compromise were often drowned out. And, along with the blunt language, what would now be called the "optics" of political activism was closely considered. Brown recalled of the Panthers, "Over the years in the party, I had never imagined buying anything for anybody that did not have a purpose—our clothing, our homes, our cars, all of which belonged to the party, were properties of our political theater, selected to make impressions."[39] The chants, posters, and other props that accompanied activist rallies all amount to elements of street theater. I remember one antiwar march in which protesters carried skinned pigs' heads on sticks. Brownmiller writes of a 1969 feminist rally in which women "treated the assembly to a Chinese revolutionary drama. They strode on stage and proceeded to cut off their long hair to cries of 'No, no! Don't do it.'" One witness reported that viewers were sobbing at the sight. Says Brownmiller, "This was pure performance art."[40] Of course, the means and ends of public protest—gaining attention,

rewarding it with drama, and delivering a message as loudly and clearly as possible—are not the same as those of performance art. Protest consolidates and is meant to project power; performance particularizes and allows for the expression of deepest vulnerability. When feminist artists began, in the middle seventies, to blur these distinctions, they were knowingly playing with fire.

There were occasions on which such combustion occurred spontaneously. Perhaps nowhere do the tangled lines of sexism, racism, militant resistance, theater aimed at the masses, and intimate harm get more knotty than with the made-for-television saga of Patty Hearst's 1974 abduction by the Symbionese Liberation Army. At a time when the remaining activist groups had grown increasingly violent and gone further underground, a small, motley collective of agitators kidnapped the nineteen-year-old heiress. The greatest material success secured by the SLA's leader, Donald DeFreeze—a nominal leftist and civil rights crusader (and the group's sole African-American)—was the chaotic and short-lived distribution of free food at stores across California, one of his conditions for Hearst's release. For the most part, though, the SLA focused on the press, issuing regular communiqués and providing taped interviews and photos. Several of the "army" recruits—who never numbered more than twenty, the majority of them women—had backgrounds in acting and performance, and their capers, which notoriously included a couple of bank robberies that turned deadly, were staged for maximum TV coverage. But most newsworthy by far was Hearst's conversion to the SLA's cause, although whether it was voluntary has remained unclear. Hearst repeatedly swore her allegiance, adopted the *nom de guerre* Tania, and was featured in surveillance footage of one of the robberies, as well as in a publicity photo, wearing a Che Guevera-style beret and (shades of VALIE EXPORT) brandishing a machine gun.

In a recent book about the affair, lawyer Jeffrey Toobin writes, "At first.... The press and the public appeared to regard the crime through

the prism of celebrity rather than politics." It was indeed richly ironic that the celebrity in question was descended from a near-mythical media dynasty (whose first ruler, William Randolph Hearst, was the model for Orson Welles's *Citizen Kane*). "In any case, the SLA was a political orphan," Toobin continues, "scorned by the Black Panthers and other stalwarts of the movement,"[41] including most (but not all) of the famously red-toothed Weather Underground. But the violence of its actions was real, producing civilian fatalities and the deaths of many SLA members, including DeFreeze, in a shoot-out with the police. The survivors, fugitives for a year and a half, engaged while on the lam in a fair amount of self-education, including in feminism; Shulamith Firestone's *Dialectic of Sex* was Hearst's "bible" during this period.

Indeed issues of gender and sex, and of sexual coercion, would play a significant role in her trial. Determining her state of mind was crucial to assessing her culpability, which in turn involved judging her relationships with the SLA's men. "'Free sex was one of the principles of the cell'" she said she was told shortly after the kidnapping. "'No one was forced to have sex in the cell. But if one comrade asked another, it was "comradely" to say yes,'"[42] Toobin reports. At her trial Hearst attested, tearfully, that she had been raped by DeFreeze and another SLA member. But ultimately a Mexican tchotchke that she was given by one of the men, and which she had put on a necklace and wore—in fond memory, it was argued—throughout the proceedings, was crucial in determining her guilt. It is impossible to say who was playing a role, and when. The SLA may not have warranted identification as a political group. The treatment Hearst submitted to while their (putative) captive may have been simply criminal. Or perhaps not. While anomalous, her situation sheds light on problems of determining guilt that is the sharper for being skewed. In a period during which radical politics went hand-in-hand with sexual coercion and drama staged for the largest possible audience, consent was perhaps never harder to judge.

Bernadine Dohrn, a leader of the SDS and then the Weather Underground, was one of the few to find qualified merit in the SLA's actions, judging them "audacious."[43] But her praise for the 1969 crimes of Charles Manson's "family" was considerably more fulsome. Just before going underground, Dohrn proclaimed to a SDS convention, "offing those rich pigs with their own forks and knives, and then eating a meal in the same room, far out! The Weathermen dig Charles Manson." And Dohrn was far from alone. *Tuesday's Child*, a paper that called itself the "Voice of the Yippies," named Manson "Man of the Year"; on the cover of the following issue it put him on a cross. Gushed Jerry Rubin—a founding Yippie (with Abbie Hoffman) and as such, more convincingly devoted to public antics than radical political change—"I fell in love with Charlie Manson the first time I saw his cherub face on TV." The *Free Press*, an underground LA newspaper of the time, provided him with an outlet, challenging the prosecution as biased against hippies and publishing Manson's own defense in the form of letters to the editor. Even assuming these endorsements are some compound of farce and would-be provocation, they are hard to excuse; the revolutionary character they took Manson to be is unrecognizable in the real man. When one interviewer suggested that he was as much a political prisoner as Huey Newton, "Charlie, obviously perplexed, asked, 'who's he?'"[44]

If the kidnapping of Patty Hearst seems an only-in-California story, with its aspiring actors, roller-coaster plot, castle-on-a-hill backdrop, and courtroom-drama denouement, the extraordinarily gruesome murders committed five years earlier by the Manson "family" were even more deeply grounded in the West Coast mix of Hollywood royalty and tabloid headlines. Mythologized as an avatar of hippie coolness who could transmute free love into a kind of ecstatic, antiestablishment chaos, Manson in fact envisioned blaming blacks—the Panthers in particular—for a paroxysm of violence he planned to unleash on the world, which whites would then inherit. He believed "'Hitler was a

tuned-in guy who had leveled the karma of the Jews.'"[45] Many of the dozens of girls in his "family" were underage, and even those who were older looked as if they were children. Manson had sex with all the females in residence, as a matter of policy; he also used them as lures to draw men into his ambit, where biker-gang members and gun and drug dealers predominated. Drugs, alcohol, and weapons abounded. And pregnancies, and gonorrhea; sanitary conditions were appalling. That this became a counterculture fantasy may seem incomprehensible or, depending on your view of the American character then and now, inevitable.

Manson's primary victims were the people he murdered, mostly at second hand—his "girls" and a few male associates did the jobs for him, at his command. As would be true in the Patty Hearst trial, the defense (also largely unsuccessful) lay mainly in arguing coercion. But of course the accused were victims, too. To be sure, they did little to help their cases, showing almost no remorse and continuing to profess a fealty to Charlie—which, in their (unavailing) defense, was based almost entirely on simple fear. Charismatic abusers abound in marginal spiritual and political communities (and are not uncommon among mainstream leaders in every field). They will continue to argue that they were only doing what their victims wanted. And in truth many young women (and men) who fall under these abusers' sway arrive there without having experienced much in the way of steady support.

The girls in Manson's family were just the kind of strays cultural critic and novelist Renata Adler had found in Los Angeles a few years before, when she delivered a 1967 report to the *New Yorker* on Los Angeles's youthful street life. Adler was barely thirty at the time, but she spoke as if from across a gaping generational divide: "At the moment, there is a growing fringe of waifs, vaguely committed to a moral drift," she wrote. "The drift is Love; and the word, as it is now used among the teenagers of California (and as it appears in the lyrics of their songs), embodies dreams of sexual liberation,

sweetness, peace on earth, equality." But, Adler continued, these waifs were exploited by all around them, having "gradually dropped out, in the Leary sense, to the point where they are economically unfit, devoutly bent on powerlessness, and where they can be used. They are used by the Left and the drug cultists to swell their ranks. They are used by politicians of the Right to attack the Left. And they are used by their more conventional peers just to brighten the landscape and slow down the race a little." Summing up their plight, Adler predicted, "there is a strong possibility that although they speak of ruling the world with Love, they will simply vanish, like the children of the Children's Crusade, leaving just a trace of color and gentleness in their wake."[46] In the event, some left behind traces a shade darker.

From this tone of distant reproach, Adler shifted, two years later, to bitter condemnation in writing about what she felt were the failures of self-described cultural radicals. She deplored a tendency in politics and art alike "To use the vocabulary of total violence, with less and less consciousness of its ingredient of metaphor, to cultivate scorched earth madness as a form of consciousness (of courage, even), to call history mad, and to dismiss every growing, improving human enterprise as a form of tokenism." Referring to the popularization of Hannah Arendt's formulation, Adler continued, "A view of evil as banal was distorted into a view of banality as evil, and of all meliorism as boring and banal."[47]

Condemning what she deemed unearned nihilism,[48] Adler hit a sensitive mark. She identified herself as a proponent of the "radical middle"; she was certainly no countercultural firebrand. But she was more alert than most at the time to the human costs of certain aspects of vanguard culture. Surveying a California street life that looked, from a distance, like a peaceable stoner's heaven, she saw that up close it harbored exploitation and danger. And she was rightly unsparing in criticizing, in opposition politics, an inclination toward the rhetoric of pure violence. One could reasonably object that the

just causes for which the antiwar and Black Power movements fought don't belong under a heading shared with the Symbionese Liberation Army and Charles Manson. Simply rebelling against the status quo does not mean a movement or organization is for social justice. And even within social justice movements, moral shades of gray abound. But from one end of this spectrum of upheaval to the other—from deeply principled, thoughtfully strategized political activism to pointless crimes of stomach-churning violence—two constants can be seen. One is that the acts of aggression were shaped for public consumption: they were forms of theater. And the other is that the roles available to young women too often featured sexual violation.

Given this history, it seems inevitable that art undertaken as activism against sexual assault emerged in Southern California. It can be said to have begun quietly, with the creation of an inexpensive little book by Suzanne Lacy called *Rape Is*. First published in 1972, it marked a leap outward from individual accounts of personal experience toward a far broader definition of rape and a much wider audience. By early 1977, Lacy and several other artists had organized *Three Weeks in May*, a program of events that produced national headlines. It proved a turning point in Lacy's career and, although this has not been sufficiently acknowledged, it heralded—perhaps it invented— a new genre of art. The development of "relational aesthetics" and "social practice" art over the past decade and more is significantly indebted to Lacy and her collaborators. Other artists, mainly women, were beginning to engage in similar efforts. But Lacy, drawing on work with Judy Chicago, and also with a wide range of collaborators including, especially, Leslie Labowitz, was singularly influential in forging a union between artists, civic leaders, community organizers, and the mainstream news and entertainment media.

While the West Coast's distance from European cultural tradition, and the greater openness in California to a range of radical experience, had provided fertile ground for introspective forms of feminist

expression, the presence of Hollywood also meant that media-savvy live art flourished on the West Coast. In the East, interest in mass media was seen first in conventional mediums (Pop painting and sculpture) and later in more academic ones (photo-based critique of commercial imagery). Of course, the era's media-aware, activist art was hardly restricted to one region. And just as a close understanding of how the mass media operate is a boon to artists seeking social change, the expressive skills of artists everywhere are greatly beneficial to achieving public reach. Jody Pinto, a New York-based sculptor who works mainly in the public realm, and who, as a pioneering feminist, founded one of the first antirape organizations, in Philadelphia in 1971, told me that the two commitments were, in her community, distinct but mutually supportive. "I knew I could get people fired up. That's what artists do. You have this stupid idea that you can get people to understand, make yourself understood. You throw yourself on your knees, with public art."[49]

But while the development of social practice can be linked to regional (and personal) circumstances, a more powerful explanation for the emergence of this hybrid of art and activism is the dawning urgency about bringing attention to sexual violence. If rape is a form of expression, and if it can been associated with a "rape culture" of aggression and permission that plays out in, and is supported by, commercial media, then there is a kind of symmetry in the fusion of public protest and performance art around the subject of sexual violence. Indeed that fusion—the new genre of activist art—helped compress the spectrum linking individual victims of violent sexual assault with the undifferentiated mass of women facing harassment, professional inequity, and other forms of injustice, including exploitation in movies, advertising, and related visual media.

Lacy's *Rape Is*, published in an edition of three hundred,[50] is a parody of the then hugely popular *Happiness Is* books featuring Charles Schulz's Peanuts characters (for whom happiness was "*a*

Sunny Day," or "*a Warm Puppy*"). Reprinted in an edition of one thousand in 1976—this is when it made its most significant impact—*Rape Is* is a small, square, staple-bound white book with wraparound covers; opening it required breaking a circular red seal on which is printed the word RAPE. Endpapers are the same glossy dark red. On the white pages inside, the title phrase is repeated on the left-hand side of every spread, each time facing a different conclusion. These twenty-one statements begin with domestic, childhood incidents ("when you are sitting on your grandpa's knee, and he slips his hand into your panties"; "when a neighbor boy forces you into a closet to 'See what girls look like'") and then move to more public, adolescent ones ("when you are skipping home from school, and are surrounded, suddenly, by a gang of large boys"; "when the man next door exposes himself and you feel guilty for having looked"; "when you're walking alone, thinking your own thoughts, and a man, driving by, shouts, "HI SWEETIE!"). It progresses next to incidents familiar to virtually all women ("when a stranger in the street uses you for his fantasy and leaves you feeling naked"; "when he pinches your ass and assumes you will be flattered") and those that express similarly common assumptions ("when your boyfriend hears your best friend was raped and he asks, 'What was she wearing?'").

Around midway, *Rape Is* leads into more adult and less universal territory, without losing sight of that terrain's profound conflicts ("when you're in a gangbang, desperately hoping for love, and they are admiring each other's performances"; "when your shrink suggests an affair with him would be therapeutic"; "when you go to an abortionist and he demands more than money for his services"; the special cruelty of this last, physical as well as emotional, is particularly shocking). There are other direct references to the times ("when your soldier brother goes into enemy territory and takes everything there, including the women"; at first printing, the war in Southeast Asia still raged) and to the place, specifically Southern California,

with its dependence on cars ("when you're driving alone at night and he pulls up to your car at a stoplight to say, 'what'ya doing out this late?'"; "when you are hitchhiking and he therefore infers you are asking for it"). By its last third, *Rape Is* has focused on the most egregious forms of criminality, and their legal and emotional sequels ("when you are tied, screaming, to a bed, so he and his friends can take turns, and he says, 'Tell me how much you like it!'"; "when a policeman asks you, as he fills out a rape report, 'do you undress in front of your windows?'"; "when you attempt to prosecute the rapist, and find yourself on trial instead"; "when your case is weakened in the eyes of the law, because the rapist did not ejaculate"). It concludes, "rape is when you're thankful to have escaped with your life."

Rape Is was conceived as an inexpensive artist's book, at a time when such publications were widely hailed as a form of public art by other means—as a method of circulating imagery and information outside the established institutions of exhibiting and selling art. The 1976 edition arrived the year that both Printed Matter and Franklin Furnace were founded, two New York City nonprofits established to support the presentation and archiving of artists' books, which Printed Matter also published and sold (and still does). This is where I entered the art world; one of my first jobs, in my early twenties, was at Printed Matter, which stocked Lacy's book. I remember clearly the anger I felt on first reading it. Shouting "Hi Sweetie" isn't rape, I thought; ass pinching isn't rape. *Everyone* has experienced these things. That this was precisely Lacy's point helped not at all. To me it completely failed its titular promise to define a pernicious crime: if there was any possibility of arriving at a clear definition of rape, this publication didn't offer it. The economy of Lacy's writing was more or less lost on me, as was the candor and incisiveness of her book's case summaries, and their carefully modulated range. Lacy was unflinching on the confusions of childhood (you feel guilty for having looked) and of adolescence (the divided loyalties to your

best friend, who was raped, and to your boyfriend, who's a bit of a dolt, but whom you're reluctant to oppose). There is the stubborn desire to please, and the overdetermined, seemingly ineradicable wish to be considered sexy. The ending is crushing; the book's effects cumulative. I still believe its definition of rape is so broad as to be counterproductive and opens the discussion to misunderstandings and conflicts that have only grown. But it also helped initiate a crucially important conversation that hasn't stopped since.

Rape Is spoke to a ready and growing audience. The feminist perspective on sexual violence was shifting: once seen as a range of isolated events, affecting one woman at a time under circumstances that might well be avoided with aggressive resistance, it was coming to be judged a clear—though otherwise unexceptional—expression of unchecked patriarchy woven into the fabric of society. Citing Brownmiller, Lacy wrote that by the early 1970s, women were "formulating an analysis of rape as a mechanism of social control"[51]; *Rape Is* made an important contribution to publicizing that notion. But it was an individually authored work, and Lacy's inclination from the start was to work in concert with others. Her intuition told her that collective action could be more than a means of effecting change—it could also help restructure the field of cultural exchange. With activist art, individual women's voices were to be subsumed—amplified and also in some respects de-individualized—into choruses of advocates. The aim was to educate, arouse, and enlist. Targets for change would include policing, legislation, physical and psychological health care and media coverage as well as safety preparedness; the broad goals of participating artists would be to alter the way people of all genders think about rape. And crucially, the mechanism of change would be called art—even if, at times, the label served only by fiat. Casting a shimmery light, bright and unpredictable, art can capture and direct attention to social issues that might otherwise seem settled and known. It promises to deliver news, to honor subjectivity, and to

welcome opinionated responses. Hyphenating art with activism was immensely energizing to both.

In 1975—the year that Brownmiller's book was published, as Lacy observed—she undertook a program called *One Woman Shows*, in Los Angeles. Its structure was transitional, reaching for collectivity while still based in personal authorship. Finding each other by word of mouth, more than fifty women, some experienced artists and some not, each asked three others to attend one-time performances. Lacy staged the first, beginning by naming herself "The Woman Who Is Raped"—in solidarity, she made it clear, not from actual experience—and reading aloud that day's police reports of rape. Among the other women who participated in the *One Woman Shows*, with performances at LA's Woman's Building, were Melissa Hoffman, Laurel Klick, and Cheryl Swannack, who performed rituals to exorcise violent experiences; Cheri Gaulke, who told a story about a battered woman; and Jerri Allyn and Anne Gauldin, who enacted skits in restaurants about harassment of waitresses by customers and coworkers. Soon, though, Lacy wanted to reach further. "Take Back the Night" marches had begun; one of the first was in Philadelphia in October 1975. An International Tribunal on Crimes Against Women was held in Brussels in March 1976, attended by over two thousand women from forty countries. (It was inspired by Bertrand Russell's international tribunal on crimes committed in the Vietnam War.) Topics included medical and economic injustices, attacks on lesbians, spousal abuse, prostitution, pornography, and femicide as well as rape. The conference opened with the reading of a telegram sent by Simone de Beauvoir for the occasion. A Take Back the Night march took place in association with the Tribunal. A broad coalition seemed necessary and possible.

Lacy's organizational abilities, which Moira Roth described at the time as "uncannily effective," were used "to draw women together not only for the purposes of protesting violence but also, and increasingly,

to celebrate and strengthen the community of and network among women."[52] Along with her prodigious ability to initiate collective action, Lacy also had the benefit of an urban context in which several factors converged to support the proposition that art could be a potent force in resisting sexual violence. Not only was Los Angeles in the 1970s a leading center for developing feminist thought and feminist art, it was also, as has been noted, a city with an enormous proportion, per capita, of sexual assaults. A spokeswoman for the department of Human Relations in LA county affirmed, in 1976, that Los Angeles deserved its reputation as the rape capital of the nation. At the same time, as Lacy and Labowitz pointed out to me, California's exceptional commitment to public higher education in the late sixties gave a wider range of people access to cultural opportunities, including those on offer at the Woman's Building in LA (founded in 1973). Labowitz, who had been in Germany from 1972 until 1977, noted that the class system in Europe kept both fine art and higher education there more restricted. But, as also observed earlier, it had far less crime. "In Europe, I experienced greater freedom walking on the streets," she recalled. "You can't be free if you don't feel safe."[53]

Three Weeks in May, Lacy's first full-blown public program—it ran from May 7 to May 24, 1977—was some time in the making. Looking back on it shortly afterwards, she wrote, "For several years, I struggled to integrate my work as a feminist educator and organizer with my work as an artist. A resolution has not come easy, for when one is trained as I was in social sciences, pre-medicine and community organization"—training she was now fully exploiting—"you learn to look for the kinds of results not readily apparent after completing a conceptual art piece."[54] In addition to her academic background, it helped, as art historian Sharon Irish has pointed out, that Lacy had been exposed to commercial movie and television production during her graduate studies, and that for nine years starting in 1974, she

lived with a man who ran a special effects business—Robert Blalack, of Praxis Film Works.[55] Reflecting on her early alternation between "personal" art-making and political activism, Lacy said, "The apparently simple solution, to look at the *structure* underlying this political activity and use it as a model for artwork, did not occur to me until new ideas in performance art provided the context for it . . . I wanted to provide . . . a structure for dialogue at a mass level—to raise the consciousness of our entire community."[56] She admitted, "These intentions were not always clear to me—most were worked out during the elaborate process of constructing the piece. . . . The value of political art lies not only in its use as a model for what is possible, but as the elucidation of a process of thinking which combines aesthetics, political philosophy, and action-oriented strategy."[57] A new art form was consciously being birthed.

It is worth noting that formulating this kind of work in the 1970s was very different—considerably harder, in many ways—than it would be now. Internet search engines and social media provide instant, relatively frictionless connections with people in every field; that connectivity doesn't guarantee response, but it does enormously ease the process. As Lacy undertook the organizing for *Three Weeks in May*, she delineated what she termed "four major 'audience-groupings,' or constituencies, roughly parallel to political or professional affiliations": local government officials, feminist activists, women artists, and representatives of the media. "These groups could simultaneously create events, serve as audiences, and increase their political awareness of each other," she explained. As the coalitions came together, the piece took shape—not the other way around. And Lacy reached out person by person, often starting with a friend or colleague, although, she said, "I also used the traditional information paths found in the phone book and newspapers."[58] Distinctions between artists, collaborators, self-chosen audiences, press, and the broader public were deliberately blurred.

Negotiating these relationships required maintaining a precarious balance. You have to know "how to hold on to your vision and yet retain the flexibility which makes it a truly community-responsive art piece," Lacy wrote, saying it was hard to decide "which 'challenges' from the milieu surrounding the piece are to be heeded and which ignored."[59] In a recent conversation, Labowitz recalled struggling to "merge self-awareness with social practice," for which, she said, the significant presence in Germany of the Frankfurt school of political philosophy provided theoretical support, and a long view of social action, that were lacking in the US (although the feminist movement was stronger here).[60] While these considerations added to the challenges of the face-to-face (or at least telephoned) negotiations with collaborators required at the time, personal discussions were essential to the program's final shape and meaning. The evident involvement of individual hands, the seams that showed when the whole was assembled, gave the work a rough texture that contributed to its vitality.

At the center of *Three Weeks in May* were two twenty-five-foot-wide, bright yellow maps of Los Angeles hung in the City Mall, a shopping center directly downstairs from City Hall. On one map, daily police rape reports were recorded with a stamped red "Rape," around each of which nine fainter "rape" stamps were added, representing the estimated number of unreported assaults. The second map provided names, phone numbers, and locations (approximate, for safety reasons) of victim support centers, from hotlines to hospital emergency rooms. Artists, activists, and politicians together created the schedule of the more than thirty events that took place over the course of the program. Media attention was actively solicited throughout. Among collaborating organizations were the LAPD, the Sheriff's Department, the Los Angeles Commission on the Status of Women, Women Against Rape, Men Against Rape, Women Against Violence Against Women (WAVAW), the American Civil Liberties

Union, the Los Angeles Men's Collective, and members of the Woman's Building. An affirmative action program presented two self-defense demonstrations. County government representatives participated in a rape prevention workshop.

Four lunchtime performances at the City Mall were conceived by Labowitz. The first addressed *Myths of Rape*, in which six black-clad and blindfolded women (representing society's blindness) carried signs while Labowitz handed out printed information. The second performance, called simply *The Rape*, explored the double victimization of survivors, first by the perpetrator and then by the criminal justice system. In the third performance, *All Men Are Potential Rapists*, members of the Los Angeles Men's Collective recreated childhood games that fostered aggression against women. *Women Fight Back*, the last performance (and the most widely publicized; it was covered on local television), involved roughly half a dozen performers concealed by large black paper cones on which were written such exhortations as "gouge eyes" and "turn fear to anger!" At the conclusion, the performers broke free of their coverings to rescue an artist representing a woman in danger.

Lacy's own contribution was a three-part, two-day piece at the Garage Gallery of the Studio Watts Workshop called *She Who Would Fly*. In the first, private part, Lacy served as witness on two afternoons as women came to the gallery to relate experiences of sexual violation. After they had spoken, the participants wrote their stories on sheets of paper and attached them to maps of the United States that covered the room. The second part, again private, was a "ritual" in which four women who had been raped—Nancy Angelo, Melissa Hoffman, Laurel Klick, and Cheryl Williams (two of whom had participated in *One Woman Shows*)—shared stories and food, and anointed each other with red greasepaint. Part three was the only segment open to the public, and then only to a few viewers at a time. A flayed lamb cadaver, to which large, white-feathered wings were

attached, was suspended from the ceiling. An account by poet and novelist Deena Metzger relating the details of her rape ("'Take off your clothes,' he says. My body is shaking....")[61]) was added to the testimonies on the wall. And on a ledge above the door crouched four nude, red-stained women, observing viewers as they entered. Their impact, along with the skinned and winged lamb, was force-ful—overwhelming, for some. In Lacy's description, "Avenging angels, metaphors for a woman's consciousness which splits from her body as it is raped, the bird-women were intended to remind visitors they were voyeurs to the pain of very real experience."[62] Wrote scholar Meiling Cheng, "The work's most important aspect is the moment when the audience members suddenly discover that they are being watched by these bird women. [It] transforms the performers from traumatized flesh/objects into accusatory subjects."[63] Clearly a searing performance, it just as obviously reflects Lacy's sensibility, however much the program was meant to subsume individual voices.

The LAPD statistics that were assembled as part of *Three Weeks in May* show that 83 rapes and attempted rapes took place during its run. As one might expect, the vast majority of victims were young (between twelve and thirty). Nine of the victims knew the suspect; eight successfully resisted assault. Weapons were used in twelve cases. One suspect was a family member; one victim was followed from a bar. The most dangerous location was South Central, with 26 rapes; Hollywood was next, with 15. Later statistics, included in a documen-tary book (printed in an edition of ten), showed that, for the entire year of 1977, 2,386 rapes and attempts were reported, the majority (1,141) in residences. There were 698 African-American victims of rapes and attempted rapes, and 764 white ones; at the time, the city was approximately 10 percent black. Again, these statistics can only be called the roughest of estimates, and fully subject to racial bias; the LAPD was notorious for racism. (Its handling of the 1965 Watts upris-ing and subsequent introduction of SWAT teams—now an acryonym

for Special Weapons and Tactics, then for Special Weapons Attack Teams—were infamously crushing.) At the same time, it seems clear that women of color were falling victim in disproportionate numbers; as with all rape statistics, those reported undoubtedly represent only a fraction of actual attacks. *Three Weeks in May* also included, as part of the documentation it assembled, the California penal code on rape, which outlined the conditions that would permit a charge to be made: they include the plaintiff's incapacity to consent because she was mentally compromised or unconscious, attacked or threated with force, or erroneously "believes the man is her husband" due to a bogus marriage. This last is explained by the code's preliminary statement, which "defines rape as an act of sexual intercourse, with a female who is not the wife of a perpetrator." In other words, a husband's right to rape his wife was at the time unconstrained by California law.

A great deal of what Lacy and her collaborators presented in *Three Weeks in May* was news to the public. In a statement to the press, the organizers wrote, "The truth is that no place is safe. It seems clear to say that women should not hitchhike: seventeen [of the victims] were raped while accepting or offering a ride to a stranger or acquaintance. But twenty-one [twenty-four, per statistics printed later] were raped at night in their own homes.... And twenty-three were raped on the streets in broad daylight! [underlined in the original]. One woman was raped by her bus driver when she fell asleep before the end of the route, another at five in the afternoon as she sat in her office." Press coverage for *Three Weeks in May* was modest but encouraging. The *Los Angeles Times*, heralding "Downtown Programs to Fight Rape,"[64] reported the collective sponsors' statement: "'This project proposes to focus critical public attention on the problem of rape in Los Angeles and, more importantly, what is being done about it." A second article in the *LA Times* quoted Lacy, who explained, "I think the definition of art is the ability of a piece to reach the audience and change it."[65] Buoying, too was the breadth of community and

political support—up to and including the Mayor, Tom Bradley. But as Lacy predicted, *Three Weeks in May* also seemed to contribute to an antifeminist backlash. Feminist abortion clinics were burned down; women working in rape crisis clinics were raped while at work. Perhaps most dismaying, she reported, "During the third week of *Three Weeks in May* a woman was brought to the City Mall and raped 100 yards from where the rape maps were installed."[66]

Lacy pressed on. Six months later, she and Labowitz again staged a program addressed to sexual violence, this time conceived specifically as a focused engagement with the news media. *In Mourning and in Rage* was a one-time public "media event" enacted on the steps of Los Angeles City Hall. The recent so-called Hillside Strangler murders (the murders were actually the work of two men), in which ten women were found raped and killed, had been sensationalized and grotesquely—if unsurprisingly—distorted by the press. At first it was reported that the victims were all prostitutes. Their pasts were investigated with salacious zeal; they were characterized as marginal and defenseless. As Labowitz put it, "the media showed helpless victims. We showed strong survivors."[67] Working again with WAVAW, and with the Woman's Building, local rape crisis hotlines, City Council members, the Deputy Mayor and others, Lacy and Labowitz conceived a dramatic memorial for the victims then known.

On December 13, 1977, a hearse, escorted by two motorcycles, traveled the short distance from the Woman's Building to City Hall, followed by a twenty-two-car motorcade. Nine performers emerged from the hearse, draped in black and wearing headpieces roughly shaped like coffins, which made them appear to be seven feet tall (it was in part an homage to the image of Death from Maya Deren's landmark 1943 film, *Meshes of the Afternoon*). As they assembled one by one on the City Hall steps, seventy performers from the following cars moved to positions behind them, unfurling a banner that read, "In Memory of Our Sisters, Women Fight Back." One at a

time, each towering, black-draped mourner strode to a microphone to deliver a statement, the first, "I am here for the ten women who have been raped and strangled between October 18 and November 29." In response to each statement, the chorus of other performers, modeled on classical tragedy, chanted, "in memory of our sisters, we fight back!" As each mourner completed her statement, a woman garbed in scarlet (for anger) draped her in a similar red cape. Their indictments grew successively broad, ending with "I am here for the rage of all women. I am here for women fighting back!" Suzanne Lacy took the microphone to say, "We are here in mourning and in rage." Singer and activist Holly Near composed and performed the now classic anthem "Fight Back" for this occasion.

As critic Jeff Kelley observed, "the performance was itself a kind of ritualistic press conference designed to capture and fix media attention by anticipating and appealing to its journalistic conventions."[68] The literally large-than-life actors; the anger-fueled sound bites; the clear symbolism of the funeral cortege; the control of the scene so that every photograph would capture what the artists intended, as with the "establishing" backdrop of City Hall and also the design of the banner (which, as Sharon Irish writes, was meant to fit in the horizontal frame of a camera), all were chosen "so that one image—of the women gathered on City Hall's steps, with banner raised—could carry a clear meaning via mass media."[69] Similarly shaped for media impact were follow-up discussions with city politicians, which repeated and consolidated the performance's themes, aligning government rhetoric with the artists' agenda.

In Mourning and in Rage had the immediate result of redirecting city money originally promised as a reward for information on the Hillside murderer to self-defense classes for women. In addition, the phone company agreed to list rape hotline numbers in the Yellow Pages. But the program's life in the press was even more important, if uneven. The decision to connect it to the Hillside crimes proved

canny; one short newspaper story ran under the headline, "Feminists Hold Strangling Victim Rites." Other press coverage addressed the project as an artwork, with an emphasis on Lacy as its author. The project was described in one report as "a public art informational piece by Suzanne Lacy," an artist "well known in the Los Angeles art community," and went on to quote her: "I consider this an art piece, because first, I am an artist, and I continually strive to address the art audience,"[70] Lacy is reported (a little suspiciously) to have said. The newspapers may not have gotten it quite right—if it was art, there had to be an artist, preferably working alone, and famous—but they were at least paying attention. In any case, Lacy would never altogether relinquish her signatory role; the unchanging fact that the press favors individual authorship continues to dog social-practice art.

In 1978, Labowitz and Lacy formed Ariadne, a "social art network of women in the arts, politics, media and women's community," which, over its roughly three-year lifespan, collaborated on events in Los Angeles, San Francisco, and Las Vegas, addressing rape and violent images of women in record advertising, news, and pornography. Prefiguring language that would be ironized by artists in the following decade (see, for example, Barbara Kruger's text-and-photograph work, *Your Body Is a Battleground*), Labowitz and Lacy wrote, "Our bodies are manipulated by the patriarchy as a battlefield for the diversion of attention away from economic systems which are themselves predicated on and preserved by violence."[71] Continuing to insist on collective action, Ariadne would move from the occasional social art performance to the establishment of a production network for works directed toward ending sexual violence. At the outset, those activities included educational programs at the Feminist Studio Workshop and the Woman's Building, with classes in production and in analysis of social action. One of the first projects was to be a handbook on producing multimedia informational art campaigns, which would be sent to communities interested in organizing such events of their own.

Ariadne's mandate can seem, in retrospect, both tendentious and a little circular. It urged others to join in a campaign of fomenting still more campaigns and claimed that "skills developed by activists for working within communities are applicable as well to sociopolitical art," while basing its work on the reciprocal idea that sociopolitical art would further the ends of activism. Nonetheless, significant events were staged under its aegis. As promised, they fell into two categories: "media performances"—one-time events designed for television coverage—and extended efforts at broadcasting information that reinforced the initial presentations. Among the projects in the ten-day 1978 program, *From Reverence to Rape to Respect*, organized by Lacy, Labowitz, and Claudia King, was *Traffic in Women: A Feminist Vehicle* by Nancy Angelo, Cheri Gaulke, Vanalyne Green, and Laurel Klick. Each took a role as, respectively, nun (Sister Angelica Furiosa), good girl (Cinderella), whore (Cleavage Woman), and a maligned Pussy Cat. Taking the show on the road, the artists traveled between Las Vegas and Los Angeles, conducting workshops for women who worked as prostitutes and entertainers and in "related jobs."[72] Further Adriane projects sustained this commitment. *Making It Safe* (1979), in Ocean Park, Santa Monica, was an eight-month community-awareness project of speak-outs, dinner parties, and informative films and video on rape, battering, incest, child abuse, and sexist pornography. There were readings of poetry on violence by a collective of Asian women, and a photography exhibition on images of strong women in history. A dinner for three hundred concluded the project. In addition to Ariadne, sponsors included the Aging Coalition, Incest Awareness Project, Older Women's Liberation, Womanspace, WAVAW, and San Francisco's Men Against Sexist Violence.

Among the projects in *From Reverence to Rape to Respect* were several at the University of Nevada at Las Vegas, including an installation by Lacy, *There Are Voices in the Desert*, which reprised elements of her earlier work. Inside a small freestanding room, which viewers

crouched to enter through an undersize doorway, was a sand-covered floor. There were three suspended lamb carcasses, as in *She Who Would Fly* but here dolled up to look like Vegas showgirls, with pink and white plumage and gaudy beads. Lacy, again seated above the entrance, draped visitors with similar beads as they entered. Once more, personal accounts of rapes, this time assaults that had occurred in the desert were posted on the walls; the recorded hiss of wind could be heard. But the most notable departure from the earlier performance was that after exiting, viewers entered a candlelit area where they were encouraged by another performer to discuss their responses.

By several accounts, this was a powerfully expressive installation; Lacy felt it wasn't complete, though, without a collective debriefing. As she and her collaborators saw it, in this work meaning and efficacy depended on conversations carried forward in a communal fashion, rather than on individual response, mulled over internally. By integrating the social and participatory elements of her work with the expressive and performative ones, Lacy consolidated the notion that everyone is in it together, all the time, as artist and as victim, as viewer and as activist. In doing so, she contributed to a wide-ranging, deeply significant adjustment of how personal experience and identity were expressed in the changing culture of the seventies.

IDENTITY CRISES

The collective action that feminist artists advanced in the mid-seventies in California took place against the backdrop of a culture of increasingly unsettled personal identity. *What's My Line? I've Got a Secret. To Tell the Truth.* Contestants on these wildly popular television shows of the fifties and sixties pretended to be someone else, or resisted revealing what they did for a living, or withheld some other identifying—and, the producers hoped, humorous—characteristic. Panels of celebrities, standing in for the home audience, tried to guess who was telling the truth, and what their secrets were. In postwar America, measures of character and affiliation—professional, financial, social, and familial—that had once been reliable became shaky. By the sixties, a roaring economy and a rising cult of stardom had made public success uniquely important and at the same time singularly hard to quantify. Crafting an image began to take precedence over providing a service or product; someone you knew—*everyone* you knew—was likely being shrewd, or hiding something, or just plain telling whoppers. It was interesting. The musician John Cage appeared on the television show *I've Got a Secret*, in 1960, performing *Water Walk*—playing various water vessels, including a seltzer bottle, a rubber duck, and a bathtub—to a giggling audience, encouraged by a wiseacre host and, for viewers at home, by canned laughter. The question the show posed was: What does a musician, or an artist, look like? Or, perhaps: What does an artist *do*? As the sixties wore on, game-show contestants and performance artists alike circled, however distant their

orbits, around shared questions of identity and its fault lines. By the mid-nineteen-seventies, a tanking economy had put further pressure on assessments of professional and personal self-worth. Once stable professions up and down the economic ladder were fragmenting; the previous generation's expectation of lifetime employment at a single job was fading fast. Within the art world, too, disciplines were fraying, as the traditional fields of painting and sculpture were yielding to new forms that included, in addition to performance art, hybrids of two- and three-dimensional work as well as film and video.

Looking back, in 1979, on the emergence of what he called "the culture of narcissism," which served as the title of his best-selling book, Christopher Lasch deplored a "preoccupation with the self" whose corollary, he said, was a vitiation of identity. The new narcissist, Lasch wrote, "doubts even the reality of his own existence."[1] Claiming the political turmoil of the sixties had produced a backlash in which Americans turned from collective activism to individual "psychic self-improvement,"[2] Lasch found the effort wholly unsuccessful; apathy and anomie combined to create what he deemed a prevailing "inability to feel."[3] Among other symptoms of the seventies, Lasch noted an "increasing interpenetration of fiction, journalism, and autobiography"[4]—the collapse of these categories is, of course, widely considered a signal crisis of our present time—and a society of the spectacle in which life was mediated by electronic images, another prescient diagnosis.[5] On the subject of gender politics, he noted, "Verbs associated with sexual pleasure have acquired more than the usual overtones of violence and psychic exploitation."[6] Grim, bitter, and fundamentally conservative in its implicit yearning for a mythic past of wise paternalism, Lasch's book nonetheless got many things right, not least on the issue of gender politics. Reflecting a less partisan culture than that of the present, he'd drawn in part on the left-leaning sociologist Richard Sennett, who had written, in *The Fall of Public Man* (1977), of the loss of shared languages of civic

engagement.[7] Introspection, both men believed, had become an affliction, sapping the spirit of social engagement. The more people examined themselves, their argument went, the more those selves fractured and frayed.

It was a condition to which many women artists were already well attuned. While some were opening themselves up in performances that put their real lives and their performance roles in painfully close contact, and others were entering into collaborative projects that redrew boundaries between art and activism, performer and audience, a number of women were taking a different tack, assuming alternate personae with results that were, arguably, even more challenging to themselves and their viewers. Rather than committing to a single, precarious position between art and life, and declining to choose between introspection and solidarity, these women ventured to occupy two places at once.

Adopting a full-blown alter ego from a starting position which is already profoundly unstable is not a gambit for the faint of heart. No one went deeper into this kind of undercover project than Lynn Hershman Leeson, a California-based artist who for more than four years, starting in 1973, became a part-time alter named Roberta Breitmore. Cultural theorist Peggy Phelan likens Hershman Leeson's performance art to Method acting, which was "based on eliminating the audience's awareness of the gap between the actor and the role."[8] It's an illuminating point of reference, suggesting a broad shift in expectation for performers: a new demand for self-exposure, however painful; a dark mirror held to the chirpy, jokey world of actors in mufti on television game shows. Hershman Leeson, though, went much further than acting. Outsourcing some of the labor of having a personality, she split the difference between inside and out, body and mind.

Described by the artist as "A simulated person who interacts with real people in real time," Roberta Breitmore "was animated through

the application of cosmetics, applied to a face as if it were a canvas, as well as through her participation in real-life adventures."[9] While her made-up (in both ways) face was fairly generic, her name was particular: it was borrowed from a short story by Joyce Carol Oates, expert chronicler of feminine disaster. In Oates's story, published in the *Partisan Review* in the summer of 1973, Roberta Bright carries on an increasingly desperate epistolary pursuit of a man she addresses first as a monumentally gifted composer she'd be honored to interview, and eventually as a mediocre talent she'd like to see dead. Her initial approach is obsequious and prim, but soon she is lurking in her target's lobby, getting close enough, she writes, to smell his shaving lotion; she imagines herself in his bed. Initially amorous, her intentions turn decidedly dark. Ultimately, she tells the musician that she's not the young woman she'd said she was, but a man of indeterminate age and aspect. Everywhere the silent recipient of her letters goes, Bright warns, she—or he—will be there, impossible to identify, watching. It's a wonderfully perverse tale of power inversions and the slow-motion detonation of selfhood.

It's easy to imagine the story's appeal to Hershman Leeson, whose own Roberta Breitmore was launched soon thereafter, when she checked into the Dante Hotel (clearly chosen at least in part for its name) in June 1974. As well as tacky makeup, a blond wig, and a slightly cheesy wardrobe, this Roberta had her own residence and job; she had a driver's license, a checking account, a dentist, and a psychiatrist. She participated in Erhard Seminars Training and, at the recommendation of the psychiatrist, attended Weight Watchers meetings (in keeping with her hapless character, she gained weight rather than shedding pounds). Roberta's activities were documented in photographs and drawings, cosmetic charts, rent checks, surveillance reports, letters, legal and medical documents, and more. A graphic artist for Zap Comix, Spain Rodriguez, was commissioned to make an eight-page strip about Roberta's escapades. She was filmed

by her friend Eleanor Coppola (wife of Francis Ford Coppola, whose first *Godfather* movie had just appeared).

At the same time, Hershman Leeson had a real-life husband, whom she was divorcing, a tween-age child, and money problems. The sheer mental and emotional energy required to keep all these plates spinning was daunting, and the effort showed. Hershman Leeson reports, "Several times I left my house as Roberta, forgot something, and had to return in 'Roberta' costume and makeup, which was a continual annoyance to my then eleven-year-old daughter." If the project took a toll on her daughter, the artist paid stiffly, too. In her recollection, "Roberta's most difficult task was staying in character during her psychiatric sessions. Lynn was going through her own agonizing identity crisis and pending divorce and did not want to squander precious therapy on fictional trauma when she was dealing with her own real-life drama. Yet in critical moments Roberta always prevailed. Lynn was left to find solace on her own."[10]

The project grew even more taxing, logistically and emotionally, when Roberta placed a classified advertisement in the *San Francisco Progress* in September 1975, which read, "Caucasian woman seeks a bright companion to share rent & interests." (Similarly, Oates's Bright ran a personal ad in the *Village Voice* midway through her pursuit, trying to hook the object of her desire.) Hershman Leeson's Roberta received dozens of responses, most from men. Inevitably, many of the social interactions that resulted were sexually fraught, and deeply risky. Roberta agreed to meet with more than two dozen of the male respondents (and furtively audiotaped them), never seeing any of them more than three times, to prevent any significant involvement. But she couldn't altogether avoid trouble. Of the "twenty-seven independent adventures" Roberta experienced, the most dangerous, Hershman Leeson wrote, "was being recruited for a prostitution ring that answered the ad."[11] To escape the ring's pimp, she changed back to Lynn in a public restroom at the San Diego zoo—like Superman

becoming Clark Kent, perhaps, though the circumstances (a toilet stall at the zoo, not a phone booth in a gleaming metropolis) were less dignified.

If there is a kind of zany, televisual appeal to these brushes with peril, there is also a deadly serious submission to the possibility of real harm, a flirtation that went much further than Yoko Ono, or VALIE EXPORT, or even Chris Burden did in their courtships with danger. Closest might be Marina Abramović's 1975 performance *Role Exchange*, for which she devised this plan: "I find a woman who has worked as a professional prostitute for ten years. At this point I have also worked as an artist for ten years. I propose to exchange roles. She accepts. Performance: The woman replaces me at my opening at the De Appel Gallery in Amsterdam. At the same time I sit in her place in a window of the red light district in Amsterdam. We both take total responsibility for our roles."[12] But Abramović is silent about what transpired; we are left to ponder the similarities between the two professions, the exposure and deception both involve, the relative power of sex workers' clients and artists' patrons. And the performance lasted a matter of hours, rather than, as with Roberta Breitmore, years. (To be sure, Roberta, too, is sparing on the details of her "adventures.")

Most provocatively, Hershman Leeson gave Roberta a history of childhood trauma. Her own early history, which she explored—or, just possibly, reshaped—in later video "diaries," included sexual abuse by her father. And one thing Roberta and Hershmann Leeson both emphasized was the lasting self-distancing that incest caused. "I endured an experience of physical and sexual abuse when I was very young. To survive, I develop that very same strategy of dissociation from the pain of the moment," Hershman Leeson said in a recent interview. "One often survives trauma by making oneself a witness to it as it is happening, as a survival tactic. Extracting oneself from the actual pain of the event and looking at the situation as if you're

alien to it, as if you're outside your own body, is something I had learned to do early in my life."[13]

She also learned to simultaneously dramatize and distance herself from the political activism she found on arriving in San Francisco in 1960 (she'd been raised in Cleveland, where she was born in 1941). Hershman Leeson was a student at University of California at Berkeley from 1963–64, and wrote twenty years later about the Free Speech Movement with which she became involved, the love-ins and be-ins she witnessed, the SDS and Weathermen and "The 'Radicalization' of nearly everything"; she mentioned such visiting speakers as Huey Newton, Eldridge Cleaver, Malcolm X, and Angela Davis. "I thought I watched it from the periphery," she wrote. "A sideline spectator. But I deluded myself. The effect of living through that decade of political theater acted like a delayed detonator in my brain—a dynamite stick that waited 10 years to explode."[14] Describing herself as having been both an insider and a spectator, she characterizes her position in these movements as distanced in a way that would recur—present at a series of dramatic social acts, she assumed a role that was deeply ambiguous, and that marked her permanently.

Roberta Breitmore became an indelible episode in Hershman Leeson's life too, although she had been conceived precisely to stand apart from it. Later, the artist wrote, "In retrospect, I believe Roberta and I were linked. Roberta represented part of me as surely as we all have within us an underside."[15] And Roberta's experiences became, inevitably, Hershman's own. "The implications of assuming Roberta's identity didn't become clear to me for a decade. Ingested experience never really ends, but rather hovers inside like a bat, fanning its wings in your psyche. Roberta's traumas became my own haunting memories. They would surface with no warning, with no relief."[16] Hence the questions raised by her later "diaries" and interviews: perhaps, she allows us to speculate, she is recalling Roberta's experiences. It's hard to tell. But—the circularity of the effects of sexual violence is

perfectly, inescapably closed—choosing to repeat, in art, this kind of dissociation can surely be attributed to early abuse. So can the cloud of uncertainty that she is unable to dispel.

Not surprisingly, Hershman Leeson found it crushingly hard to keep Roberta going. Three years into the project, in response to what Peggy Phelan calls the "stranger danger" she was facing, Hershman Leeson asked a trio of friends—one of them the feminist scholar Kristine Stiles—to share with her the responsibility for being Roberta, each wearing similar makeup, wigs, and clothes, and helping maintain her social life and professional appointments. Each had a Roberta-dedicated work and residential address. Hershman Leeson quit being Roberta shortly before these auxiliaries did. As part of the project's conclusion, a look-alike contest was held at the de Young Museum in San Francisco in 1978, in which "Roberta was fractured and dispersed across their bodies."[17] Finally, Roberta Breitmore was laid to rest later that year in an exorcism performed in the crypt of Lucrezia Borgia, in Ferrara, Italy.

Hershman Leeson is sometimes compared to Cindy Sherman, who photographs herself variously costumed and staged in roles that span a spectrum of cultural positions. Her Roberta Breitmore is also likened to other artists' experiments with alter egos, from Marcel Duchamp's female Rrose Sélavy (a French homophone for "*Éros, c'est la vie*"), to Eleanor Antin's role-playing as personae ranging from a deposed king to Florence Nightingale. Hershman Leeson included Antin in a curatorial project she undertook called The Floating Museum, along with (among others) Martha Wilson, an artist (and the founder of the nonprofit art space Franklin Furnace) who also played with gender—and age, and character—in photographic self-portraits. Hershman Leeson herself repeatedly revisited role-playing, although not again putting herself at the center of it. One of her more colorful such projects was the 1975 design of a new identity (also under the umbrella of The Floating Museum) for the activist

Jerry Rubin, whom she helped remake as a young professional. A born performer whose political work was always distinguished by its open clownishness, Rubin was ripe for conversion from Yippie to preppy; by the 1980s, he would become a successful, suit-and-tie businessman. (In fact, Christopher Lasch singled him out as a paragon of the new narcissism.[18]) The contract Hershman Leeson prepared obligated her, in part, "To create a visual identity as close to reality as possible so that image and reality merge and therefore image controls less of our lives."[19] (If the makeover of Jerry Rubin seems to border dangerously on cynicism, or at least a certain recklessness, it was familiar territory for Hershman Leeson, who from 1968 to 1972 had penned art criticism under three pseudo-nyms—Gay Abandon, Herbert Goode, and Prudence Juris; between them, they contributed to *Artweek, Studio International*, and several local newspapers and European journals. Under each of these three pseudonyms, she critiqued her own work. "With tangible reviews in hand, I was able to garner my first exhibitions and legitimate critical evaluations," she reported later, deadpan.[20] At the time, she successfully maintained the ruse.)

If the Roberta project was different only in degree from most of her other work, it differed in kind from related projects by her peers and predecessors. Diving much deeper, with Roberta, into an assumed identity than did Cindy Sherman or Duchamp, she also asks us to take more of her project on faith; the documentation is abundant, but she is its sole source. Doubt is the psychological matrix of the whole exercise. Nothing and no one can be trusted, both artist and alter suggest. People betray you. Your body, your selfhood is—literally, physically—up for grabs. Most provokingly, Hershman Leeson's varied projects suggest that art doesn't tell helpful truths, even—especially—when honest. In fact, they suggest an inverse relationship between one and the other: to look inward is to discover a proliferating host of competing propositions about identity. Different kinds

of experience, whether social, professional or deeply personal, even traumatic, shape different internal selves. There is no single line—in the words of the game show, no truth to tell. Joyce Carol Oates titled her Roberta Bright story "Passions and Meditations"; her Roberta is led by her heart from critical distance to harrowing intimacy, but at the story's end, we know far less of her (or him) than we did at the beginning; indeed we know almost nothing at all. Precisely the same is true of Hershman Leeson's Roberta.

Planting doubt and tending its rich growth is a hard way to forge a career. Despite abundant critical acclaim (by writers other than herself), Hershman Leeson is not as broadly recognized as she might be. Her resistance to identity is a liability. It is also her greatest strength. The refusal to define a fixed self speaks powerfully for the subversion of internal credibility so often caused by sexual violence. A victim doubts her memory, which is as likely to be incomplete as it is to be vivid. Recalling the event for others can produce paroxysms of emotion, but just as often a complete lack of affect. Precisely by her dispassionate accounts of Roberta's submission to danger, and of her own subjection to abuse as a child, Hershman Leeson forces us to face these discomfiting polarities.

Taking an entirely different—although no less provocative—approach to role-playing, the then East Coast-based, African-American artist Adrian Piper assumed, in the early 1970s, a part-time persona she named Mythic Being. Sharing a timeframe (if little else) with Roberta Breitmore, Piper's Mythic Being had a formidable Afro, big dark glasses, a droopy mustache, male clothes, and (although Piper is petite) male swagger. Her motivation was not simply cross-dressing—she didn't go into the role to inhabit the gender she felt better represented her sense of self, nor to satisfy a persistent urge. And her interest in conflicted identity was very different from Hershman Leeson's. What Piper was after was testing notions of power and of objectification in both political and philosophical terms. As she said

at the time, "The fact that I'm a woman I'm sure has a great deal to do with it ... at times I was 'violating my body'; I was making it public. I was exposing it; I was turning me into an object." At the same time, she conceded that the Mythic Being was "a therapeutic device for freeing me of the burden of my past, which haunts me, determines all my actions."[21]

The chronology of the project is not straightforward. There are "Preparatory Notes for The Mythic Being" that begin in January 1973, and often-reproduced Mythic Being pieces from 1974 (through 1976); in a chronology she wrote for a 1999 exhibition catalogue, Piper says she undertook the exercise in 1972. (The Being evolved, in 1980, into a more ambiguously gendered character in *Some Reflective Surfaces* and *It's Just Art*.) As early as 1970, she had declared herself an art object, a decision she attributed to social and political events that transpired that year: the bombing of Cambodia; the killings of students at Kent State and also at Jackson State College, Mississippi (in which two protestors were shot to death by police, and twelve injured, eleven days after—and a media universe distant from—the Midwestern, mostly white Kent State campus). Piper also cited the surfacing, as she dated it, of a new women's movement; she noted as well an exhibition at the Museum of Modern Art in New York marking the advent of Conceptual art.[22] After running through various professional identities in her real life as a young woman (fashion model, disco dancer) and, in the *Catalysis* series, appearing publicly and unannounced in various disagreeable guises—wearing clothing soaked in vinegar, eggs, milk, and cod liver oil, or marked "wet paint"; stuffing a towel in her mouth or balloons in her clothing; playing concealed recordings of loud belches—she was celebrating "The history of myself as self-conscious object!!"[23] When Lucy Lippard asked her in early 1972, with reference to the *Catalysis* and other early performance work, whether these works concerned being a woman, or being black, Piper replied, "Well, not in terms of intention. As far

as the work goes, I feel it is completely apolitical. But I do think that the work is a product of me as an individual, and the fact that I am a woman surely has a lot to do with it. You know, here I am, or was, 'violating my body'; I was making it public. I was turning myself into an object."[24] By the end of the year, she was eager to push it further.

Inspiration appeared serendipitously. In a journal entry of March 1973, Piper records having seen "a very tall black man" wearing a "grimy blue peacoat, black knickers, and knee-length leather boots. He looked very seedy. His hair was twisted into a thousand little 2"-long braids, which stuck straight out all over his head, giving a pincushion effect. He had an untrimmed beard, his eyes were bloodshot. He walked w/a swagger & smiled broadly. He was talking to himself in a loud singsong voice." Then another, even seedier man approached, asking for a few cents. "'How can you take some cents from a man who got no sense? Huh?' the pea-coated man asked. 'You can' take nothin from a crazy man, you know? Cause no cents is nonsense, so it's all the same to me, you dig?'" Piper was "dumbfounded" at this "near perfect balance of behavior and self-consciousness." She thought of an earlier work in which she had walked slowly down the street, muttering incoherently. "My piece suffered by comparison," she reflected. The pea-coated man's self-representation seemed to her poetic and divinely inspired, hers dry and overintellectualized. "It seems that the tension he achieved had a lot to do with the degree to which he could both EXPRESS his state of mind and also self-consciously acknowledge it."[25] In his profound ambiguity, the man seems to have offered Piper a vision of public presence that negotiated a number of exchanges: between posing and acting out—that is, being out of control; between intentional provocation and inadvertent offence.

If this spark of inspiration was crucial, it was beset by gusty winds, and for several months it sputtered. In April 1973 Piper writes in her journal, "I've been B.S.ing around this piece for months now, and I still can't bring myself to get going on it.... The fact is I'm scared

shit."[26] But in August, the light took. "I knew the damn piece would come together if I just waited long enough," she writes. "Here it is. Auburn shag wig, reflecting sunglasses, black pants and turtleneck, brown boots." She'd photograph herself and go to openings, concerts, and other events in this "disguise," then run a photo of herself thus outfitted in the gallery listings section of the *Village Voice*. But she felt the image was still not quite right; she ruminated further in this entry and then announced happily, "I should be in DRAG, dressed as a *boy*." The next entry reveals her firm determination—and much about her circumstances at the time. "I've decided to try and borrow $100 from Sol [LeWitt, the Conceptual artist and a good friend] for the piece. I'll be able to pay him back when I get my check from *Artforum* [to which she was contributing art criticism]. I have only $10 in my account and no possibility of any money coming in. Only $4 left for this coming week. I guess I'll stay home and fast a lot."[27] Another three months went by before she noted, in November, "When I went to buy the materials for this piece, I told the shopkeepers I was acting so they wouldn't start hassling me about dressing in drag."[28]

As realized, the Mythic Being had several components. For starters, there was a sequence of internal reflections: as Piper explained, "Each month in the cycle is represented by an articulated thought" to which she would direct her attention as in a guided meditation. Photo-based drawings in which the Mythic Being appeared with one of these meditations written in thought bubbles appeared once a month in the gallery listing section of the *Village Voice*—a stealthy incursion into the commercial art world—from September 1973 to February 1975. The meditations, or mantras, were generated by journal entries from the period between January 1961 and December 1972—that is, from the time she'd been a teenager and young woman to the point when the Mythic Being was conceived. Boys, eating, sex, and psychotherapy sessions are among the journal's subjects; the order by which entries were matched to the project's sequence is complex

and arcane. Personal and particular though they were, the journal prompts were meant to be routes out of Piper's own consciousness. "The mantras are pathways into the identity of the Mythic Being: I can, through careful concentration on them, transcend my own,"[29] she declared. Piper looked to these autobiographical snippets as "signs of someone else's experience, to which I have only partial access." Distancing herself from the youthful journal helped her see the arbitrariness of her present "personhood"; for instance, she muses, "I might easily grow a penis or redistribute the fatty tissue of my breasts to my stomach; sprout a moustache or coarsen the muscles in my neck. . . ." And in a footnote, she adds, "The Mythic Being is an abstract personality, a folk character. His history constitutes the folktale used to explain some current social phenomena, namely myself, my behavior, my relationships. As such it is a part of the common folklore and folk consciousness of all who read the *Village Voice*."[30]

It is a dizzying spiral, from her own intimate journal, to a folkloric character she creates and inhabits—a character who, in turn, explains her own actions to Piper, and, insomuch as s/he is present in the pages of the *Village Voice*, reaches out to a broad public. Introspective calisthenics of a particularly vigorous kind, this emotional, spiritual and, not least, metaphysical workout could only have been conceived, it seems fair to say, by an artist who would soon also become a professional philosopher. (Piper's 1987 appointment at Georgetown made her the first African-American woman to hold a tenured professorship in philosophy.[31] Following completion of an undergraduate degree, in 1969, at the School of Visual Arts in New York, she had studied philosophy at City College of the City University of New York, from which she graduated in 1974; that fall she entered a doctoral program in philosophy at Harvard. While she was enrolled—her primary philosophical interest was Kant; her 1981 dissertation, for which she was advised by John Rawls, was on "A New Model of Rationality"—the Mythic Being reached full maturity.

After an academic career replete with both honored achievements and ultimately insurmountable institutional opposition, Piper established full-time residence in Berlin in 2006, and has not been to the US since.[32])

While the conceptual basis of the project was labyrinthine and more than a little dark, the Mythic Being himself, like the tall black man who was his inspiration, strutted and grinned. His getup was a little outrageous, his gestures funny and deft. One of his appearances in the *Village Voice* took the form of a small drawing of the Being's head and shoulders, and above them a thought bubble that said, "I really wish I had a firmer grip on reality. Sometimes I think I have better ideas than anyone else around, with the exception of Sol LeWitt and possibly Bob Smithson, whose ideas I really respect. 4-12-68." (The entries were all dated.) Piper had been nineteen when she made this journal entry, and it records precocious involvement with Conceptual art; she would publish Conceptualist works in Vito Acconci's *0 TO 9* magazine (and befriend Acconci as well as LeWitt); other influences at the time ranged from the sharply honed political work of Hans Haacke to the everyday-movement dances of Yvonne Rainer. Piper would become an assistant to Lucy Lippard—she reports having typed the manuscript of Lippard's book on Ad Reinhardt—while showing her own Conceptual art at the Dwan Gallery, Paula Cooper Gallery, and elsewhere, all before graduating from SVA.

Piper's first *Voice* ads, from 1973, appeared a year before Hershman Leeson's in the *San Francisco Progress*; also in 1974, Lynda Benglis took out a full page of advertising space in the magazine *Artforum* to present a photograph of herself naked, her skin greased, her eyes shaded in dark glasses, and a giant, double-headed dildo in her fist. Benglis's ad was, in part, a response, and a challenge, to one run in the same magazine by Robert Morris, for which the prominent Minimalist had himself photographed bare-chested and buffed, wearing aviator sunglasses, a World War II vintage metal helmet, a studded metal

collar and broad metal handcuffs, as well as a necklace of heavy-gauge chain. This round robin of sexual posturing suggests the power and reach of print media as a forum for cultural exchange before online publications and, especially, social media overtook them. Cheesecake, beefcake, militarism and militancy likewise were set into a hall of mirrors, in which VALIE EXPORT's self-representation as a gunslinging terrorist and Patty Hearst's as Tania might also find a place.

But the Mythic Being didn't restrict himself to the back pages of a lefty downtown tabloid. Like VALIE EXPORT, he took to the streets, where, Piper wrote, he "basically invaded various contexts within New York cultural life." As the Mythic Being, Piper recalls, "I went to the movies, I rode on the subway, I walked around Park Avenue at night, I crashed art-world openings, I went to the opera; I did all the sorts of things I normally did except with this masculine guise." One motivation for the project, the artist says, is that it was fun, and a relief. "It was just great to be able to take the subway late at night and not worry about being mugged or raped."[33] For *Cruising White Women* (1975), the Mythic Being took a seat on the steps of Harvard Square, watching women walk by. In *Getting Back*, "the Mythic Being 'cruised' white women on the street, loitered around the Cambridge commons, and pretended to mug a young white man (in fact, the ostensible victim was Piper's accomplice)."[34] It was a dramatic reversal of the invitation to danger that VALIE EXPORT had staged ten years earlier on the streets of Vienna and Munich, and it is haunted by the same climate of menace. Describing herself in the guise of the Mythic Being, Piper writes, "I swagger, stride, lope, lower my eyebrows, raise my shoulders, sit with my legs wide apart on the subway, so as to accommodate my protruding genitalia."[35] Today, he would be charged with manspreading. The challenges he presented to the protocols for a doctoral candidate in philosophy at Harvard are hard to exaggerate. But then any woman who acts out sexually in public, even if disguised as a man, puts herself in harm's way.

These street appearances were limited. It must have been challenging to gear up for them, psychologically. But as with EXPORT's public work and Acconci's, as well as Roberta Breitmore's, the afterlife of the Mythic Being's public interventions has been powerful. Beyond his presence in the *Voice*, he appeared in a number of photo-based drawing series. In one image from 1975 that was made into a poster, Piper's alter ego, smoking a cigarette and looking at us askance through his dark glasses, announces, in a speech bubble, "I embody everything you most hate and fear." By this point in the project, Piper believed that "The content of his obsessions are shared by all of us ... he is a permanently hostile object ... but he is also the personification of our subliminal hatreds and dissatisfactions, which blind and enslave us by being subliminal."[36] Our worst nightmare and a wholly invented figment of our collective imagination, the Mythic Being is an omnipresent threat; he's out in the world, menacing us at every turn; and he lives so deep inside our heads we don't even know he's there.

Characteristically for performances of this period, Piper's Mythic Being moved fluidly between public interventions—live, in the street; print-based, in a newspaper—and studio works meant for art-viewing audiences. In a five-part series of oil-stick-on-photo images, of 1975, the Mythic Being is first seen indistinctly, amid a crowd of pedestrians at a busy urban intersection (it is Harvard Square). Thoughts are written out above his head; he, and these words, advance toward us and grow from frame to frame as the series proceeds. At the same time, the depiction of the crowd around him shifts from photography to increasingly abstracted drawing, and then mostly disappears. Divided among the images, the text reads, "I am the locus of consciousness, surrounded and constrained by animated physical objects, with moist, fleshy, pulsating surfaces"—that is, fellow pedestrians. In the final image, a cigarette hangs from the Mythic Being's mouth, while his sentiments are made visible in very big letters. What he's thinking

is, "Get out of my way, asshole." Along similar lines, a poster series of the same year pictures the Being from below, looming over us. Raking light picks out his glasses, the side of face, his hands, his cigarette. "It Doesn't Matter Who You Are," he muses aloud in the first image. Looking up and away in the second, he continues, "If What You Want to Do to Me." In the final frame, where the depicted illumination is stronger—the Being is out of the shadows now—he concludes, "Is What I Want You to Do for Me." Arms bared and brawny, he regards us, through his dark glasses, with smug self-possession. I'd guess what he means is, you can't fuck with me, because fucking is just what I want.

Piper reports the Mythic Being allowed her sexual attraction to women to flow more freely, unencumbered by competition for men; at the same time, unsurprisingly, it complicated her relations with the opposite sex. As the project ends, she writes, "I feel my masculinity to be very nearly fully articulated in me."[37] But she wonders, "Has this part of the piece taught me about myself, or about the Mythic Being?"[38] Piper worried that the Being would "gradually acquire a personal autobiography ... as particular and localized—and limited—as my own. This was the misfortune of Rrose Sélavy."[39] Along with the reference to Duchamp's alter ego (a reference point for Ana Mendieta, too), Piper shared with Hershman Leeson this concern—fully justified, it would appear—that her shape-shifting would muddy distinctions between invented and inherent personalities. The threat the Mythic Being posed to Piper's identity was real.

But, more than was true of Roberta Breitmore, Piper's project was conceived as a public confrontation. Aiming to loosen the boundaries around her experienced self, Piper created a character designed to challenge almost everyone, white and black, male and female; to keep sympathy at bay. With three hundred and sixty degrees of provocation, she hurled a perfect storm of anger and fear—and, in the same measure, balked every viewer's first response. But the Mythic Being

is not just an articulation of implacable threat. Along with suggesting that self-consciousness is the highest philosophical and aesthetic purpose, Piper inhabits, in this project, a state of hyper-vigilant acuity that can also be a consequence of surviving assault: the condition of living as if in perpetual danger.

Piper's Mythic Being has been compared, like Hershman Leeson's Roberta, to Cindy Sherman's many alternate selves, and also, by art historian Robert Storr, to Jorge Luis Borges's parable of the fictional Pierre Menard, who took on Cervantes's identity to "write" *Don Quixote*; in making these connections, Storr contends that Piper anticipated postmodernism and its challenge to the possibility of unbiased truths.[40] The slipperiness of identity and of authorship is unquestionably at issue in the Mythic Being project. But in an interview of 1990, Piper said, "I feel sorry for those artists who got stuck with poststructuralist discourse ... because I really think poststructuralism is a plot! It's the perfect ideology to promote if you want to co-opt women and people of color and deny them access to the potent tools of rationality and objectivity." That is to say, the label—postmodernism—to which Storr referred is a perfect instrument, as Piper saw it, for thwarting political activism, by making it nearly impossible "to say that racism is objectively wrong."[41]

But the Mythic Being project was not directed only at a racist society; it also served as one element of a career-long reflection on social advantages and their absence. Compiling material for a 1996 volume of her writing, Piper said, gave her "insight into my deep-seated, optimistic sense of entitlement—the sense of entitlement of an upper-middle-class heterosexual WASP male." She went on to explain, "To have that sense on this particular planet is to have no bounded sense of self at all;" it is "to presume that what one believes and perceives to be the case just simply is the case." In other words, it is to presume unchallenged privilege. "When a young colored woman talks in this voice," Piper concludes, "she is apt to get put

in her place."[42] Speaking in the voice not of a wealthy male WASP but of a streetwise, aggressive black man was a threat aimed at the heart of her sense of identity, as a philosopher and a black woman, an identity to which she—like most of us, with respect to our own identities—has an uneasy relationship at best. While the Mythic Being project addressed sexual violence obliquely, it offered Piper a voice for powerful rage, an urge to threaten that was not distant from a sexual appetite—a voice and an urge that she found to be male.

The Being's social profile—boastful, flashy; in a later decade, he'd be sporting bling—could be seen as a cartoon version of the character Michele Wallace analyzed in her *Black Macho and the Myth of the Superwoman*, which appeared only a few years after the Mythic Being project. In addition to arguing that the Black Power movement's message for black women was, "manhood was essential to revolution—unquestioned, unchallenged, unfettered manhood.... She was just going to have to get out of the way,"[43] Wallace proposed that the two figures of her book's title were reciprocally defined. Her "superwoman," so called because of her growing success in the job market, relative to black men, helped give rise to the resentful figure of "Black Macho"[44]—who could, in turn, be linked to Piper's Mythic Being. Looking back, Wallace judged her book, which generated considerable controversy, "one of those manuscripts that was never supposed to see print, which, indeed, wouldn't see print in today's more competitive and specialized marketplace."[45] At the time, though, *Black Macho* was championed by the likes of Gloria Steinem and Alice Walker and made Wallace a celebrity, putting her on network television, in major national newspapers, and on the cover of *Ms.* magazine.[46]

In the confoundingly tangled gender politics played out by Piper's Mythic Being, the artist is absorbed into a male protagonist for whom—and through whom—she feels a welter of emotions, while provoking an equally wide range of reactions in viewers, from

discomfort, anxiety, and anger to rueful recognition. This spectrum of feelings reflects the conflicts Wallace discussed so frankly. Wallace cites an incident Brownmiller related in *Against Our Will*: at the Schomburg Center in Harlem, where she'd gone to do research, Brownmiller was challenged by a black male librarian. He advised her to start with historic injustice to black men. She replied that she was interested in injustice to women. "'To black people, rape has meant the lynching of the black man,'" the librarian retorted "with his voice rising." Wallace added, "What could be more eloquent?"[47] Taking a position that, as noted earlier, differed markedly from Angela Davis's, Wallace also quotes LeRoi Jones, who had said, "the average ofay [white person] thinks of the black man as potentially raping every white lady in sight. Which is true, in the sense that the black man should want to rob the white man of everything he has."[48] Similarly, Wallace writes, "Eldridge Cleaver, Jones's ideological other half, was an even more effective voice for Black Macho. . . . His raping was not a crime against women but a political act." She continued, "Cleaver was macho" in the years when "macho was highly exalted and taken seriously by many people of all sorts of political and intellectual persuasions."[49] In short, "Black Macho allowed for only the most primitive notion of women—women as possessions, women as the spoils of war."[50]

Sexual attraction, resentment, betrayal, and interracial antagonism are only some of the points plotted on the map of this territory. To live out a myth, as Wallace believed black women were expected to do, and as black men were doing as well, is to deny reality—to have your erotic self separated from your emotional one, to be alienated from your body, its desires, its skin color. It is also to deny the formidable physical and emotional toll of living in fear—a toll that had been explored as well in earlier work by VALIE EXPORT, Yoko Ono, and Vito Acconci. But the dangers operating within "the ghetto," to use a term of the day that speaks clearly of the isolation sensed by

those inside it, went beyond shifting power relations between the races or the sexes. It also had to do with poverty and class. Wallace says she got out of the ghetto—hers was Harlem—when she realized "that its violence was not an indication of liberation," that "being poor and black means nothing so much as it means that one has no control over when or for what reason one may live or die, and this is not in any way an enriching experience."[51]

Piper, born in New York in 1948, grew up with considerable cultural opportunities. She remembers hearing Rimsky-Korsakov's *Scheherazade* during the year she spent in nursery school, and entered the New Lincoln School, a progressive, selective, racially mixed private school in Manhattan, in first grade, staying through high school. There were ballet and piano lessons, and Piper took art classes at the Museum of Modern Art before she turned ten. Her early childhood was spent in Harlem and the Upper West Side of Manhattan, then mainly middle class. Born in 1952, Wallace also attended New Lincoln High School and early on had similar advantages. She recalls that her "fellow students ranged from the son of Susan Sontag (David Rieff) and the daughter of Harry Belafonte (Shari Belafonte) to the sons and daughters of the likes of Robert Rauschenberg, Maureen O'Sullivan, and Zero Mostel." Piper is among "other luminaries-to-be" that Wallace noted in a later introduction to her book, along with Thelma Golden (now director of the Studio Museum in Harlem).[52] Wallace, a daughter of the artist Faith Ringgold, who had been a teacher and a college lecturer, says, "my sister and I . . . attended private schools from the very first, were taken to camp or Provincetown or Europe in the summers."[53] Piper enjoyed similar privileges. But Piper also writes frankly, in her photo-text work *Political Self-Portrait #3 (Class)*, 1980, of the moment when she discovered she was poor—or at least, when she found that friends had greater opportunities and more material wealth. (In this piece, a photograph of the artist as a child is overlaid with text that begins, "For a long time I didn't realize we

were poor at all. We lived in that part of Harlem called Sugar Hill," and goes on to a precise accounting of the neighborhood's decline, and of her schoolmates' wealth.)

While still in high school, in the mid-sixties, Piper experimented with drugs and left home; this was when she worked as a disco dancer, at the Ginza and Entre Nous nightclubs. She reports being picked up by police and sent to juvenile court, pleading guilty to being a wayward minor, and spending a brief stint at Bellevue.[54] Her experience was again paralleled by that of Wallace, who, the summer after graduating high school, joined a commune in Mexico City, was ordered home by her mother and then consented to be placed in a Catholic home for wayward girls, where she spent five weeks. Wallace writes, "Back in 1969 record numbers of white girls were running away from home and it made big news. But many more black girls were running away.... As with most crimes, you are usually incarcerated for it only if you are poor."[55] She is clear about the greater dangers faced by the other girls placed in this facility, many of whom had been subject to domestic abuse; she writes, as well, that they "lived in a dangerous environment, the black community, which did not protect its girl children." And she adds, "Many of the girls at the home had already been brutalized. They had been taught their very efforts to survive meant that they were bad. Nice girls simply did not survive such things."[56]

To grow up with cultural and material advantages in a community growing steadily more fractured and poor—"My grandmother insists that Harlem was in no sense a dangerous place to live in before the fifties, and it has never been nearly as dangerous as it has become in the seventies,"[57] Wallace writes—is to have alienation as a birthright. It seems both she and Piper needed to take a sharp turn from the advantages of their upbringing. It can be hard to know what class you're in—what social, cultural, and educational position you occupy—until you step outside it. Thus, with respect to a very

different community, that of the art world when she entered it in the 1970s, Piper writes, "I didn't realize I was being marginalized."[58]

Poet and essayist Audre Lorde was of an older generation than Piper or Wallace (Lorde was born in 1934 and died in 1992), but she shared some of their experiences and wrote eloquently of many of the conditions they described. Like them, Lorde grew up with considerable support and educational choices, and in her writing she confronted issues of class and of skin color. (Piper, who is light enough to pass for white, has often taken up that issue in her work.) Lorde, like Wallace, made a life-altering trip to Mexico when she was young. A lesbian (and a mother of two), Lorde explored sexual desire with rare openness and grace, writing, "When we look away from the importance of the erotic in the development and sustenance of our power, or when we look away from ourselves as we satisfy our erotic needs in concert with others, we use each other as objects of satisfaction rather than share our joy in the satisfying."[59] And she too was frank about relations among gender, race, and violence as she saw them, writing that, "Exacerbated by racism and the pressures of powerlessness, violence against Black women and children often becomes a standard within our communities, one by which manliness can be measured, but these woman-hating acts are rarely discussed."[60] Even more heatedly, in an open letter to a white feminist, in 1978, Lorde said, "surely you know that for nonwhite women in this country, [there are] three times as many chances of being raped, murdered or assaulted as exist for white women."[61]

These realities run deep in Piper's Mythic Being. He exposed fault lines within race that reflected divisions of class and politics—as Wallace drew them, for the Harlem of the 1970s, they included those between middle class and poor, integrationist and separatist—and also, more clearly, divisions between men and women. The Mythic Being also casts a spotlight on the race-based fractures within the women's movement driven by differing responses to sexual aggression

and violence. It would be wrong to exaggerate these divides. Wallace credits white feminists of her mother's circle whom she met when still a teenager, including writers Robin Morgan and Kathy Sarachild and the artist Pat Mainardi (along with white male writers and artists of note). Piper acknowledges the formative importance of friendships with LeWitt and Acconci, among many others, and insists throughout her work that race is socially fabricated. So too, to a large degree, is character.

The same argument is made by Lynn Hershman Leeson, and also by Yoko Ono and Ana Mendieta—and, for that matter, by Acconci. This may be one of art's deepest wellsprings: a sense of contested identity, of not belonging securely. While stepping outside the culture into which you were born grants clarity, it does not necessarily—or even probably—offer greater security. Representing situations that touch on the experience of sexual violation, these various performers of the self draw on that understanding. Assuming a role is not just trying it on like clothing; it is being displaced by it—shoved aside by an entity not altogether under the impersonator's control. Someone else moves into these artists' bodies and provisionally, but forcefully, takes over. The same can be said, perhaps, of all overwhelming experiences, not excluding rape.

GRAPHIC CONTENT

What does rape look like? How can it be differentiated *visually* from an act of consensual sex (especially if, for instance, both parties consent to danger, (as in any variety of sadomasochistic eroticism)? These questions pertain with special force to graphic imagery. As feminist scholar Sharon Marcus observes, the ambiguity of rape imagery can be seen to parallel the difficulties of adjudicating rape charges, so many of which require us to determine intentions—states of mind— that are invisible.[1] The question is whether rape can be pictured—in paintings, say, or photographs—without being a form of involuntary and unwanted exposure, hence of harm. Moreover some women have long wondered whether portraying victimization, as in early performances, was in feminism's best interest. But if the testimony delivered live sometimes came under criticism, in the early '70s, nothing caused greater rancor and divisiveness than graphic imagery of sexual violation, and specifically anything that could be deemed pornography, which is itself notoriously difficult to define. By any measure it constitutes a social force too wide in scope and power for any woman to escape its impact. As with physical violence, we all reckon with its presence. And as with all aspects of sexual aggression, the burden of that reckoning falls most heavily on women.

Among the few feminist artists who represented sexual violence pictorially in the 1970s, Nancy Spero stands alone for the scalding force of her text-and-image-based work on paper. The brutalization that is described in its texts is accompanied by depictions of female

subjects that are fragile, fragmented, cipher-like, and nonetheless titanically powerful. Choosing pictures over performance, Spero aimed to rewrite the script for visualizations of rape. And while no one would call her a pornographer, she engaged obscenity, in its range and depth, with unparalleled ferocity.

Recurring in her late work is a particularly horrific World War II-era photograph of a woman naked except for a headband, shoes, and the stockings that hang around her ankles. Her body is bound with rope like a rump roast; death by hanging would soon follow. The photo's caption explains it was "found on a member of the Gestapo." That is, a man who was surely at least an accessory to the public shaming this snapshot documents carried it with him for some time after her execution, perhaps as a sexual stimulant. A photo arguably kept to savor a woman's degradation and death—to keep in the palm of one's hand—it might, too, have served as a goad to further atrocity. "If you look at it briefly," Spero said, "it looks like porn."[2] In her hands, it appears stamped and collaged in a variety of contexts, remade into a grim trademark for the most barbaric kind of pornography. When asked later in her life if this "victimage" work was a series she was still working on, Spero (who died in 2009) replied, "Yes. I've left it open."[3]

By the time she began using this image, in the 1980s, the subject of women's subjugation was well established in her work. Born in Cleveland in 1926, Spero lived in Paris from 1959 to 1964, where she produced a series of *Black Paintings* that were both bleak and erotic: the darkness of sex was an early theme. Back in the US, she turned from painting on canvas to working on paper with the explicit intention of developing an alternative pictorial form that would be market-averse, antimonumental, and yet highly ambitious; it would speak first of political misfeasance in general, and then specifically of misogyny. She considered the decision to relinquish traditional painting "a personal rebellion against the art world and against doing any important, commercially viable work."[4] Deeply involved in opposing

the war in Vietnam, Spero produced an extended group of gouache drawings and paintings on paper called the *War Series* (1966–70), its antiheroic, often doodle-size images representing warfare as messy, chaotic, and above all embodied. Bombs are dropped like feces, delivered like babies, and copiously ejaculated amid gouts of watery blood and splatters of bullets. The airborne vessels from which the ordnance issues are, as in the work to follow, fragmentary and often insect-like. They enact every variety of transgression, sexual and political, and—with respect to the art world—intramural, and they ensured that Spero's reputation long remained, just as she anticipated, largely underground.

By the early 1970s she had made the commitment "to represent 'man' only though images of women,"[5] a pledge she honored for the remaining thirty-five years of her career. Having been a member of the Art Workers' Coalition (AWC), which challenged unjust museum practices and agitated against the Vietnam War, she became increasingly involved in feminist activism, helping to form Women Artists in Revolution (WAR) in 1969, a radical group of women artists who split off from the AWC, and then the Ad Hoc Committee of Women Artists. In 1972, she was a founding member of A.I.R., in New York, the first cooperative gallery in the country to show only the work of women artists, which opened that September with a group show (and remains a lively institution). In 1975, Spero was present at the first meeting (hosted by Joyce Kozloff) of a group that became the Heresies Collective.

With *Torture of Women* (1974–76) and *Notes in Time* (1976–79), Spero took on the representation of violence against women with rare commitment and unequaled passion. And, exceptionally, she shifted attention from the experiences of women in wealthy democracies to those suffering under military dictatorships. These graphic friezes, the first 125 feet wide and the second nearly a hundred feet wider, are addressed to all manner of female subjugation—and, in some passages,

triumph. Hand-drawn, stamped, printed (using handmade wooden type and also zinc plates), typed (mostly on a Bulletin typewriter, which has a sternly official-looking sans serif font), and collaged, the text and imagery in these works is almost entirely borrowed, from sources spanning millennia. But Spero's language is unmistakably her own. Often, written and pictorial material intermingles; even when wordless, the work is read as much as seen. Its visual elements are generally small and dispersed, rebus-like, across unfurled scrolls of papers glued end to end. In some places blocks of text float on empty ground; elsewhere, repeated typewritten characters frame the imagery.

Many figures recur, among them a sun goddess of Spero's invention that draws from the Egyptian goddess Nut and the she-wolf who suckled Romulus and Remus. Her body is bent into a squared arch supported by long, thin arms and legs, and spanned by a torso from which four small breasts hang; she has an oddly protuberant skull and a small mouth opened wide, as if for shouting, or howling. Other recurring figures include Artemis—shown with her hand on the head of a doe, from a drawing Spero made of a statue in the Louvre[6]—and various chimerical figures, among them female-headed snakes and women who are also insects or birds. Featured often is Sheela na Gig, a squat, pugnacious ancient Celtic figure, big-headed and earless; sitting on her haunches, she uses her hands to spread her giant vulva, with which it seems she means to devour us. Otherwise generally lean, even skeletal, and often a little blurred or slightly mis-printed—unevenly inked, deliberately misregistered—these various personages are highly active: lithe, springy, unmoored in space, they dance irrepressibly across the long scrolls and also from one work to the next.

The textual material, on the other hand, is heavy and dark as pitch. *Torture in Chile* (1974), a prologue of sorts to *Torture of Women*, is a two-panel work of relatively modest dimensions. In cut-and-pasted hand-painted letters, the explosive, all-caps text reads: TORTURE IN

CHILE WOMEN REACHING THE BUEN PASTOR JAIL HAVE BEEN
SUBJECTED TO THE MOST BRUTAL TORTURES LIVE MICE AND
INSECTS INTRODUCED INTO VAGINAS HAIR PULLED OUT BY THE
HANDFULS NIPPLES BLOWN OFF OR BURNT GENITALS DESTROYED
BY ELECTRICITY. Taken from a 1974 article in *USLA Reporter*, a pub-
lication of the US Committee for Justice to Latin American Political
Prisoners,[7] this blared text is an electrifying warning of the infor-
mation to follow. *Torture of Women*, the sequel, relies heavily on an
Amnesty International "Report on Torture" of 1975, which contains
case histories of victims of physical and psychological brutalization by
agents of several dictatorships (including those in Chile, Argentina,
and Uruguay); many of the women described in the report were
sexually violated. We read that Marta Neira, for instance, "a 29-yr-
old model, was arrested by DINA, Chile's brutal secret police—her
nose broken, body covered in welts, she'd been subjected to electric
shocks and to sexual abuse." There are also accounts from the *New
York Times* and the *Nation* of victims in Vietnam and Iran, as well as
excerpts from the writings of Antonin Artaud, which Spero had used
for an extensive body of previous work. *Torture of Women* announces
itself in big canary-yellow letters as an "Explicit Explanation," and
indeed it is that.

It also calls attention to atrocities woven into foundational reli-
gious narratives from around the world, as in a Babylonian creation
myth featuring Marduk, a sun god, and Tiamat, mother of all things.
In big, formal type, we read, "marduk caught tiamat in his net and
drove the winds which he had with him into her body and whilst her
belly was thus distended he thrust his spear into her and stabbed her
to the heart and cut through her bowel and crushed her skull with
his club. on her body he took his stand and with his knife he split
it like a flat fish into halves and of one of these he made a covering
for the heavens." By way of terminal punctuation, Spero has drawn
a small image in which human testicles become leering eyes atop a

dangling penis that opens, at its head, to a maniacal, toothy grin. In a 1983 statement, she explained that this ancient Sumerian myth, which dates from 5000 BCE, "tells what must have already been the timeless fear, hatred of and cruelty directed towards women," a cruelty "seemingly absolved by the idealization of Tiamat as the sky."[8] That "seemingly" shadows the small figures which, stamped and outlined, drift and soar above the text, sketchy, almost incidental.

When Spero began *Notes in Time*, which followed *Torture of Women* (initially, it was meant to be part of it), it was as an effort to expand the subject's emotional range and reach toward jubilation. "The history of women I envision is neither linear nor sequential," she told art historian Jo Anna Isaak, citing the rhythmic repetitions in Gertrude Stein's writing and Stein's formulation of a "continuous present."[9] Spero also relished the exclamatory writing of the influential French feminist Hélène Cixous, and in particular her 1976 essay "The Laugh of the Medusa." ("Write your self. Your body must be heard," Cixous proclaimed. "Let the priests tremble, we're going to show them our sexts!" And, of Medusa, "she's not deadly. She's beautiful and she's laughing."[10]) Among the celebrants that Spero depicted is the spry Greek baubon dancer, who wields a giant double-headed dildo. (This repeated figure appeared at roughly the same time that Lynda Benglis pictured herself holding a similar sex toy for an *Artforum* ad; another related work is the outsize phallus, which doubles as a small-breasted, long-necked female torso, that Louise Bourgeois created in 1968 and named *Fillette*.) Also in *Notes in Time* are the voices of such powerful icons of resistance as Sojourner Truth, along with a female martyr of the struggle against apartheid in South Africa and a feminized fighter for the Irish Republican Army. "I wanted to show difference amongst women, not similarity," Spero said.[11]

But for all her efforts to express a range of experience, and despite the many athletic woman leaping across yards of paper, and also across historical epochs, Spero found her research tended to lead

in a single direction: "it turned out to be about all the misogynous, really denigrating things philosophers, mostly men, had said about women's situation through the ages up to the present,"[12] she said. Friedrich Nietzsche and Jacques Derrida are among the several luminaries dimmed by verbatim evidence of their sexism. Spero couldn't help focusing on ferocious abuse at the expense of joyful triumph. (And her testimony's relevance is grimly enduring. A central panel of *Notes in Time* refers to tortures that include an explicit description of waterboarding.) Among the harrowing bodily assaults, sexual violence is often represented as the most painful. One passage, in Bulletin type, reads, "The physical torture—the interrogation, during which [Inês] Romeu was naked, the blows to the face, to the stomach, the electric shocks over her entire body, even in her vagina—hurt physically, but she did not feel humiliated … until she was raped. Then she knew the feeling of being an object in the hands of a disgusting executioner who was taking advantage of a female body, who used Ines in any way he wished" (ellipses in artwork).[13] Said Spero, "I document how men (mostly) regard these crimes of rape and violation, how the victim herself is considered guilty, not the perpetrator. Unhappily in many cases this is considered normal male behavior."[14]

As several commentators note with respect to Spero's work, violation is always at issue for victims of torture, even when forcible sex isn't part of the proceedings. But more often than not, especially with women, it is. Writes art historian Diana Nemiroff, "The methods used to torture women are largely the same as those used on men, but they can have different meanings and consequences…. For both men and women, the face and genitals—the site of personal identity and the link with future generations—are special targets, but for women rape is always central." As human rights lawyer and activist Lisa Kois puts it, "The female body in the torture chamber epitomizes the female body as it exists anywhere outside that room.

It is sexualized, objectified, commodified."[15] Moreover, the women who survive are often stigmatized by the rapes—and, if they become pregnant, further castigated for producing illegitimate offspring. Of course, the meaning of sexual assault shifts from one woman, and community, to the next, and from one act or set of conditions to another. It cannot be said that every woman made to undergo excruciating and extended pain will feel that rape is the worst of it. But it can be argued that rape is the underlying principle: the violation, the seizure of and penetration of a body to achieve the sense of its annihilation.

To the extent that this is true—that rape is a premise of torture—so too, is the silence torture incurs essential to its purpose. As Elaine Scarry wrote, extreme pain undoes speech, takes away words and replaces them with preverbal, animal cries. Conversely, finding words is a way of undoing pain, which though absolute for the sufferer is, Scarry believes, essentially inaccessible to others. Moreover, in order to do his work, the torturer must be blind to the pain inflicted: "Only this final act of self-blinding permits the shift back to the first step, the inflicting of still more pain, for to allow the reality of the other's suffering to enter his own consciousness would immediately compel him to stop the torture.... It is not merely that his power makes him blind, nor that his power is accompanied by blindness, nor even that his power requires blindness; it is, instead, quite simply that his blindness, his willed amorality, *is* his power."[16]

In undertaking not just to make the unsayable articulate but also to represent the invisible, Spero chose, perversely and effectively, to use images and texts that strain to come into focus or cohesion, either because they are literally obscured (blurry, difficult to read) or because they are deeply disturbing. She also effectively mobilizes the viewer's resistance to looking. The difficulties this body of work presents to viewers are manifold: the text is alternately bogglingly dense or jumpy and broken up, and the type varies widely

in font and size, while the imagery is sometimes fragmentary or faint. Its skittering, drifting movements deflect attention. Historical references tease; sources are tricky to identify. In a monograph on Spero, Christopher Lyon finds among sources for *Torture of Women* and *Notes in Time* the Bayeux Tapestry, an embroidery, probably of the eleventh century, that is essentially a pictorial history of events culminating in bloody battle—and, at 225 feet long, comparable to Spero's scrolls in size as well as scope. Nemiroff notes that the phrase "Explicit Explanation," which introduces Spero's *Torture of Women*, refers to the Commentary on the Apocalypse compiled in the eighth century by the Spanish monk Beatus of Liébana; it depicts the end of the world and the Last Judgment in images and text (for Beatus, "Explicit" meant "Here finishes").[17]

But Spero hardly restricted herself to such hoary source material; her indiscriminate rummaging in the archives of world art was a point of pride: no era or culture has lacked images of women in extremis. Referring to a work called *The Monsters*, she wrote, "I got that image of the woman with her hands near her crotch from a pornographic magazine, and these monstrous headless torsos are from some book on ancient civilizations."[18] Of course, beyond its visual and textual challenges, and the puzzles of its source material, this body of work is hard to look at because of its unsparing descriptions of savage and prolonged bodily harm, particularly in *Torture of Women* but also in parts of *Notes in Time*. Yet, a final paradox, the size of these works makes it hard to look away. There is nowhere to turn; and we are under an onerous moral obligation: to read it all, to see everything.

As old as history, torture is forbidden by international law and convention; while it was once a kind of political theater and conducted openly, it is now inflicted mostly in secret. But if not meant to be seen, it is surely intended to loom in its targets'—and in everyone else's— imagination. "The tortured have become the disappeared," Nemiroff writes, adding, "How to make the obscenity of torture visible without

becoming obscene is the paradox Spero must address."[19] Concerning this difficulty, Sylvère Lotringer offers, "Nancy Spero always makes sure that her victims are never presented as objects of pity or fear"; they are "impervious to the facile display of feelings."[20] Instead of easy emotionalism, we are given facts, an "explicit explanation." Reviewing *Torture of Women*, Lucy Lippard called Spero, memorably, a "secretary to the apocalypse."[21]

Surely, though, she is more priestess than curate. And while unmasking the hidden and giving voice to those who have been silenced, she forces their conditions—of muteness and shame—inside her viewers' heads. Taunting us to look away, then offering no choice but to strain to see and read, at length and with close attention, she leads us toward an experience of coercion, even violation—a minute titration of the subjects' experience. Perhaps we take up the challenge of engaging with Spero's work to test ourselves. (What physical offenses would we survive? When would we break, whom betray?) Optimally, we may be urged to political action; surely also to feel grateful for being safe. At the very least, *Torture of Women*, *Notes in Time*, and related works make us consider the enormous expressive power of hidden crimes, of their pervasiveness in the collective imagination. And if many forms of torture are devised to leave minimal traces (beating on parts of the body that cause no scars, or that aren't generally seen), rape is the ultimate disappearing act.

However frankly she dealt with the most obscene of acts, it is hard to imagine viewers finding Spero's work arousing: it could be seen as pornography's annihilating dark twin, a testimony to rape so vicious that viewers are inoculated, at least temporarily, against erotica of any kind. Perhaps not coincidentally, at the time that she began working on *Torture of Women*, the availabity of pornography was exploding, to the rising alarm of many feminist artists. In undertaking actions to resist it, they introduced a wedge issue that would widen into a damaging split in second-wave feminism.

As with activist work aimed at combatting rape, artists of the West Coast led the campaign against pornography. *Three Weeks in May* and *In Mourning and in Rage* had signaled that popular culture would be held to account for its degrading representations of women. And in August 1977, Labowitz, working with Lacy, presented *Record Companies Drag Their Feet* on Sunset Boulevard in Los Angeles. The event was produced with Women Against Violence Against Women (WAVAW)—the formation of which had been spearheaded by a protest organized in 1976 by Julia London against a pseudosnuff film—and also with the California chapter of the National Organization of Women; both boycotted three record companies in 1976 to protest rock album covers that "glorified violence against women." Like preceding activist projects, *Record Companies Drag Their Feet* was designed with the media in mind; indeed when Labowitz solicited television coverage, she provided cameramen with shot sheets along with a press statement. As site and pretext for the event, she chose a billboard advertising the album *Love Gun* by the hard-rock band Kiss. The image on both album cover and billboard was of leather-clad band members, chests thrust out and legs wide, standing above a writhing pit of lustful, seminaked women. (Notable too is the Kiss logo, in which the final letters of the band's name are rendered as the double lightning strike of the Nazi SS—the party's notoriously vicious armed wing.) For the event, Labowitz (whose mother was a Holocaust survivor) set up a "counter billboard" underneath, with rape statistics. A number of women stated their case against the image to three performers dressed as roosters, representing major record company executives. The roosters ignored the women's complaints; the women then turned their placards around to display other offending album covers, which had the words "This is a crime against women" written across them in red. The event concluded with a press conference, which was duly covered by major local networks. In these events, the symbolic complexities of such early

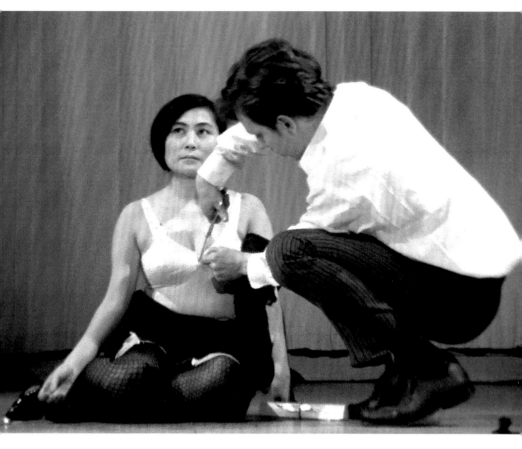

CUT PIECE 1964
Performed by Yoko Ono, March 21, 1965, at Carnegie Recital Hall, NYC
Yoko Ono/Courtesy Galerie Lelong & Co., New York. Photo by Minoru Niizuma

RAPE London, 1969
Yoko Ono, Directed in collaboration with John Lennon
16mm film, color, sound, 77 minutes
Yoko Ono/Courtesy Galerie Lelong & Co., New York

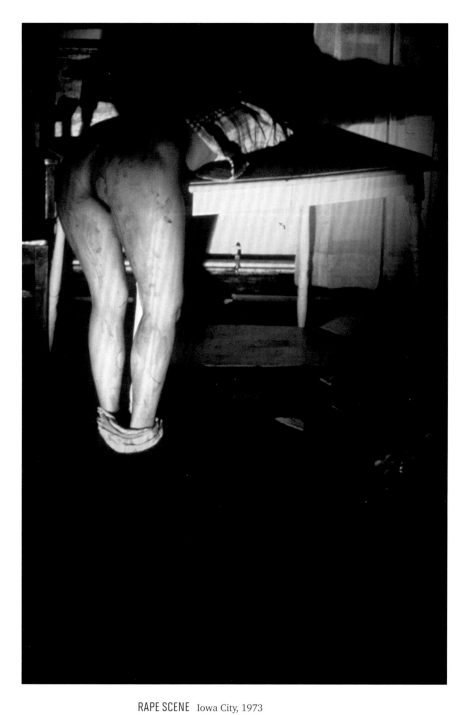

RAPE SCENE Iowa City, 1973
Ana Mendieta
Suite of five color photographs
16 × 20 in, 40.6 × 50.8 cm

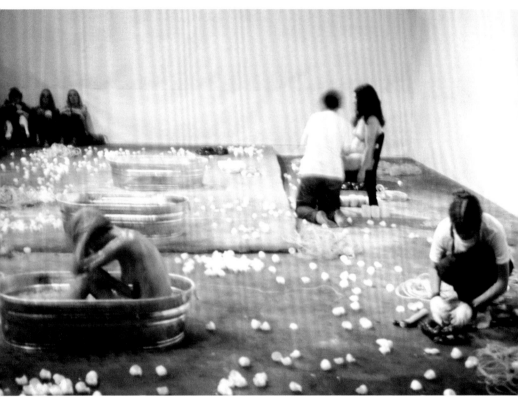

ABLUTIONS Venice, California, 1972
Performance by Judy Chicago, Suzanne Lacy, Sandra Orgel, and Aviva Rahmani

MATTRESSES Iowa City, 1973
Ana Mendieta
35mm slides
© The Estate of Ana Mendieta Collection, LLC, courtesy Galerie Lelong & Co.

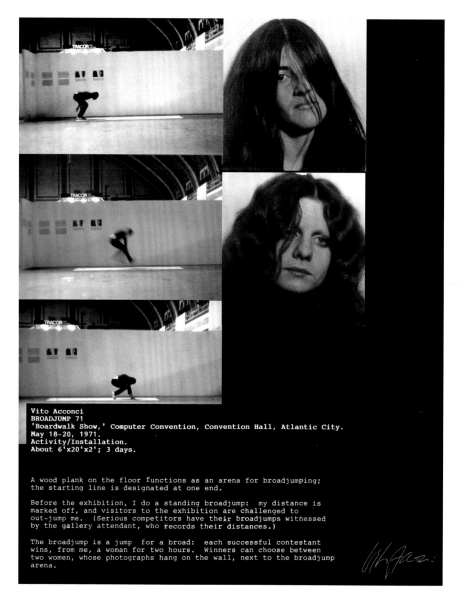

Vito Acconci
BROADJUMP 71
'Boardwalk Show,' Computer Convention, Convention Hall, Atlantic City.
May 18-20, 1971.
Activity/Installation.
About 6'x20'x2'; 3 days.

A wood plank on the floor functions as an arena for broadjumping;
the starting line is designated at one end.

Before the exhibition, I do a standing broadjump: my distance is
marked off, and visitors to the exhibition are challenged to
out-jump me. (Serious competitors have their broadjumps witnessed
by the gallery attendant, who records their distances.)

The broadjump is a jump for a broad: each successful contestant
wins, from me, a woman for two hours. Winners can choose between
two women, whose photographs hang on the wall, next to the broadjump
arena.

BROAD JUMP Atlantic City, 1971

Vito Acconci

Image courtesy Maria Acconci

THE MYTHIC BEING: I EMBODY EVERYTHING YOU MOST HATE AND FEAR New York City, 1975
Adrian Piper
Paid advertisement in the gallery section of the *Village Voice*.
Gelatin silver print photograph altered with oil crayon. 8 × 10 in (20.3 × 25.4 cm)

Private collection. © Adrian Piper Research Archive Foundation, Berlin

TORTURE OF WOMEN III 1976
Nancy Spero
Cut-and-pasted typed text, painted paper, gouache, and handprinting on paper
14 panels, 20 in × 125 ft (51 × 3,810 cm) overall

© Nancy Spero and Leon Golub Foundation for the Arts /Licensed by VAGA at Artists Rights Society (ARS), NY
Photo: Courtesy Galerie Lelong & Co.

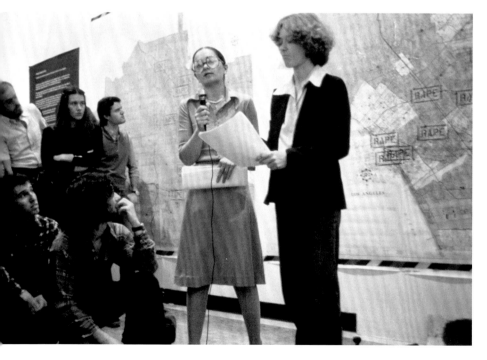

THREE WEEKS IN MAY First performed in Los Angeles, 1977
Pictured: Installation/Performance at Bologna Art Fair, Italy, 1977
Suzanne Lacy

LUCRETIA 1666
Rembrandt van Rijn

L'INTÉRIEUR (INTERIOR) or THE RAPE 1868–69
Edgar Degas

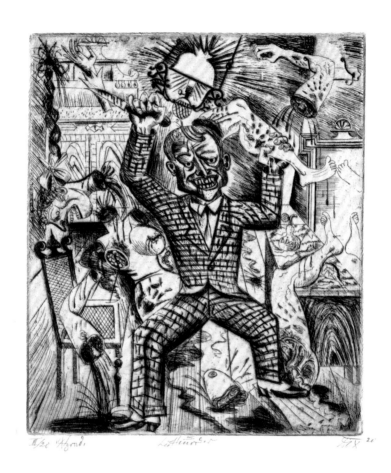

SEXUAL MURDERER (DER LUSTMÖRDER) 1920
Otto Dix
Etching

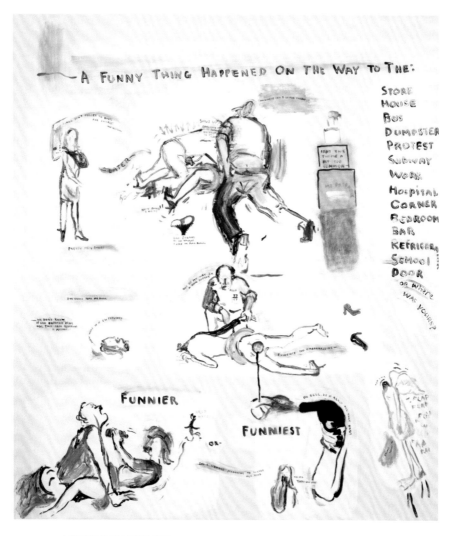

A FUNNY THING HAPPENED 1992
Sue Williams

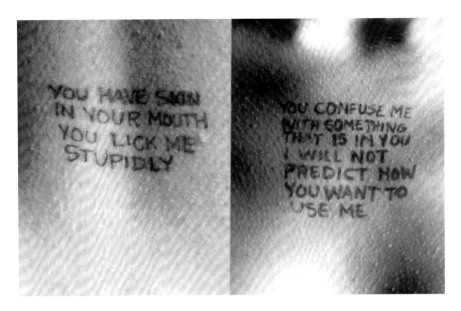

LUSTMORD 1993
Jenny Holzer
Ink on Skin. Originally published *Süddeutsche Zeitung*, Germany.

GONE: AN HISTORICAL ROMANCE OF A CIVIL WAR AS IT OCCURRED B'TWEEN
THE DUSKY THIGHS OF ONE YOUNG NEGRESS AND HER HEART 1994
Kara Walker
Cut paper on wall. Approximately 156 × 600 in (396.2 × 1,524 cm)

FROM THE DAY AFTER RAPE SERIES: GATHERING WATER 2009
Joyce J. Scott
Glass beads, thread, glass jar, and wooden pipes

FROM THE DAY AFTER RAPE SERIES:
THE DEVIL MADE ME DO IT! 2008
Joyce J. Scott
Glass, beads, thread, fabric

ME AS MUSE 2016

Mickalene Thomas

Multimedia video installation. Dimensions variable

12 video monitors: 19.1 × 24.1 × 18.5 in, 48.5 × 61.2 × 47 cm each

Total running time: 4:02, Edition 1 of 3, with 2 APs

AND NOTHING HAPPENED 2016
Naima Ramos-Chapman
Film

performances as *Ablutions* were decisively rejected in favor of legible, nonnegotiable messaging.

Labowitz and other WAVAW members, like many other feminists, argued that the violence against women rife in pornographic imagery contributed to the growing incidence of abuses in real life. They noted, too, the coercion—and worse—often involved in producing pornography; some women contended that pornography constituted a form of violence in itself. Far outpacing Hollywood in income, the fast-growing porn industry became a frequent target, along with increasingly aggressive and graphic sexual imagery in commercial movies, television, and advertising. Moreover, some activist women, including Lacy, felt that artists themselves were occasionally guilty of representing rape irresponsibly. She writes that in a performance of the late 1970s, a male artist, dressed as a futurist action figure, enacted a symbolic rape with an oversize machine gun; afterward, female actors who had been victimized earlier in the performance came back to form a "bridge of human understanding." This work "failed miserably," Lacy claimed, "because... like pornography and, increasingly, media, its portrayal of violence was its real reason for being"; in her view, presenting such explicit acts of violence was simply irredeemable. Women artists were not exempt from such criticism. One who had herself been raped revisited the experience during an opening at the Artemesia Gallery in Chicago; she arranged to have an actor stalk her and throw her to the ground, "and, in front of horrified spectators, he (apparently) raped her." Some guests interceded; there was understandable anger when it became clear they had been manipulated. Writes Lacy, of the cultural climate at the time, "Violence against women was exploited and sensationalized everywhere."[22]

Active though Lacy and Labowitz were in the crusade against porn, it was hardly a regional phenomenon. Prominent New York-based feminist Robin Morgan had proclaimed, in 1974, "Pornography is sexist propaganda, no more and no less.... Pornography is the

theory, and rape the practice."[23] Morgan argued that the widespread incidence of what she sarcastically called a "normal, corn-fed kind of rape"—that is, rape by husbands and other committed partners, or by acquaintances, friends, and family—"is less shocking if it can be realized and admitted that the act of rape is merely the expression of the standard, 'healthy,' even encouraged male fantasy in patriarchal culture—that of aggressive sex. And the articulation of that fantasy into a billion-dollar industry is pornography."[24]

Morgan conceded that civil libertarians would be dismayed by a campaign that could be construed as censorship; her response was to spare producers and instead aim at purveyors, and also to shame consumers—for example, by photographing them entering porn shops. She was particularly angered by "so-called female-oriented pornography, as if our sexuality were as imitative of patriarchal man's as *Playgirl* is of *Playboy*"; Morgan suggested—a little dubiously—that more women were turned on by *Wuthering Heights* than frank erotica. More questionably, she went on to decry the "Mick Jagger/sadism fad, the popularity of transvestite entertainers, and the resurgence of 'Camp,'" which seemed to her to be "part of an unmistakable backlash against what feminists have been demanding."[25] Though Morgan opposed blaming victims, she deplored sex workers and "go-go girls," and "articles extolling the virtues of anal intercourse, 'fist-fucking,' and other 'kinky freedoms.'"[26] Clearly, she and others were deeply confused about who the enemy was; lesbians, gay men, transvestites, and others in the LGBTQ community were given good reason to believe they were being attacked, and rather viciously. Morgan seemed willing to condemn not just pornographers but everyone engaging in any but the most conventional—and straight—kinds of sex.

She was hardly alone. Susan Brownmiller's 1999 memoir includes a long chapter on "The Pornography Wars," which she dates to a 1973 Supreme Court decision that relaxed obscenity rules and precipitated

a "staggering rise" in the production and consumption of "over-the-counter" pornographic material of all kinds. This explosion was "cheerfully analyzed by the pornographers as a male counterreaction to Women's Liberation," an analysis to which Brownmiller replies, "They had a good point."[27] In the fall of 1976, she met in Los Angeles with Julia London and six members of WAVAW. "London's group," Brownmiller recounts, "formed to combat the snuff film genre, was zeroing in on another unsettling trend, the sadomasochistic imagery creeping onto the covers of rock music albums,"[28] which Labowitz and other WAVAW members would soon address.

After the meeting, London came to New York, and she and Brownmiller engaged a number of feminists on the issue, including Morgan, Adrienne Rich, Grace Paley, Gloria Steinem, Shere Hite, and, notably, Andrea Dworkin. Brownmiller maintains they were less worried about pornography's general transgressions against propriety than its consequences for males of all ages: "Conservatives believed that porn's danger lay in its exposure to innocent young girls. We believed that its exposure to and effects on young boys and men were the problem."[29] Their actions were splashy. Tours conducted by Women Against Pornography to expose the abuses (and mob involvement) in the Times Square-area sex industry were the group's "most popular tactic," Brownmiller writes, and were covered, as with all successful activism of the time, in the major print publications: the *New York Times, Time*, the *Philadelphia Inquirer, People*, and several European dailies.

Of the feminists addressing the tsunami of smut, few were as dedicated, or as extreme, as Dworkin. In her 1979 book, *Pornography*, she proclaimed, "Fucking is an act of possession—simultaneously an act of ownership, taking, force; it is conquering." This is the case whether intercourse is consensual or not; indeed it was only the more true in marriage: "Marriage as an institution developed from rape as a practice," she contended. While Dworkin (who has lately regained

favor for her uncompromising radicality) never actually equated intercourse with rape, she did firmly believe that pornography and rape were one and the same. "The celebration of rape in story, song, and science is the paradigmatic articulation of male sexual power as a cultural absolute," she wrote.[30] She saw the everyday "strains of male power" operating in pornography's form and content, and claimed, "The fact that pornography is widely believed to be 'depictions of the erotic' means only that the debasing of women is held to be the real pleasure of sex."[31] Male power at its worst, Dworkin argued, is at work in pornogrpahy's production: "Real women are tied up, stretched, hanged, fucked, gang-banged, whipped, beaten, and begging for more."[32]

Illustrating her argument in detail, Dworkin describes, for instance, a photograph that shows "two women in an elegant living room. Both women have cream-colored skin, taut and flawless.... One woman, blond-haired, lies on the sofa, her legs bent back toward her stomach, the spread of her legs shown by the distance between her feet posed in the air. She is wearing a garter belt, nylon stockings that stop a few inches above her knees and spiked heels.... One of her hands disappears between her legs"[33]; the description goes on for two pages. In the copy of this book I borrowed from a university library, these and other similar pages had been torn out, and then carefully replaced with photocopies. Had some readers found pleasures there worth keeping? Or, had some zealous patron done the author one better, censoring the censor? The momentum of her argument, which aims a leveling blast at the variety of desire, is perilously hard to govern.

Later, the lawyer and feminist theorist Catharine MacKinnon, who often collaborated with Dworkin, took up the argument, denying any distinction in harm between visual representation and physical action. In *Only Words* (1993), MacKinnon writes that pornography (like sexual harassment) is a form of rape, and while she does not believe that all heterosexual intercourse is criminal, she contends

that loving, consensual sex is categorically different from sex made available to a camera. Bracingly vigilant at their best, though more often rigid and extreme, Dworkin's and MacKinnon's positions—and the legislation they helped generate, with the help of the religious Right—fractured the antipornography movement. A Feminist Anti-Censorship Taskforce (FACT) was formed in 1984, uniting hundreds of women including Kate Millett and Betty Friedan, and also Adrienne Rich, reversing her earlier position.[34] Brownmiller concludes: "There had been an innocent bravery to the anti-pornography campaign in the beginning, a quixotic tilting at windmills in the best radical feminist tradition. But the innocence was soon submerged in a tide of philosophical differences and name-calling. Movement women were waging a battle over who owned feminism, or who held the trademark to speak in its name." In fact, Brownmiller believes this rift spelled the end of the women's movement. "Ironically," she wrote, "the anti-porn initiative constituted the last gasp of radical feminism. No issue of comparable passion has arisen to take its place."[35]

The proclamation of feminism's death was premature. But a blow had landed, signaling that a plural feminism was afoot. Not that acrimony had ever been absent, nor that every founding second-waver's position was unassailably true and virtuous. But on pornography, some feminists advocated a narrow judgmentalism about sexual practices that seemed to many others (and to me) to have been flat wrong.

The pushback against antiporn crusaders consolidated around a conference at Barnard College in April 1982. Called "Toward a Politics of Sexuality," it was not meant to be a forum on pornography, but it became a watershed in the debate. Conference coorganizer Carol Vance treated the underlying issue forcefully: "The single-minded concentration on eliminating sexual danger," she wrote, "makes women's actual experience with pleasure invisible, overstates danger until it monopolizes the entire frame, positions women solely as victims, and doesn't empower our movement with women's curiosity,

desire, adventure, and success. The notion that women cannot explore sexuality until danger is first eliminated is a strategic dead-end."[36] Worse, she wrote, was the contention that pornography was "the central engine of women's oppression, the major socializer of men, and the chief agent of violence against women."[37] In saying so, Vance noted, these critics had put themselves in league with right-wing crusaders against abortion and other feminist causes, helping support those "Moral conservatives [who] premiered their novel argument that sexual abuse and violence against women was caused by feminism."[38] (This uneasy alliance between some feminists and the newly named "moral majority" was also forged, at the same time, around the issue of victims' rights.) Answering the attack on the music industry launched in Los Angeles by Labowitz and Lacy, one conference participant quoted critic Karen Durbin's endorsement of rock, which she said "provided me and a lot of women with a channel for saying, 'I want,' for asserting our sexuality without apologies." Summarizing the conference themes, Vance wrote, "feminism should encourage women to resist not only coercion and victimization, but also sexual ignorance, deprivation and fear of difference."[39]

Vance's argument put her in league with some eminent female forebears, including, notably, Simone de Beauvoir, whose most prominent defense of pornography appeared in her 1951 essay, "Must We Burn Sade?" Like all feminists who have confronted pornography directly, Beauvoir found herself walking an ideological tightrope. While allowing that Sade's treatment of women was inexcusable, she defended his literary output on fundamentally Existentialist grounds. As Beauvoir saw it, Sade's writing—and his commendably unyielding self-determination—demonstrated a rather brutal axiom: "vice apprehends a truth, and the proof is that vice ends in orgasm, that is, in a sure sensation; whereas the illusions which nourish virtue can never be recovered by the individual in any concrete way."[40] One reaches this truth only through acts of will: "One must *make*

himself a criminal to avoid being wicked in the manner of a volcano or a policeman; this is not a question of submitting to the universe, but rather of imitating it in free defiance."[41] Sade is to be admired, Beauvoir argues, for adhering "only to the truths that were given to him in the evidence of his lived experience"; he practiced "an ethics of authenticity." For placing "cruelty over indifference,"[42] Beauvoir absolves him not only of his moral failings but also of his literary shortcomings, conceding at the outset, "Even his admirers readily admit that the great part of his work is unreadable."[43] No matter; his work neither warrants nor benefits from critical acclaim. Indeed, "we betray Sade if we dedicate to him a too easy sympathy," Beauvoir concludes. As she sees it, "The supreme value of his testimony is that it disturbs us."[44]

This assessment of Sade is striking for a founding, lifelong feminist. Like so many of his apologists, women included, Beauvoir is more interested in his writing's connection of cruelty with sexual satisfaction than its predictably gendered—although, it must be said, not entirely male-centric—dispensation of pleasure and pain, aggression and passivity. But her argument is consistent with the French cultural vanguard's long-standing admiration for his transgressions. As Beauvoir writes approvingly, Sade "makes us think of Rimbaud's demand in favor of a 'systematic deregulation' of all the senses; and also of the surrealists' attempts to penetrate beyond human artifice into the mysterious heart of the real."[45] After having been more or less forgotten for half a century after his death, Sade returned to scattered attention in the mid-nineteenth century. He was read enthusiastically by Flaubert and Baudelaire, and, as Beauvoir noted, his esteem soared with the advent of Surrealism. Lionized by Apollinaire in the first Surrealist Manifesto of 1924, he was deemed by the poet Paul Éluard "more lucid and pure than any other man of his time."[46] Maurice Blanchot and Michel Leiris championed Sade, as did, later, Roland Barthes.

In fact, among pornographers, Sade has been rivaled for cultural prestige only by the anthropologist Georges Bataille, whom Michel Foucault, a leading social theorist for the art world of the 1980s, called one of the most important writers of the twentieth century. Adopting Bataille's use of the term *"informe"* or formless art, historians Rosalind Krauss and Yve-Alain Bois launched a campaign in the late 1990s on behalf of this "formlessness." It became an ideological and aesthetic curriculum for a generation of artists attracted to its notions of polymorphous, materially dissolute, and counter-anthropomorphic form. But Bataille's writing, in its violence and misogyny, is more extreme than Krauss and Bois—or the Surrealists before them—have suggested. Indeed, he is said to have been outraged by the Surrealists' casual appropriation of Sade, complaining, as historian Roger Shattuck relates, "they had no conception of [Sade's] truly excremental vision and shirked the duty not just to imagine his excesses but to practice them." As for Bataille himself, Shattuck adds, he "had plans for trying out human sacrifice."[47]

In *Erotism: Death and Sensuality* (1957 in French, 1962 in English), Bataille outlined his ideas about the link between violence and sex. Starting with single-celled organisms, he proceeded up the food chain to argue that just as death means the merging of self with the organic plenum, so does sex. Hence, he claims, "In essence, the domain of eroticism is the domain of violence," and asks, "what does physical eroticism signify if not... a violation bordering on death?"[48] In Bataille's view, this state of affairs is not gender-neutral. If it is inevitable that "The lover strips the beloved of her identity,"[49] this assault is only what she desires: "Many women cannot reach their climax without pretending to themselves that they are being raped,"[50] he assured his readers. Along with gender, social class plays a role in Bataille's scheme. "Extreme poverty releases men from the taboos that make human beings of them," he wrote, producing "a sort of hopelessness" that "gives the animal impulses free rein." In short,

"evil is only evil when it leads to the abject condition of the thieving rabble."[51] As with Sade, considerable exertions (or, willed acts of blindness) are required to find the value—for poetry and visual art, and for the human spirit—in Bataille's work.

Susan Sontag was among the many fans of Bataille's pornographic *Story of the Eye*, an opinion she expressed in her 1967 essay "The Pornographic Imagination." Breezily, she offered that if, in porn, "the size of organs, number and duration of orgasms, variety and feasibility of sexual powers, and amount of sexual energy all seem grossly exaggerated," the spaceships and the teeming planets depicted in science-fiction novels were unreasonable, too. More seriously, she contended, "The pornographic books that count as literature are, precisely, one of the extreme forms of human consciousness."[52] Defending pornography's aim of exciting the reader sexually—"The physical sensations involuntarily produced in someone reading the book carry with them something that touches upon the reader's whole experience of humanity—and his limits as a personality and as a body," she writes—Sontag comes close to Beauvoir.[53]

Sontag insisted that the "psychic dislocation" pornography induces is universally appealing. "Everyone has felt (at least in fantasy) the erotic glamour of physical cruelty and an erotic lure in things that are vile and repulsive," she wrote, adding that they may be sources of conflict. "Normally we don't experience, at least don't want to experience, our sexual fulfillment as distinct from or opposed to our personal fulfillment. But perhaps in part they are distinct." Following these forces to their logical conclusion, she proclaimed, "What pornography is really about, ultimately, isn't sex but death."[54] That's what makes it obscene—but this is to be understood in a positive way, as a kind of blazing rapture. At the end, she admits that some people think porn is dirty because it can be "a crutch for the psychologically deformed and a brutalization of the morally innocent," adding, "I feel an aversion to pornography for those reasons, too, and am

uncomfortable about the consequences of its increasing availability." But, then again, "*all* knowledge is dangerous."[55]

Writing in the frenetic sixties, before second-wave feminism gathered steam and well ahead of its campaign against pornography (and the ensuing resistance), Sontag addressed extreme literature in extreme terms. She wasn't concerned with women's experience in particular, and she didn't reckon with pornography's victims. But Sontag offered something important: the voice of a strong woman insisting on permission for the representation of forbidden and unreasonable desires.

For the British novelist and essayist Angela Carter, the contemplation of pornography, and of Sade in particular, offers something quite different from mere sensual provocations. Carter condemned pornography mainly for its alliance with what she called the static structures of myth; in *The Sadeian Woman* (1979) she begins by arguing that pornographers are the enemies of women only to the extent that they behave "as if we were the slaves of history and not its makers, as if sexual relations were not necessarily an expression of social relations, as if sex itself were an external fact, one as immutable as the weather."[56] Unsticking such rigid assumptions is recommended as erotic literature's goal.

Like Sade's detractors, Carter says that in his writing, "man proposes and woman is disposed of, just as she is disposed of in a rape." But she diverges sharply by suggesting that injury is done to the perpetrator, too: while women's fear of rape is "a fear of psychic disintegration," that loss "is not confined to the victim."[57] And in marked contrast to Sontag, Carter argues that during sex we may "feel we touch the bedrock of human nature itself. But we are deceived.... Although the erotic relationship may seem to exist freely ... it is, in fact, the most self-conscious of all human relationships."[58] Pornography, like marriage and the other universalizing fictions of romantic love, only further obscures our true desires.[59]

Carter is particularly valuable for judging pornography by its ability to effect social change for the good. She credits Sade with the belief that "it would only be through the medium of sexual violence that women might heal themselves of their socially inflicted scars, in a praxis of destruction and sacrilege,"[60] and also with exposing the fact that "A free woman in an unfree society will be a monster." Such monstrousness can be salutary. The sexual behavior of Sade's women, like that of his men, Carter writes, magnifies "the ambivalence of the word 'to fuck,' in its twinned meanings of sexual intercourse and despoliation. . . . Women do not normally fuck in the active sense. . . . Whatever else he says or does not say, Sade declares himself unequivocally for the right of women to fuck."[61] Who can argue with that?

Defending women's license to be aggressive, to take what they want, to be unruly and even offensive, places Carter on the side of the kind of erotic literature (and art) that can be called not just pornographic but also perhaps obscene. It is a defense of a principle that goes beyond free speech, though of course that too is at the heart of the matter. The right to appall people is not revoked without damage to civil liberty and to emotional honesty. Maggie Nelson cites Sade when she writes, "Cruelty is simply the energy in a man civilization has not yet altogether corrupted."[62]

For me, it is also true that Sade's accounts of cruelty—the penetrations and whippings, the sewing up and cutting off, poisoning and murdering (including infanticide)—sets up a powerful revolt. It puts me among a venerable league, as old as his enduring prestige, of those who find his writing nearly unreadable, unthinkable. I am balked. I find its spirit of opposition cannot be converted into good. Such writing (and such art) doesn't feel liberating to me, it feels asphyxiating. But by clarifying the distance between acts and representation, does that work help us see rape for what it is? Does all pornography? I would say yes—with the crucial caveat that those who perform for pornographers should be protected, physically and

legally. And if, as some feminists have said, we can best prevent rape by coming to grips with the narrative that makes it seem natural and inevitable, both in the act and in the emotional consequences for its victim, extreme imagery might be considered a tool for editing that script. When we are talking about sexual violence, a finely discriminating clarity, along with acceptance of some irreconcilable differences, is what we need above all.

There is good reason for the women cited above to have addressed pornography when they did. As already noted, and affirmed by feminists on both sides of the issue, it was proliferating with furious speed in the seventies, a concomitant of the era's changing attitudes toward sex. I recently stumbled across a monologue that is not among the best known in Spalding Gray's celebrated repertory, in which the much-loved performer tells of his experience starring in a low-budget porn flick. Called *Farmer's Daughters*, the film was actually released, in 1976, and Gray—young and bearded—was indeed one of its main actors. (At this writing, a very short and chaste clip is viewable on YouTube.) In his monologue, Gray presents himself, as always, as hapless and beleaguered; he is also, as usual, an alert and ruefully funny observer. But the movie as he describes it is simply vile; it involves three escaped convicts raping a rural housewife and her daughters. Gray took the role, he says, to earn money for a cross-country trip on the kind of hippie bus where, in his (reported) dreams, everyone gets stoned and lies around on paisley sheets. (His costar's motivation, he also reports, was paying his psychoanalyst's fees.) In advance of the shoot, Gray had reservations. He writes of screaming at the sun and of a disturbing episode of dissociation. But once he finds he'll play the gang's leader, he becomes "more enthusiastic about the day's work." Alas, chosen to rape the mother, who was played by a big, "gaudy" middle-aged woman, he fails to maintain an erection. An alternate with less delicate tastes is called in. Writes Gray, "I was horrified by the size of his organ and the violent way

in which he hit her, but most of all I was horrified by the way she seemed to like it, as she moaned and rolled back on the bed." When another actor cheerfully admits that "he was in it to get laid. It was fun, and he really liked it," Gray finds himself jealous.[63]

At a distance of forty-plus years, it is hard to know how to take this. It isn't terribly helpful to denounce self-involvement in the creator of autobiographical monologues—in someone who basically invented the genre as a form of live theater and was generally brilliant at performing it. But Gray's comprehensive disregard for the women who were acting alongside him on this shoot, and his off-camera view of them as uniformly dumb (especially those that are Southern), and either ravishably lovely or hopelessly unattractive, is too offensive to be given a pass. Equally baffling—or, finally, crystal clear—is how little shame there was in telling such a tale. "The Farmer's Daughter" appears in *Wild History*, a 1985 anthology of artists' prose compiled by the painter Richard Prince (who has since achieved considerable acclaim, and not a little notoriety); in addition to Prince, contributors included renowned artists and writers as varied as Gary Indiana, Kathy Acker, and Lynne Tillman. Then as now, being "wild" in a sufficiently ironic way was enough to grant standing in progressive art circles; different, though, is that acting out a sordid and vicious scene of gang rape was considered pretty good work, if you could get it.

In *Thy Neighbor's Wife* (1981), Gay Talese traces the sexual revolution of the preceding decade and more, the rise of *Playboy* and of the prestige of its founding editor, Hugh Hefner; he writes of swingers, nudists, and various newly charted erogenous zones, and of the 1972 publication of Alex Comfort's *The Joy of Sex*—a male doctor's response, perhaps, to *Our Bodies, Ourselves*. In many ways, Talese speaks of and for the men of the postwar generation that Betty Friedan had reported on nearly twenty years earlier: mid-level corporate executives, suburban husbands, ex-GIs, who, to hear Talese tell it, were as benighted, as imprisoned by their roles and as

uninformed about their sexual options—as trapped in their lives—as their wives. Pornography was novel information to them, he suggests, and a safe way to satisfy appetites they barely acknowledged.[64] (He guessed that many men found the close-up view of squatting women in some porn "sexually educational, for Talese [he refers to himself in the third person throughout] had long theorized that most men of his generation had no idea that a woman urinated from a different opening than the one she used for making love."[65])

Frankly sexual material was not only welcomed by the rank and file, he notes, but celebrated by public figures as varied as Lenny Bruce, Wilhelm Reich, and Norman O. Brown; it was cheerfully showcased on Broadway in *Hair* and, less innocently, in cinema by *I Am Curious (Yellow)*, *Deep Throat*, and *The Devil in Miss Jones*. The decidedly raunchy magazine *Screw* found a large following. So did massage parlors.[66] Talese watched a "hard core" film being made, spending a week with the cast and technical crew, and concluded, "while critics of pornography often accused sex films of exploiting women and glorifying violence, such views did not conform to what Talese was watching in person, or what he had seen in the numerous films that he had sat through in Times Square and in shabby theaters elsewhere around the nation. If it was violence that an audience wanted, then it was more readily available in the R-rated and even the PG-rated films—war movies, the Godfather epics, the psycho-spiritual horror thrillers that were shown in endless imitation of *The Exorcist*. Sex films were passive by comparison."[67]

If Talese's assessment of the violence in pornographic films is hard to credit, he helpfully illuminates the enormous chasm between how a man who considered himself enlightened saw the new contours of relations between the sexes, and how they looked to feminists. And he complicates, also usefully, the picture of what pornography was and did at the time. More than roiling societal changes, what undermined the antipornography activists was their presumption of

consensus about what is acceptable in sex and what is reprehensible, a presumption that slid toward censoriousness and homophobia (see, for instance, Morgan's jibes about "kinky sex," "Camp," and "transvestite entertainers"). With reason, the LGBTQ community resisted antiporn activism forcefully and was supported by "pro-sex" feminists who argued that sex cannot and should not be legislated. The antiporn activists had no clear definition for pornography, nor did they specify where to position the boundary between it and sexually explicit—or merely suggestive—art.

Some female artists happily exploited the confusion, Lynda Benglis prominent among them. In addition to the *Artforum* ad, in which she appeared naked and flaunting a dildo, she also produced, as an exhibition announcement card, a Betty Grable-style cheesecake shot she commissioned which shows her with her back to the camera and her jeans around her ankles, peering saucily over her shoulder. Surely in these images Benglis teased the line with porn, changing such imagery's meaning by seizing control of its production. So did Hannah Wilke, repeatedly, as in a provocatively slow, indisputably seductive disrobing enacted before a baffled audience at the Kitchen (a New York City nonprofit) in 1974, and in a striptease performed in front of Marcel Duchamp's *Large Glass* at the Philadelphia Museum of Art in 1976, which earned her both praise and feminist opprobrium. Her reply to the criticism was a poster showing her bare-chested, arms akimbo, and captioned "Beware of Fascist Feminism." Wilke shifted gears for a series of 1978 photographs in which she appears naked but for high-heeled sandals, and wielding a handgun both defensively and in threat, in the then derelict rooms of the public-school-turned-artspace PS 1 (now part of MoMA). Playing nudity both for affirmation and abjection, she performed a tricky balancing act. The effect is of helplessness transmuted into powerful provocation. And although Benglis and Wilke deemed themselves feminists, many of those they provoked were women.

While Benglis and Wilke were using their bodies in full to taunt pornographers and censorious female colleagues alike, Spero was presenting women who were flattened, stylized, and de-sensualized: the radical absence of female embodiment was crucial. But the scrolls can also be read as scripts, or musical scores, or dance notations; Spero herself compared her cast of hundreds of figures, carried from work to work, to a theatrical stock company,[68] and, in more personal terms, explained, "Painted and printed images of many types are substitutes for my body";[69] these images, she continued, "act out resistance in ritual dance and gesture."[70] Confirming an observation often made by critics, Spero admitted, "On reflection, I do think of the scrolls as having a cinematic character," not just because of their extended, frame-by-frame sequencing, but also for "seeing the various scales of the images as analogous with the movement of a movie camera zooming in and out, the use of framing devices, etc."[71] In this range of associations to various kinds of time-based work—music, dance, theater, film—a connection emerges between Spero's representation of violence against women and the performances that were its most prominent expression in art of the time.

That is true to a striking degree of other pictorial work of the 1970s that addresses violence against women. Ida Applebroog is a painter of formidable honesty and power whose early work includes a now legendary series of small blue-covered artist's books distributed to a lucky group of friends and colleagues; their pages, like a storyboard, present what seem to be frames from a short animated film. Generally, an image repeats from page to page, and is then interrupted by a novel, bitterly funny image, annotated with a few words. Romantic and sexual relations are often at issue; the laconic protagonists mostly seem well known to each other. In *Now Then* (1979–80), we see—through a window, between curtains drawn aside, and below a shade pulled partly up—a stout man in a sports coat, seated with his hands on his knees. This simple cartoonlike image is repeated;

the second time it is captioned "now then," and the fourth "take off your panties." No one else is visible. In later paintings, Applebroog pushed the mischief further; the written language falls away and danger prevails, still generally off-screen, although in one case a woman hangs herself, and in several there are gruesome masks and pointed guns. But as a rule, as Lippard observed, harm "lurks behind the melancholy of the ordinary. It has happened to these resigned figures, or it will happen to them, and they know it."[72] In a 1984 interview, Applebroog wrote, "My work is a series of images where nothing ever really happens… composed more of silence (of what isn't being said) than of words…. Actually all the stories are the same story. It doesn't matter how I tell them, it all comes out the same. By the time you arrive on the scene the story is over."[73]

Applebroog's statement appeared in the catalogue for a ground-breaking but seldom cited exhibition called "Rape", which opened in 1985 at the Ohio State University Gallery of Fine Art before touring at university galleries across the country. Representing both nationally recognized and regional artists, the works were drawn from an open call and were selected by a three-woman jury consisting of Susan Brownmiller and the artists Jenny Holzer and Barbara Kruger. Stephanie Blackwood, credited as the show's curator, explained to me that the exhibition was actually conceived by the gallery's director, Jonathan Green, making it the exceptional rape-centered cultural program initiated by a man. Committed to art engaged with social and political issues, Green was aware that sexual violence was a simmering issue on campus; assault charges had been brought against some of the school's football players. Blackwood, brought in from the university president's office to coordinate the show, admits she didn't have any background in the arts, and says the experience was pivotal for her. "I was astonished," she says, "at the power of art to change lives." She was particularly struck by the atmosphere at the exhibition's well-attended reception. Despite the crowd, Blackwood

remembers, "the opening was silent. You heard feet shuffling along and people talking softly to each other, but there was none of the boisterousness that you usually have at an opening."[74]

In an essay for *Rape*'s catalogue, critic Arlene Raven, who had contributed testimony to Suzanne Lacy's *Ablutions*, again recounted her rape and added, "Rarely have we seen a realistic portrayal of a woman raped in any form of art." Raven cited the peerless honesty of Ana Mendieta's installations and performances, represented in this show by her photo-documentation of the bloodied mattresses in an abandoned farmhouse, and of her naked and bloody body facedown in the wooded field. Two months before the show opened, in September 1985, Mendieta was killed by a fall from her window. Her husband, the well-known sculptor Carl Andre, was charged with her death, and acquitted. The exhibition was dedicated to her memory, and it was noted on the catalogue's title page that her death "underscores the violence in our society."

The exhibition was introduced, on opening night, with a searing performance of testimony about incest produced by Jerri Allyn, which had first been performed in 1983. But most of the contributions to the exhibition were pictorial—as indeed Mendieta's installations have been for the vast majority of viewers, who have seen them only in photographs—and most were made in the first years of the 1980s, although earlier work by Applebroog and Spero was included. Also from the seventies was an embroidered drawing by Marcy Hermansader of a gaily bedecked, grim-faced bride clasped by a dragonfly-like groom with a cadaverous head and phallic body. In the catalogue Hermansader wrote, "When I did this drawing, in 1977, it was legal in the state of Vermont (where I live) for a man to rape his wife."[75] Margaret Harrison's 1977 text-and-image painting *Rape* features, to cumulatively maddening effect, art-historical chestnuts of women who are shown gratuitously—in fact, inexplicably—nude (including the female subject in Manet's *Déjeuner sur*

l'herbe); Harrison added headlines from newsclips ("Rape Case Men Go Free in 'Missing' Girl Mix-Up"), along with images of assorted makeshift weapons (knives, scissors, a Coke bottle). First shown at the London Rape Crisis Center, Harrison's painting was excluded from a 1978 exhibition at that city's public Serpentine Gallery, on the grounds that it wasn't family friendly.

Among paintings based on first-person experiences (as made clear in catalogue statements) was Helen Mangelsdorf's *Rape Group: Cheryl, Mia, Rose, Bobbie, Debby, Barbara, Helen* (1983): it is a gridded series of portraits, painted, collaged, and/or assembled, of victims Mangelsdorf met in a survivors' support group she joined ten years after being raped by three strangers. Pat Ralph's painted narratives, based on news accounts, are also long-postponed responses to her own rape while on a camping trip. Jerri Allyn, the performance artist who had participated in *In Mourning and in Rage* and in other activist projects in Los Angeles, wrote in a statement for the catalogue of a gang rape that she endured when she was seven.[76]

Sue Coe, known for acid political graphics in the tradition of Goya and Daumier, and a contributor of drawings to mainstream media (including the *New York Times*), made a quintet of paintings at this time on the theme of rape; the exhibition included the stygian allegorical image *Romance in the Age of Raygun* (1983). Her catalogue statement, written with her sister Mandy, refers like Allyn's to the abuse of girls and implicates family, church, corporation, and state in producing the everyman-rapist. Stephanie Brody Lederman's *She Was a Slut Anyway or Most Women Are Up in the Air After They Fall Off the Roof* (1985) is based on a murder in which the victim managed to murmur, as she died from stab wounds, "I should have given in." Her assailant's confession is included in the first half of Brody Lederman's title, which is also handwritten across the painting, along with fragmentary imagery and the words "I'm bleeding to death Please Help me!!"

In *Meditations on Pornography*, a print and text portfolio, Lynette Molnar argues, in photographs showing, for instance, a man in front of images of X-rated movie posters and magazines, that "The philosophy of pornography is one and the same as that of rape": a salvo in the pornography wars. Like Spero's, Paulette Nenner's paintings, *Nicaraguan Rape* and *Central American Rape* (both 1983), address victims of state-sponsored crimes; the imagery is of women as icons of pain and resistance. Paul Marcus, a lonely voice of male outrage ("Men must become much more socially aware..." he writes[77]), offered the Expressionist, nighttime painting *Rape on the Roof* (1983); it could well refer to the act represented by Brody Lederman.

Atypically, the artist Leela Ramotar worked in collaboration, with counselor Marty Schmidt, to produce two pencil drawings, one of them *Then He Said Give Me Everything* (1983), which shows a figure in silhouette: the hand of an unseen assailant points a knife at her head. Ramotar's catalogue statement, written in verse, describes talking "about it" and laughing and, along with a host of self-recriminations, lingering fear. Schmidt describes the easy back-and-forth she had over the phone with Ramotar, each taking notes. "I talked with people about rape all the time," Schmidt writes. "It was then my job, talking with students, faculty, doctors, police, administrators, legislators... What I did not expect, after all these years of talking, was that as soon as I hung up, my hand still on the telephone receiver, I began sobbing." It is a powerful testament, written a decade after *Ablutions* and the activist work that followed, to all that remained unsayable.

Performance work had allowed women to use their own bodies in an exploration of sexual violation and then to place themselves on the front lines of actions taken against it, while keeping their own relationship to the subject at a safely ambiguous distance. Representing rape pictorially, in paintings and graphic images with or without text, made it easier to relate personal experience without physical exposure. It also situated representations of rape within a

very long lineage, from canonical paintings of biblical and mythical subjects to contemporary commercial imagery. If the performances of the early and mid-seventies constituted a rupture in art's historical continuum, graphic content permitted reentry into a current of imagery that runs deep. Troubling that current profoundly, women in the seventies and eighties continued to clarify—for viewers and often also for themselves—our understanding of sexual violence.

THE CANON

While art of the 1970s that targeted sexual assault introduced radically new forms and content, the image bank for rape is as old as picture making, a historical record as illuminating as it is robust. It is a virtual timeline, written visually, often grounded in age-old narrative, of patriarchy at its most aggressive. Pagan mythology abounds with stories of sexual coercion. Zeus was a notorious serial predator; taking the form of a swan to have his way with Leda, he provided a particularly voluptuous scenario painted, for instance, by Michelangelo in 1520, and, in even steamier versions, by Peter Paul Rubens, in 1601 and 1602. Ovid tells of the rapes of Europa, Io, Chloris, and Proserpina, and the attempt on Daphne, all abundantly represented in Renaissance painting and sculpture. Many of these painted rapes conform to what Susan Brownmiller named the "heroic" tradition, in which women's various acts of submission to gods and heroes allow peace and virtue to triumph.

In the story of the rape of Lucretia, as recited by Livy, the victim yielded to Tarquin, the reigning tyrant's son, because he threatened her with death if she refused; he also promised to accuse her of adultery with her African slave, whom he'd kill, too. After submitting, Lucretia summoned her father, husband, and two witnesses, told them what had transpired, secured their pledge of vengeance, and, as virtue required, took her own life. The men she enlisted did avenge her, and a republic replaced the rule of tyrannical kings: a triumphant, even heroic outcome. Late in his life, toward the end of

the sixteenth century, Titian painted the rape of Lucretia three times, always at the moment when she is attacked by Tarquin. The most widely known and largest version renders Tarquin as unstoppable: fully dressed, he raises a knife over her head and thrusts his knees between her parted thighs. She is nude, prone, and completely help-less before him—and equally vulnerable to viewers.

In the following century, Rembrandt painted Lucretia twice, in 1664 and 1666, the first time picturing her just before she plunges the knife into her own chest, the second just a moment after—her gown is bloodied (a sexually suggestive wound), but her eyes are still open.[1] Writing about Rembrandt's Lucretias, art historian Mieke Bal notes that rape "makes the victim invisible," both literally—("First the perpetrator covers her") and figuratively (it "destroys her self-image, her subjectivity, which is temporarily narcotized"), concluding, "rape cannot be visualized because the experience is, physically as well as psychologically, *inner*"[2] (emphasis Bal's). As Bal sees it, Lucretia reverses that invisibility by taking up the dagger, murdering herself physically—signaled by the bloody stain on the second version's virginal white robe, where the dagger points between her legs—as Tarquin has done psychologically. She has agency and is exercising it, and she has emotions more complex than simple terror. Yet Bal is right that all these images deliver her to our spectatorship at a moment of mortal danger and give us no reason to wish for her rescue—no less than the inception of Rome's republic is at stake. It almost goes without saying that in both of Titian's renderings, which take place before the assault's consummation, and Rembrandt's, which follow it, the sexual act is not shown. As in almost all traditional depictions, rape is an act without physical or psychological reality, despite Rembrandt's subtlety and acuity. It is, instead, remade as pure allegory: bodies converted wholly to meaning, specifically to the necessary female subjugation on which (patriarchal) history is constructed.

The rape of the Sabines, as told by both Livy and Plutarch, predates that of Lucretia; it is a foundational story of Rome and a subject of paintings by Nicolas Poussin, Jacques-Louis David, and Peter Paul Rubens, among many others. When the Roman settlement was just four months old and made up entirely of men—some described as outlaws and local rowdies—the need for women as partners and breeders became acute. None having been courted with success, a ruse was deployed. The young Romans invited families of the nearby Sabine tribe to a festival of games. On a signal from Romulus, the unmarried women were seized. Their feckless menfolk fled. What followed for the captive women was marriage to the Romans, and however deceitful and rapacious their new husbands had been, the Sabine wives soon reconciled themselves to their fate. Belatedly, the Sabine men returned to exact justice; a negotiated settlement was reached, and the women remained in an ascendant Rome. It is an establishing event for a recurrent story line (Lucretia is another example), in which a regime of moral vigor is secured through the sexual sacrifice of women.

A depiction of the subject by Nicolas Poussin, ca. 1633–34, in the collection of the Metropolitan Museum of Art, which now calls it *The Abduction of the Sabines* (when it was acquired in 1946 it was known as *The Rape of the Sabines*; another Poussin painting on the subject at the Louvre retains the original title), is meant to be faithful, in Neoclassicist fashion, to both the warriors' valor and to the pathos of the event. Half a dozen young women, all clothed, are seen being hoisted up by armored men or dragged across the forum. They twist away and fling up their arms, more in protest to fate, it seems, than to their captors. Desperate old men and women and a few howling babies on the ground add to the frenzy, which is presided over by the stolid, commanding figure of Romulus. Order, we are given to understand, will presently be imposed. In the meantime, the drama—despite the title, and all the commotion—is perfectly chaste.

Diane Wolfthal, an art historian who has significantly expanded on Brownmiller's notion of heroic rape, writes, "Poussin makes clear that the Romans are seizing women against their will. Several Romans have drawn their swords; some chase, grab, or hold the women," who kick and struggle. Nevertheless, the artist "reflect[s] Roman attitudes by idealizing the crimes of their ancestors,"[3] which meant supporting the notion that rape—from *raptus*, which is Latin for seized—was a crime of property, and specifically a crime against the woman's husband or guardian.

Jacques-Louis David's *The Intervention of the Sabine Women* (1799) celebrates a later occasion, when Hersilia, daughter to the Sabine king and wife (post-abduction) of Romulus, negotiates the competing claims of her father and husband. (As is so often the case, the burden of reckoning with men's sexual claims and maintaining social order when they compete falls on a woman's shoulders.) Dressed in simple, virtuous white, Hersilia throws her arms wide to separate the Romans from their belated Sabine avengers. The scene is an ocean of ruddy, near-naked athletes; babies again litter the ground. David considered this his finest painting, and his ambitions for it were considerable. Arriving a decade after the start of the French Revolution, the vicissitudes of which David barely survived (though he had served it ardently), it was meant as a paean to reconciliation. Who better to symbolize it than a woman who had proven her virtue by submitting to a brutal stranger? And what better way to make rape disappear than to subsume it, again, into the very basis of democracy?

The association of marriage and heroic rape as represented by the story of the Sabines goes back, Wolfthal notes, to ancient Greece, and forward to the present, where it survives in the tradition in which a bride, after being "given away" (albeit often at her family's expense, in the form of a dowry—or the cost of a wedding party) by her father, is carried over the threshold into her new home by her husband.[4] As in this modern rite, so in the canonical paintings of the Sabines, actual

rape—and with it, any woman's experience of it—is nowhere in sight. Historical painting has been strict about maintaining this protocol, and an extensive roster of eminent twentieth-century art historians have followed suit. One such scholar argued that Rubens portrayed the princess Europa being carried off by a bull "because he wished to avoid 'violent and brutal subjects (for instance, the hunts of wild beasts).'" Another proclaimed that Europa's tale "ended happily." H. W. Janson, whose comprehensive art-history textbook was the unchallenged standard for students in the 1970s, argued that the Baroque sculptor Giambologna "was 'noncommittal about subject matter'" in creating his sculpture of the *Rape of the Sabines*, ripe with violence though it is. (When Janson's son updated the text, he saw no reason to alter the assessment.) In the much-admired textbook *The History of Italian Renaissance Art* (1974), Frederick Hartt praised, for the artist's "healthy acceptance of the erotic life of man,"[5] Correggio's swoony painting of the 1530s in which the princess Io is attacked by—or rapturously succumbs to—the rapacious Jupiter, disguised as a dark, billowing cloud.

In a more recent essay, the highly regarded art historian Norman Bryson begins with assessments of Poussin's Sabines and Titian's best-known Lucretia to argue that rape has, in our time, fallen under a "babel" of rhetoric that silences the individual voices of rapists and victims alike, drowned out not by euphemizing artists but by a bothersome "discourse" of sociologists and psychologists. Hence, "The possibility of its being *visualized* [Bryson's emphasis] no longer exists."[6] But he goes on to say that in the story of the Sabines (which he identifies as one of the "two great narratives of rape"[7] bestowed by antiquity, Lucretia being the other), "individual acts of sexual violence committed against individual women" are anyway not at issue. For one thing, as Bryson sees it, "sexual restraint is the order of the day," since married women were left unmolested. (That's because, though he doesn't say it, the capture of the married women would

violate the Sabine husbands' rights.) For another, the women were not to be used as slaves but rather as wives; hence, "their position within the household is honorable." As neither a "specifically sexual crime," nor "a crime against individual women in any direct sense," the abductions we see in Poussin's paintings are, Bryson judges, "hardly a crime at all."[8] In sum, "the episode of the rape of the Sabine women is about law, not seizure, and about the creation of stable relations between the sexes and between states, rather than… political treachery or sexual transgression."[9] He allows that Poussin's own view is diffracted, being bound both to historical accuracy and to the Christian metaphysics of his time, and thus his efforts amount to "alms for oblivion,"[10] spent on a vision no longer retrievable. But, he suggests, it was fundamentally noble.

Less forgivably, as Bryson sees it, Titian's Lucretia lacks political "sensitivity,"[11] since the painter chose to portray the rape itself rather than her suicide or Brutus's oath of revenge. Shown naked and under attack, Titian's Lucretia offers, "for the first time in the present discussion, a specifically sexual crime."[12] And yet, Bryson believes, there is reason to doubt this verdict. Perhaps we can see the ghost of a smile? Surely squinting hard, he thinks we can. Thus, "the pose is much more clearly one of seduction." It follows, by "the consent which involuntary pleasure gives to the act," (i.e., the inevitable sexual satisfaction a victim feels, in Bryson's view) that Lucretia, as with every woman, "is after all like man; no more than he, can she hide or prevent her lust." In fact, "she is after all like him, like *us*." Bryson adds up the evidence that it is a case of "seduction" rather than "forcible rape." The signs include Lucretia's nudity, the "isolation of the bed from domestic and social space, the presence of the linen and pillow; and, of course, her actual consent." Indeed, the painting is "a conundrum: we seem to be seeing two separate icono-graphic subjects superimposed—a man who rapes, and a woman who seduces." It's a whiplash-inducing analysis, whose offenses against

logic—and women—culminate in the judgment that this Lucretia is· "strikingly modern."[13]

Bryson finishes with a short discussion of Eugène Delacroix's *Death of Sardanapalus* (1827), which portrays the dying Assyrian king (as imagined by Lord Byron) surveying the wives he has condemned to expire with him. Bryson believes the painting epitomizes an unfortunate double movement. In the first, individual emotional life emerges in the public realm of history painting; this "confessional" mode is familiar to us, he says, from Romanticism. The second, less familiar movement fragments the "achieved public" generated by the long-established language of history painting, a loss of a culture of coherent subjectivity. His conclusion: "it is this second movement which, in its current phase, extends towards rape its enormous and still proliferating array of discourses and agencies," and spells "the disappearance of rape from coherent and transmissible iconographies."[14] As I understand Bryson (and this essay is hardly transparent), this rape-obscuring "array of discourses and agencies" includes, prominently, feminists who want to dismantle the heroic tradition and see sexual violence for what it is.

By the time David had painted his *Intervention*, the literature of sexual violation had progressed considerably, moving from the structures of myth to stories of contemporary men and women. But demonstrations of virtue were still required; often they required sacrifice; the desirability of the victim was, as always, essential. Paramount among early modern literary accounts of rape is Samuel Richardson's 1748 novel, *Clarissa*. Monumental in every way, it runs to nearly a million words (some 1,500 pages in the Penguin paperback now in print), its breadth matched by its emotional subtlety—and its longueurs. The spirit and wit of the protagonists have kept this epistolary novel high on the list of the English literary canon. (It is the book that Cecilia Tallis is reading, desultorily, in Ian McEwan's *Atonement*, which centers on unacknowledged connections

between social class and liability in cases of sexual assault.) Clarissa abhors, with cause, the man her parents want her to wed; they are determined to see the marriage take place to prevent a liaison with an unsuitable but appealing rogue, whose villainy becomes slowly but increasingly apparent. The progression toward the rape at the novel's heart is beyond dilatory—it is a kind of hysteria of decorum. When it happens, it comes as a considerable relief, and we readers are thereby (and long since) implicated. In what serves as a model for centuries to come, we are made to pay for sympathizing with Clarissa; the social rules of the time permitted sorrow when she dies, from illness caused by mental duress, but prohibited the satisfaction of her health and happiness.

What began with *Clarissa* remained a theme in Anglophone literature. In Thomas Hardy's *Tess of the D'Urbervilles* (1891), the heroine must die in the end because she has killed a man. And as in Richardson's novel (and almost invariably in novels centering on this subject until the last decades of the twentieth century), the assault at the heart of Hardy's moral parable is unseen. But Tess's case is otherwise different. Almost certainly raped—Hardy is just a little evasive about this—by a dissolute pretender to the aristocracy, she conceals the loss of her virginity from the man she loves. A paragon of decency—his name is Angel—he marries her. But then he discovers her secret. From this point on, the novel is increasingly painful to read; ultimately, Tess murders her rapist and is executed for the crime. By way of a happy ending, Angel weds her unblemished sister. As with Clarissa, we are invited to sympathize with Tess—the novel's subtitle is "A Pure Woman"—but only with the understanding that she'll submit to the moral dicta of her (Victorian, in this case) time. As Terry Eagleton puts it, Hardy sacrifices Tess on the altar of social propriety.[15] Along with exploring the social issues involved—again as with Clarissa, virtue is held hostage by financial disadvantage— Eagleton spots a puzzle presented by the novel's psychological and

moral calculus. It concerns the dynamics of tragedy, which requires, some critics believe, an active victim. "It might follow," he writes, "that Tess Durbeyfield's seduction by Alec D'Urberville was more tragic if it was not a rape"—that is, if she took pleasure in the enounter, rather than being a passive victim—"than if it was."[16]

Angela Carter applies the same formula to Sade's Justine, whose tragedy-proof "virtue" is the obverse of Tess's. Justine's inability to experience pleasure is the sign of her Sadeian "purity"—in Carter's view, her chastity survives "in the form of frigidity." It is also, in a nasty syllogism, proven only in the act; thus her "virginity is perpetually refreshed by rape." Even a lust for revenge is denied her, which allows Sade to achieve "an immoral victory over the reader, who is bound to urge the spotless Justine, just this once, to soil her hands with crime."[17] Incapable of anger, Justine is rendered morally indifferent, Carter writes.

Although Clarissa and Tess remain on academic reading lists, they hardly compete—especially among students of the visual arts, as we have seen—with Sade, who was Richardson's near contemporary and shared with him a greater concern for violations against codes than against persons. In eighteenth-century England as in France, rules governing behavior were as convoluted and elaborate as they were consequential. The theater of the time reflected the extent of coded wisdom required for elite culture, and while emotional expression was highly demonstrative by modern standards—men and women alike, in Richardson's world and in Sade's, are given to outbursts of sobbing, prostration, fainting, and expostulations of every kind, and, for men, dueling to the death—all were constrained by strict rules of behavior. Making love—that is, professing admiration to a romantic prospect—was also, rather literally, "paying court." Where Richardson and Sade part, of course, is that the first conforms to these rules, and the second defies them, which helped ensure his ongoing cultural importance.

In articulating the pathos governing emotional expression in the late nineteenth century, Hardy could draw on then recent work by visual artists representing the decline of agrarian values, from Jean-François Millet to Gustave Courbet. And for evocation of sexual degradation, he could refer to a much-debated painting by Edgar Degas that now bears the title *The Interior* (1868–69), although at one time it was known as *The Rape*. Associated from the start with the literature of its time, it was judged "the most puzzling of Degas' major works" by Degas scholar Theodore Reff, and "among his masterpieces, *the* masterpiece." The painting's subject is a small bedroom, windowless and uncomfortably close. At the right a man leans against a door, his legs braced, and hands in pockets—he could hold this pose for a while. He has a pointed reddish beard, and his face, in the room's low light, is gaunt and a little feral, though there is a faint glint in his eye. A looming shadow exaggerates his height. At the left a woman perches precariously on a barely indicated chair. Her back is to the man, and she looks away from him into darkness; her face, in profile, is also mostly lost in shadow. Between them is a table with a flowery little gas lamp aglow at the center, and it illuminates, warmly, a jewelry box, its opened top lined with rosy, flesh-toned plush: this is the composition's focus. A few jewels are on the table, a woman's undergarment lies on the floor. We view the scene from below, as if it were being performed on a stage. The narrow bed with its tasseled white coverlet is undisturbed, though a man's coat is tossed across the metal footboard.

Some of Degas's contemporaries were confident of the subject; indeed one wrote, "The subject was defined precisely, even too precisely."[18] Others said the artist was violently opposed to identifying the painting as *The Rape*; in either event, that title was applied decades later, five years before the artist's death in 1917. Reff contends that this painting is derived from an episode in *Thérèse Raquin*, a novel by Émile Zola, in which the heroine and her lover, having disposed

of her husband, are about to consummate their own doomed marriage. It is not a happy scene. Nor, for all its drama, is it in any way resolved. And no rape is explicitly involved, only, notably, deep guilt on both lovers' parts; the novel ends with their double suicide.

Art historian Carol Armstrong doubts the painting refers to a sexual assault, arguing that the image, however rife with suggestion, is ultimately indeterminate. "All that one may be sure of," she writes, "is the latent violence and the probably sexual nature of the relationship between two figures."[19] According to her colleague Griselda Pollock, the debate is moot because in spite of Degas's "obsessive" focus on women, "there are no women present"[20]—she means present emotionally, armed with will and thought. Nonetheless, as Pollock notes, women were his primary subject, and his preferred mise-en-scènes were dressing rooms, antechambers to the stage, and the stage itself. Bathers and dancers were favored: on the one hand, women caught as if unawares, lost in the quotidian; on the other, artists of the body, turned inward only to serve their performance, their craft. In a short explanatory text, the Philadelphia Museum of Art, which owns *The Interior*, keeps an even greater distance from its early titular subject, focusing on Degas's "exploration of lighting effects—the dramatic play of artificial light and evening shadow,"[21] and quoting an entry in a Degas notebook: "Work a great deal on nocturnal effects, lamps, candles, etc. The fascinating thing is not always to show the source of light but rather its effect."[22] As would often be the case in later paintings, a scene that suggests rape is safely absorbed into a discussion of formal, literary, and technical concerns.

Oddly, a few years before completing *The Interior*, Degas painted a scene of uncontested rape and murder, *The Misfortunes of the City of Orléans* (1865). The last of his youthful academic history paintings, it too has baffled art historians. Its most prominent figures are three men on horseback, in costume of the Middle Ages; on the ground below them are four naked female corpses (one under the hoof of a

horse); another woman, presumably alive—we see her robust but-tocks and legs—is being carried off by a horseman. Four more naked women are stumbling away in horror. It has recently been argued[23] that the story depicted is of an episode in the Hundred Years' War of the fifteenth century, in which English invaders abducted, raped, and murdered French women of Orléans. Joan of Arc, whose cult soared in the mid-nineteenth century in France (hence the story's putative interest to Degas), was credited with breaking the English blockade and freeing the city. But the painting offers no confirmation of the connection. The dead women, although in the foreground, are cast in shadow. Those stumbling away are ciphers, obscured by their posture, by their relatively diminutive scale, and, strikingly, by hair falling over their faces—one thinks of the many bathers to come in Degas's work, wringing their heavy wet locks. All the dead are pallid, gray, already effigies. The aggressors, by contrast, bathe in golden sunlight. Whereas the myth of the Sabines construes rape as a tool of diplomacy, this is rape as a tactic of war, and also as a weapon with the power of Medusa, turning living beings to stone, insensate and unspeaking. An astute but, it is said, misanthropic modernist whose surpassing ability to balance deftness and calculation was matched by his precise observations of psychological conflict, Degas created hundreds of indelible images of vulnerable, even violated women while rarely exposing their thoughts.

The early decades of the twentieth century witnessed social upheavals of catastrophic proportions and, with them, newly explicit representations of violence against women, particularly in the work of artists associated with Expressionism and the Neue Sachlichkeit (New Realism) in Germany, and with Surrealism in France. The Weimar Republic of interwar Germany saw a degree of political and economic instability, urban crime, and scandalizing entertainments that make the US of the 1970s look safe, stable, and prim; while the culture of the Roaring Twenties in the US is remembered as

boisterous and frothy, in Germany its tones were decidedly darker. Fatal crimes against women, with or without rape, abound in the novels and movies of this period, as well as in its painting, prints, and drawings. In fact, such imagery has its own name: *Lustmord*, which can be translated as sex murder. As described in a book of that title by Maria Tatar, the term names an act of homicidal violence that is converted into sexual satisfaction, an inversion of the common understanding that rape is sex converted into a gratifying (for the assailant) act of violence. The genre produced uniquely gruesome paintings and works on paper, notably those by George Grosz and Otto Dix, in which gore spills from the bodies of women who have been viciously knifed and sometimes dismembered or disemboweled. Generally shown partially clad and often meant to be identified as prostitutes and alcoholics—a single high-heeled black boot was a nearly mandatory accessory—the subjects are usually rendered face-less and in every way emotionally negligible. In the narrative logic of *Lustmord*, the tragedy is of the assailant, whether shown or absent. The women, Tatar argues, are to be understood merely as the ciphers setting these events in motion, the men their victims.

The genre had some close precedents. Käthe Kollwitz's etching *Raped* (1907–08; it is part the series *Peasants' War*) is a rare historical image of sexual violation created by a woman. The victim's body lies heavily on leaf-strewn ground, her feet thrust toward the viewer in a deliberate reference, it seems, to Mantegna's famous *Dead Christ* (or, it has been suggested, to Constantin Meunier's romantically tragic image of *Death*[24])—although in Kollwitz's image, the woman's legs are, tellingly, spread. She too is rendered anonymous—while a bit of her chin is visible, her face is not—yet exceptionally, she is granted some dignity. Her skirt, while slightly hiked up, is spread across her body; her breasts are not visible. Most important, her innocence is not in question. The abundant foliage is both lush and menacing.

By the end of World War I, related imagery had begun to pro-
liferate. There was a "Sex Murderer Grotto" in Kurt Schwitters's
Cathedral of Erotic Misery, part of an epic assemblage begun in 1920.
Max Beckmann's *The Night* (1918–19) is a boiling painting crammed
with acts of defilement. Grosz went so far as to stage a photograph of
himself as Jack the Ripper (*Self-Portrait with Eva Peter in the Artist's
Studio*, 1918): nattily dressed in evening clothes, he is shown lurking
behind a big mirror, aiming a knife at the crotch of woman who preens
in front of a second, smaller mirror that she holds in her hand. The
same year, Grosz painted *John the Lady Killer*, in which a woman,
naked but for her black boots, drifts above the back of a man who
scurries away. He is black-hatted, dark-eyed, and black-bearded; she
is buxom and glowingly pink, her body articulated by the cuts that
separate limbs at joints and sever her head—its eye gouged and its
teeth bared—from her neck.

Ferocious though Grosz's renderings are, it is Dix who is mostly
closely associated with the *Lustmord* genre. Along with many works
on paper, Dix completed two substantial paintings about sex murder,
both set in his own bedroom. The first, *Lustmorder (Selbstbildnis)
(Sex Murderer: Self-Portrait)*, 1918, is dominated by a puppet-like
male figure of cartoonish fury, his paper-flat arms and legs spread
wide, his suit spotted like a leopard's; two of his clenched teeth are
sharpened to fangs. In one fist he brandishes a bloody knife, in the
other a woman's severed leg. Dismembered female body parts are
flung across the room behind him. As if to certify the authenticity of
the likeness, Dix pressed his red handprints onto the canvas. Referring
to this painting, he told a friend, "I had to get it out of me—that was
all!"[25] The second painting features only the dead woman, her head
and arms dangling from the bed in which she was killed. Unlike the
vaguely Cubist stylization of the previous image, this *Lustmord*, from
1922, is precisely detailed, in keeping with developing tenets of Neue

Sachlichkeit. The nightmarish scene focuses on the disemboweled corpse, its legs spread wide (again, at least one visible foot is shod, a sign, perhaps, of prostitution, and certainly a way to emphasize the otherwise naked corpse); there is blood on the wall, sheets, and floor.

Dix's looser and more Expressionist prints and drawings on the theme include a watercolor of 1922 in which a broken woman is seen heaped on the floor, tangled with a dirty bed sheet that is twisted between her legs. Her throat is slit, and her head lies on a puddle of blood; on one foot is the requisite black boot. But the composition focuses attention on her exposed genitals. In an etching of the same year—it is the second in a series of six, titled *Death and Resurrection*—a murdered woman (again wearing black boots) is thrown across a bed, her pubic area covered with blood. On the floor in front of the bed are an empty liquor bottle and a pair of copulating dogs, the more endearing of the two looking straight at the viewer.

As observers have been quick to point out, both Grosz and Dix served in the First World War, a conflict notorious for its indiscriminate carnage—Grosz was active briefly; Dix spent four years at the front—and, critics argue, both artists developed their ferociously hostile images of women in direct response to that experience. Dix supported the idea, saying, "In the final analysis, all wars are waged over and because of the vulva."[26] Tatar invokes a transposition in which "mother earth," devastated by trench warfare and aerial bombing, became itself a devouring rather than nurturing figure, swallowing soldiers in never-ending mud. (It is a dark mirror of Sade's notion that the maternal principle is of voracious hunger for death.) There is also an argument that returning soldiers experienced burning resentment toward the thankless women (and children) they'd fought to defend, who not only survived unharmed but in many cases became emotionally and sexually independent during the war years. Tatar says that Grosz, "like Dix, viewed women as anxious conspirators in a plot to lure men into the frenzied brutality of military bloodbaths."[27]

At the same time, support was growing for the new psychoanalytic proposition that overbearing, demeaning mothers were a primary cause of emotional damage to their children, boys in particular. However one judges these arguments, the connection between war and rape is immemorial and universal. Dix is said to have relished killing—and to have been, like Grosz, an outspoken misogynist; again, of course, neither characteristic is uncommon. What is distinctive in the culture of Weimar Germany is the wildly volatile mix of fear and revulsion associated with sexual desire. Writes Tatar, "Given the close association between women and carnality, it is not surprising that the bodily devastation inflicted in combat could be repressed and displaced onto female rather than male bodies."[28]

If the experience of combat was formative for men in this era, another immediate source of *Lustmord* imagery came from an avalanche of crime, notably as reported in a book of forensic evidence published by Erich Wulffen in Germany in 1910; it was illustrated with shockingly graphic photographs of both sadistic sexual practices and murder victims. Dix made a group of works on paper that seem to have relied on Wulffen's book; after noting that "these images take the viewer into the world of sexual perversion, presenting tortured, even slain victims and offenders—some portrayed as exotic, others as vulgar—in chambers of horror," curator Olaf Peters proposes, rather delicately, that "It can be speculated whether Dix did not also create these sheets for the purpose of potentially catering to a certain market segment of lovers of both art and the subject matter."[29] Closer to home, literally, was a sex killing, likely of a prostitute, said to have taken place not far from Dix's Dresden apartment in 1921.[30] When Grosz was questioned about the murder of a sex worker near his own studio, he proclaimed, "he probably would have had to commit such a murder himself if he hadn't been able to paint it."[31]

This body of work, grisly even by the standards of the time, was not publicly celebrated. Both of Dix's two major *Lustmord* paintings

are lost, as are many of his smaller works on the subject. Peters notes that Dix's *Trench* (1920–23), with its "mountain of corpses," was by far the most famous and controversial work Dix made during the Weimar years, while the sex murders were ignored or rarely seen.[32] Similarly, Tatar writes that depictions of mutilated male bodies by both Grosz and Dix threatened to weaken the military's morale, and so unnerved the authorities "that they failed to pay much attention to pictures of women disemboweled, with their throats slashed."[33] Perhaps more surprisingly, a century later Peters also writes women out of the picture. Comparing Dix's two *Lustmord* paintings, he explains that while the first aimed at portraying the mental state of the perpetrator, the second shifted to "a coldly dissecting assessment of reality"[34] consistent with the tenets of the emerging Neue Sachlichkeit movement, a shift Peters deems "a strategically chosen gesture of aesthetic one-upmanship."[35] Thus the paintings "can and must be understood as nothing short of artistic manifestos."[36] Peters concludes by pronouncing, "The sex murder was . . . always the multifunction-ally employed symbol of impulse-driven ecstatic experience, proof of an extremely war-brutalized society." In confirming the connection between horrific violence and (male) ecstasy, and ending on a note about cynical stylistic maneuvering, Peters—for all the acuity of his analysis—makes pitilessly clear how little the women at the center of these compositions count.

In the 1920s and '30s, Alberto Giacometti was not making the sculptures for which he is best known, of figures attenuated nearly to the point of vanishing. Instead, he was associated in these years with Surrealism, which sought to convey the symbolic operations of dreams as understood in terms recently provided by psychoanalysis: condensation and displacement of the everyday, and the eruption of deep-seated experience both personal and cultural. Giacometti's *Woman with Her Throat Cut* (1932), a sculpture meant to be shown on the floor, portrays a woman reduced to a roughly life-size skeleton:

an arched spine, a ribcage that extends to two substantial serrated blades, and flopping arms. One arm suggests a fallen leaf. The other, thrown over her neck, is hinged at the wrist by a little loop and terminates in a long pod, which can be moved about; inviting manipulation, it makes the figure seem a puppet, or perhaps a broken doll. This hand, which also evokes a plumb weight, must be what Giacometti had in mind when he linked the sculpture to "the common nightmare experience of feeling one's hand to be too heavy to lift."[37] An elongated neck, also arched, its vertebrae articulated, bears a deep but tidy nick suggesting a heavy, sharp knife. The tiny, eyeless head's small mouth is open wide, having expelled a last breath, or scream. But the figure's lean legs remain vividly alive. Schematic as a line drawing, they thrust forward at the knees, which are opened wide; a shin and long foot angle back sharply; it is as if the woman is straining to spring, or to give birth. Dead in her mind, she is still resisting with her body—and still an open target for assault. The arm thrown over her neck suggests an unsuccessful effort at self-protection.

Conceived under the influence of Surrealism, this sculpture shares that movement's literary inclination (just as *Interior*, exceptionally in Degas's work, has been associated with fiction): it is possible to see in the insect-like woman a resemblance to Kafka's Gregor Samsa, who metamorphosed into a cockroach in a story published in 1915. As *Interior* was for Degas, *Woman with Her Throat Cut* is easily Giacometti's most melodramatic work. Yet the bent and broken figure tossed on the floor is also his most unspeaking subject. That artless slit in her windpipe, easy to miss without the title, could nonetheless be considered the sculpture's point: she is mute as well as blind. It is only recently that this work (which exists in several castings) has been frankly described (for instance on websites of two museums that own it, the Museum of Modern Art and the Guggenheim) as depicting the victim of a sexual crime. Oddly, the Tate calls it (as of 2017) a "powerful image of sexual pleasure" as well as of violence,

and describes it as a praying mantis that devours its mate after copulation, though the victim here is surely the female.[38]

Perhaps the hybridity of this work's forms—the gracefully organic spine and leafy limb; the rigidly geometric neck and leg—compound a resistance to understanding: not only blind and mute, this woman is a visual Babel. For his part, Giacometti wrote of his need, at the time he made this sculpture, "to find a solution between things that were rounded and calm, and sharp and violent. It was this which led during those years (32–34 approximately) to objects going in directions that were quite different from each other… a head lying down, a woman strangled, her jugular vein cut."[39] He does not mention sex, much less sexual violation. In other words, the assault he represents is to be seen as an affront to expressive capacity. For Giacometti, it seems, rape, is a metaphor for blindness and silence, not the other way around.

An artist associated with the Surrealists but distinguished even in their company by the explicitly violent eroticism of his imagery, the German Hans Bellmer is known for his lifelike female dolls, their parts mismatched in provocative ways. The first, from 1934, was conceived as a kind of automaton: a sequence of tiny pictures, some sexual, became visible through its belly button when a nipple was pushed. The second doll appeared the following year, this one a version of the four-legged, headless, and armless figure that Bellmer toyed with throughout the 1930s. Repositioning its separable limbs, buttocks, and breasts, he photographed it in various states of danger and damage: flung, legs splayed, in the grass at night; tied to a tree while a man lurked nearby; hung from a doorway; tossed down a flight of stairs. With these early objects and photographs, and in later drawings, paintings and photographs that are even darker, Bellmer invited psychoanalytic interpretations.

A youthful witness to the catastrophe of World War I, Bellmer was friendly with Grosz and Dix, and also with the German artist

John Heartfield, who, in addition to his well-known collages, created assemblages of various wood and metal elements. Such concatenations of unlike things can be linked with the widespread presence in Weimar Germany of veterans whose injuries required medical prostheses; this new alignment of bodies fed a preoccupation with inanimate things brought uncannily to life, as is seen in Bellmer's dolls and automata, and also in other Surrealist work. The period produced a distinctive reversibility: if the animate body requires mechanical parts to rouse it to action, the inanimate may be reciprocally susceptible to awakenings, whether benevolent or malign. More often than not, the subjects Surrealists represented as not quite wholly or reliably human were women.

Noting the abundance of sexual mayhem in Surrealist imagery, Sue Taylor points out that we should beware the "challenges" posed by self-described transgressive artists. "As much as we may want to read them as an overturning of the repressive conventions of an entrenched aesthetic category (the idealized classical nude)," Taylor cautions, "the fantasized assaults on the female body that characterize so much of the iconography of the twentieth-century avant-gardes... must also be interrogated for their complicity with a dominant (male) ideology."[40] Many artists of the 1920s and '30s who explored eroticism's dark side took cover under the notion that only timid pleasures deserve being called guilty. The Surrealists' embrace of Sade is worth recalling in this context, and while René Magritte, who has long been the most popular painter among the Surrealists, is hardly known for Sadeian provocations, he certainly made a bid for outrage when he named a painting of 1934 *Le Viol* (*The Rape*). Obscurely funny, like much of Magritte's work, it is a well-known image of a woman with breasts for eyes, a belly button nose, and pubis for mouth. André Breton, the "Pope of Surrealism," reproduced this image the year it was completed on the cover of the exhibition brochure *Qu'est-ce que le surréalisme?* Magritte said of it, "The subject of woman yielded *The*

Rape," a surpassingly cryptic statement that Magritte elaborated only by continuing, "In this painting, a woman's face is made up of the essential features of her body. Breasts have become eyes, the nose is represented by the navel, and the sexual organ replaces the mouth." In 1990, Sarah Whitfield noted, "When this work was first shown in [in 1934] it was hung in a separate room and hidden behind a velvet curtain... More than fifty years later its capacity to shock, or at least to astonish, does not lie simply in the powerful sexuality of the image—'one of the most beautiful images of carnivorous love in the service of passion,' according to [the Belgian artist] Pol Bury—but in the way Magritte delivers such an image with all the stylish wit and breezy confidence of, say, one of the cigarette advertisements he was designing around the same time."[41]

Neither Whitfield nor, most strikingly, the artist had anything to say about the work's title. It could be argued, at a stretch, that Magritte's portrayal is of rape as an event that deprives a woman of speech and vision, and forces her sexual parts to take the place of both internal and social identity. Her breast-eyes boggled, her hair windswept, her torso made to seem monumental against a watery background, she could be testimony to forbearance—or, perhaps, to a violent shock. But more plausibly—the tone of the painting is absurdity, not trauma—she is simply dumb. Instantly and wholly available, she is sexual without being sensible. She has been called exemplary of "Breton's concept of *humour noir*";[42] grim comfort. Hers is a violated body that will have to bite its tongue forever, and we can only laugh.

When trauma does come into the discussion of Surrealist imagery, it generally has been in the form of normative childhood experiences: the frightful pain of separation from the mother and of early gender anxiety as formulated by Freud. Writing about a boyhood fantasy recalled by Giacometti in 1933, just after completing *Woman with Her Throat Cut* ("I remember that for months while a schoolboy I

couldn't get to sleep unless I imagined first that I had gone through a thick forest at nightfall and reached a great castle rising in a most secluded and unknown place. There I killed two defenseless men… [and] raped two women, first the one who was thirty-two… and then her daughter. I killed them too, but very slowly… Then I burned the castle and, satisfied, went to sleep"), scholar Hal Foster duly notes the artist's contempt for women, but he's impatient with its moral claims. What Giacometti's fantasy, and his *Woman with Her Throat Cut*, are really about, Foster writes, is "a lack in the masculine subject that the female subject only represents."[43] Even in extremis, women are merely the device that sets the real (male) drama in motion.

By the end of World War II, both the luridly vicious sexuality of interwar Berlin and the hectic dream life of the same period in Paris were history; in the war's aftermath, transgression was hard to redeem as art. Hannah Arendt didn't introduce the phrase "The Banality of Evil"—the subtitle of her book about the trial in Jerusalem of Nazi Adolf Eichmann—until 1963; her argument was easier to make when the war had been drained not of its horror, perhaps, but of some of its heroism. Relying on irony (it is of course goodness, not evil, that is notoriously banal), Arendt's coinage was an instant sociopolitical meme. Renata Adler cited it to condemn, for what she called their unearned nihilism, those youthful radicals who distorted a view of evil as banal into a view of banality as evil.[44] But in advocating for clarity and philological as well as ethical rigor—for rigorous attention to the language of fascism—Arendt was swimming against the tide. Violence and madness were to be the cultural dialect of the sixties, not just the circumstances from which it emerged. And sexual assault was easily absorbed into the plotlines of vanguard as well as mainstream fiction, theater, and film.

The scathing and often very funny summaries of sex-besotted novels by Henry Miller and Norman Mailer with which Kate Millett introduced her classic *Sexual Politics* in 1969 still hit the mark today.

Millett writes that Rojack, the protagonist of Mailer's *An American Dream* (1964), after killing his wife and "relieving his feelings by buggering his maid," offers "little motive for the killing beyond the fact that he is unable to 'master' his mate by any means short of murder."[45] Adding that Mailer—who in fact knifed and nearly killed his own wife—transparently identified with his hero, Millett concludes, "*An American Dream* is a rallying cry for a sexual politics in which diplomacy has failed and war is the last political resort of a ruling caste that feels its position in deadly peril."[46] A best seller, *An American Dream* won widespread praise from men and women alike, including Joan Didion (who for all her sensitivity to the zeitgeist was no friend of feminism).

Foremost on the backlist of novels that addressed rape with force and nuance was Richard Wright's blistering *Native Son* (1940). That the rape of a young white woman by a black man at the novel's heart did not actually take place is clear; his innocence of that crime is the story's driving motive. But a second, incontrovertible rape, this one of a virtuous young black woman, is fairly easy to flip past in a quick accounting of the novel's moral economy. Looked at differently, that imbalance is Wright's real point. His protagonist, Bigger Thomas, is a storm of emotions, almost all of them a variant of anger or fear. It is fear that makes him smother the young, beautiful, rich, politically progressive and very white Mary Dalton. Having carried the stuporously drunk princess of capitalism to her bed, Bigger, the family's new chauffeur, finds himself standing over her when her mother, who is blind, unexpectedly enters the room. To stifle Mary's inebriated mumbling, which might give his presence away, Bigger puts a pillow over her face. Death follows, then immolation (in a panic, Bigger takes her corpse to the furnace), then dismemberment (she won't fit in one piece). The crime, in other words, unfolds backwards, and intention along with it: the will to commit the deed accrues just as inexorably as the accumulation of grisly postmortem deeds, as

Bigger systematically enacts the violence for which he knows he'll be found guilty.

As the police pursuit grows, Bigger's fuse shortens. But it takes him a surprisingly long time to see what the charge against him will be; it is his girlfriend, Bessie, who spells it out. He accepts the accusation, with relish. "Had he raped her? Yes, he had raped her. Every time he felt as he had felt that night, he raped." Sure enough, when Mary's bones tumble out of the furnace, it is rape of which he is accused. It may seem that Wright means sexual violence is the same whether it occurs in the flesh or never leaves the accused's mind; some feminist activists of the seventies would make an uncannily similar argument. But Wright is clearly making a point about race and how it distorts truth and judgment. "Rape was not what one did to women," Wright's narrator says. "Rape was what one felt when one's back was against a wall." If the attack on Mary is wholly consumed by metaphor in this passage, the opposite is true when Bigger attacks Bessie, taking her against her vigorous protests and smashing her head against a brick wall—no soft pillow for her, or numbing drink. Wright looks unblinkingly at what counted as sexual violence in the American judicial system and what didn't. For a black woman, it was a negligible, disposable fact. At Bigger's trial, his well-intentioned but ineffectual lawyer admits, "Bigger Thomas is not here on trial for having murdered Bessie Mears. And he knows that."

That the alleged attack for which Bigger is convicted did not take place allows Wright to deploy rape as an appropriately ferocious metaphor for what one race does to another. But in other novels before and since, alleged rapes are clouded by ambiguity for reasons that are themselves unclear. In Harper Lee's beloved 1960 novel *To Kill a Mockingbird*, for instance, a black man is falsely accused of sexually assaulting a white woman (in truth, she'd made advances toward him); though innocent, he is killed by a racist mob. The woman in question, an outcast whose father, the town drunk, beats her for

her behavior, is merely a device, in a novel that is nominally about race and tolerance and largely about the heroism of Atticus Finch. Published in 1960, it was written, with considerable nostalgia, about the rural South of the 1930s; in the end, a black man is dead, and a lonely, abused young woman is forgotten, both obscured by the triumph of a white man's benevolence.

Anthony Burgess's *A Clockwork Orange* was published only two years later, but it seems a century distant. Looking forward to a grim near future of unchecked urban crime and brutal, technocratic policing (and also backward, to the totalitarianism of the 1930s), Burgess crafted a dystopian novel untroubled by sentiment of any kind. Alex, its protagonist, who at the outset is a dirty-minded fifteen-year-old droog, propels an allegory whose very Sadeian moral is that it's wrong to brainwash evil out of people, and that taking away the freedom to choose to be evil doesn't make a person good. Burgess also wants us to know that a willingness to treat others badly for political purposes is as common among liberals as fascists. It's skimpy philosophical cover for a rollicking tale of gore and woe, from which a reader learns that boys will be boys, and that creative ardor is often tied up with violence.

It's hard to condemn Burgess's book without sounding censorious or mawkish; *A Clockwork Orange* is in fact a wild ride, as inventive as it is barbaric, and if alienating at first, it becomes—like the invented crypto-Russian patois Burgess has Alex speak—increasingly compelling as one gets the hang of it. By the end, when Alex has been relieved of his carefree rapaciousness, we miss both the language and the violence. But when Stanley Kubrick released the movie version in 1971, he turned the child-protagonist into a full-grown adult—he'd done the same with Nabokov's *Lolita*—and transformed a short literary novel of euphoric terrorism into a dazzling spectacle of sheer brutality. Burgess wasn't happy. But what most angered him was that Kubrick, like the original American publisher of *A Clockwork*

Orange, had lopped off the novel's last chapter, in which Alex finds himself—rather implausibly—pining for true love and fatherhood. Thus bowdlerized, Burgess fumed in a 1986 preface to a restored paperback edition, the story became a simple-minded, unredeemed smut-fest—hence, wrote the English novelist, typically American. Not that it's a great book even intact, Burgess added, saying that if he could have disowned one piece of writing, this would have been it.

Whether read as bildungsroman or a report from the front lines of urban warfare, *A Clockwork Orange* invokes a world that is insular, even claustrophobic, and almost wholly male. (It is notable, in this connection, that in 2017 an all-male theatrical production of the novel played in New York, following a run in Edinburgh.) With gangs of predators on the prowl, the gray, broken city's residents are afraid to leave their homes. Burgess was writing about social and political conditions; he showed no concern whatsoever for the women whose lives his hero devastates. The two whom Alex attacks most brutally both die, rather conveniently, one on the spot from her injuries (she was old; he beat her but did not rape her) and the other afterward, from "shock" (she was young and beautiful, and was gang-raped, Alex in the lead). Alex has little regret about either death. Though rape might seem the plot's most dramatic event, it is once more just a device, without emotional value; its victim has no voice at all.

Nor does the victim in Evan Connell's 1966 *The Diary of a Rapist*, for which the setting is San Francisco, rendered a nondescript city of deadly vapidity and relentless boosterism, and of numbingly frequent murders and sexual assaults. The diarist in question, Earl Summerfield, is a small man trapped in a dull job and stuffed to bursting with rage and delusions of grandeur. (These circumstances are common to the era's thriving literature of grim irony and paranoid fear of implacable, omniscient institutions, as in novels by Thomas Pynchon, Kurt Vonnegut, and Ken Kesey.) Belittled and emasculated on the job, Earl has an older wife (she turns thirty-four, he twenty-seven, during the

course of the book) who makes him feel even smaller, and angrier. And more feminine: Earl describes himself as being like a woman, cross-dresses furtively, and reviles his wife for being mannish. He follows with compulsive interest proliferating news reports of murder and other physical assaults, especially against women, and of the regular trips convicted perpetrators make to execution chambers.

As in Hardy's *Tess*, Lee's *Mockingbird*, and Wright's *Native Son*, the act of rape at the book's climax becomes progressively murky—if, indeed, it occurs at all; in Connell's clammily and profoundly disturbing book the act is referred to as rape only in the title. For several months, Earl stalks (possibly) a teenage cheerleader for Christian virtue and fantasizes about her with hallucinatory vividness. His entry for July 4 is blank, but subsequently he elaborates on an attack he says took place that day, at the victim's invitation. He reflects on her passivity ("If only she'd resisted..."), on his decision to hit her rather than gutting her like a fish, and rants copiously (all the beauty queens are whores, shamelessly parading themselves in public, and so on). In Connell's America, outlaw sexuality is an outcome of desperate loneliness and suffocating repression, each man inching up a shaky professional ladder in solitude. "Well sing softly, Earl. The night of the soul is dark, twice as dark as the ocean floor," the would-be rapist whispers to himself. The diary, which begins on New Year's Day and ends on Christmas Day, is marked throughout by empty public pageants and, internally, by cloying platitudes. Earl's last words are, "In the sight of our Lord I must be one of many."[47] It is either the suicide note of a remorseless criminal, dead at heart—or, perhaps likelier, of a man reluctantly relinquishing dreams of glorious evil.

All these works preceded (or were contemporary with) Duchamp's completion of his last major work, *Étant donnés: 1° la chute d'eau, 2° le gaz d'éclairage* (Given: first the waterfall, second the gas light), on which he apparently worked intermittently from 1945 to 1966. Duchamp's crowning achievement, it shows a very lifelike woman (her

body is covered in pigskin) effectively headless and spread-eagled, set within an idyllic landscape. A jumpy little electric flame in the background and a waterfall seemingly in motion only heighten the subject's immobility. Viewers, too are pinned to the spot, since the scene is hidden behind a heavy wooden door, into which a pair of peepholes have been drilled, making us voyeurs—to peer through them, one presses one's nose against the door, now a little funky with the oily evidence of viewers' anxious presence. Art historian Rosalind Krauss, in a bravura poststructuralist analysis of this installation, considers it a staging of the embodiment of sight. On the far side of the picture plane—the impregnable wall at which we are positioned—the tableau's vanishing point can be located precisely, Krauss writes, between the woman's spread legs. It is an Albertian diagram of one-point perspective situated not in the landscape of the built world but in the matrix of embodiment and desire.[48] Although Krauss doesn't say so, the position into which viewers are put, and the helplessness of the woman at whom they stare, also stage viewing as an act of sexual aggression. The fact that voyeurism can itself be a form of assault and a metaphor for rape may be too plain a truth to merit Krauss's comment. Nonetheless, her insistence on a purely phenomenological reading, and her silence on the question of violence—whether represented in the splayed female figure, or in the penetrating gaze allotted the viewer—is striking. Having begun *Étant donnés* just as World War II ended, Duchamp worked on it through the repressive fifties to conclude amidst the raging social chaos of the sixties, but it is barricaded against all that. In a sense, it is a time capsule—or a sealed diorama, as in a natural history museum—of the kind of enforced female submission Breton called black humor.

Duchamp's title for this final work doesn't much clarify its subject (although like everything Duchampian, it has been exhaustively analyzed). Indeed it is noteworthy how often something fishy is afoot in the titles of artworks that take sexual violence as their subject.

Either the word "rape" is applied without cause, from paintings of the Sabines to Degas's ambiguous tableau and Magritte's blind, mute nude, or it drops away where it seems most apt—as with Giacometti and Duchamp. Through all the long years of iconographic and then formalist criticism's consecutive reigns, almost comic exertions were undertaken to circumvent art's emotional subject matter, and never more than when that subject matter was rape. The question of what people thought they were looking at—of what was acknowledged and what not seen at all—is tied inextricably to who created the image, and, no less, to who was presumed to be the viewer. The roster of visual artworks and novels discussed above is hardly comprehensive, but I would argue it is representative. Until the last quarter of the twentieth century, the artists and writers who represented sexual violence were almost entirely men. And it was men whom they addressed. Canonically, rape was allegorical or metaphorical and/or historical, or perhaps simply a question of stylistic and formal choices—anything, that is, except an experience of consequence for its victim.

Perhaps it is not surprising that with the entry of significant numbers of women into the cultural scene of the early seventies, a short burst of celebratory literature—as epitomized in Erica Jong's *Fear of Flying* (1973), the era's most popular manifesto for liberated and joyously heedless female desire—was soon eclipsed by stories of less happy encounters. The mid-nineteen-seventies saw a wave of women's novels concerned with rape. And in striking contrast not only to Jong's novel but also to most work in the visual arts, this fiction was marked from the start by raw, angry, and sorrowful confusion.

In 1981, the literary scholar Elaine Showalter, noting a "staggering increase... in reported cases of rape during the 1970s," undertook to summarize the fiction produced in response. "Women's novels are testing the limits of the liberated will and the metaphysics of violence," Showalter wrote. She found some bruising inner conflicts in these novels, in which rapists and killers are often drawn as

phantoms, and in which fantasy collides with guilt, rage with self-doubt. Showalter speculated that these shadowy, mercurial predators may be "a projection of female violence, the extreme form of an anger women have only recently begun to imagine and explore."[49] But she concluded that anger was ultimately a less potent emotion for these novels' female characters than dread. "Women as a group are so conditioned to the victim's role," Showalter argued, "and so far from attempting any kind of violence, even in self-defense, that their expanded awareness of sex crimes only increases their sense of helplessness, vulnerability, and fear."[50]

She may have been right. But the extraordinary courage with which these authors broke open new narrative territory can't be denied. An early, outlying salvo is Muriel Spark's *The Driver's Seat* (1970), a marvel of social discord, emotional collapse, and ethical mayhem. The protagonist, Lise, searches for her "type," the man who will do her bidding and slash her to death, having first bound her wrists and ankles. She does find such a man, having met him by chance on a plane; his mental health is parlous, and he does what she asks. Lise is not remotely likeable; brusque and obtuse, she dresses outlandishly, and is generally offensive to everyone. Fulfilling the title's promise, Lise does—literally—take the driver's seat (she steals a car at one point), but never gets it right. As Showalter says, "she wants the illusion of control that comes from choosing her own destruction."[51] The same is true, in some measure, for Teresa, who, in Judith Rossner's best-selling novel *Looking for Mr. Goodbar* (1975), turns away from her good Catholic girlhood and the benevolent relationship she has with the deaf children she teaches. Hearkening to inner demons, Teresa picks up the wrong men in neighborhood bars and uses them for sex—for which, in the end, she is well and duly punished. (Her death is grisly.)

The moral arc of Rossner's novel is considerably more conventional than others in this genre. Gail Godwin's *The Odd Woman* (1974)

is a long, careful examination of independence balanced against loneliness, honesty against illusions, the satisfactions of professional ambition against those of sexual desire. There is a delicately drawn romance with a married man. And on the last page, which finds the titular "odd woman," Jane, home in bed, there is the unheralded incursion—perhaps—of an intruder. The question of whether he is imagined or real is not answered, nor even long entertained; the novel (which doesn't otherwise skimp on details) simply ends. We're left to question our expectations, even perhaps our hope, that an act of violence will serve judgment on Jane's self-absorption. Or, that we will be told in no uncertain terms that fantasizing about rape is understandable, even inevitable. Neither resolution is on hand.

Published the same year, Diane Johnson's *The Shadow Knows* develops a character far more open to risk; she slaloms recklessly through marriage and infidelity, prosperity and poverty, motherhood and rebellion against its constraints, and a wide range of acquaintances of several classes and colors. The unnamed protagonist's disposition is a polar opposite to Godwin's plain Jane: Johnson's heroine is wry, restless, sometimes careless, not given to sentiment. Menace stalks her throughout, and when the housekeeper and nanny—and good friend—who shares her cramped public housing unit dies (not violently), we think the threat of danger has been met and satisfied. But we're wrong. Once again, an assailant finds the protagonist on the novel's last pages, raping her in the back seat of her car.

Her response to the attack reads, forty-odd years later, as sharply unexpected. While the attack was underway, Johnson's protagonist recalls, "I think I was struggling," kicking at his hands and struggling not to part her legs, "crying out and gasping resistance." Her tone remains speculative, flat, and distant, as if she's reciting someone else's story. "As they say you so often do, I had the feeling this wasn't happening to me, yet I was wondering if he would strangle me afterward and they would discover me dead stuffed in my trunk, and I

thought of my children. Your life goes through your mind like drowning and so you don't pay too much attention to what's happening to your bottom half. But it was happening all right." It is, perhaps, an approximation of traumatic dissociation; certainly it is as clinical as an EMS technician's report. As her account continues, she goes so far as to wonder whether she might have cooperated. "So wrapped up was I in my thoughts and my dread I may have, for all I know, moved rhythmically according to long habit with the deep purposeful thrusting inside me of the organ of this unknown man or maybe I lay there unresentfully." And she wonders about the assailant. "Was he unknown? Could I tell from the feel of him? Are all men the same in the dark? I can't remember, I just remember thinking well, this part won't take very long, and it didn't."[52]

Afterward, Johnson has her character say, "I felt happy... There is a badness to things that satisfies your soul, confirming that you were right about what you thought was what." She'd like to know the rapist's identity—she couldn't make out his face in the dark—but she reports, "I feel better." We can't quite trust her on that, since she also says she feels herself "to have taken on the thinness and the lightness of a shadow, like a ghost slipping out from his corporeal self and stealing invisibly across the lawn while the body he has left behind meantime smiles stolidly as usual and nobody notices anything different. You can join the spiritually sly, I mean."[53]

Creating an enormously sympathetic protagonist who declines to fight back, to express moral outrage, or indeed to show any potent emotion at all, Johnson addressed her subject from a position that seems diametrically opposed to that of the activist women, visual artists among them, who were speaking out at the time against sexual violence. But they are, perhaps, two sides of the same coin. The body left behind to Johnson's central character after she is attacked, spiritually sly and smiling, is the one with which some feminist artists were performing. It may be superficially stolid but, precisely because it is

presented for an audience, it is split internally. Being in and not in one's body at the same time, as it is expressed in these novels of the seventies—enacting and inhabiting one's physical self—is also the condition of performance, however stark the differences between the disciplines in addressing sexual violation. And it is worth noting as well, with respect to the crucial physical presence of living bodies in performance art, that in Godwin's and Johnson's novels, the female victims are alive at the end—a marked contrast with the (male) literary tradition with respect to stories of rape. (It is the bloody death of Teresa in *Looking for Mr. Goodbar* that marks it as conventional.)

Strange and uncomfortable as *The Shadow Knows* may now seem, Lois Gould's *A Sea-Change* (1976) is far more perplexing. This time, the violent assault, of a woman with the doubly fluid name Jessie Waterman, occurs on the first pages. Again the victim (a beautiful blond and a successful fashion model) is oddly impassive. Bound at her ankles and wrists by a hulking intruder she refers to as "the black gunman," she finds it "Useless to struggle," and having abandoned the effort to resist, sighs with relief, "as if her victim's license had been automatically stamped VALID after a routine examination." Soon, she finds "she could barely concentrate on the fear; only her muscles held on to it for dear life."[54] We quickly learn that her flattened affect is not meant to represent a traumatic symptom, but instead the reasonable consequence of an avalanche of crime to which she and her fellow urbanites have been subjected—and to which they've become ostentatiously inured ("It must have been just after their second or third break-in that the Watermans began to talk seriously about moving"; "at parties they would huddle in corners swapping endless survival stories with other 'lucky' victims,"[55] etc.). This caricature of a jaded white professional is soon abandoned. When Jessie does move, with her two children, to a home on the sea, the short novel turns sharply allegorical, and by its end Jessie has transformed herself, amidst a hurricane named Minerva, into the black gunman, internalizing his

indomitable power. It is, to put it mildly, a disturbing tale, whose conclusion swallows whole the seeming realism of its opening scene, recasting the rape as a fever-dream, its meaning inextricably stuck in a swamp of anger, fear, and desire. It is impossible to avoid seeing racism where Gould clearly meant to express honesty.

Gould was an ambitious and graceful writer, and for all her novel's faults (and mixed reviews), it was taken seriously. At a minimum, it exemplified a trend: we're told repeatedly, in these novels of the seventies, that an assault may have been a fantasy; that the female protagonist may, literally, have asked for it, or at the least been guilty of overstating its consequences. Indignation about women doing so in real life found ample voice at the time, including from such prominent women novelists as Margaret Drabble, who huffed in a 1979 op-ed piece for the *New York Times,* "Clearly there are women who suffer severe psychological as well as physical damage from rape. But equally, there are those who do not."[56] Drabble's blunt impatience with whingers speaks, altogether unintentionally, for one aspect of these fictional characters' internal experience. Writes Showalter, "What does often surprise the reader of [this body of] women's literature is the heroine's guilty analysis of her terror of being attacked, as if this fear were childish and neurotic."[57] To restate a theme, the seeds for such guilt were planted by the early feminist exhortation that women resist rape with confident vigor (and practiced martial-arts moves) rather than succumb—or even admit—to fear. For her part, Gould concluded a book talk by citing a *New York Times* article in which a female martial-arts instructor suggested that women "have only to learn to tap the violence within them ... violence becomes a friend, once you learn how to deal with it."[58]

While the women's literature of the 1970s that explored female bodies under assault clearly had a complicated relationship to feminist performance art, the latter's kinship with theater and film of the time was only more complex. Antonin Artaud's "Theater of Cruelty,"

a subject of renewed interest in the 1970s—it was championed by Nancy Spero and Susan Sontag, among others—was conceived in the late 1930s by the erstwhile Surrealist as a thorough dismantling of traditional theater in which sets, props, costumes, and even stage would be abolished; ideally, the audience would be seated in the center of an empty room, and the actors performing around them. Wrote Sontag, "The value of emotional violence in art has long been a main tenet of the modernist sensibility. Before Artaud, however, cruelty was exercised mainly in a disinterested spirit, for its aesthetic efficacy." With him, an opposition arises—as it would in performance art—to "all theatrical forms that imply a difference between reality and representation. He does not deny the existence of such a difference. But this difference can be vaulted, Artaud implies, if the spectacle is sufficiently—that is, excessively—violent."[59] Less sympathetically, Christopher Lasch groused, "Avant-garde playwrights... believe that reality is itself an illusion and thus make no attempt to sustain illusions in their work."[60] Especially with respect to violence, boundaries between stage and audience, the scripted and the spontaneous, were tumbling down. And not without harm.

Reviewing Living Theater's widely acclaimed and fondly remembered 1969 production *Paradise Now*, Leslie Epstein (writing for the *New American Review*) reported a scene of near total pandemonium. "Do what you want! Free Theater! Do what you want," Epstein reports that director Julian Beck shouted to the audience. They took him at his word. "A few seats from me," says Epstein, "a man reached beneath the brassiere of the loveliest girl in the cast, who was standing in the aisle, and began kneading her breasts from behind. On stage, another man, fully clothed, pulled a participant from the Rite of Universal Intercourse and dragged her on her bare back to the wings, where he knelt between her legs. If he took her, no jury could convict him of rape. We had all been solicited."[61] Occupying a cultural sphere adjacent to Happenings, Fluxus, and the earliest performance

work, the Living Theater brokered new relationships between drama enthusiasts and those seeking the immersive experiences on offer in the visual arts. Beck's company presented, in the raw, information about sexual liberties which were also on offer in more popular ways, as by the runaway hit *Hair* (which had debuted in 1967 and opened on Broadway the following year). Subtitled "The American Tribal Love-Rock Musical," it featured sweet-natured hippies, clueless parents, sex and drugs, and, briefly, full-frontal nudity; by the end of the increasingly grim decade that followed, it seemed a paean to an innocence irretrievably lost.

Mod Donna, a play written by Myrna Lamb and set to music by Susan Hulsman Bingham, was produced in 1970 by Joe Papp at the Public Theater. Reviewing it, Brownmiller wrote that Lamb "tells that Donna is not very Mod. Rather, she is old fashioned, the kind of girl who grew up believing that the world was attainable if only she gave her body to the right people. 'I gave at home, I gave at the office, I gave at the beach,' she says wistfully."[62] It was often described as "the first women's liberation musical," and although many critics dismissed it, for "women who were bristling at subjugation, double standards and the innate oppressiveness of a patriarchal society, the work was a significant breakthrough," a 2017 obituary noted.[63] Like all of these productions, it shone light on conditions that still affect women nearly fifty years later, and put cracks in a wall that, while battered, still stands.

The same was true of commercial cinema. The distance from the achingly sweet *Barefoot in the Park* (1967) to the stygian depths of *Looking for Mr. Goodbar* (made into a movie in 1976) was barely a decade. Lois Gould's lecture called out Marlon Brando for raping leading ladies in movies ranging from *Streetcar Named Desire* (1951) to *Last Tango in Paris* (1973), while remaining "the quintessential male sex symbol." In the notoriously explicit *Last Tango*, Gould noted, "he does not even speak before raping," while "Maria Schneider, the

heroine/victim, is instantly orgasmic." (Schneider, who was not told the details of the scene in question before it was shot, was not able thereafter to sustain her acting career; many years later, she expressed her anger at the film's director, Bernardo Bertolucci.) Gould also noted that it was only after feminists picketed outside theaters showing the film *Snuff*—in which a woman is slowly cut up, sexually mutilated and finally disemboweled as the climax to an erotic orgy—that the movie became a sellout; she reported, "the distributor remarked delightedly, 'I was praying they'd show up.'"[64]

In the 1973 book, *From Reverence to Rape*, Molly Haskell, a film critic for the *Village Voice* and the *New York Times*, put it flatly: "today we are insulted with the worst—the most abused, neglected, and dehumanized—screen heroines in film history."[65] As she saw it, "From a woman's point of view, the ten years from, say, 1962 or 1963 to 1973 have been the most disheartening." Castigating a number of directors, Haskell singled out Stanley Kubrick; while his 1962 *Lolita* was "guilty only of covert misogyny," she wrote, his *A Clockwork Orange* of ten years later, like Sam Peckinpah's *Straw Dogs* of the same year, featured the worst kind of brutalization.[66] Even such beloved movies as Milos Forman's 1975 *One Flew Over the Cuckoo's Nest*, based on Ken Kesey's novel of 1962, betray the tenor of the times: when the villainous martinet, Nurse Ratched, is violently raped at its climax, moviegoers can only cheer; her unchecked power called out desperately for revenge, duly taken by the ward's patients, all of them men (the only other women in the film are tipsy and cheerfully willing young prostitutes). Part of the problem, as Haskell saw it, was pushback: men were putting down women who'd acted up. "Sexual liberation has done little more than reimprison women in sexual roles, but at a lower and more debased level," she claimed, comparing the leading actresses of the time unfavorably to such "pre-code stars" as Pola Negri, Mae West, and Jean Harlow, who were smart, sensual, and confident. By contrast, "the sex kittens of the sixties"[67] played

dumb to "Godfather-like machismo," while the alternative—all-male buddy films such as Dennis Hopper's *Easy Rider* (1969)—wasn't much better. Even "the poor, pallid, uptight fifties,"[68] Haskell wrote, had produced more substantial female roles. The Supreme Court ruling that violence is less "injurious to public morality" than sex didn't help matters, in her view; instead, "movies went from prudery to pornography with very little in between."[69]

While some argued that fantasies of brutal sex could "be seen as a woman's way of exorcising her very real fear of rape, and of situations in which she is pure victim," the grisly outcomes proved the emptiness of the promise. Haskell concludes, "nowhere was there a glimpse of the life-affirming, passionately erotic female to which the women's movement and the sexual revolution were meant to give license."[70] And neither did this paragon of strength figure prominently in women's fiction of the time, invaluable though its insights are. It fell to visual artists to provide that model of life-affirming passion—and also to candidly represent the fully embodied experience of violation.

SINCE THE SEVENTIES

The number of rapes per capita in the United States plunged by more than 85 percent between the 1970s and the mid-2000s, and fell even while other violent offenses increased, reported the *Washington Post* in 2006.[1] The rate has continued to fall even as the definition of rape has widened considerably, and as social and legal institutions have grown substantially more responsive to rape charges. In recent years, the decline has been joined by a steep downward trend in crime generally. As one reporter writes, "The fear, once common, that walking around city parks late at night could get you mugged or murdered has been relegated to grandmothers; random murders, with few exceptions, simply don't happen anymore."[2]

Art tends to see things early. Even before the incidence of rape began to drop, women who had addressed it in their work had moved on to other concerns—as had their audience. Indeed, art concerned with women's experience of any kind was fairly well eclipsed by the mid-nineteen-eighties. In the introduction to her book about feminist performance in the 1970s, Moira Roth wrote, with considerable alarm, "The situation that confronts the American feminist movement in late 1981 is a beleaguered one. After an amazing decade of achievement, we are now in the throes of a violent backlash against feminism; many long-term feminists are exhausted by, and sometimes disillusioned with, the struggles of the last decade." As Roth went on to note, Lacy and Labowitz were among those turning elsewhere. "Both artists," she wrote, "have drawn back from their earlier

immersion in violence against women as a central core of their work."
Labowitz initiated an ongoing involvement with a community-based
organic gardening enterprise called Sproutime; Lacy continued her
own community-organizing-as-art for a variety of social causes. The
art world's attention turned elsewhere, too. In the years of Reagan
Republicanism and a growing economy, and of an effervescent art
market dominated by big, brash Expressionist painting, interest in
the searching, intimate, fugitive—and fundamentally unsalable—
women's work of the preceding years receded sharply.

By the early 1990s, the pendulum had swung again—a swing
that accompanied a sharp (if brief) economic dip. As had been true
in the similarly threadbare 1970s, less salable forms of art appeared
in force, and bodies in danger began to receive renewed attention,
this time including those threatened by HIV/AIDS. The term "identity
politics" arose to frame this work, which was often addressed in psy-
choanalytic terms. Strikingly, though, the teachings of Freud, Lacan,
and their followers, including several women, Julia Kristeva foremost
among them, were almost always used to investigate the structures of
representation and perception rather than particular experiences of
physical and psychological pain. Looking back recently, art historian
Hal Foster wrote, "In the late 1980s and early 1990s, there was a
shift in much art and theory, a shift in conceptions of the real—from
the real understood as an effect of representation to the real seen
as an event of trauma."[3] That may sound like a turn, by critics and
artists alike, toward engagement with emotional and bodily harm;
there was, indeed, a good deal of such work being made. But Foster
and others praised it instead for offering a "critique of the subject,"
which he defended against a pernicious "therapy culture, talk shows,
and tell-all memoirs, [in which] trauma was treated as an event
that guarantees the subject."[4] In other words, the poststructuralism
favored by Foster and like-minded theorists put collective assumptions
about physical integrity on the couch, but refrained from doing so to

personal lives. The confusion this engendered was considerable. On the positive side, museums were held to account for longstanding policies of gender-based and racial exclusion. Commercial imagery was examined for biases. The contributions of artists of color and of non-gender-conforming individuals began to be given more airtime in mainstream culture. But as attention turned to institutional failings, personal experience tended to be eclipsed.

As it happened, scanting subjective expression was not what drew most fire for politicized work of the nineties. *Culture of Complaint* (1993), a popular update by art critic and historian Robert Hughes to Christopher Lasch's earlier jeremiad against the *Culture of Narcissism*, targeted art that fell under the suddenly inescapable term "political correctness," complaining (as do conservatives today) that identity politics (a term almost always used dismissively) inhibited free expression. Dave Hickey, a writer also much admired at the time, published *The Invisible Dragon* in 1993; his *Air Guitar* followed four years later, confirming him as a leading voice in a loud chorus singing the praises of beauty, which, like Christmas, is always seen by some to be in mortal peril, assailed by the malignant forces of social awareness and political activism.

And, arguably, alignment can be found between such critics and a few vocal writers, including Katie Roiphe and the outspoken feminist scholar Camille Paglia, who criticized women they believed to be overstating their grievances. Roiphe did so more systematically, with her best-selling *The Morning After: Sex, Fear and Feminism* (1993). Written not long after its author had graduated from Harvard and completed a degree in literature at Princeton, it was an angry rebuke to a campus-based feminist movement promoting awareness of two newly named crises: date rape and rape culture. Roiphe railed against the young (and, largely, white and privileged) women who, as she saw it, flirted and drank too much and then cried rape when they had regrets about sexual encounters they could scarcely remember.

Roiphe doubted the widely reported statistics showing that one in four college women were subject to rape or attempted rape, and condemned what she believed to be a self-congratulatory impulse in women who spoke out against sexual assault or coercion.[5] She was able to draw on the opinions of some esteemed feminists, including no less than Betty Friedan, who had recently assailed the "rape-crisis movement," writing, "Obsession with rape . . . is a kind of wallowing in that victim state, that impotent rage, that sterile polarization."[6]

Of course, the exhortation to toughen up, take responsibility, and fight back is where the feminist push against rape began, two decades earlier. Roiphe's target demographic was fairly small, consisting largely of anxious yuppies in a moment of imperiled prosperity and diminishing political engagement. And while gentrification was on the rise, crime was becoming ever more concentrated in urban areas where poverty and violence were still epidemic. In calling out women who spoke up about dubious cases of sexual misconduct, she tacitly denied the experiences of all those who'd been violently assaulted in such alarming numbers, on college campuses and off. Another two decades would pass before a new groundswell against sexual assault would be met with a similarly divided reaction.

In any event, coddling women who proclaimed their frailty and promoting a culture of militantly enforced emotional safety was neither the dominant position taken by feminists in the early 1990s nor the leading position in the arts. The 1992 exhibition "Helter Skelter," curated by Paul Schimmel and presented—where else?—in Los Angeles, used the Beatles song title borrowed by Charles Manson for his would-be Armageddon to headline a survey of regional art from the early 1990s. Its theme, not quite unifying and far from "correct," by any definition, was a span of behavior and expression ranging from spirited mayhem to plain violence, some of it sexual. In a catalogue essay, Lane Relyea quotes without judgment Bernadine Dohrn's statement to an SDS convention ("Offing those rich pigs . . .

far out!")[7] before noting that the phrase "helter skelter" had been taken to mean "all things chaotic, from apocalyptic warfare to rocking-good fun… from running scared to running wild."[8] Other catalogue texts included contributions by novelists Dennis Cooper and Charles Bukowski; for both, violence is inescapable, not a plot point but the fabric of the language; nothing in the work lies outside it. The same could be said of the enormously influential and undeniably convention-shattering LA artist Paul McCarthy. His contribution to the show was work from the 1970s, in which blood and viscera gush from scalps, mouths, and crotches; animal parts and human ones commingle, as do, in videos, live subjects and plastic, made-for-movies human parts. The exhibition's catalogue did not altogether lack fervent expressions of pain. Michelle T. Clinton, an African-American poet (raised on the East Coast), was alone in addressing rape frankly. In "Anti-Erotica," a poem published in the catalogue, she writes, "… he was a short man inside my family / with big teeth & a hunting knife," and later, "he cut into my cave / this is something that takes me / this is fucked up inside / … i do it best when i leave / through the opening in my head… he carved his name & left semen that stinks & drips out slow."[9] It is a work of searing imagery and considerable courage.

The following year, in New York, four students in the Whitney Museum's Independent Study Program assembled a small exhibition called "The Subject of Rape." A very different exhibition from "Helter Skelter"—or the 1985 "Rape"—it suggested the influence that poststructuralist theory had had on ambitious artists and scholars, causing identity and behavior to be understood as cultural constructions. The curators pledged, in their introduction, to depart from earlier feminist antirape movements (such as those of Suzanne Lacy) that had admitted to their purview "metaphorical instances of rape—verbal abuse, manipulations of power, and legalistic, media or social practices," instead avowing, "we have chosen to move away from such a metaphorical understanding to avoid confusing these

instances with the real event of rape as experienced by real bodies in real lives."[10] But the declaration was too categorical for an exhibition organized by a committee in which opinions clearly diverged. In fact, the introduction also declares, "The subject of rape, then, is both the rape survivor and anyone, everyone, living in a culture in which rape exists as a means of control and violent domination." In its first essay, the point is repeated: "In effect, we all experience rape *everyday*, whether literally through our own bodies, or experientially through those of our friends, through representations in the media, through fear, or through fantasy."[11]

The very inconsistency of this catalogue's texts and of the work the exhibition included, while in part a consequence of the curators' youthfulness and zeal, also illuminates the quickly changing, deeply fractured landscape they had gamely set out to chart. Some of the contributions went back to the 1970s, including Ana Mendieta's work on rape and documentation of *Three Weeks in May*. There was also more recent, activist work influenced by these precedents: Annie West's *A Portable Guide to Rape Prevention* and *Stop Rape* (1993) were printed on toilet-paper rolls installed in public bathrooms, both for men (where the instructions were for restraint) and women (on active self-protection). The previous year, Peggy Diggs had used the sides of milk cartons, where public-service-announcement space had been made available for alerts about missing children, to encourage victims of domestic abuse to speak up and seek aid. Also in 1992, working together, Hope Sandrow and Robin Tewes solicited testimony from residents of prisons, homeless shelters, and elsewhere about experiences of sexual assault; viewers were invited to contribute their own stories. First-person accounts were present as well in several videos, including those by Jennifer Montgomery, Margie Strosser, and Deborah Orloff, the last of which addressed date rape.

Working with material from the commercial media, Lutz Bacher used the transcript of the 1991 trial of William Kennedy Smith in

her video; Smith had been acquitted of a rape charge brought by a woman he'd met at a Palm Beach bar while with his uncle, Senator Ted Kennedy. The spectacle of a royal family of American politics rallying behind a young man who had been accused of assault several times previously (and would be again later) proved riveting; his accuser, her face hidden behind a much-satirized blue disc on copious television coverage of the trial, never had the satisfaction of getting in front of her own story. (The Guerilla Girls, an anonymous feminist collective formed in 1985 that has been skewering the patriarchy ever since, created a poster in 1992 deploring the low rate of convictions for accused rapists; it features twenty yearbook-style photos of women, each blocked by a blue disc.) Equally rapt attention was paid to the vicious beating and rape, in 1989, of a woman long known as the Central Park Jogger; the victim's injuries made it seem unlikely she would survive. Five black boys, ages fourteen to sixteen at the time, were convicted of what was dubbed "wilding," with the prosecution suggesting a savage, unstoppable rampage. The characterization helped ensure the boys' convictions. All were exonerated in 2002, when the confession of a known serial rapist led to proof (with the help of DNA evidence) of the five teenagers' innocence; one had been imprisoned for thirteen years.

Joan Didion wrote about the case shortly after it occurred, airing her suspicion that the teenagers had been railroaded, and, in a further act of surprising independence, arguing against maintaining the anonymity of the victim, as was (and largely still is) customary. "The convention assumes," she wrote, "that this violation [i.e., rape] is of a nature best kept secret, that the rape victim feels, and would feel still more strongly were she identified, a shame and self-loathing unique to this form of assault, in other words that she has been in an unspecified way party to her own assault, that a special contract exists between this one kind of victim and her assailant. The convention assumes, finally, that the victim would be, were this special contract

revealed, the natural object of prurient interest; that the act of male penetration involves such potent mysteries that the woman so penetrated (as opposed, say, to having her face crushed with a brick or her brain penetrated with a length of pipe [as was true of the Central Park victim]) is permanently marked, 'different,' even—especially if there is a perceived racial or social 'difference' between victim and assailant, as in nineteenth-century stories featuring white women taken by Indians—'ruined.'"[12]

As it happened, the victim in this case, Trisha Meili, ultimately identified herself. She'd been in a coma for twelve days following the attack, and had no memory of it. But first in anonymous interviews, then in a book with her name on it, she expressed her wish to use her recovery as an inspiration for others; she must also have wanted to better reassemble the "before" and "after" parts of her life. Didion's contention that maintaining secrecy is a disservice to rape victims doesn't appear to have entered into Meili's considerations. But Didion's essay remains relevant not only because she delivers a forthright, incisive argument about unspoken assumptions that are still in place, but also because her essay is astutely particular to a time and place. That is not to say that rape victims ever escape prurient interest, and they are still expected—demanded, in some families and some cultures—to feel shame. The victim in this case was no exception; indeed, the response to her rape exemplified deep-seated biases along racial and gendered lines. But some of these conditions have since been mitigated, or at least more plainly exposed.

Central Park was well known at the time of Meili's assault, thanks partly to sensationalized media coverage, as the setting for repeated acts of depravity and violence; located amid some of Manhattan's most costly real estate, and then thinly guarded, it was a place where crime and wealth lived side by side. The 1986 rape and murder there of a young woman by a young man (both white) she'd met at an Upper East Side bar also long held headlines, as the "Preppie Murder." In

these closely watched dramas, complicated by crude identifications of class, race, and power, sexual violence was seen by an eager public as a terrifying specter haunting an unlucky—or unwary, or perhaps only disingenuous—few. It was understood that victims and accused alike were given to walks on the wild side. (Before and after she unexpectedly recovered and identified herself, Meili was characterized in those terms; she was described by the press as an ambitious—perhaps over-ambitious—investment banker, a graduate of Wellesley and Yale. Her running at night in the park was taken as further proof of her competitiveness, and her recklessness.) The media message was that if you didn't mess with the Kennedys (with whom you anyway probably didn't belong), if you stayed out of singles bars, and weren't dumb enough to go running in Central Park after dark, you'd be fine. Rape, many still believed, didn't happen to just anyone.

At the same time, by the 1990s these brittle narratives had begun to shatter. They were plainly exposed in Laura Fields's contribution to "The Subject of Rape," with a 1992 wallpaper design featuring terms used to characterize (and denigrate) women who report rape, and also the strikingly similar language used to diagnose female hysterics in the late nineteenth century. In *Three Seated Figures* (1989), Lorna Simpson also suggests, with elegance and economy, how little credence is given to women who report assault. Here, three identical photographs of a kneeling and anonymous black woman (the image is cropped at her chin) are flanked by the phrases "her story" and "each time they look for proof," and captioned with the designations "Prints," "Signs of Entry," and "Marks"; the imagery powerfully suggests that proof will not be established and that the victim will remain faceless and mute. Clarissa Sligh, like Simpson an African-American artist, also deploys captioned black-and-white photography toward insurrectionary ends in *Wonderful Uncle* (1988). It presents a little black girl dwarfed by the words circling around her: "Everyone said her uncle was a wonderful guy. One day he pulled a big fat thing

out of his pants and said, 'feel it! it won't bite!' She tore away from him and ran down the house. Her momma whispered, 'Hush, your father won't believe you.'" Similarly subversive is Sligh's *One Day Her Big Brother Said, "Take Off Your Pants and Lay on Top of Me."* Rape happened within families, Sligh insisted, and inside tight-knit communities; the very intimacy of the communities could help suppress the crime.

On the subject of rape and other forms of physical abuse within domestic environments and intimate relationships, no one in this period produced work more caustic than Sue Williams's. Her paintings of the early 1990s, which drew on her subjection to vicious domestic abuse, teem with small, cartoonish black-and-white vignettes depicting women beaten, humiliated, and sexually assaulted—and ruefully reflecting on their experience. Bodies are penetrated in a gruesomely wide range of ways, while other kinds of damage occurs almost incidentally: eyes are blackened, heads slammed. Critic and curator Dan Cameron took aim at theorists like Foster to write that Williams's work "flips reified discourse back on itself, lifting the veil of its dehumanizing smugness." Williams's work, as Cameron saw it, "insists that feminist critique be in contact with the crises of everyday life."[13] There is degradation aplenty in this work—indeed, the "abject" was sometimes said, and not sympathetically, to characterize a fair amount of art in this period—but Williams was too boldly, scathingly honest, and, often, too mordantly funny, to suit the term. In Cameron's account, she uses black humor "to tease the unconscious into tipping its hand."[14] Taking the subject of sexual abuse into her own hands, deflating its perpetrators by illuminating its plain, dumb ugliness—and, even better, having the last laugh—was, to put it simply, a way of fighting back. And she didn't linger there; Williams's work since has been, in the main, a jubilant hybrid of abstraction and eroticism, though her knives remain sharpened for the evisceration of male malfeasance.

On the other hand, the work of British-born graphic artist Sue Coe does not permit even the shadow of a smile. Coe, (who was represented in the 1985 "Rape" exhibition), has long moved between the realms of political cartoons and fine art; she calls herself a "visual journalist," and among the subjects she has helped bring to light is the intersection of sexual assault and the AIDS crisis. One typically unsparing drawing, from a 1993 series based on interviews with female patients at a Texas clinic for HIV-positive women, is captioned, "I was sexually assaulted by a family member at age 8." It shows a little girl lying on a bed, her eyes glassily hopeless, and a big man with his pants around his ankles pushing her down; the only points of color in the otherwise gray and black scene are the girl's tiny red flip-flops. Coe returned to the subject in 2006, talking with and portraying imprisoned women who had AIDS; their prospects on release were grim. One such drawing, of a woman's clothed corpse lying in a pool of lurid light in a narrow cobbled lane, is captioned, "Some of the women on the street sold their babies too. Only last week they raped and murdered a woman and dumped her body in the alley a few blocks from here. I don't want to die on the street."

Of course most early victims of AIDS were men, not women, and most victims of prison rape are male as well. David Wojnarowicz brought his ferocious candor to bear on the subject in *Gang Rape* (1983), which presents two gray figures in the foreground, one holding a knife to the other's neck; together these figures nearly obscure a churning sea of men in prison stripes, a melee of sexual aggression. As recently reported, the official tallies for rape don't count "the hundreds of thousands of crimes that take place in the country's prison system, a vast and growing residential network whose forsaken tenants increasingly bear the brunt of America's propensity for anger and violence." *All* prisoners are at risk of rape, this report suggests.[15] But far more of Wojnarowicz's work was addressed to the threat posed to the general population by AIDS, which, soaring in

the late eighties and throughout the nineties (it would take the art-ist's life in 1992), did so much to demonize gay sex. For gay men in those years, it suddenly seemed that rape—indeed any unprotected sex—could be lethal even without the infliction of additional violence.

As part of its global toll, AIDS has added to the horrors of rape used as a war tactic, which has gained growing attention in recent decades as local conflicts proliferate around the world, most putting civilians in their cross hairs. Few such campaigns of sexual vio-lence have been as systematic as that in Bosnia in the early 1990s, when tens of thousands of women were raped by Serbian soldiers (precise numbers aren't available). Most of the rapists have never faced prosecution; many live near their victims to this day.[16] Jenny Holzer's 1993–94 *Lustmord* makes reference in its title to the wave of lethal sex crimes in Germany between the two world wars, and to the artists who took those murders as a subject. "I knew that work reasonably well, so it was in mind, in consciousness," she says. But its proximate cause was the then recent Bosnian atrocities: "rape as policy," she calls it, adding a hellish twist to what she suggests are rape's garden-variety causes: "habit, and privilege."[17] Holzer approached the Bosnian attacks from three perspectives—victim, perpetrator, and observer—with texts voicing each position branded, as if on flesh, on the red-leather-quilted walls of a small enclosure that viewers could enter. They were also projected as red light inside two Plexiglas canisters, seemingly written in fire on air, and, more grimly still, they were etched into metal bands circling human bones. But the texts were most widely circulated, and most provoking, as photographs of tattoos written in ink on human skin and published in an otherwise wordless pamphlet inserted in the Sunday magazine of the *Süddeutsche Zeitung*, a major daily newspaper in Germany (where *Lustmord* was first shown). "I AM AWAKE IN THE PLACE WHERE WOMEN DIE" is the best known of these texts; it appeared on the magazine's cover. Others include "I WANT TO FUCK HER

WHERE SHE HAS TOO MUCH HAIR," and "THE COLOR OF HER WHERE SHE IS INSIDE OUT IS ENOUGH TO MAKE ME KILL HER."

Holzer's texts are always hard to read, physically and emotionally. Often, they are presented in a way that impedes legibility, as on LED signs that scroll too fast to quite catch, or, more recently, on giant projections that slide off building facades in the night. Even when they are (literally) carved in stone, as on the seats of granite benches, Holzer's texts resist comprehension. While the sentence construction could hardly be more straightforward, the words defy understanding. With *Lustmord*, that difficulty reaches an extremity. Meaning jerks around and logic falters; the language chokes the mind. Holzer severs eroticism from rape with an authority that seems conclusive—and also, collaterally, helps distinguish the merely graphic from the irredeemably obscene. When an interviewer observed, of *Lustmord*, "The texts are frankly, pornographically precise," Holzer replied, "I know, it was a trip to the edge. On the one hand you have to be completely realistic: in war the violent satisfaction of a soldier's urges plays an important role. It's part of his pay, a fringe benefit. On the other hand, the realistic portrayal creates the danger of its being misused as pornography." She cited documentary films about the rapes in Bosnia being sold as video porn—and, she noted, bringing the highest prices.[18] It seems safe to say her own work wouldn't satisfy the same appetites.

Over the years Holzer had alluded to rape many times. Earlier references include "Murder has its sexual side," from *Truisms*, her first series (1977–79), and, from *Under a Rock*, of the mid-nineteen-eighties, "Blood goes into the tube because you want to fuck. Pumping does not murder but feels like it. You lose your worrying mind. You want to die and kill and wake like silk to do it again." The brutality of these texts can make the acts described seem alien, almost inhuman. By contrast, *Oh* (2001) is explicitly intimate. Addressed to a child, the text states, "I have not raped you although this would

be familiar enough if I remember the family habit." The perpetrator is identified as a grandfather, "lover of any woman he could catch then rapist of children and grandchildren got from the women." *Oh* was Holzer's last work to incorporate original text. Since then, she has turned to poetry written by others and, increasingly, to paintings based on heavily redacted government documents relating to the torture of terrorism suspects; here, the black bars of censorship impede reading without suppressing meaning. Rape is not excluded from these paintings, but it has not been at the center of Holzer's work since *Lustmord*.

Sexual assault as a tactic of war, or an inevitable accessory to it, is represented as well in Joyce J. Scott's *Day After Rape* series (2008–11), in which some subtitles name combat zones: Darfur, Congo, Bosnia. Scott's exquisite little glass sculptures, assembled mostly from found and hand-blown glass beads, are the more wrenching for their delicacy. Beckoned by their seductive sparkle we come close, only to find women reduced to ravaged baubles. A tiny, brown woman, her eyes frozen wide, is hog-tied wrists-to-ankles, her legs thrust up; blood-red beads puddle beneath her buttocks. In a few examples, mangled, misassembled limbs clutch tiny glass bottles, evoking the many women victimized in African conflicts when they came out of hiding to collect water. Others were caught gathering firewood; one thus attacked is represented by Scott as a headless body impaled on a slender barked branch. In a work subtitled *Suicide*, we see the livid, ruddy, heavy-lidded face of a smirking perpetrator; he is oblivious to the wire-thin black figure, her head a staring skull, perched atop his head. Several of these sculptures employ paired tobacco pipes, their bowls serving as buttocks and stems as spread-open legs. Seen up close, these pipes reveal long use (they belonged to the grandfather of a friend of the artist), and the evidence of a man's routine touch on a familiar masculine object—of a mouth clenched around the stems and sucking hard—heightens the work's horror, and also

a sense of how commonplace such crimes are. In other work, Scott, still a resident of the tough Baltimore neighborhood in which she was raised, addresses sex trafficking, police brutality, and other crimes committed routinely, close to home—and sometimes inside it.

Scott, who is African-American, has also addressed the crimes committed against black women during slavery. Faith Ringgold took up the subject in 1985 with her *Slave Rape Story Quilt*, in which an example of one of Ringgold's favored formats—the patchwork quilt—serves as backdrop for a hand-written account that begins with rape and then proceeds to heroic resilience. But few artists addressing sexual violence as an institutionalized practice have attracted more attention, or controversy, than Kara Walker, who in the early 1990s began presenting epic murals depicting barbarities committed in the slave-holding American South. Walker's first significant exhibition, in 1994, was "Gone: An Historical Romance of a Civil War as it Occurred b'tween the Dusky Thighs of One Young Negress and Her Heart," its title (which opens with a reference to *Gone with the Wind*) an early indication of the deep internal conflict that she would continue to address with such unsettling honesty. Composed of silhouettes cut from black paper with remarkable grace and precision—reprising a genteel art popular in the Victorian era—Walker's early work introduced her distinctive vocabulary, in which acts of polymorphous libidinousness and frank brutality are conducted by figures in period dress. Masters and slaves alike, including women and children, are penetrated in every conceivable way. Walker gives the Sadeian debauchery the visual sweep of historical cycloramas, another form favored in the nineteenth century. In subsequent work, involving various forms of freehand drawing on paper as well as video using animations of the black-paper silhouettes, Walker has continued to stoke an incendiary mix of virulent racism and bawdy humor; her graphic facility, itself deeply seductive, only raises the temperature of her work's provocations. In her most recent imagery,

she addresses current political conditions, without losing a focus on the sexualized rage animating so many acts of racial violence.

Yvonne Rainer's 1990 film *Privilege* confronts received narratives about race, violence, and gender in a way that compounds their complications. Beginning with documentary footage of interviews Rainer conducted about menopause, *Privilege* soon opens out to a number of narrative threads alternately fictional and true; the central strand, she later explained, is based on a personal experience. In the late 1960s she lived on the Lower East Side of Manhattan, and a man from the building next door, who she recalls was drunk, climbed through the window of her downstairs neighbor; this neighbor's screams brought Rainer to her aid. An accusation of rape was made. The alleged perpetrator (like almost everyone on the block) was Latino; his accuser was white. It is not clear, at the film's conclusion, whether a sexual assault occurred. Rainer's dizzyingly refracted consideration of an ambiguous event that had occurred, at the time of the film's creation, more than twenty-five years earlier, pries open the buried fault lines of a culture under stress. Its protagonists, straight and lesbian, Latino and Anglo, all members of a small community—a single block in Manhattan—each struggle to construct a sense of safety and independence, and to understand the social forces constraining their efforts. In its refusal to reach a verdict about the guilt of the accused, or about even whether a crime took place, *Privilege* echoes the many literary representations, in the 1970s, of similarly equivocal assaults. At the same time, it points toward a tendency in subsequent work to address rape in historicized and otherwise conceptually distanced terms.

For example, in 2007, Eve Sussman turned to a venerable subject with her feature-length film, *The Rape of the Sabine Women*. Elegantly stylized, it is set in the 1960s, although Sussman says its inspiration was paintings of the subject by canonical masters: Poussin, Rubens, David. It features men in natty suits and women in sleek sheaths and

dark glasses, disporting themselves at various sites of modern luxury and anomie—the waiting area of an airport in Berlin, poolside at a villa on the Greek island of Hydra. But the action at the story's heart takes place in a bustling, crowded market in Athens, where, amid heaps of produce and hanging sides of bloody meat, one woman after another is silently disappeared, yanked downward and away amid the commotion by unseen assailants. In Sussman's telling, rape is an aporia: an event that vanishes in plain sight.

Shirin Neshat's *Women Without Men* (2009), another full-length film, is also set in the near past (it follows three shorter videos, all based on a novel of the same name). In this case the setting is Iran in 1953, when a coup, supported by Britain and the US, overthrew the democratically elected Mohammad Mossadegh and installed Shah Mohammad Reza Pahlavi (who was deposed in turn by the revolution of 1979). The political tensions of the period established the conditions in which Neshat grew up, and they are evoked with both warm nostalgia and blunt terror; as in all of Neshat's work, allegory and realism intertwine. One of the characters, Faezeh, is victimized twice, first during a stylized passage that has the shape of myth; this violation, in a misty wooded grove, is seen in short glimpses of silent, dreamy horror. Later, in an act that is grounded in reality and no less frightening, Faezeh is assaulted by two men who see her in a coffee shop in Tehran and follow her out. Danger, in *Women Without Men*, shifts kaleidoscopically; it arrives with the implacable advance of marching troops; with abusive men bent on sexual gratification; and also with the eruption of deeply rooted fears that, nourished by circumstances, overwhelm consciousness as effectively as the impact of one body against another.

The past to which Mickalene Thomas's *Me as Muse* (2016) refers is that of Eartha Kitt's childhood and early adulthood in the 1930s and '40s. Various images of the legendary singer and activist, and also of the artist, play across the stacked monitors of this twelve-screen video

installation. Reclining in a pose borrowed from Titian's *Odalisque*, Thomas appears and disappears part by part and screen by screen, from her long legs to her grave, tear-stained face. The imagery also includes patterning—Benday dots, snakeskin—and photographs of various models of beauty: Grace Jones, Saartje Baartman, a portrait by Modigliani, the Titian nude. We hear Kitt, in a rare recorded interview, tell of abuse she suffered in the home where she was placed as a housekeeper by her mother; Kitt explains, too, that she was conceived when her mother was raped by a plantation owner's son, and that her skin color betrayed this offense. After revealing these hairline breaks within families and communities, Kitt concludes, with withering dignity, "a man has always wanted to lay me down but he never wanted to pick me up."

As these younger artists addressed sexual predation and assault, some of the women on whose work they'd built continued to do so as well. With *Vanilla Nightmares* (1986–90), a series of charcoal and crayon drawings executed on pages taken from the *New York Times*, Adrian Piper took on sexual violence even more explicitly than she had in the Mythic Being project. Calling these works "illuminated manuscripts," Piper explained that she selected pages "for their racially loaded content, their graphic imagery," and their "subliminal connotations." Bigots, she argued, justify their rage by constructing fantasies "about blacks as supernaturally strong or sexually potent; as feral, lascivious, wanton invaders." Then they paint themselves as victims: in Piper's analysis, racists are deadly frightened of the monsters they fashion and, in essence, are driven by a "fear of the violation of boundaries, of invasion, of penetration"—a fear shared by all in power. In short, "fantasies of rape, and fears about sexuality... are central to an understanding of racism."[19]

Vanilla Nightmare #3 is drawn across a newsprint ad for Bloomingdales, in which a white female model is menaced by a big dark man, drawn in charcoal. Grimacing slightly, staring straight at the

viewer, he places one enormous hand on the model's shoulder—protectively, maybe, although its placement also suggests strangulation. Another Bloomingdales ad is the backdrop for *Vanilla Nightmare #12*, which features a white model whose body is swapped with a nude brown one, visible beneath a transparent dress; Piper also adorned her with a costume-ball-style mask for her eyes. Two standing black figures serve as wary sentries. Highlighted in the ad copy are the words, "Say Yes." In *Vanilla Nightmare #1*, Piper adds "What If?" to the headline, "The World Is Watching," which appears on a page of news and opinion about South Africa (then still under apartheid). The drawing laid over most of the newsprint is of a naked white woman on her hands and knees, cautiously smiling; a powerful black man with his hands on her hips is penetrating her from behind.

When Anita Hill testified to sexual harassment by Clarence Thomas in 1991, a galvanizing moment in feminism's history, Piper initiated the series of photo-and-text works *Decide Who You Are*. In nineteen of its twenty triptychs, one or more news photos—subjects include a young white woman screaming at a black female student attempting to cross a color line, and a young black man being arrested—are flanked by two images. On one side, there is a drawing featuring the proverbial "three wise monkeys" (with paws over their ears, eyes and mouth, they neither hear, see, nor speak evil), overlaid with texts by Piper about, among other things, exposure and vulnerability. On the other side is a photograph of Hill as an eager, smiling child, on which is superimposed a long, run-in assembly of dismissive comments made to Piper by colleagues: "I don't know what you mean. I didn't notice anything wrong. It seems fine to me. You're overinterpreting the data. You're blowing the whole thing out of proportion," and so on. Linking the idiom of contempt, and photo-documentation of abuse and violence, with shorthand images of willed blindness, deafness, and silence, Piper fully honors Hill's experience. Her testimony to violation was dismissed; Clarence Thomas sits on the Supreme Court.

With the Mythic Being, Piper had taken all the energies of her argumentation into her own body, which virtually bristled with conflict. In *Vanilla Nightmares* and *Decide Who You Are,* she restored those tensions to the world from which they come—a shift that aligned her with those younger women who, even when addressing sexuality and violence, by and large declined to put themselves into their work as nakedly (in every sense) as so many women in the 1970s. That is not to say the work's force is thereby blunted. *Vanilla Nightmares* is an indictment as clear as the headlines it appropriates and no less compressed. While Piper says her aim in bringing awareness to the sexualized nature of racism is that it can thereby be better "managed,"[20] she offers no promise of solution (which is not, properly, required of those on the receiving end of violence). And, like many other women, she firmly moved away from the internalization of aggression.

There were exceptions to this choice. Along with pioneering cyber-art, Lynn Hershman Leeson also revisited sexual exploitation in the 1980s, in a series of videotaped monologues called *The Electronic Diaries*. Positioning herself very close to the camera, and at a slight angle, which makes her face nearly monocular (like a camera) and a little menacing, Hershman Leeson speaks in a quietly authoritative, falsely soothing voice (like, perhaps, a molester) of being subjected to incest as a child. She talks about the dissociation that is a consequence of rape. And as in the earlier Roberta Breitmore project, the artist visibly struggles to control the narrative, a struggle that, she says, is tied to her early, doomed effort to control her own body. She has written of her early life, "When I was growing up, my 'bedroom' was a well-traveled hallway between the kitchen and the bathroom. I often felt like a lower case 'I' who longed for both privacy and visibility. The pursuit of autonomy became my life's work. Eventually, through persistence and vigilance, I became my own witness and my own private 'I'."[21] While encouraging us to doubt her reliability as a narrator,

and at the same time actively seducing us, Hershman Leeson "drops us," one critic has written, "in an abyss between belief and denial."[22]

Suzanne Lacy, too has remained intermittently engaged with sexual violence, most recently in *De tu Puño y Letra* (By Your Own Hand). For this project, undertaken in Quito, Ecuador—a city where, statistics show, the majority of women are victims of violence, many at the hands of their partners—Lacy worked with city government departments, NGOs, art organizations, and educational institutions toward a 2014 event presented in a bullring. Its most consequential departure from precedent was to put men center stage, reading aloud the testimony of women: a remarkable turn. There have also been partial recreations of Lacy's *Three Weeks in May*, in Los Angeles in 2012 and in Milan in 2014. Prominent among other revivals of landmark performances from the 1970s was *Seven Easy Pieces*, presented at the Guggenheim Museum in 2005. Conceived by Marina Abramović, who worked with curator Nancy Spector, the program reconstructed six performance works, including VALIE EXPORT's *Action Pants: Genital Panic*. Yoko Ono's *Cut Piece* has been re-presented many times, by Ono and others, including a 1993 version by Hershman Leeson. The Cuban social-practice artist Tania Bruguera early on paid homage to Ana Mendieta's blood-based imagery. Other artists who have revisited performance work of the 1970s include Sophie Calle, whose artist's book *Suite Vénitienne*, first published in 1988 and recently reissued, documents her project of following a man she'd recently met through the streets of Venice; among other things, it redirects the gendered energies of Vito Acconci's *Following Piece*. Andrea Fraser, in an untitled work of 2003, engaged in videotaped sex with a collector in a hotel room, an act she considered a collaborative performance (for which the collector paid an undisclosed sum). Though Fraser raised the stakes of work by Hershman Leeson and Abramović that had also toyed with prostitution, the questions at issue, about coercion, choice, and compensation, were the same.

Of course mainstream media productions about sexual violence continued to proliferate in the decades after the seventies. Among recent examples is *The Witness*, a 2016 documentary about Kitty Genovese, whose 1964 murder in a quiet area in Queens, New York, quickly became a famous symbol of urban indifference. (A headline newspaper account at the time claimed, without basis, that thirty-eight people witnessed the crime but did nothing to help her.) In the documentary, the murder and its distortion in the press are analyzed by Genovese's brother, a dedicated sleuth. Little attention had been paid to the rape that preceded Genovese's death. Still less discussed, even after the documentary's release, were the assailant's additional confessed rapes and murders—including one of a black woman who was knifed, sexually assaulted, and then burned to death in her home. (Scanted too was Genovese's sexuality; she was a lesbian survived by her devastated female partner.) In the mid-nineteen-sixties, the murder sounded a strident—and false—alarm for what were pictured as remnant middle-class residents trapped in once-promising neighborhoods, now lawless and pitiless. *The Witness* could hardly have been made at that time, though by the '90s, when the commercial media turned to sexual violence in force, it would have had a chance.

The well-regarded television series "Law & Order: Special Victims Unit" has been running for roughly twenty years—there are more than four hundred episodes to date—having premiered in 1999; the NY Police Department unit to which its title refers handles sex crimes, and some of the grisly plotlines are derived from actual events. (It was initially impelled by the "Preppie Murder" case of 1986.) The wide spectrum of crimes addressed in these shows, like the new information that *The Witness* brings to a seemingly well-worn narrative, suggests the cataract of changes that have occurred over the past several decades in understanding the complexities of sexual assault.

These complexities—or better, confusions—are on full display in *Elle* (2016), a film directed by Paul Verhoeven. As it opens, in

darkness, we hear the unmistakable sounds of assault—fists slamming into flesh, grunts and groans, crockery shattering—but also heavy breathing that suggests pleasurable sex. The film's protagonist, a successful, no-nonsense businesswoman played by Isabelle Huppert, is first shown lying on the floor amid the broken plates and glasses; wearing a slinky black dress, she looks angry but not much rattled, maybe even a little intrigued. Following another brutal rape, this one shown in full, she pulls off the assailant's mask and discovers he is a neighbor to whom she'd been attracted; indeed, she'd been watching him and masturbating. The next time they meet, it is for consensual sex which gets rough; she enjoys it. But he doesn't want her pleasure, so she reverts to (feigned) fear. After a third uninvited attack, again involving brutality, her adult son walks in and, aghast, kills the intruder: job done. We're left with the image of a woman so strong and self-possessed she can turn the power of evil against itself, jujitsu-style, and find pleasure in the bargain. Or so the director would have it. *Elle* was promoted, and to some degree accepted, as a film about a kind of female sexiness fully compatible with rather stunning strength—a feminist film.

The argument has also been made that in *Elle* (as in some other recent movies featuring vengeful, powerful women), unmasking a kindly, handsome neighbor as a predator provides a useful counter-example to the stereotype of rapists as degenerate brutes. Be that as it may, *Elle* seemed to me the rankest male fantasy (along with the director, the screenwriter and the author of the novel on which *Elle* is based are men)—a thoroughly misogynistic dream of women who dress as babes and enjoy getting fucked by masked intruders while being beaten almost to death. Along with many kinds of art addressing rape with sensitivity, this too is part of our current culture.

While commercial media continue to dominate the representation of violence, performance remains a potent form for younger artists addressing sexual assault. In 2014, Emma Sulkowicz, then

an undergraduate at Columbia, began carrying her mattress around campus on a daily basis. Called *Carry That Weight*, the performance was undertaken to draw attention—it did, in spades—to a rape she said had been perpetrated by a fellow undergraduate (the charge was challenged). Sulkowicz was both deplored and lionized: the feminist scholar Camille Paglia called her performance "a parody of the worst aspects of that kind of grievance-oriented feminism"; NOW presented her its 2016 Woman of Courage award (one wonders what Betty Friedan would have thought). Sulkowicz has followed up with several even more provocative, though less newsworthy, works.[23] The enormous response Sulkowicz generated, particularly with *Carry that Weight*, suggests that attention paid to victims of sexual violence, particularly within the art world, is disproportionately on privileged, young, and attractive women who have the wherewithal to state their cases.

But the bulk of recent work addressing sexual violation suggests, more promisingly, that in the decades since the 1970s, artists' responses have become increasingly specific and nuanced. Where early performances expressed a generalized experience of threat, and then a nearly wordless horror, later work has grown more articulate and particular. There are losses and gains in this progression. Competing grievances vie for attention. On the one hand, righteousness threatens; feminism continues to fracture. On the other, perspectives have grown more acute, and a multiplicity of voices has arisen, offering a wealth of emotional and practical information—and abating the loneliness that was once among the most painful aspects of surviving rape.

CONCLUSION

When I asked Jenny Holzer whether she felt that sexual violation had become a more—or less—pressing subject since she first addressed it in her work, in the early 1980s, she said, "Unfortunately, not a whole lot has changed. There's my whole manifesto." Then she added, without missing a beat, "Well, to the point, and since more people are saying it these days, it's easier: I was raped when I was a little kid. So, this hasn't been an abstract topic."[1]

As Holzer went on to acknowledge, simply saying so, publicly, was a fairly significant change. She credited the #MeToo movement as an important factor in opening up the discussion, permitting the widespread incidence of experiences like hers—they are horribly common, as she was quick to point out—to become better known. The importance of speaking out has become inescapable, even to those deeply reluctant to relinquish their privacy. Stephanie Blackwood, a long-time fundraiser for feminist and LGBTQ causes, who organized the groundbreaking 1985 exhibition "Rape" and who noted at the time that the show rendered its audience largely silent, recently came across its catalogue and related material and told me, "I realized I had dissociated myself from the fact that I was sexually molested as a child and date-raped more than once while in college. In the 1980s, I didn't think of the subject of the show as having anything to do with me. The times were inhospitable to that discussion."[2]

Shocking, perhaps, though neither implausible nor rare, that kind of dissociation appears to be breaking down in the present cultural

climate. But the still urgent need for collective action only supports Holzer's initial response. Susan Griffin, when I put the same question to her, gave a similar assessment of progress since the seventies. I asked whether the condition she described in the opening sentence of her first book—"I've never been free of the fear of rape"—still held true, and she replied, "Very much so. We're still carrying around that kind of fear. You can't walk down a street at night without being worried if there are footsteps behind you." "So things haven't really changed substantially?" I pressed her. And she said, "Not enough."

That judgment was painfully corroborated on the national stage in the response to Christine Blasey Ford's testimony during Supreme Court Justice Brett Kavanaugh's confirmation hearings in fall 2018. Her account of his attempt to rape her when they were both teenagers—like Anita Hill's reports of sexual harassment by Clarence Thomas under similar circumstances—was met with appalling ridicule. Shattering to Blasey Ford, the hearings mark a nadir in civic decency. It is cold comfort that the crime she recounted, like those committed by Bill Cosby and so many others recently in the news, occurred decades ago. Too many men are, like Kavanaugh and Thomas, exonerated; indeed these men are validated when they describe themselves as victims. In a series of collages (all 2018) titled *Apologia*, Betty Tompkins has taken small reproductions from art history books of canonical paintings, often featuring sex, violence, or both, and written over their subjects, in pink letters, excerpted statements of decidedly unapologetic responses to accusations of predation by men ranging from Charlie Rose and Les Moonves to the the Columbia University photography professor Thomas Roma and the celebrated painter Chuck Close ("No one ever ran out of the place . . . I acknowledge having a dirty mouth but we're all adults"). The cumulative doublespeak is grimly amusing. Even for men with access to the best that public relations advisors can offer, and alert to the possibility of real professional (if not legal) consequences for their behavior, remorse does not come easy.

Indeed by some measures, things have gotten worse. In the Internet age, pornography has become not only vastly more widespread but also more violent, and more degrading. As one recent account puts it, "Pornography has changed unrecognizably from its so-called golden age—the period, in the sixties and seventies, when adult movies had theatrical releases and seemed in step with a wider moment of sexual liberation."[3] The shift has been toward the short and hard-core, making porn even more "conservative, brutal, and anonymous." And its reach has exploded; Pornhub, the most popular online porn site, had 80 million visitors a day in 2017. Moreover, according to another recent report, familiarity with pornography now comes early; on average, boys are around thirteen and girls a year older when they first encounter it, often inadvertently. A 2008 study of college students showed that 93 percent of males and 60 percent of females had seen online porn before they were eighteen. Perhaps most alarming, a study of best-selling porn videos revealed that the great majority of scenes showed verbal or physical aggression, "mostly spanking, slapping and gagging." Both porn and mainstream media, this report concludes, have made "anal and rough sex seem almost commonplace." The percentage of eighteen-to-twenty-four-year-olds who reported trying anal sex rose to 40 percent in 2009 from 16 percent in 1992.[4] It may be possible (just barely) to interpret this last statistic as a positive sign of greater openness about the full range of sexual activities open to consenting partners. But the more powerful implication, that women's desires (and aversions) are not being acknowledged, is certainly reason for despair. Further down the rabbit hole one finds *RapeLay* (released in 2006) and *The Guy Game* (2004), first-person video games with avatars that are rapists rather than shooters. No doubt there is worse.

If this inundation of the teenage brain by crude representations of rough sexual acts, so many of them particularly debasing to women, is clearly troubling, there is cause for worry, too, in a more diffuse

way, over growing up in the age of social media. To be sure, there are upsides to coming of age in a wired world. The connectedness of contemporary life, the ease of access to information and the emphasis on collaborative learning, and the surge of collective projects in the art world as in other fields are among the positive outcomes. From some perspectives, solitude seems an ever-receding horizon. On the other hand, bullying—a hallmark of social media—and the blurring of boundaries between digital and physical connectedness have deleterious repercussions. Being digitally shamed and physically attacked can have remarkably similar psychological (if not yet legal) consequences, especially for those who have grown up with digital forums as essential mediums of friendship. Nevertheless, and incontrovertibly, we're all still animals, not extensions of a digital hive mind or just the wet matter connecting better, abler mental and physical prostheses. We would like, as humans always have liked, to control our bodies, and especially the parts of them named private.

And—headline-grabbing events to the contrary—it appears that, at least statistically, considerable progress is still being made in reducing the number of sexual assaults. Data show that in recent years in the US, the incidence of rape has continued to decline. According to an FBI Unified Crime Report, in 1993, there were roughly 900,000 rapes and sexual assaults in the US; in 2011, there were 250,000.[5] During the period 1990 to 2011, the rate of rape per 1,000 people aged twelve and over dropped from 4.3 to 0.9.[6] True, such data are as open to challenge as ever. A *New York Times* editorial of May 12, 2018, reports, "From 2009 to 2017, detectives in the Special Victims Division [of the New York Police Department] investigating adult sex crimes saw their caseloads rise by 65 percent."[7] Noting that only two detectives were added in that time, the editorial affirmed, "While other major crimes have continued to fall, reported rapes have increased."

The key word in accounting for such discrepancies is, of course, "reported." In June 2015, Ginia Bellafante, who has written repeatedly

on this subject for the *New York Times*, noted statistics showing a growing incidence of rape (alone among violent crimes), but added, "those ministering to rape survivors... attribute the rising numbers to an uptick in the reporting of the crimes."[8] And Bellafante drew attention to an important distinction. Of 540 rapes recorded in the city in the first five months of 2015—an 8 percent increase over the same period in 2014—only thirty-nine were committed by someone the victim did not know; in 2012, 7 percent of all rapes were attributed to a stranger in New York City (half the national average). She further noted that of the "roughly 166 so-called stranger rapes" in New York in 2015, the highest concentration, nine, occurred in and around the Mott Haven section of the Bronx,[9] a neighborhood of deep-rooted poverty. In other words, stranger rapes, of the kind that rose so frighteningly in the 1970s, are uncommon now. And the women targeted continue to be disproportionately poor, nonwhite, and unheard.

In June 2016, Bellafante returned to the subject of violence against women, this time focusing on domestic assault. "The statistic that one in five women will be sexually assaulted is surpassed by the figure that one in four women will experience domestic violence in the course of her lifetime," she wrote. Moreover, the danger is not evenly distributed. "The truth is that you are far more likely to become a victim of domestic violence if you live in Central Brooklyn than if you live on the Upper East Side or in Georgetown. According to city data, domestic homicides are 65 percent more likely to occur in neighborhoods with high rates of poverty." Nonetheless, she continued, "Those who commandeer the cultural conversation online are more apt to know someone who has experienced a traumatic sexual encounter in a [college] dorm room than someone who has been beaten or shot by a disgruntled former boyfriend who did not graduate from high school." Bellafante concludes by asking, "What would a war against domestic violence look like? To some extent it

would look like a war on poverty. A war against the bouts of social narcissism that afflict the upper classes."[10]

In a further exploration of race- and class-based disparities in rates of crime, and of recourse for its victims, the *Times* explored the findings of a "blistering" Justice Department report on police behavior in Baltimore, following the death in police custody there of a young African-American, Freddie Gray. In addition to bias against black men, the report, according to the *Times*, "also exposed a different, though related concern: how the police in that majority-black city treat women, especially victims of sexual assault." The Justice Department "painted a picture of a police culture deeply dismissive of sexual assault victims." The report found "officers sometimes humiliated women who tried to report sexual assault, often failed to gather basic evidence.... Some officers blamed victims or discouraged them from identifying their assailants, asking questions like, 'Why are you messing that guy's life up?'" A victims'-rights worker said she had worked with women "who had been the victims of sexual misconduct by officers themselves." From 2010 to 2014, "rape kits, which hold forensic evidence gathered by doctors and nurses, were tested in only 15 percent of Baltimore cases involving sexual assault victims." The abusive culture apparently extended to prosecutors. "In one email exchange," the Times reported, "a prosecutor referred to a woman who had reported a sexual assault as a 'conniving little whore.'"[11]

The glaring inequality between the protection on offer in wealthy and poor neighborhoods was also the subject of a report that in 2016, the Bronx had the highest violent-crime rate of New York City's five boroughs but the thinnest detective staffing.[12] For plenty of good reasons, residents of disadvantaged communities don't trust police—whether to find culprits, to keep residents safe, or to refrain from shooting them. If white women remain leery of bringing rape charges to the police, the likelihood that women of color will do so seems far lower.

These injustices pale, in turn, beside the record of ongoing sexual assaults around the world: an eight-year-old girl gang-raped and killed in Pakistan, her assailants unpunished; thousands of women taken into sexual slavery by ISIS, in Iraq and Syria, and by Boko Haram, in West Africa; and on and on. In 2017, a major victory was heralded when Lebanon, following Jordan, Tunisia, and Morocco, repealed a law that allowed rapists to escape punishment by marrying their victims; similar laws remain in force elsewhere. The Nobel Peace Prize committee honored two activists against rape as a weapon of war in 2018. One, Denis Mukwege, helps the uncounted victims of sexual violence in the Democratic Republic of Congo. The other, Nadia Murad, a Yazidi-rights activist, is a survivor of sexual slavery by the Islamic State. But as Murad noted, at the time of the award, three thousand Yazidi women and girls remained in sexual captivity with Islamic State fighters.

At year's end in 2018, I had the good fortune to see a performance of a segment of the Mahabharata enacted and danced by students in a rural South Indian school for disadvantaged youth.[13] The performers, many of them girls and young women (though traditionally the Hindu epic is performed by men), presented the scene in which the royal woman Draupidi is threatened with being stripped and assaulted by a clutch of men to whom her husband has just gambled her away. Foiled, the tale goes, by a magical, never-ending sari, the aggressors were also opposed, in this version, by a performance of staggering ferocity. The young actress, in gloriously unfurling silks, spun her slender body furiously; her ankles rang with bells, her heavily made-up face was livid with rage. She had cause. The next day, five million women in the South Indian state of Kerala are reported to have lined up shoulder-to-shoulder to protest their country's tolerance of violent misogyny; in 2018, a Thomson Reuters Foundation poll found India the world's most dangerous country for women.[14]

Horrific policies and crimes elsewhere are, needless to say, no cause for minimizing lapses in protection for women in the wealthy global North, nor for demonizing other cultures. Least of all should they obscure the injustices done too often to women of color and poor women by the American judicial system, press, and culture. Children as young as eleven are coerced by family members to marry rapists who have impregnated them in the US, with the support of the legal system; as of 2018, only one state (Delaware) forbids the practice.

Among Adrian Piper's recent works is a four-part series, *Everything #19: Megan Williams* (2007), which draws attention to a young African-American woman allegedly assaulted by six whites. The first in the series is a text work written in white on a wall painted pale gray, a shade achieved by mixing nine parts white to one part black—the approximate proportion of African-Americans in the US population. The nearly illegible text is taken from a report that appeared in the *International Herald Tribune* in mid-September 2007, "but not," Piper explains, "in the American edition of the *New York Times*, owner of the *Tribune*, or in any other major American newspaper of national stature." This wall work was followed by a "page work" composed of sixty-four pictures representing all the women named Megan Williams that Piper found on Google Images on a search in October 2007; the victim was not among them. The pictures are grouped in fours; at the bottom of each set is a different paired combination of mugshots of the perpetrators. The *Tribune* report described a week-long attack on the twenty-year-old Williams, in the Virginia trailer where she lived, by six "European Americans" (as Piper describes them); they included two parent-child teams, one of a mother and daughter, the other of a mother and son. Williams was allegedly forced to eat animal feces and drink her tormentors' urine; she was raped and made to perform oral sex, beaten with sticks, stabbed with a butcher knife, doused with boiling water, called a n***er, and

threatened with death. Not least disturbing, Piper reports searching the press for a year and finding this crime received no mainstream media attention in the US whatsoever.[15]

Admittedly, the protracted assault on Megan Williams was, as reported by its victim, exceptionally gruesome. But it falls into a category—specifically, vicious attacks on nonwhite, nonprivileged women, and more generally, rapes by strangers—that almost never appear in the torrential current coverage of sexual violations. A standout in a 2018 exhibition of contemporary artwork about rape organized by Monika Fabijanska for the gallery at the John Jay College of Criminal Justice in NYC was a 2016 video by Naima Ramos-Chapman. A young woman of color, Ramos-Chapman recounts being wakened from sleep by a man she found "behind me, on top of me, inside me." In this stunningly honest account of the assault's aftermath, we learn of her numbness, rage, and fear, and we hear the cheerful assessments of a counselor and lawyer. But the video's title, *And Nothing Happened*, summarizes best how Ramos-Chapman experienced the responses of others to her rape.

These are not the kinds of stories with which the press is principally concerned. Instead, we read about date rapes and, increasingly, about sexual liberties taken by those with professional, academic, or other institutional advantage. There is no reason in the world to minimize the damage done by such abuses, and their extent continues to shock. But we should question why we hear about certain violations repeatedly, while others go unreported. We should consider that harm also lurks in the clamorous need for attention inherent to a movement identified by the assertion, "me too." How is it that, while in the twenty years up to 2011 the number of rapes per one thousand people aged twelve and over dropped to less than one,[16] the number of reported rapes for female college students per one thousand students stood at 27.7?[17] In 2015, roughly a third of female undergraduates at Harvard reported nonconsensual penetration and/

or sexual touching.[18] Why are women on campuses falling victim at such a catastrophically epidemic rate? Why are so many of the victims who are speaking up, on campus or off, young, white, and privileged? Is it not possible that these numbers reflect an imbalance in the abuse that is reported—to the authorities; by the media—rather than so steep a discrepancy in the victims of sexual violence?

To place the blame on "rape culture" is to deploy a fraying term that tends to hypostasize regressive gender stereotypes that are otherwise now being widely challenged; it is no longer generally accepted that men, as a known, fixed quantity, are all by nature physically strong, socially implacable, and inherently predatory, nor that women, also a known and fixed quantity, are the opposite: virtuous, weak, undefended by social institutions. But in discussions of sexual aggression, this moldy binary lives on, an inheritance from the early years of second-wave feminism, when these definitions were seldom questioned. There are other bafflements to the current situation. It cannot be denied that a culture of impunity still exists, maddeningly. But it is also true, twenty-five years after Katie Roiphe's manifesto, that many young women seem to expect victimization will be part of their maturation process. As Melissa Gira Grant writes, in *Bookforum*, "The usual feminist origin story unfolds as a series of firsts: first feminist book read, first feminist action attended. Or a series of wounding rites of passage: first grope, first shaming, first rape."[19]

This sense of inevitability—and the passivity it implies—has not escaped notice. Neither has the disjunction between the language of consent that young men and women are urged to use and their ability, or willingness, to do so. Observing an episode in Emily Witt's book *Future Sex*, Alexandra Schwartz writes, "In the 'red hot desire' orgasmic-meditation exercise, Witt tells her partner that her wish is 'to surrender to another person without having to explain what I wanted.' The expectation that a person learn to articulate his or her pleasure is crucial to contemporary sexual mores, the key to consent.

It also means that you have to know the right words for what you want."[20] And, she might have added, you have to choose to use them.

It has been noted, too that lapses in sexual correctness have repercussions beyond their effect on young women's experience. Zoë Heller, writing in the *New York Review of Books*, addressed extra-judicial date-rape penalties against alleged sexual offenders handed down without trials by college administrations: "The perils of this ends-justifies-the-means calculus . . . ought to be self-evident. It is a moral and strategic error for feminism—or any movement that purports to care about social justice—to argue for undermining or suspending legitimate rights."[21] The following year Heller addressed this issue again, in a review of Peggy Orenstein's book *Girls and Sex*, which included a study that found "girls are four times as likely as boys to consent to sex they don't want." Such studies, Heller wrote, challenge the assumption that "it is useful or fair to apply the bright line of 'yes means yes'" when young women have specifically demonstrated they lack the ability or willingness to enunciate their wishes. She concluded, "Much of the recent discourse about girls and sex has tended to reinforce rather than to challenge the idea of female vulnerability and victimhood. It would be a salutary thing to have some old-school feminist pugnacity injected back into the culture."[22]

Heller is hardly alone. Among the old-school activists to have weighed in is historian and one-time SDS leader Todd Gitlin, who wondered, in a 2015 op-ed piece for the *New York Times*, "Why the lust for 'safe spaces'? Why the clamor for 'trigger warnings'?" Dismayed that students offended by Ovid's accounts of rape in *Metamorphoses* had caused its removal from the syllabus for a required course at Columbia University, where he teaches, Gitlin pronounced, "Radical change is not for the narrow-minded or weak-hearted."[23] Similarly, when I asked Susan Brownmiller, in 2016, how conditions had changed since the 1970s, she replied, "Our movement was not a college campus movement. We were already out in the world"[24]—a statement that

was shorthand for a teeming welter of contention. Just a few months earlier Brownmiller had been asked by *New York* magazine if she was following the discussions of rape on college campuses; she had replied, "Yes, very closely," adding a rueful comment about young feminists' apparent ignorance of their predecessors. Urging women to stand up for themselves, to refrain from drinking themselves into oblivion and then claiming to be innocent of responsibility for their behavior, she called for attention to the broader range of women who are attacked: "women in housing projects and ghettos are still in far greater danger than college girls,"[25] she pointed out. Before the day was out, Brownmiller's remarks were headlined on *The XX Factor* as "Former Feminist Hero Somehow Thinks That Victim-Blaming Can Stop Rape."[26]

As a panel discussion at a PEN America Town Hall Meeting in early 2018 made clear, there is a formidable generational divide on such questions of responsibility: older women, it was agreed, are more inclined to give the benefit of doubt to men. Panelist Masha Gessen—a cultural critic who, born in 1967, perhaps bridges the generational gulf (and, as a queer activist living alternately in Russia and the US, several other divides as well)—noted that "older people are more sensitive about privacy," which inclines them toward protecting the accused until judgment can be rendered in court, rather than toward preserving the freedoms of social media and an increasingly incautious mainstream press. Echoing the pro-sex feminists of the 1980s, Gessen posed the rhetorical question, "Why are we still talking about men getting sex and women giving it?" Her answer, in part: "at the root of this conversation is this idea that sex is inherently scary."

Some continue to be concerned, not without reason, about prejudicial judgment of men charged with sexual assault and also about abuses of the legal process. Historian Jill Lepore reports that in the penalty phase of the 2018 trial of Larry Nassar, the doctor best known for treating—and molesting—Olympic gymnasts, nearly 150 women

were allowed to make victim-impact statements, although he had already been sentenced to sixty years in prison. The courthouse, in Lepore's description, became a theater of catharsis, awash in tears. "Some of what happened in the Nassar trial," Lepore observes, "is as new as #MeToo. Much of it is as old as stoning." Summarizing the surge of activism on behalf of victims, a movement born in the mid-nineteen-seventies in an unlikely partnership between activists against sexual assault and right-wing politicians, Lepore writes, "Because victims' rights is a marriage of feminism and conservatism, the logic behind its signal victory, the victim-impact statement, rests on both the therapeutic, speak-your-truth commitment of a trauma-centered feminism and the punitive, lock-them-up imperative of law-and-order conservatism. Arguably, this has been a bad marriage."[27] That is not to say that activism is bad, but that performative theatrics do not belong in a courtroom, and that abridging the rights of the accused is (as Zoë Heller and others have argued) no help to feminism.

Among the few to speak in the first person about preferential treatment for victims and correspondingly threatened rights of the accused is feminist cultural critic Sarah Schulman, who contends, "when I hear 'When a woman says *no*, she means *no*,' I know that that is too simple, because I have said *no* when I didn't mean it."[28] The statement appears in a book titled, bracingly, *Conflict Is Not Abuse*. In its subtitle, *Overstating Harm, Community Responsibility and the Duty of Repair*, Schulman outlines her themes: that taking risks is a vital part of being human, that "the fact that something could go wrong does not mean that we are in danger. It means that we are alive." And that dwelling on—celebrating—fear and threat is not just unhelpful but morally culpable: "Experiencing anxiety does not mean that anyone is doing anything to us that is unjust,"[29] she writes. "Refuting male supremacy does not mean pretending that we all understand ourselves completely."[30] And "making an accusation does not make us right, being angry does not make us right, refusing

to communicate does not make us right."[31] Finally, "We're not talking here about the tired false cliché of the vindictive woman who 'cries rape'.... What we have instead is a devolved definition of personal responsibility."[32] Schulman's book is intemperate and in some places muddled, but it has the force of candor in an area where bromides and prevarication too often prevail.

Arguing against the celebration of victimhood, Schulman charts territory also mapped by feminist scholar Sharon Marcus, who believes it is imperative we drain rape of its emotional force. We might start, Marcus wrote in 2002, by changing the story it tells: one way "to refuse to recognize rape as the real fact of our lives," she suggests, "is to treat it as a *linguistic* fact."[33] Women have internalized a sense of themselves as wholly and irremediably vulnerable and sexualized, she contends, which leads us "to equate rape with death, the obliteration of the self."[34] Following a famous statesman, she believes fear itself is our worst enemy. "Even though women in fact are neither the sole objects of sexual violence nor the most likely targets of violent crimes," Marcus points out, "women constitute the majority of fearful subjects." She is hardly among the first to suggest we reject the rape "script" by "resisting the physical passivity which it directs us to adopt." (In a recent conversation, she cited criminology studies that counter the undying belief that fighting back puts victims at greater risk.[35]) But Marcus is on her own in suggesting that a rewritten rape script might include "treating it as a farce."[36]

Marcus insists it is not just within our ability as women to avert attack—by treating it as a joke, by retaliating physically—it is essential to our liberation. "The horror of rape," she writes, "is not that it steals something from us but that it makes us into things to be taken." A little grudgingly, she ends by admitting, "the ethical burden to prevent rape does not lie with us but with rapists and a society which upholds them," but then adds, "we will be waiting a long time if we wait for men to decide not to rape."[37] No doubt. And while novel in

some respects, Marcus's argument echoes elements of Didion's bid for identifying survivors by name. Both authors put unfamiliar pressure on the intractable question of exactly where rape does harm. Is it to the body? To the mind?

It can be said that rape sometimes does most damage by its offense to honor. Although it is an injury that can certainly be felt by the victim, violated honor is fundamentally a culturally constructed malignancy whose worst effects are often felt by the victim's family and community. In this leakage of pain and outrage from individual to collective bodies, responsibility for the assault shifts, too, sometimes disastrously. Thus are victims discredited—and at worst, blamed.

The questions Marcus, Lepore, Schulman, and others raise about qualifying injury and rewriting conventional narratives bear directly on the visual representation of sexual violation. Is ending rape an attainable goal? Can art help with that? Venturing to answer in the positive requires also acknowledging that it is still, despite everything, hard to talk about. Harassment is easier, inequity in pay is easier, injustice is easier. Bad dates are easier. Terror is hard. It isn't a subject that unifies, and unity is not a diminishing value. On the contrary. In a recent book about loneliness, Olivia Laing indicts a "gentrification [of the] emotions."[38] That seems just right to me. Too often, in contemporary culture, feeling is cleaned up—is renovated for cogency at best, for wide marketability at worst. In VALIE EXPORT's urban interventions, as in Suzanne Lacy's spectacles of testimony and activism, Ana Mendieta's tableaux, and Nancy Spero's scrolls, and even in Vito Acconci's performances, one sees emotions before renovation: raging, sorrowing, unconscionably intrusive, unspeakably shameful, unforgettably honest.

To be clear: we have abundant cause for celebration. Some forms of rape have long been declining. Over the past several decades a wealth of artists—and not only female ones—have addressed sexual violence with increasing freedom and received sympathetic

consideration. More flexible and tolerant attitudes toward sexual identity have opened and enriched discussions of gender relations generally. That doesn't mean sexual violence is no longer a problem. But it does suggest that moving forward, we need to remain alert to the specifics of violation. Vulnerability is not equally distributed. Not all harms are equivalent. Danger must be faced honestly and openly—by artists, by viewers, by everyone. Opposing the unfortunate tendency to circle the wagons, Johanna Fateman, writing in *Artforum*, calls for difficult work—for art that is painful, challenging, "triggering": "To want to be triggered by art," she writes, "is perhaps as simple as wanting objects and images that cut through, that synthesize the evidence in jolting ways, or that distill our era's dreadful background hum into compelling new symbols."[39] It is an invitation to make just the kind of work pioneered by artists in the seventies and extended in its wake: an art that is unyielding in its truth to unspeakable experience.

ENDNOTES

CHAPTER 1

1. Suzanne Lacy, *Leaving Art: Writings on Performance, Politics, and Publics, 1974–2007* (Durham and London: Duke University Press, 2010), 95.
2. Oral history interview with Suzanne Lacy, 1990, March 16–September 27, conducted by Moira Roth, Archives of American Art, Smithsonian Institutions, 8. Accessed May 7, 2016 at www.aaa.si.edu/collections/interviews/ oral-history-interview-suzanne-lacy12940#transcript.
3. Terry Eagleton, *On Evil* (New Haven and London: Yale University Press, 2010), 84.
4. Eagleton, *On Evil*, 12–13.
5. Judith Butler, *Precarious Life: The Powers of Mourning and Violence* (London and New York: Verso, 2006), 27.
6. Butler, *Precarious Life*, 29.
7. Judith Herman, *Trauma and Recovery: The Aftermath of Violence—From Domestic Abuse to Political Terror* (New York: Basic Books, 2015), 51.
8. Elaine Scarry, *The Body in Pain: The Making and Unmaking of the World* (New York and Oxford: Oxford University Press, 1985), 4.
9. As literary theorist Shoshana Felman explains, speech acts admit no challenge: "Austin's fundamental gesture ... consists in substituting, with respect to utterances of the language, the criterion of *satisfaction* for the criterion of *truth*." Shoshana Felman, *The Scandal of the Speaking Body: Don Juan with J. L. Austin, or Seduction in Two Languages* (Stanford: Stanford University Press, 2003), 41. Hence speech acts are terminal, or in Felman's term, "untranslatable" (59).
10. Art historian Mieke Bal has made a similar argument, calling rape a speech act that "appropriates" its subject. Mieke Bal, *Looking In: The Art of Viewing* (Amsterdam: G+B Arts International, 2001), 109.
11. Maggie Nelson, *The Art of Cruelty: A Reckoning* (New York and London: W. W. Norton, 2011), 260.
12. Maria Tatar, *Lustmord: Sexual Murder in Weimar Germany* (Princeton: Princeton University Press, 1995), 13.
13. Susan Brownmiller, *Against Our Will: Men, Women and Rape* (New York: Fawcett Columbine, 1993), 8.
14. Simone de Beauvoir, *The Second Sex* (New York: Vintage Books, 2011), 3.
15. Beauvoir, *The Second Sex*, 62.
16. Beauvoir, *The Second Sex*, 283.
17. Beauvoir, *The Second Sex*, 104.
18. Beauvoir, *The Second Sex*, 171.
19. Beauvoir, *The Second Sex*, 332.
20. Beauvoir, *The Second Sex*, 395.
21. Beauvoir, *The Second Sex*, 335.
22. Beauvoir, *The Second Sex*, 365.
23. Beauvoir, *The Second Sex*, 367.
24. Beauvoir, *The Second Sex*, 412.
25. Beauvoir, *The Second Sex*, 396.
26. Beauvoir, *The Second Sex*, 459.
27. Beauvoir, *The Second Sex*, 419.
28. Beauvoir, *The Second Sex*, 311.
29. Beauvoir, *The Second Sex*, 642.

30. Beauvoir, *The Second Sex*, 749.
31. www.ourbodiesourselves.org, 16.
32. Typescript in the Brownmiller archives, Arthur and Elizabeth Schlesinger Library, Radcliffe Institute for Advanced Study, Harvard University.
33. It formed the core of the deceptively slender volume called *Rape: The Power of Consciousness*, published in 1979.
34. Susan Griffin, "Rape: The All-American Crime," *Ramparts*, September 1971, 26–35, at 30.
35. Griffin, "Rape: The All-American Crime," 33–34.
36. Brownmiller, *Against Our Will*, 12.
37. Transcript in the Brownmiller archives.
38. Brownmiller, *Against Our Will*, 252.
39. Brownmiller, *In Our Time: Memoir of a Revolution* (New York: Delta, 1999), 217.
40. Jill Lepore, "The Rise of the Victims'-Rights Movement," *New Yorker*, May 2018, 50.
41. Conversation with the author, October 27, 2016.
42. Menachem Amir, *Patterns in Forcible Rape* (Chicago and London: University of Chicago Press, 1971), 327.
43. Amir, *Patterns in Forcible Rape*, 130.
44. Amir, *Patterns in Forcible Rape*, 299.
45. Amir, *Patterns in Forcible Rape*, 184.
46. Amir, *Patterns in Forcible Rape*, 296.
47. Amir, *Patterns in Forcible Rape*, 189.
48. Amir, *Patterns in Forcible Rape*, 229.
49. Amir, "Victim Precipitated Forcible Rape," *Journal of Criminal Law and Criminology* 58 (1968), 493.
50. Amir, *Patterns in Forcible Rape*, 163.
51. Amir, *Patterns in Foricible Rape*, 173.
52. Amir, "Victim Precipitated Forcible Rape," 501.
53. Amir, *Patterns in Forcible Rape*, 267.
54. Amir, *Patterns in Forcible Rape*, 173.
55. Amir, *Patterns in Forcible Rape*, 254.
56. Amir, *Patterns in Forcible Rape*, 333.
57. Amir, *Patterns in Forcible Rape*, 245.
58. Gay Talese, *Thy Neighbor's Wife* (1981, revised 2009; HarperCollins e-books).
59. Amir, *Patterns in Forcible Rape*, 326.
60. Susan Griffin, *Rape: The Politics of Consciousness* (San Francisco, Harper & Row, 1986), 5.
61. Conversation with the author, March 30, 2018.

CHAPTER 2

1. Linda Nochlin, "Why Have There Been No Great Women Artists?" (originally published in *ARTnews*, January 1971), in *Women Artists: The Linda Nochlin Reader*, ed. Maura Reilly (New York: Thames & Hudson, 2015), 45.
2. Michael Kirby, "On Acting and Not-Acting," in *The Art of Performance: A Critical Anthology*, ed. Gregory Battcock and Robert Nickas (New York: E. P. Dutton, 1984), 98.
3. Kirby, "On Acting and Not-Acting," 103.
4. Jane Blocker, "No one true identity exists prior to the act of performing," *Where Is Ana Mendieta?: Identity, Performativity, and Exile* (Durham and London: Duke University Press, 1999), 25.
5. In the 1971 paperback edition of *Grapefruit*, Ono added, "the performer, however, does not have to be a woman."

6. Alexandra Munroe with Jon Hendricks and others, *Yes Yoko Ono* (New York: Japan Society and Harry N. Abrams, 2000), 277.
7. Alexandra Munroe, "Spirit of YES: The Art and Life of Yoko Ono," in *Yes Yoko Ono*, 28.
8. Kristine Stiles, "Between Water and Stone: A Metaphysics of Acts," in *In the Spirit of Fluxus*, Simon Anderson and Elizabeth Armstrong (Minneapolis: Walker Art Center, 1993), 85.
9. Kristine Stiles, "Cut Piece, 1964," in *Yes Yoko Ono*, 158.
10. As well as *Cut Piece* she performed *Whisper Piece* (like the game "telephone" but with whispered messages, which progressively decay) and *Shadow Piece* (in which she traced the bodies of twenty participants on a long piece of cloth at a playground bombed during World War II "and still littered by debris.") Stiles, "Cut Piece, 1964," in *Yes Yoko Ono*, 168. Ono was also represented by performances in which she did not appear.
11. Stiles, "Cut Piece, 1964," 158.
12. Munroe, "Spirit of YES," 28.
13. Yoko Ono, "'If I Don't Give Birth Now, I Will Never Be Able To,' Just Me! The Very First Autobiographical Essay by the World's Most Famous Japanese Woman" (Tokyo: Kodansha International, 1986). Originally published in the Japanese magazine *Bugei Shunju*, Summer 1974. Translation commissioned by Kevin Concannon, for "Imagine Peace: Yoko Ono's CUT PIECE: From Text to Performance and Back Again," in *PAJ: A Journal of Performance and Art* 90, September 2008, accessed March 13, 2017, imaginepeace.com/archives/2680.
14. In Concannon, "Yoko Ono's CUT PIECE."
15. Munroe, "Spirit of YES," 28.
16. In Concannon, "Yoko Ono's CUT PIECE."
17. Peggy Phelan, "The Returns of Touch: Feminist Performances, 1960–80," in *WACK! Art and the Feminist Revolution*, ed. Cornelia Butler and Lisa Gabrielle Mark (Cambridge and London: MIT Press, 2007), 358.
18. Chrissie Iles, "VALIE EXPORT: Body, Space, Splitting, Projection," in Iles, Kristine Stiles, Gary Indiana, and Robert Fleck, VALIE EXPORT: *Ob/De+Con(struction)*, (Philadelphia: Goldie Paley Gallery/Moore College of Art and Design, [1999]), 36.
19. Kristine Stiles, "CORPORA VILIA, VALIE EXPORT's Body," in *VALIE EXPORT: Ob/De+Con(struction)*, 27.
20. Robert Fleck, "VALIE EXPORT," in *VALIE EXPORT: Ob/De+Con(struction)*, 9.
21. Fleck, "VALIE EXPORT," 9.
22. Stiles, "CORPORA VILIA, VALIE EXPORT's Body," 27.
23. Iles, "VALIE EXPORT," 35.
24. Roswitha Mueller, *VALIE EXPORT: Fragments of the Imagination* (Bloomington: Indiana University Press, [1994]), xix.
25. Fleck, "VALIE EXPORT," 13.
26. Jovana Stokić, "The Art of Marina Abramović: Leaving the Balkans, Entering the Other Side," in ed. Klaus Biesenbach, *Marina Abramović: The Artist is Present* (New York: Museum of Modern Art, 2010), 24.
27. Arthur C. Danto, "Danger and Disturbation: The Art of Marina Abramović," in *Marina Abramović: The Artist is Present*, 31.
28. Klaus Biesenbach, "Marina Abramović: The Artist is Present. The Artist Was Present. The Artist Will Be Present," in *Marina Abramović: The Artist is Present*, 17.
29. Danto, "Danger and Disturbation," 32.
30. Danto, "Danger and Disturbation," 32–33.
31. Biesenbach, "The Artist Is Present," 14.
32. "Liquid Knowledge: Marina Abramović in conversation with Adrian Heathfield," in *The Cleaner: Marina Abramović* (Berlin: Hatje Cantz, 2017), 34.

33. Hans Ulrich Obrist: *Marina Abramović: The Conversation Series 23* (Cologne: Walter König, 2010), 86–89.

34. Conversation with the author, June 7, 2018.

35. Lucy Lippard, "The Pains and Pleasures of Rebirth: European and American Women's Body Art," originally published in *Art in America*, May–June 1976, reprinted in *From the Center: Feminist Essays on Women's Art* (New York: E. P. Dutton, 1976), 123.

36. Lippard, "The Pains and Pleasures of Rebirth," 126.

37. Lippard, "The Pains and Pleasures of Rebirth," 137.

38. Robert Nickas, "Introduction," *The Art of Performance: A Critical Anthology*, ed. Gregory Battcock and Robert Nickas (New York: E. P. Dutton, 1984), ix.

39. Nickas, "Introduction," xiii.

40. Nickas, "Introduction," xvi.

41. Robert Pincus-Witten, "Vito Acconci and the Conceptual Performance," in *Postminimalism* (New York: Out Of London Press, 1977), 143, 147.

42. Transcript, oral history interview with Judith Richards, June 21–28, 2008, Archives of American Art, Smithsonian Institution.

43. Oral history interview with Judith Richards, Archives of American Art.

44. Quoted in Kate Linker, *Vito Acconci* (New York: Rizzoli, 1994), 22.

45. Interview with Liza Bear in *Avalanche* magazine, Fall 1972, 71.

46. Vito Acconci and Gregory Volk, *Vito Acconci: Diary of a Body, 1969–1973* (Milan and New York: Charta, 2006), 39.

47. It was sponsored by the Architectural League in New York, and also included works by Arakawa, Scott Burton, Les Levine, John Perreault, Marjorie Strider, and Bernadette Mayer (to whom Acconci was then married).

48. Acconci, *Diary of a Body*, 76.

49. They included critics David Bourdon, Michael Kirby, and Willoughby Sharp (all of whom would later write about his work); the gallery owners Paula Cooper and John Gibson; artists Dan Graham, Richard Serra, Walter de Maria, all highly respected; and the then Whitney Museum curator Marcia Tucker.

50. He wrote, "When I did the piece, nobody photographed me. I didn't want anybody to photograph me because I thought, If I'm following a person and somebody is in turn photographing me, whoever I'm following—I mean, this might be too visible; it didn't make sense." But then he realized that in "art terms," it would have no lasting impact if there were no pictures. "Art magazines deal with images. So I thought, I have to have photographs of *Following Piece*." Interview with Judith Richards, oral history transcript, Archives of American Art.

51. David Bourdon, "An Eccentric Body of Art," in *Art of Performance*, 185.

52. Bourdon, "An Eccentric Body of Art," 192.

53. Acconci, *Diary of a Body*, 82.

54. Acconci, *Diary of a Body*, 373.

55. Acconci, *Avalanche*, Fall 1972, 31.

56. Acconci, *Diary of a Body*, 77.

57. Acconci, *Avalanche*, 30.

58. Acconci, *Diary of a Body*, 186.

59. Acconci, *Avalanche*, 72.

60. Kay Larson, "Art in Review: Vito Acconci—'Performance Documentation and Photoworks, 1969–1973,'" *New York Times*, February 9, 2001, accessed May 7, 2017, nyt.com.

61. Acconci, *Diary of a Body*, 263.

62. Acconci, *Avalanche*, 43.

63. Linker, *Vito Acconci*, 44.
64. Gregory Volk, "1969–1973: Vito Acconci's Archives," *Diary of a Body*, 11.
65. Acconci, *Diary of a Body*, 359.
66. Linker, *Vito Acconci*, 56, 61.
67. Linda Montano, *Performance Artists Talking in the Eighties* (Berkeley and Los Angeles: University of California Press, 2000), 43.
68. Rosalind Krauss, "The Aesthetics of Narcissism," *October*, vol. 1 (Spring 1976), 52.
69. Krauss, "The Aesthetics of Narcissism," 50.
70. It concludes the essay. Krauss, "The Aesthetics of Narcissism," 64.
71. Ono, *Yes Yoko Ono*, 216.
72. Iles, *Yes Yoko Ono*, 216.
73. Iles, *Yes Yoko Ono*, 216.
74. Ono, *Yes Yoko Ono*, 299.
75. Anne Wagner, "Performance, Video, and the Rhetoric of Presence," *October*, vol. 19 (Winter 2000), 63.

CHAPTER 3

1. "Political Performance Art: A Discussion by Suzanne Lacy and Lucy R. Lippard," in Suzanne Lacy, *Leaving Art: Writings on Performance, Politics, and Publics, 1974-2007* (Durham and London: Duke University Press, 2010), 155.
2. Elaine Showalter, "Rethinking the Seventies: Women Writers and Violence," *The Antioch Review* vol. 39, no. 2 (Spring, 1981), reprinted in vol. 70, no. 1 (Winter 2012), 171. (She taught during those years at Douglass College, Rutgers University, and then at Princeton University.)
3. Rick Perlstein, *The Invisible Bridge: The Fall of Nixon and the Rise of Reagan* (New York and London: Simon & Schuster, 2014), 567.
4. Perlstein, *The Invisible Bridge*, 416.
5. "The Crime Wave," *Time* 105, no. 27 (June 30, 1975), 12.
6. *Estimating the Incidence of Rape and Sexual Assault,* ed. Candace Kruttschnitt, William D. Kalsbeek, Carol C. House (Washington, D.C.: National Academies Press, 2014), 69.
7. Perlstein, *The Invisible Bridge*, 481.
8. Perlstein, *The Invisible Bridge*, 290.
9. Susan Griffin, *Rape: The Politics of Consciousness* (revised edition, San Francisco: Harper & Row, 1986), 31–32.
10. Griffin, *Rape: The Politics of Consciousness*, 35.
11. Susan Brownmiller, "Street-Fighting Woman," *New York Times*, April 18, 1973, 47.
12. In the collection of the Schomburg Center for Research in Black Culture, and exhibited in the exhibition "Black Power," Feb.–Dec., 2017.
13. Leslie Labowitz, "Evolution of a Feminist Art," in *Heresies #6: On Women and Violence* (Summer 1978), 80.
14. *Heresies #6*, 54–55.
15. *Heresies #6*, 13–15.
16. *Heresies #6*, 13–15.
17. Conversation by phone with the author, January 19, 2017.
18. Jessica Stern, *Denial: A Memoir of Terror* (New York: Ecco, 2010).
19. Joanna Connors, *I Will Find You: A Reporter Investigates the Life of the Man Who Raped Her* (New York: First Grove Atlantic, 2016), 115.
20. While I was writing this book, a friend told me of an incident that occurred when she was a college student in the early '70s: a young man of color had come to the house she and a classmate were sharing, pleading for refuge from the police. Once inside, he separated the two women, raped my friend's roommate, and tied both women with

rope, warning them as he left not to call for help. When a third roommate returned—a somewhat older man who was a political activist—he too urged them not to call the "pigs" or to make a fuss. He offered not a word of sympathy. I know of other similar crimes. Judy Chicago, *Through the Flower: My Struggle as a Woman Artist* (Garden City, NJ: Doubleday, 1975), 217–19.

21. Stern, *Denial*, 7.
22. Suzanne Lacy, *Three Weeks in May: A Political Art Performance by Suzanne Lacy, May 7–May 24, 1977*, ed. Linda Macaluso, sponsored by Studio Watts Workshop, the Woman's Building, the City of Los Angeles, published semiprivately in an edition of ten copies (Los Angeles: Documentation commissioned by Studio Watts Workshop, September 1, 1980), 13.
23. Oral history interview with Suzanne Lacy, Archives of American Art, 8.
24. Chicago, *Through the Flower*, 217–19.
25. Lacy, oral history interview, Archives of American Art, 5.
26. Lacy, oral history interview, Archives of American Art, 5.
27. Lacy, *Leaving Art*, 92.
28. Lacy, oral history interview, Archives of American Art, 5.
29. Lacy, oral history interview, Archives of American Art, 7.
30. Lacy, *Leaving Art*, 96.
31. Lacy, oral history interview, Archives of American Art, 9.
32. Arlene Raven, *Crossing Over: Feminism and Art of Social Concern* (Ann Arbor and London: UMI Research Press, 1988), 27.
33. Arlene Raven, "We Did Not Move from Theory / We Moved to the Sorest Wounds," in *Rape: Dedicated to the Memory of Ana Mendieta, Whose Unexpected Death on September 8, 1985, Underscores the Violence in Our Society* (Columbus: Ohio State University Gallery of Fine Arts, 1985), 11.
34. Raven, *Crossing Over*, 26.
35. Moira Roth, ed., *The Amazing Decade: Women and Performance Art in America 1970–1980*, with contributions by Mary Jane Jacob, Janet Burdick, Alice Dubiel, and Moira Roth (Los Angeles: Astro Artz, 1983), 86.
36. Roth, *The Amazing Decade*, 18.
37. Roth, *The Amazing Decade*, 21.
38. Roth, *The Amazing Decade*, 27.
39. Julia Herzberg, "Ana Mendieta's Iowa Years, 1970–1980," in *Ana Mendieta Earth Body: Sculpture and Performance, 1982–1985*, ed. Olga Viso (Washington D.C.: Hirshhorn Museum and Sculpture Garden, Smithsonian Institution with Hatje Cantz, 2004), 256 n59.
40. Jane Blocker, *Where Is Ana Mendieta? Identity, Performativity, and Exile* (Durham and London: Duke University Press, 1999), 15.
41. Herzberg, "Ana Mendieta's Iowa Years," 156.
42. Julia Herzberg papers, Museum of Modern Art, New York.

CHAPTER 4

1. Roth, *The Amazing Decade*, 94.
2. Robin Morgan, "Goodbye, goodbye forever," *Rat*, February 9–23, 1970, quoted in Todd Gitlin, *The Sixties: Years of Hope, Days of Rage* (revised edition, New York and Toronto: Bantam Books, 1993), 362.
3. Susan Griffin, *Rape: The Politics of Consciousness*, 28.
4. Norman Mailer, *The Armies of the Night: History as a Novel/The Novel as History* (New York: Signet, 1968), 301.
5. Mailer, *The Armies of the Night*, 302–7.
6. Cathy Wilkerson, *Flying Close to the Sun: My Life and Times as a Weatherman* (New York and Toronto: Seven Stories Press, 2007), 150.

7. Mailer, *The Armies of the Night*, 307–8.
8. Gitlin, *The Sixties*, 371–72.
9. Gitlin, *The Sixties*, 370.
10. Gitlin, *The Sixties*, 363.
11. Susan Brownmiller, *In Our Time: Memoir of a Revolution* (New York: Delta, 1999), 56.
12. Gitlin, *The Sixties*, 364.
13. Wilkerson, *Flying Close to the Sun*, 242–43.
14. Wilkerson, *Flying Close to the Sun*, 84.
15. Wilkerson, *Flying Close to the Sun*, 107–8.
16. Wilkerson, *Flying Close to the Sun*, 233–34.
17. Gitlin, *The Sixties*, 375.
18. Wilkerson, *Flying Close to the Sun*, 272.
19. Wilkerson, *Flying Close to the Sun*, 318.
20. Brownmiller, *In Our Time*, 47.
21. Showalter, "Rethinking the Seventies," 167.
22. Elaine Brown, *A Taste of Power: A Black Woman's Story* (New York: Anchor Books, 1994), 109.
23. Brown, *A Taste of Power*, 115.
24. Brown, *A Taste of Power*, 192.
25. Brown, *A Taste of Power*, 367.
26. Brown, *A Taste of Power*, 192.
27. Franz Fanon, *Black Skin, White Masks* (1952; trans. Charles L. Markmann, Grove Press, 1967), 179, 156; cit. Brownmiller, *Against Our Will*, 250.
28. Perlstein, *The Invisible Bridge*, 89–90.
29. Adam Gopnik, "Kill Box: Learning from the Slaughter in Attica," *New Yorker*, August 29, 2016, 81.
30. Angela Davis, *Women, Race & Class* (New York: Vintage Books, 1983), 91.
31. Davis, *Women, Race & Class*, 173.
32. Davis, *Women, Race & Class*, 172.
33. Davis, *Women, Race & Class*, 183.
34. Davis, *Women, Race & Class*, 197.
35. Davis, *Women, Race & Class*, 199.
36. Michele Wallace, *Black Macho and the Myth of the Superwoman* (London and New York: Verso, 2015), 164.
37. Audre Lorde, *Sister Outsider: Essays and Speeches* (Berkeley: Crossing Press, 2007), 97.
38. Lorde, *Sister Outsider*, 137.
39. Brown, *A Taste of Power*, 441.
40. Brownmiller, *In Our Time*, 63.
41. Jeffrey Toobin, *American Heiress: The Wild Saga of the Kidnapping, Crimes and Trial of Patty Hearst* (New York and London: Doubleday, 2016), 127–28.
42. Toobin, *American Heiress*, 134.
43. Toobin, *American Heiress*, 128.
44. Vincent Bugliosi with Curt Gentry, *Helter Skelter: The True Story of the Manson Murders* (New York and London: W. W. Norton, 1974; afterword 1994), 301.
45. Bugliosi, *Helter Skelter*, 319.
46. Renata Adler, "Fly Trans-Love Airways," in *After the Tall Timber: Collected Nonfiction* (New York: New York Review of Books, 2015), 50–51.
47. Adler, "Toward a Radical Middle," in *After the Tall Timber*, 8–9.
48. Adler, "Toward a Radical Middle," 8.
49. Jody Pinto in conversation with the author, October 16, 2016.

50. Colophon page: "For: Deena Metzger and Sheila Levrant de Bretteville who guided me in creating this book. Written and designed by Suzanne Lacy. First edition, 300 copies, 1972; Second edition, 1000 copies, 1976. Printed at Women's Graphic Center, Los Angeles."
51. Suzanne Lacy, "Introduction," *Three Weeks in May: A Political Art Performance by Suzanne Lacy, May 7–May 24, 1977*, 14.
52. Roth, *The Amazing Decade*, 30.
53. These remarks by Labowitz and Lacy from conversation with the author, June 6, 2016.
54. Lacy, "Introduction," *Three Weeks in May*, 1.
55. Sharon Irish, *Suzanne Lacy: Spaces Between* (Minneapolis and London: University of Minnesota Press, 2010), 38.
56. Lacy, *Three Weeks in May*, 3.
57. Lacy, *Three Weeks in May*, 4.
58. Lacy, *Three Weeks in May*, 31–32.
59. Lacy, *Three Weeks in May*, 32.
60. Labowitz in conversation with the author, June 6, 2016.
61. Irish, *Suzanne Lacy*, 66.
62. Lacy, *Three Weeks in May*, 54.
63. Irish, *Suzanne Lacy*, 67.
64. *Los Angeles Times*, April 24, 1977, 17.
65. *Los Angeles Times*, May 8, 1977, 22.
66. Lacy, *Three Weeks in May*, 15.
67. Labowitz, in conversation with the author, June 6, 2016.
68. Jeff Kelley, "The Body Politics of Suzanne Lacy," in Nina Felshin, ed., *But Is it Art? The Spirit of Art as Activism* (Seattle: Bay Press, 1995), 241.
69. Irish, *Suzanne Lacy*, 71.
70. "25-Foot Rape Map: 'Three Weeks' to Dispell [sic] Myths, Alleviate Guilt for Rape Victims," *Civic Center News*, May 10–23, 1977, unsigned.
71. Cited in Irish, *Suzanne Lacy*, 43.
72. Moira Roth, *The Amazing Decade*, 31.

CHAPTER 5

1. Christopher Lasch, *The Culture of Narcissism: American Life in an Age of Diminishing Expectations* (New York: Warner Books, 1979), 21–22.
2. Lasch, *The Culture of Narcissism*, 29.
3. Lasch, *The Culture of Narcissism*, 39.
4. Lasch, *The Culture of Narcissism*, 49.
5. Lasch, *The Culture of Narcissism*, 96–97.
6. Lasch, *The Culture of Narcissism*, 128.
7. In an essay on "Narcissism and Modern Culture," Sennett urged "escape from the curse that is psychic activity." Richard Sennett, *October*, vol. 4 (Autumn 1977), 70–79, at 79.
8. Peggy Phelan, "The Roberta Breitmore Series: Performing Co-Identity," in *Lynn Hershman Leeson: Civic Radar*, ed. Peter Weibel (Karhsruhe: ZKM and Hatje Cantz, 2016), 103.
9. *The Art and Films of Lynn Hershman Leeson: Secret Agents, Private I*, edited by Meredith Tromble (Berkeley and Los Angeles: University of California Press, 2005), 25.
10. *The Art and Films of Lynn Hershman Leeson*, 26, 33.
11. *The Art and Films of Lynn Hershman Leeson*, 26.
12. In ed. Biesenbach, *Marina Abramović: The Artist is Present*, 82.
13. Hou Hanru, "Interview with Lynn Hershman Leeson," in *Lynn Hershman Leeson: Civic Radar*, 175.
14. Quoted in Kristine Stiles, "Landscape of Tremors: Lynn Hershman Leeson, Toward an Intellectual History," in *Lynn Hershman Leeson: Civic Radar*, 134.

15. *The Art and Films of Lynn Hershman Leeson*, 33.

16. *The Art and Films of Lynn Hershman Leeson*, 26.

17. Robin Held, "Foreword: Hershmanlandia," in *The Art and Films of Lynn Hershman Leeson*, xiii.

18. Lasch, *The Culture of Narcissism*, 44.

19. Stiles, "Landscape of Tremors," 135.

20. *The Art and Films of Lynn Hershman Leeson*, 17.

21. Quoted in Lucy Lippard, "The Pains and Pleasures of Rebirth: European and American Women's Body Art," in *From the Center: Feminist Essays on Women's Art* (New York: E. P. Dutton, 1976), 129.

22. Laura Cottingham, quoting an interview in Maurice Berger, *Adrian Piper: A Retrospective* (Baltimore: University of Maryland Fine Arts Gallery, 1999), 63.

23. Adrian Piper, *Out of Order, Out of Sight, Volume I: Selected Writings in Meta-Art 1968–1992* (Cambridge, Mass., and London; MIT Press, 1996), 91.

24. Lucy Lippard, "An Interview with Adrian Piper," *The Drama Review* 16, no. 1, (March 1972), 76–78, at 78.

25. Piper, *Out of Order*, 92.

26. Piper, *Out of Order,* 94.

27. Piper, *Out of Order*, 102.

28. Piper, *Out of Order*, 107.

29. Piper, *Out of Order*, 112.

30. Piper, *Out of Order*, 112.

31. Maintaining the two roles simultaneously had been torturously hard. She has argued in a book-length account that the termination of her professorship was unjust and resulted from bias. Adrian Piper, *Escape to Berlin: A Travel Memoir* (Berlin: Adrian Piper Research Archive Foundation, 2018).

32. See *Escape to Berlin*.

33. Piper, *Out of Order*, 263.

34. Maurice Berger, "Styles of Radical Will: Adrian Piper and the Indexical Present," *Adrian Piper: A Retrospective*, 22.

35. Piper, *Out of Order*, 117.

36. Piper, *Out of Order*, 138.

37. Piper, *Out of Order*, 123.

38. Piper, *Out of Order*, 118.

39. Piper, *Out of Order,* 117.

40. Piper, *Out of Order*, cit. Robert Storr, Foreword, xx.

41. Maurice Berger, "The Critique of Pure Racism: An Interview with Adrian Piper," *Adrian Piper: A Retrospective*, 83–84.

42. Piper, "Introduction: Some Very FORWARD Remarks," *Out of Order*, xxxiv.

43. Wallace, *Black Macho*, 13.

44. Wallace, *Black Macho*, 161.

45. Michele Wallace, *Dark Designs and Visual Culture* (Durham, NC: Duke University Press, 2004), 109.

46. Another source of tension between black women and men—and between black women and the largely white leadership of second-wave feminism—was even more sensitive: the perception that men in the Black Power movement tended, as a result of that resentment, to prefer white women. "Black men often could not separate their interest in white women from their hostility toward black women," Wallace wrote. She wasn't alone in making the point. In a 1971 cover story for the *New York Times* magazine called "What the Black Woman Thinks of Women's Lib," Toni Morrison had mentioned "the growing rage of black women over unions of black men and white women." Reprinted

in *We Wanted a Revolution: Black Radical Women 1965–85: A Sourcebook* (New York: The Brooklyn Museum, 2017), 77.

47. Wallace, *Black Macho*, 119–20.

48. Wallace, *Black Macho*, 64.

49. Wallace, *Black Macho*, 67.

50. Wallace, *Black Macho*, 68.

51. Wallace, *Black Macho*, 41.

52. Wallace, *Dark Designs*, 97.

53. Wallace, *Black Macho*, 92.

54. "Chronology," in Christophe Cherix, Cornelia Butler, and David Platzker, *Adrian Piper: A Synthesis of Intuitions 1965–2016* (New York: Musuem of Modern Art, 2018), 314.

55. Wallace, *Black Macho*, 99.

56. Wallace, *Black Macho*, 103–4.

57. Wallace, *Black Macho*, 42.

58. Piper, *Out of Order*, cit. Storr, Foreword, xxx.

59. Lorde, *Sister Outsider*, 59.

60. Lorde, *Sister Outsider*, 120.

61. Lorde, *Sister Outsider*, 70.

CHAPTER 6

1. Conversation with the author, June 7, 2018.

2. Hans Ulrich Obrist, "Interview I: The Woman as Protagonist: Museum in Progress, Vienna, January 1994," in *The Conversation Series: Nancy Spero* (Cologne: Walther König, 2008), 38.

3. Obrist, "Interview I," 38–39.

4. Obrist, "Interview I," 25.

5. Christopher Lyon, *Nancy Spero: The Work* (Munich and London: Prestel, 2010), 10.

6. Hans Ulrich Obrist, "Interview IV: Then and Now: Artist's Studio, La Guardia Place, New York City, April 2007," in *The Conversation Series*, 72.

7. Lyon, *Nancy Spero: The Work*, 195.

8. Artist's statement, 1983, in Diana Nemiroff, Luisa Valenzuela, Elaine Scarry, ed. Lisa Pearson, *Nancy Spero: Torture of Women* (Los Angeles, Siglio, 2010), 103.

9. "Jo Anna Isaak in conversation with Nancy Spero," in Jon Bird, Jo Anna Isaak, and Sylvère Lotringer, *Nancy Spero* (London: Phaidon, 1996), 24.

10. Hélène Cixous, "The Laugh of the Medusa," *Signs*, vol. 1, no. 4 (Summer 1976), 885, 893.

11. Obrist, "Interview I," 32.

12. Obrist, "Interview I," 31.

13. Lyon, *Nancy Spero: The Work*, 218.

14. Spero on *Sexual Abuse of Women and Children* (1979), in Stephanie Blackwood, *Rape: Dedicated to the Memory of Ana Mendieta, whose Unexpected Death on September 8, 1985, Underscores the Violence in our Society* (Columbus: Ohio State University Gallery of Fine Art, 1985), 87.

15. Diana Nemiroff, "Fourteen Meditations on Nancy Spero's Torture of Women," in *Torture of Women*, 120.

16. Elaine Scarry, *The Body in Pain: The Making and Unmaking of the World* (New York and Oxford: Oxford University Press, 1985), 57.

17. Nemiroff, "Fourteen Meditations," 114.

18. "Jo Anna Isaak in conversation with Nancy Spero," 30.

19. Nemiroff, "Fourteen Meditations," 114, 115.

20. Sylvère Lotringer, "Focus," in Bird, Isaak, Lotringer, *Nancy Spero*, 101.

21. Lyon, *Nancy Spero: The Work*, 199.

22. Lacy, *Leaving Art*, 104–5.

23. Robin Morgan, *Going Too Far: The Personal Chronicle of a Feminist* (New York: Random House, 1977), 168–69.

24. Morgan, *Going Too Far*, 166.

25. Morgan, *Going Too Far*, 167.

26. Morgan, *Going Too Far*, 168.

27. Brownmiller, *In Our Time*, 295–96.

28. Brownmiller, *In Our Time*, 298.

29. Brownmiller, *In Our Time*, 299.

30. Andrea Dworkin, *Pornography: Men Possessing Women* (New York: G. P. Putnam's Sons, 1979), 23.

31. Dworkin, *Pornography*, 201.

32. Dworkin, *Pornography*, 201.

33. Dworkin, *Pornography*, 45-46.

34. Carol S. Vance, "More Danger More Pleasure: A Decade after the Barnard Sexuality Conference," in *Pleasure and Danger: Exploring Female Sexuality*, ed. C. S. Vance (London: Pandora/HarperCollins, 1989; first published by Routledge, 1984), xxvi.

35. Brownmiller, *In Our Time*, 325.

36. Vance, "More Danger More Pleasure," xvii.

37. Vance, "More Danger More Pleasure," xix.

38. Vance, "More Danger More Pleasure," xxviii.

39. Vance, "More Danger More Pleasure," 24.

40. Simone de Beauvoir, "Must We Burn Sade?," translated by Kim Allen Gleed, Marilyn Gaddis Rose, and Virginia Preston, with notes by Lauren Guilmett, in *Political Writings* ed. Margaret Simons and Marybeth Timmermann (Urbana: University of Illinois Press, 2012), 85.

41. Beauvoir, "Must We Burn Sade?," 86.

42. Beauvoir, "Must We Burn Sade?," 93–94.

43. Beauvoir, "Must We Burn Sade?," 45.

44. Beauvoir, "Must We Burn Sade?," 92, 95, 90.

45. Beauvoir, "Must We Burn Sade?," 90.

46. Roger Shattuck, *Forbidden Knowledge: From Prometheus to Pornography* (San Diego and New York: Harcourt Brace, 1996), 237–38.

47. Shattuck, *Forbidden Knowledge*, 238.

48. Georges Bataille, *Erotism: Death & Sensuality*, trans. Mary Dalwood (San Francisco: City Lights Books, 1986), 16.

49. Bataille, *Erotism*, 90.

50. Bataille, *Erotism*, 107.

51. Bataille, *Erotism*, 135, 138.

52. Susan Sontag, "The Pornographic Imagination," in *Styles of Radical Will* (New York: Farrar, Straus and Giroux, 1975), 213.

53. Sontag, "The Pornographic Imagination," 214.

54. Sontag, "The Pornographic Imagination," 223–24.

55. Sontag, "The Pornographic Imagination," 232.

56. Angela Carter, *The Sadeian Woman & the Ideology of Pornography* (London: Virago, 1979), 3.

57. Carter, *The Sadeian Woman*, 6.

58. Carter, *The Sadeian Woman*, 9.

59. Carter, *The Sadeian Woman*, 13.

60. Carter, *The Sadeian Woman*, 29.

61. Carter, *The Sadeian Woman*, 31.

62. Nelson, *The Art of Cruelty*, 17.

63. Spalding Gray, "The Farmer's Daughter," in *Wild History*, ed. Richard Prince (New York: Tanam Press, 1985), 203–22.

64. Gay Talese, *Thy Neighbor's Wife*, (HarperCollins e-book; first published New York: Doubleday, 1980), 37.

65. Talese, *Thy Neighbor's Wife*, 502.

66. Talese, *Thy Neighbor's Wife*, 257.

67. Talese, *Thy Neighbor's Wife*, 502.

68. Obrist, "Interview III: A Polyphony of Protagonists, Telephone Interivew," in *The Conversation Series*, 70.

69. Spero, Artist's project for *Artforum*, March 1988, reprinted in Bird, Isaak, Lotringer, *Nancy Spero*, 140.

70. Spero, statement in *Torture of Women*, 103.

71. Quoted in Susan Harris, "Dancing in Space," in *Nancy Spero* (Malmö Konsthall: Malmö, 1994), 13.

72. Lucy Lippard, "Taking Liberties," *Village Voice*, December 14, 1982, reprinted in *Ida Applebroog* (New York: Ronald Feldman NY, 1987).

73. Ida Applebroog, statement, in Blackwood, *Rape*, 19.

74. Conversation with the author, January 31, 2019.

75. Marcy Hermansader, statement, in Blackwood, *Rape*, 47.

76. Jerri Allyn, statement, in Blackwood, *Rape*, 15.

77. Paul Marcus, statement, in Blackwood, *Rape*, 59.

CHAPTER 7

1. Recent research has challenged the attribution of the earlier painting.

2. Mieke Bal, "Calling to Witness: Lucretia," in Bal, *Looking In: The Art of Viewing* (Amsterdam: G+B Arts International, 2001), 100.

3. Diane Wolfthal, *Images of Rape: The 'Heroic' Tradition and Its Alternatives* (Cambridge, UK, and New York: Cambridge University Press, 1999), 9.

4. Wolfthal, *Images of Rape*, 17.

5. Wolfthal, *Images of Rape*, 30–32.

6. Norman Bryson, "Two Narratives of Rape in the Visual Arts: Lucretia and the Sabine Women," in *Rape: An Historical and Cultural Enquiry*, ed. Sylvia Tomaselli and Roy Porter (Oxford: Basil Blackwell, 1986), 153.

7. Bryson, "Two Narratives of Rape," 154.

8. Bryson, "Two Narratives of Rape," 156.

9. Bryson, "Two Narratives of Rape," 159.

10. Bryson, "Two Narratives of Rape," 153.

11. Bryson, "Two Narratives of Rape," 167.

12. Bryson, "Two Narratives of Rape," 168.

13. Bryson, "Two Narratives of Rape," 170.

14. Bryson, "Two Narratives of Rape," 173.

15. Terry Eagleton, *Sweet Violence: The Idea of the Tragic* (Oxford: Blackwell, 2003), 89.

16. Eagleton, *Sweet Violence*, 103.

17. Angela Carter, *The Sadeian Woman*, 127.

18. Paul Jamot, cited in Theodore Reff, *Degas: The Artist's Mind* (New York: Metropolitan Museum of Art/Harper and Row, 1976), 201.

19. Carol Armstrong, *Odd Man Out: Readings of the Work and Reputation of Edgar Degas* (Chicago and London: University of Chicago Press, 2011), 96.

20. Griselda Pollock, "What Difference Does Feminism Make to Art History?" in *Dealing*

with Degas: Representations of Women and the Politics of Vision, ed. Richard Kendall and Pollock (New York: Universe, 1992), 25.

21. From *Philadelphia Musem of Art: Handbook of the Collections*, accessed January 2019, www.philamuseum.org/collections/permanent/82556.html.

22. Cited in *Masterpieces from the Philadelphia Museum of Art: Impressionism and Modern Art*, accessed January 2019, www.philamuseum.org/collections/permanent/82556.html.

23. Jeffrey Meyers, "Degas's 'Misfortunes of the City of Orléans in the Middle Ages': A Mystery Solved," *Notes in the History of Art*, vol. 21, no. 4 (Summer 2002), 11–16.

24. Wolfthal, *Images of Rape*, 197.

25. Maria Tatar, *Lustmord: Sexual Murder in Weimar Germany* (Princeton: Princeton University Press, 1995), 15.

26. Tatar, *Lustmord*, 74.

27. Tatar, *Lustmord*, 111.

28. Tatar, *Lustmord*, 128.

29. Olaf Peters, "'Painting, A Medium of Cool Execution': Otto Dix and Lustmord," in *Otto Dix*, ed. O. Peters (Munich and Berlin: Prestel, 2011), 99; exhibition catalogue, the Montreal Museum of Fine Arts and Neue Galerie, New York.

30. Peters, "'Painting, A Medium of Cool Execution,'" 101.

31. Tatar, *Lustmord*, 97.

32. Peters, "'Painting, A Medium of Cool Execution,'" 103.

33. Tatar, *Lustmord*, 90.

34. Peters, "'Painting, A Medium of Cool Execution,'" 102.

35. Peters, "'Painting, A Medium of Cool Execution,'" 105.

36. Peters, "'Painting, A Medium of Cool Execution,'" 94.

37. David Sylvester, *Looking at Giacometti* (New York: Henry Holt, 1994), 60.

38. Tate website, accessed January 2019,www.tate.org.uk/whats-on/tate-modern/exhibition/surrealism-desire-unbound/surrealism-desire-unbound-room-9-her

39. *Alberto Giacometti* (New York: MoMA/Doubleday, 1965), 24.

40. Sue Taylor, *Hans Bellmer: The Anatomy of Anxiety* (Boston: MIT, 2000), 96.

41. Sarah Whitfield, *Magritte* (London: Hayward Gallery, 1992), exhibition catalogue.

42. https://www.moma.org/interactives/exhibitions/2013/magritte/#/featured/4 (site discontinued).

43. Hal Foster, *Compulsive Beauty* (Cambridge, MA, and London: MIT Press, 1995), 95.

44. Renata Adler, "Toward a Radical Middle: Introduction," in *After the Tall Timber*, 8. Cited in chapter 4.

45. Kate Millett, *Sexual Politics* (New York: Ballantine Books, 1978), 13.

46. Millett, *Sexual Politics*, 21.

47. Evan S. Connell Jr., *The Diary of a Rapist* (New York: Simon and Schuster, 1966), 251.

48. Rosalind Krauss, *The Optical Unconscious* (Cambridge, MA, and London: MIT Press, 1993), 111–19.

49. Showalter, "Rethinking the Seventies," 164.

50. Showalter, "Rethinking the Seventies," 166.

51. Showalter, "Rethinking the Seventies," 170.

52. Diane Johnson, *The Shadow Knows* (New York: Plume, 1974), 275–76.

53. Johnson, *The Shadow Knows*, 276–77.

54. Lois Gould, *A Sea-Change* (New York: Simon and Schuster, 1976), 14, 15.

55. Gould, *A Sea-Change,* 18

56. Margaret Drabble, "Thinking About Rape," *New York Times*, January 21, 1979.

57. Showalter, "Rethinking the Seventies," 171.

58. Leslie Maitland, "Women Learn to Take a Stand: Meeting Violence With Violence," *New York Times*, April 1, 1975, 40. Typescript of Gould's talk in Susan Brownmiller

papers, Schlesinger Library, Radcliffe Institute for Advanced Study at Harvard University.
59. Susan Sontag, "Artaud," in *Antonin Artaud: Selected Writings*, ed. Sontag (New York: Farrar, Straus and Giroux, 1976), xxxiv–xxxv.
60. Lasch, *The Culture of Narcissism*, 161.
61. Leslie Epstein, "Walking Wounded, Living Dead," in *Sixties: The Art, Attitudes, Politics, and Media of our Most Explosive Decade*, ed. Gerald Howard (New York: Washington Square Press, 1982), 375.
62. Typescript of review in Susan Brownmiller papers.
63. Neil Genzlinger, "Myrna Lamb, Feminist Playwright in an Unwelcoming Era, Dies at 87," *New York Times*, September 22, 2017.
64. Typescript of talk in Susan Brownmiller papers.
65. Molly Haskell, *From Reverence to Rape: The Treatment of Women in the Movies* (Chicago and London: University of Chicago Press, 1987), 30.
66. Haskell, *From Reverence to Rape*, 323, 361.
67. Haskell, *From Reverence to Rape*, 31.
68. Haskell, *From Reverence to Rape*, 323, 329.
69. Haskell, *From Reverence to Rape*, 365.
70. Haskell, *From Reverence to Rape*, 386, 388.

CHAPTER 8

1. David Fahrenthold, "Statistics Show Drop in US Rape Cases," *Washington Post*, June 19, 2006.
2. Christopher Glazek, "Raise the Crime Rate," *n+1* Issue 13: Machine Politics (Winter 2012); accessed January 2019, https://nplusonemag.com/issue-13/politics/raise-the-crime-rate/.
3. Hal Foster, *Bad New Days: Art, Criticism, Emergency* (London: Verso Books, 2015), 7.
4. Foster, *Bad New Days*, 29.
5. Katie Roiphe, *The Morning After: Sex, Fear, and Feminism* (Boston and New York: Little, Brown), 36.
6. Roiphe, *The Morning After*, 4.
7. Lane Relyea in *Helter Skelter: L.A. Art in the 1990s*, exhibition organized by Paul Schimmel (Los Angeles: Museum of Contemporary Art, 1992), 34.
8. Relyea, *Helter Skelter*, 42.
9. *Helter Skelter*, 55.
10. Monica Chau, Hannah J. L. Feldman, Jennifer Kabat, and Hannah Kruse, "Introduction," *The Subject of Rape* (New York: Whitney Museum of American Art, 1993), 8–9.
11. Hannah J. L. Feldman, "More Than Confessional: Testimonial and the Subject of Rape," in *Subject of Rape*, 13.
12. Joan Didion, "New York: Sentimental Journeys," *New York Review of Books*, January 17, 1991, reprinted in Joan Didion, *Sentimental Journeys* (London: HarperCollins, 1993), 86.
13. Dan Cameron, "Reverse Backlash: Sue Williams' Black Comedy of Manners," *Artforum*, November 1992, 71.
14. Cameron, "Reverse Backlash," 73.
15. Glazek, "Raise the Crime Rate."
16. Sue Turton, "Bosnian War Rape Survivors Speak of their Suffering 25 Years On," *Independent*, July 21, 2017.
17. Conversation with the author, March 31, 2018.
18. *Jenny Holzer: Lustmord*, Kunstmuseum des Kantons Thurgau (Ostfildern-Ruit: Cantz, 1996), 122.
19. Piper, *Out of Order*, 253–54.

20. Piper, *Out of Order*, 253.
21. *The Art and Films of Lynn Hershman Leeson*, 14.
22. *The Art and Films of Lynn Hershman Leeson*, 147.
23. The first, *Ceci n'est pas un viol* (this is not a rape; the title plays on two works by Magritte), of 2015, is a "restaging" of her alleged rape. Using footage from four video cameras, Sulkowicz presents a sexual encounter that starts out clearly consensual and then goes into territory involving a few hard slaps and unwanted anal intercourse. It is viewable online and open to comments; those I saw were not friendly; many viewers treated the video as pornography. With *The Ship is Sinking*, in 2017, Sulkowicz stripped down again, enacting a tepid S&M scenario: wearing a very teeny bikini, she had herself tied to a wooden beam and hoisted aloft. A performance series presented in 2018, titled *, has her standing naked except for a G-string and asterisk-shaped panties in front of paintings by famous men who have been accused of abuse. It's hard for me to see beyond this work's exhibitionism.

CONCLUSION

1. Conversation with the author, March 31, 2018.
2. Conversation with the author, January 31, 2019.
3. Katrina Forrester, "Lights. Camera. Action: Making Sense of Modern Pornography," *New Yorker*, September 27, 2016, 64.
4. Maggie Jones, "What Teenagers Are Learning from Online Porn," *New York Times* magazine, February 7, 2018, accessed February 2019, nyti.ms/2BfErWv.
5. Figure 4-1, "Number of victimizations of rape and sexual assault estimated by the National Crime Victimization Survey," (source: Bureau of Justice Statistics), *Estimating the Incidence of Rape and Sexual Assault* (Washington, DC: National Academies Press, 2014), 67.
6. Table 4-4, *Estimating the Incidence of Rape and Sexual Assault*, 68–69. According to the FBI's own information: "In 2013, the FBI UCR [Uniform Crime Reporting] initiated the collection of rape data under a revised definition and removed the term 'forcible' from the offense name. The UCR program now defines rape as follows: Rape (revised definition): Penetration, no matter how slight, of the vagina or anus with any body part or object, or oral penetration by a sex organ of another person, without the consent of the victim. (This includes the offenses of rape, sodomy, and sexual assault with an object as converted from data submitted via the National Incident-Based Reporting System.) Rape (legacy definition): The carnal knowledge of a female forcibly and against her will." Accessed February 2019, https://ucr.fbi.gov/crime-in-the-u.s/2016/crime-in-the-u.s.-2016/tables/table-1/table-1-data-declaration.pdf. In 1993, National Women's Study found that approximately 13 percent of adult women had been victims of completed rape during their lifetime. (Using a definition of rape that includes forced vaginal, oral, and anal sex, 1n 2000 the National Violence Against Women Survey found that one in six US women and one in thirty-three US men has experienced an attempted or completed rape as a child and/or adult.)
7. *New York Times*, May 12, 2018, A22.
8. Ginia Bellafante, "In Grim Rape Statistics, Signs of Progress," *New York Times*, June 7, 2015.
9. Ginia Bellafante, "Rape by Strangers," *New York Times*, January 24, 2016.
10. Ginia Bellafante, "The Violence Off Campus," *New York Times*, June 12, 2016.
11. Sheryl Gay Stolberg and Jess Bidgood, "Some Women Won't 'Ever Again' Report a Rape in Baltimore," *New York Times*, August 11, 2016.
12. The borough's robbery squad is smaller than Manhattan's, even though the Bronx had 1,300 more cases that year. And its homicide squad had one detective for every four

murders, compared with one detective for roughly every two murders in Upper Manhattan and more than one detective per murder in Lower Manhattan. Benjamin Mueller and Al Baker, "Death, Distrust and Too Few Officers," *New York Times*, December 31, 2016.

13. It is Kattaikkuttu Sangam, under the direction of Dr. Hanne M. De Bruin, Kanchipuram District, Tamil Nadu, India.

14. Sabarimala temple: Indian women form '620km human chain' for equality," www.bbc.com, January 1, 2019. Accessed April 2019, https://www.bbc.com/news/world-asia-india-46728521.

15. Piper, *Escape to Berlin*, 245.

16. *Estimating the Incidence of Rape and Sexual Assault*, 68.

17. *Estimating the Incidence of Rape and Sexual Assault*, 83.

18. "Harvard's Sexual Assault Problem," *Harvard Magazine*, November/December 2015, 18.

19. Melissa Gira Grant, "A Life's Work: How Internal Conflict Fuels Feminism," *Bookforum*, February/March 2017, 42.

20. Alexandra Schwartz, "What She's Having: Emily Witt's Adventures in a Sexual Wonderland," *New Yorker*, October 17, 2016, 84.

21. Zoë Heller, "Rape on the Campus," *New York Review of Books*, February 5, 2015, 10.

22. Zoë Heller, "'Hot' Sex & Young Girls," *New York Review of Books*, August 18, 2016, 23.

23. Todd Gitlin, "A Crisis of Confidence on Campus," *New York Times*, November 22, 2015.

24. Interview with the author, October 27, 2016.

25. Katie Van Syckle, "*Against Our Will* Author on What Today's Rape Activists Don't Get," "The Cut," *New York*, September 17, 2015.

26. Amanda Marcotte, "Former Feminist Hero Somehow Thinks That Victim-Blaming Can Stop Rape," *The XX Factor: What Women Really Think*, September 17, 2015.

27. Jill Lepore, "Sirens in the Night: Do Victims' Rights Harm Justice?" *New Yorker*, May 21, 2018, 50.

28. Sarah Schulman, *Conflict Is Not Abuse: Overstating Harm, Community Responsibility and the Duty of Repair* (Vancouver: Arsenal Pulp Press, 2016), 49.

29. Schulman, *Conflict Is Not Abuse*, 36.

30. Schulman, *Conflict Is Not Abuse*, 41.

31. Schulman, *Conflict Is Not Abuse*, 48, 49.

32. Schulman, *Conflict Is Not Abuse*, 61.

33. Sharon Marcus, "Fighting Bodies, Fighting Words: A Theory and Politics of Rape Prevention," in *Feminists Theorize the Political*, ed. Judith Butler and Joan Scott (New York: Routledge, 2002), 388.

34. Marcus, "Fighting Bodies, Fighting Words," 394.

35. Conversation with the author, June 7, 2018.

36. Marcus, "Fighting Bodies, Fighting Words," 392.

37. Marcus, "Fighting Bodies, Fighting Words," 400.

38. Olivia Laing, *The Lonely City: Adventures in the Art of Being Alone* (New York: Picador, 2016).

39. Johanna Fateman, "Fully Loaded: Power and Sexual Violence," *Artforum*, January 2018, 183.

INDEX

INDEX

INDEX

ACKNOWLEDGMENTS

The longer I worked on this book, the more complicated it got. For their invaluable help in unraveling its many knots, I would like first to thank the artists, writers, curators, and activists who so generously shared their thoughts. They include Susan Brownmiller, Suzanne Lacy, Susan Griffin, Leslie Labowitz, Jenny Holzer, Stephanie Blackwood, Jerri Allyn, Joyce Scott, Jody Pinto, Joyce Kozloff, Ida Applebroog, Sharon Marcus, Julia Herzberg, Batya Weinbaum, Elise Siegel, and Nina Felshin. Lisa Corinne-Davis, Jo Anna Isaak, Anna Chave, Christopher Lyon, and Sandra Green all read parts of the manuscripts at various stages, and their feedback and encouragement is enormously appreciated. I would also like to acknowledge the Schlesinger Library, Radcliffe Institute for Advance Study at Harvard for providing access to the Brownmiller papers. As for managing this book's tangles, I could not have asked for a more dedicated, thoughtful, and clear-eyed editor than Elizabeth Keene, and I owe her a huge debt of gratitude, as I do to Will Balliett and everyone at Thames & Hudson for getting behind this project. Finally, I want to thank my husband, Joseph LeDoux, who has supported it, and me, unstintingly throughout.